Fashioning the City

FASHIONING THE CITY
Paris, Fashion and the Media

Agnès Rocamora

I.B. TAURIS
LONDON · NEW YORK

Published in 2009 by I.B.Tauris & Co Ltd
6 Salem Road, London W2 4BU
175 Fifth Avenue, New York NY 10010
www.ibtauris.com

Distributed in the United States and Canada Exclusively by Palgrave Macmillan,
175 Fifth Avenue, New York NY 10010

Copyright © 2009 Agnès Rocamora

The right of Agnès Rocamora to be identified as the author of this work has been asserted by her in accordance with the Copyright, Designs and Patents Act 1988.

All rights reserved. Except for brief quotations in a review, this book, or any part thereof, may not be reproduced, stored in or introduced into a retrieval system, or transmitted, in any form or by any means, eletronic, mechanical, photocopying, recording or otherwise, without the prior written permission of the publisher.

ISBN 978 1 84511 897 6

A full CIP record for this book is available from the British Library
A full CIP record is available from the Library of Congress

Library of Congress Catalog Card Number: available

Typeset by JCS Publishing Services Ltd, www.jcs-publishing.co.uk
Printed and bound in Great Britain by CPI Antony Rowe, Chippenham

CONTENTS

List of Illustrations — vii
Acknowledgments — xi

Introduction — xiii

PART I

1. Paris, France — 3
2. Paris, Fashion City — 24
3. Fashion Media Discourse — 54

PART II

4. Paris, *Capitale de la Mode* — 65
5. *La Parisienne* — 86
6. *Passante de Mode* — 126
7. The Eiffel Tower in Fashion — 156

Conclusion — 185

Endnotes — 189
Bibliography — 218
Index — 231

ILLUSTRATIONS

1	'Ça c'est Paris.' *L'Officiel*. October 2004. © L'Officiel	xii
2.1	John Singer Sargent. *In the Luxembourg Gardens*. 1879. Oil on Canvas, 65.7 x 92.4 cm. Philadelphia Museum of Art, Pennsylvania. The John G. Johnson Collection, 1917	41
2.2	'Avenue du Bois de Boulogne; Max de Cazavent suivant ses amours, Paris, 15 Janvier 1911' ['Avenue du Bois de Boulogne; Max de Cazavent following his lovers, Paris, 15 January 1911']. Photograph by Jacques Henri Lartigue © Ministère de la Culture – France / AAJHL	43
4.1	The Fabric of Paris. 'Le Marais.' *Bag*. Issue 3. Summer 2004	82
4.2	'Green spring in Le Marais.' French *Elle*. 7 November 2005. © Elle	82
5.1	Claude Monet. *Camille*. 1866. Oil on Canvas, 231 x 151 cm. Kunsthalle Bremen. Germany	87
5.2	John Singer Sargent. *Madame X* (Madame Pierre Gautreau). 1883–4. Oil on Canvas, 208.6 x 109.9 cm. The Metropolitan Museum of Art, New York. Arthur Hoppock Hearn Fund, 1916 (16.53). Image © The Metropolitan Museum of Art	88
5.3	*Les Parisiennes* by Kiraz. Cover of the Artist's *Je Les Aime Comme Ça* [That's the way I like them], a collection of *Parisiennes* drawings. First Published in 2000. © 2000 Éditions Denoël, Paris, France	88
5.4	A stencil by Miss.Tic. Paris, 13th *arrondissement*. 2007. Photograph Agnès Rocamora	89
5.5	Émile François Chatrousse. *Une Parisienne*. 1876. Plâtre patiné. Musée des Beaux Arts de la Ville de Paris, Petit Palais. © Petit Palais/Roger Viollet	93

5.6 Charles-Alexandre Giron. *Femme aux Gants* (*La Parisienne*). 1883. Oil on Canvas. Musée des Beaux Arts de la Ville de Paris, Petit Palais. © Petit Palais/Roger Viollet 93
5.7 Charles Carolus Duran. *Madame Edgar Stern*. 1889. Oil on Canvas. Musée des Beaux Arts de la Ville de Paris, Petit Palais. © Petit Palais/Roger Viollet 93
5.8 'La Parisienne. Ses 80 Looks.' *Vogue Paris*. August 2006. Photograph Mario Testino. © Vogue Paris 94
5.9 Some *Parisienne* looks. *Vogue Paris*. August 2006. Photograph Mario Testino. © Vogue Paris 104
5.10 Edouart Manet. *La Parisienne*. 1875. Oil on Canvas. © The National Museum of Fine Arts, Stockholm 108
5.11 *La Parisienne* is Paris. *Vogue Paris*. October 1998. © Vogue Paris 111
5.12 'Haute couture, L'Esprit Parisien.' *Vogue Paris*. September 1989. Photograph Peter Lindbergh. © Vogue Paris 111
5.13 'Paris, France.' 1999. Photograph Michael Ackerman. © Michael Ackerman/Agence Vu 113
5.14 'Nocturne Parisien.' *Vogue Paris*. August 2006. Photograph Mario Sorrenti. © Vogue Paris 115
5.15 'Nocturne Parisien.' *Vogue Paris*. August 2006. Photograph Mario Sorrenti. © Vogue Paris 116
5.16 Paris and the myth of love. *Vogue Paris*. May 1991. Photograph Christian Moser. © Vogue Paris 117
5.17 'Portraits de Femmes Rive Gauche vues par Vogue.' *Vogue Paris*. October 1995. © Vogue Paris 122
5.18 Vogue fashion dolls. *Vogue Paris*. September 1989. © *Vogue Paris* 123
6.1 *Passantes de mode*. *Numéro*. August 2006. Photograph Sofia Sanchez and Mauro Mongiello. © Numéro 128
6.2 *Passante Parisienne*. *L'Officiel*. September 1990. Photograph Peter Hönneman. © L'Officiel 138
6.3 'Une Fille à Paris.' *L'Officiel*. August 2005. Photograph Élina Kéchicheva. © L'Officiel 139
6.4 'Filature.' *Stiletto*. Spring/Summer 2005. Photograph Benoit Peverelli. © Stiletto 139
6.5 The street as catwalk. *Vogue Paris*. March 1991. Photograph Alistair Taylor-Young. © Vogue Paris 140
6.6 'Toutes en scènes.' *Vogue Paris*. March 1991. Photographs Claus Ohm, Piero Biasion. © Vogue Paris 140

Illustrations ix

6.7 The male gaze. French *Glamour*. April 2006. Photograph Peter Stanglmayr. © Glamour 146
6.8 'Fur Play.' *Vogue Paris*. September 1989. Photograph Wayne Maser. © Vogue Paris 148
6.9 'La Nouvelle Parisienne.' French *Elle*. January 2005. Photograph Alexia S. © Elle 153
6.10 'Extérieur, jour.' *Vogue Paris*. August 1992. Photograph William Garrett. © Vogue Paris 154
7.1 Robert Delaunay. 'Femme et la Tour.' 1925. © L&M Service B.V. The Hague 20080309 168
7.2 Robert Delaunay. 'La Ville de Paris.' 1910. © L&M Service B.V. The Hague 20080309 168
7.3 Lisa Fonssagrives on the Eiffel Tower wearing a Lucien Lelong dress. 1939. Photograph Erwin Blumenfeld. © ADAGP, Paris and DACS, London 2007 170
7.4 2007 advertisement for Repetto. © Repetto. 171
7.5 1997 advertisement for 'Paris', by Yves Saint Laurent. © Yves Saint Laurent/Gucci Group 171
7.6 2005 advertisement for the Salon International de La Lingerie, Interfilière. © Salon International de La Lingerie 173
7.7 The tower as a woman. *Vogue Paris*. September 1982. Photograph Arthur Elgort. © Vogue Paris 173
7.8 1995 advertisement for Jean-Paul Gaultier 174
7.9 2004 advertisement for Love in Paris, Nina Ricci. © Parfums Nina Ricci. All rights reserved. © Tour Eiffel – Illuminations Pierre Bideau 175
7.10 2005 advertisement for Yves Saint Laurent. © Yves Saint Laurent/Gucci Group 175
7.11 1992 advertisement for Dentelle de Calais. Reproduced with the kind permission of Fédération Française des Dentelles et Broderies 176
7.12 1990 advertisement for 'Paris', Yves Saint Laurent. © Yves Saint Laurent/Gucci Group 181
7.13 2006 advertisements for Charles Jourdan. Photograph Bettina Rheims. Agency: Wolkoff et Arnodin. Courtesy Wolkoff et Arnodin 182

ACKNOWLEDGMENTS

Many people have helped me to bring this book to completion. I have found in my colleagues at the London College of Fashion and Central Saint Martins a permanent source of intellectual and emotional support, and my heartfelt thanks go to them. I am particularly grateful to Andrea Stuart for supporting the submission of my book proposal to I.B.Tauris, and to Professor Caroline Evans for her extremely insightful and encouraging comments on an early draft.

I would also like to thank Professor David Gilbert, from the University of London, for taking the time to look at an early version of the book and providing stimulating suggestions.

Thank you to I.B.Tauris too, in particular my editor Philippa Brewster for her enthusiasm for the project.

The Research Centre for Fashion, the Body and Material Cultures provided me with a grant for the acquisition of images, and the University of the Arts with a timely sabbatical in the 2006 spring term. I would like to thank both institutions for supporting my project.

Jean Larivière kindly agreed to let me use his beautiful photograph for the cover of this book, and I would like to express my deepest gratitude to him.

Finally, endless *mercis* to Rupert Waldron, the best and dearest companion, mentor, inspiration (and proofreader) I will ever have.

Some material from articles I have published in past years has been included in this book, and I am grateful to the publisher for allowing me to do so with regard to the following sources:

'Paris Capitale de la Mode', in Breward, C. and Gilbert, D. (eds) *Fashion's World Cities*. 2006. Oxford: Berg; 'Over to you', in *Fashion Theory*, 10 (1/2), 2006. Oxford: Berg; 'High Fashion and Pop Fashion', in *Fashion Theory*, 5 (2), 2001. Oxford: Berg.

Every effort has been made to obtain the copyrights for the illustrations featured in this book. If a copyright holder feels their material has not been properly acknowledged please contact I.B.Tauris, who will rectify the credits in the next edition.

Fig. I 'Ça c'est Paris.' *L'Officiel*. October 2004. © L'Officiel.

INTRODUCTION

The October 2004 cover of French fashion magazine *L'Officiel de la Couture et de la Mode de Paris* (hereafter *L'Officiel*) shows a beautiful woman wearing a Chanel jacket, her face partly hidden by a cap tilted to the side (see fig. 1). It is bereft of cover lines except for the proverbial 'Ça c'est Paris' ('that's Paris'), which French popular singer Mistinguett made famous with her eponymous 1927 song. 'Paris c'est une blonde', she sang, 'Qui plaît à tout le monde [. . .] Tous ceux qui la connaissent/Grisés par ses caresses/S'en vont mais reviennent toujours/Paris à ton amour!/Ça, c'est Paris! Ça c'est Paris' (Paris is a blonde/Everybody likes [. . .] All those who know her/Drunk on her caresses/Leave but always return/Here's to your love, Paris/That's Paris/That's Paris).[1]

For *L'Officiel*, as for many authors and artists, as I will be discussing in this book, Paris is a woman, the 'ça' ('that') which the magazine enjoins us to contemplate, at once the femininity the model signifies and the woman she poses as – the *Parisienne* of *Last Tango in Paris*, we learn within – the model's curly locks echoed, on the cover, in the typeface of the word 'Paris' the better to link the attractive face with the city's name, and to name the beautiful woman Paris. But 'ça' is also that which lies behind the front page; that which a cover line, by definition, announces as included in the magazine: a world of luxury goods, glamorous haunts, and fashionable lifestyles, made all the more seductive by the flow of enticing images and words that will pass by the eyes of the readers as they flick through the pages of the magazine. 'Ça c'est Paris', *L'Officiel* is telling us, a Paris captured in its pages, contained in it, indeed a Paris reduced to fit within the borders of the glossy as if the magazine itself, 'ça', were Paris, and to open it was to enter the French capital. The city is no longer a material city of flesh and stones, but a textualized city, a city put into words and images, fashioned by the work of photographers, stylists and journalists.

This book focuses on such a Paris, the Paris of discourse and more specifically that of the contemporary French fashion press, which, like many paintings, novels and films on the French capital, have glamorized the city and sustained its mythical status, not least as a fashion city. For one of the main objects of discourse of the fashion media is the city, with many images and words devoted to key locations such as New York, London or Paris. However, whilst the cities of literature and the visual arts have long been a popular topic of enquiry,[2] with Paris in particular a key object of interrogation, scholars have largely failed to approach the cities of the fashion press, including the French capital. They have thus neglected one of Paris's central sites of representation. As a consequence, the sheer reach of the discursive field in which the meanings and values that have been attributed to Paris circulate has not fully been captured.

The neglect of the Paris of fashion media must also be seen in the light of the lack of attention, in academic studies of fashion, to the field of fashion journalism. Although fashion has become a central field of enquiry in social and cultural studies, the fashion media remain largely under-researched despite their sheer visibility and popularity in contemporary culture. However, the fashion press is central to the field of fashion, to the definition and consecration of its many agents and institutions, and although its significance has been repeatedly acknowledged,[3] little is known about its discourse: about the objects it creates and represents, cities such as Paris included; about the values it conveys and is informed by; and about the way it operates *qua* discourse. Thus, although Paris has long been established as a dominant player in the global field of fashion, one of its most important institutions, the fashion media, has been given little attention, with the bulk of writings on Paris fashion devoted to its designers and past history.[4]

This book attends to these gaps in studies of the city, Paris and fashion, by focusing on French discourses on the French capital, and the fashion media in particular. Based on an original analysis of fashion writing and images in contemporary French fashion magazines and newspapers, *Fashioning the City* interrogates the 'Paris' of the fashion press to comment on the way it has contributed to the reproduction of the Paris myth and the consecration of the city in the 'geography of fashion'.[5] In doing so the book sheds light on the dense network of French texts and ideas which French fashion media discourse is caught in, carrying through time visions of the French capital. For, as Caroline Evans argues, and it is a comment equally true of 'written fashion':[6]

Introduction

> Contemporary fashion images are bearers of meaning and, as such, stretch simultaneously back to the past and forward into the future. [...] they can generate new ideas and meanings and themselves carry discourse into the future, so that they take their place in a chain of meaning, or a relay of signifiers, rather than being an end product of linear history.[7]

This is particularly true of the discourse of the French fashion media on Paris, in which the values, concepts and images that inform both 'written fashion' and fashion images reach back to earlier times and earlier genres of discourse in their ways of seeing the city. The nineteenth century in particular, as I discuss in Part I, saw a proliferation of texts on Paris central to its construction as an object of desire, a site of prestige and a place of sartorial elegance and fashionable display. The contemporary French fashion press has supported this proliferation, carrying into the present day mythical visions of the city and further contributing to its celebration.

Thus *Fashioning the City* consists of two parts. Part I (chapters 1, 2 and 3) foregrounds some of the themes and ideas that have long run through discourses on Paris in the French fields of literature and the arts, and which, I show in Part II (chapters 4, 5, 6, 7), also inform representations of the city in the contemporary French fashion media. Although in the first part of the book I focus on French visions of the capital, in some instances I also comment on non-French texts, drawing attention to the broad reach of some of the recurring themes and images in discourses on Paris, a reach the international circulation of many of the French texts mentioned has also supported.

Thus, the book starts with a discussion of the rise and consecration of Paris as the capital of France and its celebration as a world-leading city (Chapter 1). In doing so it addresses a key topic in debates on French cultural life: the centralism of French culture, with the division Paris/the provinces and the dominance of the former over the latter. Comment is made on the material fashioning of the city and its staging as a site of prestige superior to the provinces, as well as on its putting into discourse in a wide range of texts that have supported the mythologizing of the capital and the split Paris/*province*.

In Chapter 2, attention is given more specifically to the making of Paris as a fashion city. The focus is on its geography of fashion and the spaces, sites and institutions that have emerged, both on the city's stage and in discursive constructions of the French capital, as key places for the production and consumption of fashion. Indeed, places such as the Parisian

boulevards which literary character Emma Bovary, for instance, fantasized about when, living in a small French provincial city, she 'bought a street map of Paris and with the tip of her finger, on the map, [. . .] shopped in the capital',[8] were also real spaces of fashionable display to which artists and writers gave a symbolic dimension that cannot be split from the city as experienced in the flesh.

Thus in Chapter 2 as in Chapter 1 I discuss Paris as an entity at the junction of both real phenomenological space and of discourse, as a textualized city of literature, painting, photography and cinema that has fed into practices, in the same way that practices have fed into its representations. The discursive city is no less central to experience than the city one encounters when walking through its streets. It too impacts on ways of thinking, seeing and being. It too has potency: that of its highly visible presence in the 'mediascape'[9] and the collective imaginary it nourishes. It is this presence I focus on when commenting on the Paris of the contemporary French fashion press.

In Chapter 2, the role of fashion in the cultural economy of cities is also discussed, which draws attention to the importance of the field of fashion in cities' quest for global hegemony, an idea I also comment on in Part II.

Chapter 3 concerns the notion of discourse. Through a critical engagement with the work of Pierre Bourdieu and Michel Foucault, the chapter offers a definition of the terms 'fashion discourse' and 'fashion media discourse' that sets out the parameters for an understanding of the way media texts work to create value and meanings within a given field – fashion – and a given culture – the French.

In Part II, and to further engage with the idea of the 'symbolic production'[10] of Paris and its putting into discourse, I turn to the contemporary French fashion media and unpack four key themes: the trope of 'Paris, *capitale de la mode*' (Chapter 4), the figure of '*la Parisienne*' (the Parisian woman) (Chapter 5), the figure of '*la passante*' (the female passer-by) (Chapter 6), and the Eiffel Tower. These have all been central to French discourses on the capital in literature and the visual arts, and are mobilized regularly by the contemporary French fashion media. The Parisian woman, and her frequent visualization in the figure of a Parisian passer-by, the Parisian *passante*, is presented as the apex of fashion. The incarnation of Paris, she is the model to follow, a visual and written metaphor, therefore, for the high symbolic value that has long been attributed to the French capital. Similarly, the Eiffel Tower often features in fashion images as a sign of Paris and Paris fashion, whilst the status of '*capitale de la mode*' is regularly attributed

to the French city. In the process, a certain discourse on fashion and the city is produced, and various values are attributed to the French capital; a certain 'Paris' is created. Thus critical attention is given to the significance of the French fashion media in the promoting of the French capital and its contributing to the centrality and high visibility, discussed in Part I, of the city in French life.

By attending to the discourse of the French fashion press on Paris, this book brings together four significant areas of research in social and cultural theory: fashion, the city, the media, and the Paris myth. Through its take on the theme of fashion and the metropolis, the book illuminates both the role of the fashion press in the construction of the city, and the way fashion and urban life are connected in such media. Through its interrogation of the discourse of the French fashion press on Paris it contributes to knowledge both on the discursive Paris and on Paris fashion and French culture. Finally, through its critical attention to the notion of discourse and the idea of discursive production, it sheds light on processes of media representation. In doing so it draws attention to the diversity of texts from various genres and historical times amongst which the values attributed a particular object – here Paris – in a particular textual space – the fashion media – and at a particular time – contemporary France – can circulate.

Part I

I
PARIS, FRANCE

Paris is both a material and a discursive reality, a city of buildings, streets and people, but whose physical tangibility has been the object of a multitude of words and images. Its creation is a product of these two realities. Through them it has arisen as a central site of social distinction, a space, both physical and imagined, attributed a superior value in the socio-cultural hierarchy of French and foreign cities, and a high degree of resonance in the collective landscape. Both a symbol and an inhabited geographical space, Paris has been placed at the center of the French nation, as I discuss in this chapter.

I first comment on the rise of Paris as the capital of France. I discuss the way this rise has been paralleled and supported by a pronounced centralism of French political, economic and cultural life, with Paris constructed as the site of prestige – at once a representative of the French nation but also above and superior to it. This has translated into an opposition Paris/*province* with the latter the devalued half of the relation. I then turn to the putting into discourse, in France, of the capital, to comment on the importance of the many texts, and genres of texts, that have participated in the construction of the Paris myth and the consecration of the city in the collective imaginary, a consecration that many non-French texts have also supported.

'Paris, c'est la France'

In 250/225 BC a Celtic tribe called Parisii settled on what was later to be known as Paris's Ile de la Cité. Named Lutecia in 54 BC, it was conquered in the same year by Julius Caesar, to become part of the Roman Empire.

In 300 AD 'Lutèce' took the name 'Paris', having spread in the meantime across the river Seine onto the Left Bank. In 508 Clovis, king of the Franks from 481 to 511, made Paris the capital of his kingdom. Merovingians (500–750s), Carolingians (754–987) and Capetians (987–1789) succeeded one another as rulers of the city until the 1789 Revolution.[1]

The city's history has been punctuated by periods of growth and success, as in the years 1000 to 1300, which saw a flourishing trade on the right bank and a thriving scholarship – including the foundation of theology college La Sorbonne – on the left. It has also endured decline and setbacks, with recurring bouts of famine and violent episodes of social and political tensions culminating in the 1789 Revolution.[2] Paris was then reestablished as the governing heart of France, returning from Versailles. Indeed, King Louis XIV (r. 1643–1715) and his successors – Louis XV (r. 1715–74) and Louis XVI (r. 1774–92) – had been reluctant to embrace the city, preferring to reside outside its walls, fearful as they were of what they saw as the unavoidable decay generated by its steady growth.[3] By the mid-eighteenth century Paris had nevertheless risen to fame to become a city distinguished for its significant size and its 'cultural modernity', the capital of letters and public opinion with the Palais Royal a key literary quarter.[4] The growth of the city – which reached a population of 650,000 in 1789 – was accompanied by booming commercial and cultural activities.[5] Intellectuals from around the world moved there, lending further weight to its status as literary capital; the 'Kingless Capital of Enlightenment' as Jones puts it.[6]

In 1789 the Revolution not only 'brought the capital back to Paris from Versailles',[7] but also signaled the growing centralism of French culture: the concentration in the city of administrative, economic and cultural powers, which the recurring debates on the subject in French political life have still not found an answer to.[8] Drawing on the work of Querrien, Prendergast notes that 'a capital is a political and cultural "centre", with the power and authority to dominate and protect a wider "territory"; to keep in place a "social hierarchy" and to "subjugate a population . . . to a common heritage"'.[9] This comment is particularly true of France, where a strong centralism has long been a defining trait of the nation – a 'French specificity', as Deyon puts it.[10]

In the sixteenth century Montaigne had declared: 'I am French only through this great city [Paris] [. . .] the glory of France',[11] but the Revolution truly consecrated the dominant role of the capital in both the nation's everyday life and its imaginary. New at the time was the desire to turn France into a single being and nation whose greatness would reside in the

prestige attributed its capital, which thereby became 'the symbol of the agreement between the parts and the whole'.[12] France was reorganized into clearly defined departments, giving Paris better control over the French territory.[13] From then on, and in spite of various projects towards decentralization, the political, administrative and cultural life of France would revolve around its Parisian center. As Corbin notes, 'by taking the Bastille, Parisians conquered the right to claim to guide the whole of France'.[14]

After the French Revolution the educational system, for instance, was centralized, with the most prestigious schools and universities all based in Paris.[15] Moving there became a trajectory necessary to one's move up the socio-cultural hierarchy.[16] During the first half of the twentieth century 50 per cent of all French students studied at the University of Paris.[17] At the end of that century Parisian students were no longer a majority, but the Ile-de-France region, with Paris at its heart, still included a significant proportion of the French academic population as well as those working in the sciences – 30 and 55 per cent respectively.[18] Today Parisian institutions still dominate the educational hierarchy, with elite schools such as Sciences-Po (Institut d'Etudes Politiques), HEC (Hautes Etudes Commerciales), the Ecole Normale or Polytechnique all based in, or on the outskirts of, Paris. Similarly, all powerful administrative and regulatory bodies such as the Conseil d'Etat, the Cour des Comptes and the Inspection des Finances are located in the French capital, and so are the headquarters of most major companies.[19] Thus in the late twentieth century Paris hosted twice as many managers and engineers as the provinces,[20] an illustration of the 'imbalance' which, George observes, exists 'between functions of direction, reserved for the capital, and functions of execution, reserved for *la province*, a division characteristic of France compared to other European countries'.[21]

Moreover, during the second half of the nineteenth century a railway network was developed, centered on the capital and organized according to it.[22] This network was just one instance of the growing centralization that took place at the time of the Second Empire.[23] The transport system, whether by car, train or plane, carried into the twentieth century the 'système étoilé' ('star-shaped system') inherited from royal roads and concentrated on Paris,[24] with the Ile-de-France region attracting, in the early 1990s, '90 per cent of State funds allocated to public transport'.[25] At the time it also absorbed '70 per cent of the expenditure of the ministry of culture'.[26]

The strengthening of centralism that the Revolution heralded also signaled the subsuming of the nation by its capital. With the Revolution,

Paris emerged as that which was above local particularisms – the space for the expression, celebration and consecration of the nation,[27] as many spectacular Parisian stagings make clear.

In 1888, for instance, the French government instigated an event intended to celebrate the republican spirit by inviting all French mayors to an impressive banquet set in the capital.[28] The 1889 gathering led the newspaper *Le Temps* to state in August that year that 'never since the 14th of July 1790 nor in any other country had such a spectacle been seen: the whole nation gathered together at the same place'.[29] More than 20,000 mayors attended the 1900 Grand Palais reception.[30] In 2000 the Senate hosted a similar banquet in Paris's Luxembourg Gardens, bringing together French mayors and their spouses for the 14th of July celebration of the Republic.[31]

Ihl argues that the Third Republic banquets supported the legitimation of Paris as the 'privileged site of assembly', and this comment is equally true of the 2000 event.[32] Indeed, the city is where the *République*, constructed as 'one and undivided', is celebrated and administered,[33] a unity and indivisibility *de facto* established as synonymous with a nation reduced to its capital. Thus Ihl argues that, like the festivities that had been taking place there on the 14th of July every year since 1880 – and are still taking place there, with the yearly Champs-Elysées parade systematically broadcast on French TV – the banquets signaled a dematerialization of Paris.[34] For such events have helped turn the French city, a material and empirical place, into a symbolic space of projection, in which a sense of nationhood is articulated.[35] Thus symbolized, Paris has emerged as transcending local particularisms; Ihl notes that its construction as the repository of the nation's republican imaginary and identity has counterbalanced 'attachment to the land'.[36]

The material building of spectacular Parisian sites also testifies to the importance of the capital for the staging of the nation and the state, its assimilation to all things prestigious. This was already the case under King Philip II Augustus (r. 1180–1223), who in 1190 began the construction of the Louvre as a defensive building. In the late sixteenth century, and after it had become the official site of royal residence in the fourteenth century, Henry IV (r. 1589–1610) refurbished the palace, placing it at the heart of his project to display the nation and his power.[37] In the late seventeenth century Louis XIV did the same, giving the palace a new façade as well as initiating a series of projects to give the city more 'monumentality'.[38]

Under the reign of Napoleon III (1852–70) this strategy of spectacularization and inscription of the state in the material make-up of the city found a particularly impressive expression.[39] Napoleon III appropriated

the French capital as a means of strengthening his image and that of France, for example with the 1855 Exposition, an advertisement for the city's modernity and its excellence in the arts and trade and the industry.[40] However, his desire to display the city, and through it himself, as well as the state and the nation, took on a particularly spectacular and ambitious form with Baron Georges Haussmann, his Prefect of the Seine between 1853 and 1870. During this period, the Prefect presided over a major reconstruction of the city by replacing the many squalid, narrow streets and passageways of medieval Paris with large straight arteries of boulevards that were to give pedestrians vantage points on key Parisian monuments and buildings.[41] *Places* (squares) would break the line of boulevards and constitute oases of health in the middle of the city.[42] The congestion arising from densely packed streets would be eliminated, allowing for a fluid traffic of carriages.[43] A sewage system was also put into place to purify a city still marked by dirt and stench, and so were 15,000 gaslights illuminating streets lined by shops open until 10 PM.[44] Paris was redefined to become a unified and unifying space,[45] one that could easily be grasped and made sense of 'at a glance'.[46] The building work continued well after Napoleon III's time, and was only completed after 1900.[47] '2.5 billions *franc-or*' had been spent by 1890, the equivalent at the time of the annual budget for the whole of France.[48]

When Haussmann took on the redesigning and modernizing of Paris, large straight streets were already a feature of the capital. As Bernard observes, Haussmann's Paris was outlined in the seventeenth-century geography of the city.[49] At the time, *places* (such as the *Place des Vosges*, first named *Place Royale*), and broad, straight avenues such as the *Grand Boulevard* on the old city ramparts – 'boulevard' indeed comes from the German 'bolwerc', 'bulwark' or 'rampart'[50] – had already begun to be inscribed in the Parisian landscape.[51] The Prefect, however, made wide arteries a more systematic and spectacular component of the city. One aim was to control possible revolutionary activities, keeping barricades at bay, and also allowing for a better defense of the capital in case of aggression. However, as many cultural commentators have noted, the Haussmannian reconstruction was not purely military and defensive in intention.[52] Indeed, barricades certainly did not disappear from Paris. They were 'resurrected', Benjamin notes, 'during the Commune', stretching 'across the great boulevards, often reaching a height of two stories'.[53] Rather, central to the Emperor's project was also the wish to 'show off' the city[54] by offering the world a vision of the capital as modern, bourgeois, ordered and clean,

at peace with itself, indeed enjoying itself through the consumption of the many goods showcased in the boulevards' windows. Parisians and tourists were invited 'out of doors to take part in the vast pantomime of the imperial city'.[55] With Haussmann, as Hancock puts it, 'Paris itself was being staged as spectacle'.[56] Café terraces, boutiques, department stores and sumptuous façades were now supposed to take over barricades and scenes of insurrection in visions of the capital. The Parisian bourgeoisie openly displayed its wealth and luxurious lifestyle, whilst poor people were forced to move to the periphery of the city.[57] Haussmann's Paris became a template for France, the model to follow, with the streets of cities such as Lyon redesigned according to his vision of the capital.[58]

Napoleon III's spectacularization of Paris and the state, and indeed a state associated with the Parisian territory, found an echo in twentieth-century France with four successive Fifth République presidents – Georges Pompidou, Valéry Giscard d'Estaing, François Mitterand and Jacques Chirac – eager to leave their mark on the French landscape by way of various projects located in Paris. These projects have become known as *les grands travaux*, with the vast majority pertaining to the field of culture.[59] The rest of France has featured relatively little in this quest for personal, governmental and national prestige, with projects there often left to local initiatives.[60]

Pompidou's presidency saw the creation of the Pompidou Center, commonly known as 'Beaubourg'. Its building, Short argues, was an answer to 'the perennial French need to play the role of cultural heavyweight', and a manifestation of France's appropriation of the field of culture to position itself as a leading country on the global map.[61] Subsequent presidential projects, often located in Paris, have further reinforced the representative role of the capital on the global stage and sharpened its 'global edge'.[62] Thus Giscard presided over the building of La Villette, the redevelopment of Orsay as a museum and the building of the Institut du Monde Arabe. With François Mitterand, the *grands travaux* found their most impressive and often controversial manifestations. Amongst them is the construction in the Louvre's Cour Napoleon of a glass pyramid designed by I.M. Pei and inaugurated in 1989. As for Chirac's *grands travaux* legacy, this is exemplified by the musée du quai Branly, opened in 2006.

Paris then, as Higonnet notes, 'has always borne the mark of the state, be it royal, imperial, or republican', and more than in other countries, the state has become associated with the French capital, and the nation with Paris.[63] Thus, as Jones also observes, a large proportion of the French sites and

monuments which French historian Nora and his team single out as key French *Lieux de Mémoire* (Sites of Memory) are located in Paris, the French location of prestige.[64] They include the Panthéon, the Mur des Fédérés (Communards Wall), the Louvre and the Collège de France, to name but a few, as well as the Eiffel Tower, to which I return in Chapter 7. As the saying goes, 'Paris, c'est la France'. In his 2001 *Spleen de Paris*, French poet Michel Deguy captures it thus:

> Paris is not *a* city, even big. It is the capital; which does not simply mean a bigger city, or one more populated than another city. One can imagine a Provincial town twice the size of Paris in terms of the number of inhabitants. That would not change a thing [...] It [Paris] is the exception; the *integrating part*, space and time, that which offers and leads to everything, history and regional co-belonging; that is, France as capital, the Ile-de-France, the Collège de France, the History of France among other things.[65]

However, Paris's power to transcend local particularisms conjures up the opposition between body and mind that has long structured judgements on social and cultural practices, with intellectual activities seen as superior to physical ones. In this opposition, a dematerialized and abstracted Paris stands for the mind in contrast with the rest of France, its body, defined through materiality – the land – and therefore given a value inferior to that of France's head. Indeed, whilst the opposition Paris/*province* translates into an opposition between functions of direction and functions of execution, as mentioned earlier, Scheibling notes that it also translates into a split, in today's French productive system, between abstract – administration and commerce, for instance – and concrete – fabrication and transport, for instance – functions of production.[66] Where Paris is predominantly host to the former, material production has been decentralized to the provinces, as is the case, for instance, in the perfume and cosmetic sector.[67] This decentralization can only reinforce the superior status attributed to the capital, in effect endowed with the socially highly valued role of center of conceptualization and direction, the thinking head of the French nation. Indeed, 'brain' and 'head' are images invoked regularly in the French literary discourse on the capital.[68]

Moreover, the idea that Paris stands for France can easily lead to a reduction of the French nation to its Parisian component, and therefore to the idea that outside of Paris, France is nothing. The equation turns into a difference and imbalance, at the expense of France outside of the French

capital, as the centralism of French life also makes clear. The position of Paris in the nation's imaginary, then, is a contradictory one.[69] It is both perceived as a representative of France, part of it, but also somehow detached from it, and ultimately superior to it. Indeed, so powerful is Paris, both in real and in symbolic terms, that the rest of France has famously been depicted as a 'desert'.[70]

This symbolic hierarchization of the French geography is captured in the binary pair Paris/*province*, where the second term – *la province*, the provinces – stands for the devalued remainder of the French nation that is not Paris. As many authors have observed, geographical space is socio-cultural space reified.[71] The opposition Paris/*province* is an example of such a reification, which has structured many French practices and discourses since the seventeenth-century centralization of political power and the court in Versailles and then Paris.[72] As Corbin notes, 'since the beginning of Louis XIV's reign, being from the provinces means being excluded from the Court, being deprived of the light the King's presence gives one, being condemned to decay in the place of disgrace'.[73] The rise in centralization that followed the French Revolution has compounded the opposition Paris/*province*,[74] leading journalist and writer Louis Veuillot to claim, in 1871, that centralization 'led to unification at the expense of unity'.[75]

It is also in the seventeenth century that *la province* appears in literature to become an object of derision.[76] It has also been irreversibly associated, since then, with boredom, as conveyed most famously perhaps in Flaubert's *Madame Bovary*. Though *la province* is sometimes depicted, as in the work of the Romantics, as a wholesome land of purity and nature in contrast with Parisian excess,[77] Paris nevertheless is the place one has to travel through to arrive at success. Local personalities are only 'individuals who have not succeeded in Paris'.[78]

The binary Paris/*province* opposes one single city to many other localities, whose differences and particularities, however, are negated by a homogenizing singular article and term: '*la province*'. Where in English variety and differentiation is acknowledged through the use of a plural – 'the provinces' – the French singular denies it, allowing for one possible difference only: that from Paris. The opposition between Paris and *la province* is also translated into everyday language in expressions such as 'monter à Paris' – 'going up to Paris' – which implies that Paris is in a high position compared to the low one of the provinces.[79] 'Monter à Paris' does not have a precise English equivalent. Whether one lives in Marseille or Calais, geographically below or above the capital respectively, one goes up

to Paris, for the city is 'up', socially. As Bourdieu notes, social oppositions such as *capitale/province* 'tend to reproduce themselves in minds and language in the shape of oppositions which are constitutive of a principle of vision and division, that is, in the shape of categories of perception and appreciation or mental structures'; categories which would also include 'Parisian /provincial', but also 'chic /not chic',[80] as I also discuss in Chapter 2 and in Part II. In France, *la Capitale*, Bourdieu adds, is 'the place of capital [...] where the positive poles of all fields [...] are concentrated: thus it can only be conceived adequately in relation to the provinces (and the "provincial"), which is nothing but the privation (strictly relative) of *la capitale* and capital'.[81]

Thus, more than a geographical reality, the Paris/*province* binary refers to a symbolic one, 'imaginary'.[82] It is not so much a territorial division as a 'relation'.[83] As Corbin notes, 'one can seem "province" in Paris; that is, incapable of learning the code that constitutes "Parisianité", of adopting the *tempo*, the rhythm that defines Paris'.[84] Indeed, the word 'provincial' itself has taken on pejorative senses, which French dictionary *Le Petit Larousse* defines as: 'Pej. Lacking in the ease usually attributed to the inhabitants of the capital'.[85] Being provincial means an inherent lack of, a deficiency of, Paris,[86] land of plenty.

Another term also epitomizes the prestige and socio-cultural privileges accorded Paris: *'parisianisme'*. Of this expression Martin-Fugier notes, talking about the Parisianism of Delphine de Girardin's column on Paris in *La Presse* during the July Monarchy, that:

> Paris, in that sense, does not designate a city but an ensemble of phenomena – from vestimentary elegance and the quality of good manners to the presence of eminent people in all domains – that are supposed to testify to the high degree of civilisation France has reached. To use today's language, Paris and the Parisian world are the luxury 'window' of French quality.[87]

The term is still current today, and it has retained the idea of the supremacy awarded the capital and its association with prestigious practices. It has thereby also come to carry with it a critique of this state of affairs, with the word often used to refer to the centralism of French life. Dictionary *Le Petit Larousse*, for instance, defines it as follows: '1. Expression, turn of phrase pertaining the spoken French. 2. Usage, habit, way of being particular to Parisian people. 3. Tendency to value Paris only, what happens and is created there, and to neglect the rest of France or the French-speaking world'.[88]

The superior status accorded Paris has sometimes, however, been paralleled by a certain hostility towards the capital. Life in Paris has been challenged, for instance, by those advocates of life in the countryside as truer, more honest, than life in the big city. Here, though, the opposition is not so much between Paris and *la province*, but between Paris and the countryside, within a wider context of opposition to modern urbanism.[89] 'Parisian' then, is a term that, like 'provincial', can be, and has been, turned into a derogatory attribute, as the famous expression 'parisien, tête de chien, parigot, tête de veau' also illustrates.[90] But the contempt for Paris can also be read as much as an expression of envy and fascination as of disdain.

Putting Paris into discourse

A city is more than simply the sum of its physical and human components. It is also an abstract entity, an imagined space.[91] Paris in particular cannot be thought of outside the many texts – books, paintings, films or photographs, for instance – that have given it a resonance and symbolic dimension which its status as mythical city has come to encapsulate. Its rise on the French and international maps via pragmatic and material measures is coextensive with its rise as an object of discourse in the symbolic order of French literature and the arts. Indeed, in France, Paris has been the object of a proliferation of texts that have ensured its highly visible place in the collective imaginary. While it has been redefined through successive redevelopments of space such as Haussmann's, the city has concurrently been shaped by the many French writers and artists that have written about it, painted it, photographed and filmed it, as I now discuss.

Jean de Jandun's 1323 *L'Eloge de Paris* (In Praise of Paris) is the first piece of writing entirely devoted to the city,[92] and in the second half of that century Guillaume de Villeneuve celebrated it in a ballad entitled 'Crieries de Paris', arguing that 'Nothing can be compared to Paris'.[93] However, one has to wait until the late eighteenth century and the nineteenth century especially to see the multiplication of texts and genres of texts devoted to Paris. Amongst these is Louis-Sébastien Mercier's highly successful *Le Tableau de Paris*, in which the author discussed the social, political and cultural life of the city as well as some of its key sites.[94] His notion of 'tableau', borrowed from the world of theater, conveyed the idea that Paris was like a stage peopled with various actors.[95] It was subsequently taken

up by other authors – Edmond Texier in 1852, and Jules Vallès in 1882 and 1883, for instance, who both wrote their own *Tableau de Paris*[96] – making it a recognizable genre of discourse on the city amongst those eager to capture it in writing.

Included in Mercier's *Tableau* are texts on typical Parisian figures such as the *Secrétaire du roi*, the *bourgeois* and the *grisette*. This approach to the city in terms of constitutive categories of Parisian characters was to become a fashion in nineteenth-century Paris that came to be called 'physiologies'.[97] These reflected a wider interest, at the time, in making sense of the city. Indeed, in the first half of nineteenth century the social changes brought upon the French capital by the death of King Louis XVI and the Revolution had triggered curiosity and the desire to shed light on the city's new social system.[98] Attempts were made to turn Paris into a legible whole by surveying, describing and classifying it.[99] Physiologies alleviated the anxieties triggered by the modern emphasis on 'purely visual social interaction' – an idea I return to in Chapter 6 – by supporting the idea that one's identity could be read on one's body and therefore captured by others during the fleeting moments characteristic of encounters between strangers in urban space.[100]

The physiology genre was inspired by the eighteenth century's scientific physiognomies of Lavater and von Gall,[101] but it is with Balzac and his 1826 *Physiologie du Mariage*, influenced by Brillat-Savarin's 1825 *Physiologie du goût*, that portraits of the city and its inhabitants took on the more historically contextualized form in which they were to become fashionable as physiologies in the 1840s.[102] Balzac also contributed a *Physiologie de l'Employé*, a *Physiologie du Rentier de Paris*, a *Physiologie de la Toilette* and a *Histoire et Physiologie des Boulevards de Paris*.[103] Physiologies were both a visual and a written form of expression of the Parisian identity, for written texts were often supported by drawings, most famously perhaps those of Gavarni and Daumier as in *Les Français Peints par Eux-Mêmes*.[104] An 'Encyclopédie Morale du dix-neuvième Siècle' informed by the physiology genre, this was published between 1840 and 1842 and had contributions from various authors, including Balzac, such as his *La Femme de Province*, a text I return to in Chapter 5, and his writing on the *Rentier de Paris*. *Les Français* aimed to profile the city, its inhabitants and social customs. Tellingly, eight volumes were devoted to Paris, with only three to *la province*.

A significant moment in the history of representations of Paris occurred with the 1830 Revolution, for, Citron shows, the upheaval that brought

the Parisian people together against the politics of Charles X (r. 1824–30) inspired a vast output of poetic writings on the city.[105] Citron argues that this is when the Paris myth (a myth first 'noticed' by Caillois in 1938[106]) was truly created in literature. Only after the 1830 Revolution did literary productions on the capital coalesce into a dense ensemble connected by a range of recurring themes and images that previously had been mostly 'scattered' across texts – Paris as revolutionary, for instance, or Paris as a prostitute, ideas I return to later in this chapter and in Part II.[107] The French capital became the object of a 'collective adventure of thought', Citron argues, citing Max Milner's definition of myth.[108]

On the margins of the influence of the 1830 Revolution but nevertheless central to the Paris myth, Citron argues, is the work of Balzac, whom the German author Stierle also singles out as key to the myth. In Balzac's *Comédie Humaine* (1833–7) attempts at comprehending the capital and synthesizing discourses on the city find an 'exemplary form' that also gives the Paris myth 'a new poetic force'.[109] With his novels – novels of the city – Paris is further entrenched in the collective imaginary, coalescing as the myth which other cultural forms such as painting, cinema, or, as I show in Part II, the contemporary French fashion press, have fed into.

Balzac's Paris is a Paris of aspirations, the place associated with social success but also fashionability and love affairs. His *Comédie Humaine* is the novelistic counterpart to his vitriolic 1841 attack on all things provincial, *La Femme de Province*. Both works support the prestige of Paris and the idea that *la province* is a desolate area. The capital is a place where specific rules of conduct and social codes develop, and whose mastery is necessary to one's rise up the social ladder. In Chapter 2 I return to Balzac's work.

More generally, the nineteenth century saw the multiplication of novels on Paris, including those of Flaubert, Zola, Hugo, and the Goncourt brothers, and, at the beginning of the twentieth century, Proust. Thus, as Hancock notes, 'French centralism is also reflected in the popularity of Paris as literary object'.[110] Translations and many reprints have allowed such novels to carry their visions of the capital through space and time. Their continuing influence and popularity makes of today's Paris a city that cannot be dissociated from its nineteenth-century novelistic construction. As Claude Arnaud wrote in his *Paris Portraits* of 2007, invoking the names of Zola and Balzac: 'a sort of literary essence still hovers over the city like the phantom of the Opera'.[111] This essence is firmly anchored in nineteenth-century Paris and the literary names that still haunt visions of the capital, for they too have made the city. With Hugo, for instance, Paris

is the city of revolution, an image that since the 1789 and 1830 revolutions has been intimately associated with Paris.[112] Contemporary shows such as the Broadway interpretation of Hugo's own *Les Misérables*, like Dayan's 2000 French television series of the same name, with actors such as Gérard Depardieu supporting its international distribution on DVD, have participated in sustaining the mythical status of Paris as 'world capital of revolution'[113] and an emblem of liberty.

For Balzac Paris is also the center of the world, that which brings light to it. 'This crowned city', Balzac wrote, 'is a queen who, always pregnant, has irresistibly furious desires. Paris is the head of the globe, a brain bursting with genius which guides human civilisation, a great man, a permanently creating artist [. . .] a sublime vessel full of intelligence.' Similarly, for Zola, Paris is 'the sun that fecundates Paris with the future world, which will emanate from it alone', and the 'fumes' that, in *Paris*, Pierre and Marie observe hovering over the city, are like 'millions of golden vessels that are leaving the Paris ocean to go and instruct and pacify the earth'.[114]

Balzac and Zola are conveying visions of Paris that others before and after them have shared. For Paris's celebration as capital of France has been paralleled by its celebration as a world-leading nation. 'Paris is the world', Marivaux claimed in 1734, 'the rest of the earth is nothing but its suburbs'. Paris, according to Charles de Peyssonel in 1782, is 'the epitome of the Universe, a vast and shapeless city, full of marvels, virtues, vices and follies', and for Mercier, in 1799, it is the 'torch of the universe'.[115]

In the eighteenth century Paris had established itself as a center for culture, and in the nineteenth it became consecrated as the capital of modernity in politics, sciences and the arts:[116] 'the Capital of the Nineteenth Century' as Benjamin famously declared.[117] A high concentration of artists and intellectuals, together with a string of 'self-celebrations' such as the international exhibitions of the second half of the century, helped cement this reputation.[118] But with the eighteenth-century Enlightenment and the 1789 Revolution, followed by that of 1830, Paris also emerged as the defender of freedom, liberty and reason – all values promoted as universal, to be diffused the world over. Indeed, if the expression 'Paris, ville lumière' (Paris, city of light) can be seen as referring to the physical make-up of the city – its streets having become increasingly brightly lit following the installation of lanterns in the late seventeenth century and gas lamps in 1822[119] – it must also be seen as a metaphor for the idea of Enlightenment. As Prendergast notes: 'In more allegorical mode, the public provision of light represented a triumph over social and cultural "darkness"; light

meant *lumières* in more than one sense; the project of the illuminated city was connected with, and even captured, the older idea of the enlightened city'.[120] But it also conjures up the project of the French revolutionaries and the proponents of an enlightened universal reason, who, in Paris, rebelled against the obscurantism of the old regime. The French Revolution and its values was to be a model for the whole world, Paris a universal symbol for civilization, freedom and liberty which the 1830 Revolution, together with nineteenth-century literary representations of the city, sealed in the collective imaginary.[121]

Thus Alfred de Vigny writes of Paris in his eponymous poem of 1831 that it is 'the pivot of France [. . .] The axis of the world'. For Texier in his 1852 *Tableau de Paris*, it is 'the eye of intelligence, the brain of the world, a résumé of the universe, the commentary on man, humanity made into a city'.[122] Foreign commentators also praised the city. In the 1833 French translation of Heinrich Heine's 1831 and 1832 articles on Paris for the German newspaper *Augsburger Allgemeine Zeitung* one reads: 'Paris is not the capital of France alone, but of the whole civilised world; it is the rendezvous of its intellectual notabilities. [. . .] it is here that the creators of a new world happily disport.'[123] As we shall see in Part II, discourses on the capital as capital of fashion have carried such celebratory visions of the city into the twenty-first century.

The nineteenth century constitutes a key moment of Paris's history, and the identity of the city remains 'deeply rooted' in it, as Rice observes.[124] The past is always part of the present of cities, but the French capital is paradigmatic of this meeting of times.[125] This is true of Haussmann's material city, and it is also true of the Paris of French literature. The status of the city was sealed in the nineteenth century. Thus, in 2005 the façade of Chanel's boutique in the prestigious Ginza district in Tokyo featured projected images including Paris's rooftops and photographs of the city's nineteenth-century exhibitions.[126] Similarly, the Eiffel Tower's presence in many contemporary fashion visuals, as I discuss in Chapter 7, is symptomatic of this resonance of the nineteenth century in visions of the city.

Paris, however, can no longer be said to dominate the world. In the *Belle Époque* of the late nineteenth century and early twentieth century,[127] as indeed up to the present, celebrated Parisian artists and intellectuals have helped perpetuate the representation of the city as a leading force, but its dominant position, both in political, economic and cultural terms and in terms of images of the city, has been relativized by places such as New

York and London, which, like Paris, have competed for the title of world capital. Moreover, conflicts and tensions with, and in, the suburbs, have brought to the attention of the world less glamorous images of the city and its surroundings. However, countering such images are those of cultural forms such as cinema, an idea I return to shortly. Similarly, the contemporary French fashion press, I show in Part II, has helped consolidate and celebrate Paris's position in the collective imaginary, bringing to its readers glowing visions of the capital. Moreover, if new political, cultural and economic developments have supported reassessments of the position of the French capital, discourses on *la province* have not shifted significantly, in spite of its modernization.[128] The relation between the two French entities is still unbalanced, and 'the consciousness of the Parisian specificity remains very strong', as Corbin points out.[129] This specificity is regularly brought to the attention of the French people, with Paris's dominance over *la province* a salient trait of many contemporary French visions of France, such as that of the fashion media, as I argue in Part II.

Following the nineteenth-century literary construction of Paris, another key moment in the history, in France, of the putting into discourse of the capital came with the work of the Surrealists in the early twentieth century. Their project constituted a shared enterprise of literary engagement with the French capital and its celebration as a place for 'the exploration of *individual* mental space'.[130] One's walks across the city, its uncovering, constitute journeys into one's mind, but also into 'the collective unconscious'.[131] City space, as typified by the Parisian space, and mental space form a coterminous whole one can never, however, exhaust and master.[132]

No such collective project has been undertaken since the Surrealists, but Paris has remained highly present in the novels of many French contemporary writers,[133] most systematically perhaps in crime novels and thrillers, such as those of Fred Vargas, Jean-François Vilar and Dominique Sylvain, yet again allowing the city to stand out in the French symbolic landscape of cities. The prestige attributed to Paris in literature has of course been reinforced by the many non-French novels which have praised the city too, such as Henry James's *The Ambassadors*, where the French capital is the place of self-realization for the American protagonist who moves there and also finds love, culture, and pleasure.[134]

Paris, then, has been put into words and images in the numerous physiologies and novels on the city that, since the nineteenth century especially, have supported celebratory discourses on the capital. Also

significant in such putting into discourse and symbolic ordering of the French city are the many guidebooks which, since their early appearance in the late seventeenth and early eighteenth centuries, have helped tourists – known as visitors until the 1840s – to navigate the city and its newly cobblestoned streets, its monuments and its large fleet of shops.[135] The newly installed lanterns and gas lamps that lit Paris at night and helped cement the city's reputation as a modern capital represented another source of attraction, allowing visitors to stroll through the capital's streets and partake in its pleasure long after dark.[136]

In the second half of the eighteenth century 'deluxe cultural tourism' took off.[137] This supported the multiplication, in the nineteenth century, of Paris guidebooks.[138] The city established itself firmly as a key center of attraction, with the proverbial Parisian love of all things pleasurable and extrovert a regular topic of praise integrated in the books' promotional take on the city.[139] Indeed, in the nineteenth century Paris increasingly became perceived as 'the "city of pleasure", to be contrasted with the "city of business" across the channel',[140] and 'it has remained so ever since', as Higonnet notes.[141] Thus in Galignani's 1862 *New Paris Guide*, for instance, published in Paris and addressed to British and American readers, one reads that 'Dancing being the favourite amusement with the Parisians both in winter and summer, there is no quarter of the capital in which ballrooms suited to all classes are not to be found'.[142] 'This lively metropolis', the guide states in the preface, 'is the most attractive emporium of pleasure and literature in the world'.[143] This conjures up Balzac's description of the city as 'a vast workshop of pleasures'.[144] The guide informs the reader that it is a common practice for Parisians to eat out in the evening in the city's many restaurants; an elegant scene, it claims, for the visitor to enjoy. It enjoins them to select a table in a café window so as to be able to delight in the spectacle offered by stylish passers-by.[145]

Similarly, in his 1867 *Les Plaisirs de Paris* Alfred Delvau notes, echoing Galignani's comment on the Parisian's fondness for eating out:

> To live at home, to think at home, eat and drink at home, to love at home, suffer at home, die at home seems boring and inconvenient to us. We need publicity, broad daylight, the street, the cabaret, the café, the restaurant, to testify favorably or unfavorably about ourselves, to chat, to be happy or unhappy, to satisfy the needs of our vanity or our mind, to laugh or to cry: we like to pose, to show off, to have a public, an audience, witnesses of our life.[146]

According to Galignani's guide the Boulevard des Italiens was 'the most fashionable'.[147] This had been the case since the late eighteenth century, with the Boulevard also hosting, in the nineteenth century, the exclusive Café Tortoni and Café de Paris.[148] However, following the redefining of the city under Napoleon III and Haussmann's building plans, the city took on a spectacular dimension as yet unequaled. Its physical landscape was reshaped to give way to more luxury displayed on the boulevards' façades, in sites of pleasurable consumption such as cafés and restaurants, and on the bodies of elegant bourgeois consumers and *flâneurs*. The French capital was increasingly perceived in travel books as 'an object of consumption', 'an object to be viewed and enjoyed' and 'groomed' as such.[149] Contemporary French fashion discourse, as I discuss in Chapter 4, still contributes greatly to this objectification and commodification of Paris.

Moreover, to argue that the French capital was the capital of pleasure also meant by implication, as Higonnet notes, that the rest of France, and also foreign cities, were by contrast more sober and reserved.[150] Writers such as Balzac and Flaubert did nothing to change the then already wel-established association of *la province* with boredom, this 'ennui' – 'silent spider' – that famously plagued the life of Madame Bovary.[151] Flaubert writes that Emma herself found in the work of Balzac 'imaginary satisfactions for her personal desires'.[152] The author thereby draws attention to the importance of literature, and of the writing of Balzac in particular, in supporting enticing visions of the city. Thus, Flaubert notes that of the capital's many 'tableaux', Emma Bovary could only see two or three: those which plunged it in 'a gilded atmosphere',[153] that of the boulevards and theaters she projects herself into by way of the street map she has bought, yearning for a more colorful life than the one she was experiencing in *la province*. With her finger on the map, 'she walked up the boulevards stopping at every corner, between the lines of streets, in front of the white squares standing for houses. Her eyes tired in the end,' the writer continues, 'she would close her eyelids, and in the darkness see gas-jets writhing in the wind, the steps of carriages unfolding with a great clatter at theatre porticos'.[154]

In the nineteenth century, then, Paris became increasingly perceived and fashioned as a center of pleasure, and amongst the pleasures it offered the visitor was sex.[155] Indeed, Paris was already established as a major destination for the purchase of sexual encounters, to the point that the city itself had been likened to a prostitute, with this figure becoming a regular trope of French discourses on Paris,[156] including today's fashion discourse, as I discuss in Chapter 5.

A particular kind of prostitute, the 'courtisane', became particularly associated with the French city.[157] Courtesans mixed with 'proper' ladies in the many spaces devoted to the entertainment of the Parisians such as cafés, ballrooms and theaters, and which guidebooks brought to the attention of visitors. Their body was linked not only to the idea of sexual pleasure but also to that of the pleasures born out of those other commodities: food and fashion. The life of two famous literary courtesans Nana (Zola) and Esther (Balzac), for instance, is punctuated by sex, fashion and spectacular meals – all recurring themes in visions of the French capital. Indeed, in *Les Plaisirs de Paris* Delvau devotes a whole chapter to the various 'femmes légères' (women of easy virtue) one encounters in the city, including those women whose 'beauty is a capital that must be made to produce the most excessive dividends'.[158] 'They have a portfolio very well endowed with excellent shares and guaranteed bonds', he notes, adding, 'This is the fruit of their work, the savings acquired from the five, ten, fifteen or twenty spendthrifts who have joyfully thrown their capital out of the window for them'.[159] Although the author condemns what he says is the depraved life of such women, featuring after 'Les restaurants de Paris', 'Les concerts', 'Les courses' and other recommended sites, they are one of the many pleasures available in 'la capitale du plaisir', the guidebook suggests, one of its 'charming black holes' and 'gilded traps'.[160]

Since their proliferation in the nineteenth century, endless travel guides on the French city have continued to convey visions of Paris as an object of consumption and pleasure. Thus, for instance, the back cover of the 1994 edition of the *guide vert Michelin* states: 'Enjoying a reputation for taste and elegance which it owes largely to its *couturiers*, perfumers, jewelers, Paris is also the City of light enhanced by the brilliance of its parties, by the exceptional diversity of its theatrical life, by its famous cabarets, and the scintillating glitter of its famous shows'.[161]

Guidebooks are a particularly clear instance of the intimate relation that exists between empirical reality and discourse in the formation of cities. Not only are they discourses generating practice – the visiting of cities – but they are also discourses generated by practice, as is the case with travel guides reporting on the pleasurable sites of Parisian life. The rise of Haussmannian Paris fed into the guidebook industry, creating practices – those of writing and visiting. But this interplay between the real and the discursive also informs literature. As Prendergast notes the city both produces, and is produced by, the novel. 'The city may live by remembering', he writes, 'but at what point do its memories and records

start to become stories in fictions, generating the images through which we construct the city to ourselves?' 'Life as lived in the city itself', he adds, 'is modeled on the "inflationary" fictions of the city'.[162] Novels on revolutions in the capital, for instance, such as Hugo's *Les Misérables*, are rooted in the very history of the city, whilst also contributing to forging a Parisian consciousness of itself as revolutionary that will nourish yet more experiences as well as texts on 'Paris as revolution',[163] including those of French fashion media discourse, as I discuss in Chapter 5. As Citron observes:

> The weight of real Paris sustains mythical Paris and keeps it from entirely drifting into utopia and fantasy. And the rise of mythical Paris operates on real Paris an undeniable historical influence: that Paris's population experiences the diffuse feeling of its city's poetry; that, in some circumstances, its pride and volatility find in it an exaltation that leads it to act, is, without any doubt, since the XIXth century, a political parameter that cannot be ignored.[164]

Compounding the evocative power of physiologies, novels and guidebooks, and stretching the reach of the discursive field on Paris, are the many paintings that have taken the French city as their subject, with artists such as Manet and Monet but also Delaunay often turning to its inhabitants and spaces as a topic of representation.[165] Gronberg argues that the Delaunays' promotion, in postwar France and abroad, of Simultaneity in art and fashion, participated in the promotion more generally of Paris as center of cultural excellence and its 'mythic status [. . .] as a world center of both art and female consumerisms (particularly of luxury goods such as fashion)'.[166] The title of their 1925 exhibition – French Embassy – testifies to this representative role of art, and to the quest for the influence across the world of Paris, and through it, France.[167]

The many paintings of Paris by non-French painters also contributed to the spread of images of the city, not least those emphasizing its beautiful sites and people, as in Charles Courtney Curran's 1889 paintings of the Luxembourg and Cluny gardens, for instance.[168]

In the twentieth century, photography and the cinematic image overtook painting in visual representations of Paris. Yet more texts were produced that contributed to Paris's mythical status, giving it a visibility unknown to other French, and non-French, cities, their circulation across the world facilitated by their quality as reproducible images. By the mid-nineteenth century, photographic images of monuments and cities emerged as a

response to the growing interest in travel, allowing those unable to visit other places still to discover new territories.[169] Such images have since reached broader audiences, often offering romanticized visions of the French capital such as Robert Doisneau's famous photograph of lovers kissing in Paris streets, and which much of Hollywood cinema has also helped sustain. Indeed, many Hollywood films show the capital as a setting for love stories, and romantic promenades as well as unbridled extravagances and a permissive sexuality.[170] It is the place where one discovers one's inner passionate self, as in Billy Wilder's *Ninotchka*, for instance, where cold, distant and strict-looking Russian emissary Greta Garbo transforms herself into a lighthearted, stylish and consummate lover. In Merchant Ivory's 2003 film *Le Divorce* the French capital is also the setting for love stories and the main character's transformation from a 'regular' American girl into a fashionable sexy woman embarked on a love affair with a married man.

In French cinema the *Nouvelle Vague* significantly chose Paris as its main setting, clearly epitomizing the idea that 'French cinema is very Parisian'.[171] Indeed, a large proportion of French films are staged in Paris – to the point where the French capital has established itself as the French city par excellence.[172] In contrast, Claude Chabrol's films are often set in *la province*, but its established representation as a space of boredom and void precisely serves the claustrophobic tone of his stories and the dysfunctional bourgeoisie they are frequently about, as in *La Fleur du Mal* and *La Fille Coupée en Deux*, for instance.

Numerous French films also bear the word 'Paris' in their title, further compounding the symbolic power of this name, its resonance. *Sous les Toits de Paris* (Clair), *L'Air de Paris* (Carné), *Paris nous Appartient* (Rivette), *Paris Vu Par* (various directors) *Les Rendez-Vous de Paris* (Rohmer), *Dans Paris* (Honoré) are examples, with the recent *Paris Je t'Aime* (various directors) also adding to the long-established tradition, in the Paris myth, of declaring one's love for the city.[173]

A significant body of work exists, then, with Paris at its center, and which has supported the central positioning of the French city in the symbolic ordering of both French and non-French cities, ensuring the persistence of its mythical status. I have discussed some of the key genres and texts that constitute the discursive field on Paris. The sheer extent of this field, however, has forced me to exclude other genres. These include songs – from those of Edith Piaf to those of Etienne Daho – as well as comics and graphic novels, as in the work of Tardi, Dupuy-Berberian or Multier and Tévessin.[174]

However, in Part II I pursue my discussion of the discursive construction, in France, of Paris and its construction as a place of prestige by paying particular attention to one significant site of symbolic production of the city I have so far overlooked: the French media, and more precisely the contemporary French fashion media. Their rich combination of visuals and written text represents a platform of choice for the circulation and promotion of visions of Paris, and they have contributed greatly to the well-established tradition of textualization of the city and its inhabitants. Before I turn to these media, however, I first pursue, in the next chapter, my discussion of the rise and consecration of Paris as the capital of France and a dominant city on the world map, by focusing more specifically on the field of fashion.

2
PARIS, FASHION CITY

The celebration of Paris as the capital of France and a site of prestige has gone hand in hand with its celebration as a fashion city, with haute couture in particular a prestigious field of practices, experiences and representations that has fed into the city's mythological status. From Louis XIV's use of the fashion and luxury industries to build his and the nation's aura to contemporary promotions of the city by way of promotion of the field of fashion, *la mode* has been tightly linked to the history and definition of Paris. In this chapter I look at the rise and consecration of Paris as center for fashion. I comment on key moments in the fashion history of the city, drawing attention to the interplay between the phenomenological and the symbolic in the construction of the Parisian geography of fashion and the French fashion map. Drawing on the idea, discussed in Chapter 1, of the material basis of myths and the relation between the imaginary and the lived, I comment on those Parisian spaces of fashion that have contributed to the making and mythologizing of Paris and its celebration as a site of prestige and sartorial distinction.

Paris: Center of fashion

Although the rapid development of fashion is firmly associated with the rise of cities in the eighteenth and nineteenth centuries and the Industrial Revolution that enabled its democratization, fashion – the constant renewal of styles and vestimentary aesthetics – first emerged in Renaissance Italian court society where the sartorial attire of court members was central to their quest for status distinction, and a visible – and regulated – sign of social power.[1] However, France had to wait until the seventeenth century

with the reign of King Louis XIV to see its position as a trend setter acknowledged. Known as *le Roi Soleil* – the Sun King – Louis XIV used fashion as a token of royalist and nationalist power in France and across Europe.[2] By the time of his death, the fashion and textile industries were successfully established as central to the nation's positioning as a leading European culture and were acknowledged as a distinctive field of French excellence. Indeed, as DeJean notes, in the late seventeenth century across Europe 'fashion began to be referred to by its French name, *la mode*, and to be considered something inherently and indisputably French'.[3] Thus in the *Lettres d'un Sicilien à ses Amis*, a collection of letters published anonymously in 1700 and commenting on Paris, one reads that 'fashion is the true demon that ceaselessly torments this nation'.[4] In the eighteenth century, fashion also became increasingly gendered as feminine.[5] It was perceived as the frivolous occupation of the frivolous sex, that of Frenchwomen in particular.[6] Thus, it was commonly believed at the time 'that there was an intrinsic link between fashion, frivolity, Frenchness and femininity'.[7]

The work of Henri Gissey and Jean Bérain, costume designers for the royal theater, as well as that of the many French fashion workers whose creations traveled across European court societies, helped Louis XIV strengthen his symbolic hold on France and Europe.[8] Their creative designs and lavish fabrics were displayed during the many masquerades the King and other royals were so fond of attending, clad in luxurious attire foreign nations tried to equal.[9]

Central to Louis XIV's project was Jean-Baptiste Colbert, his general minister of finance between 1661 and 1683, and a key player in the promotion of French luxury goods. Under his influential economic policies, French fashion and the luxury trade more generally moved to the heart of the government's project to create a powerful image for itself, and ensure the nation's domination over other European countries.[10] As Colbert famously said: 'fashion is to France what the goldmines of Peru are to Spain'.[11] Expert fashion professionals from all over the world – weavers, leatherworkers, lace makers, for instance – were invited to France in order for the national production to profit from their knowledge, whilst French products were privileged over foreign ones, and companies were set up to compete with foreign manufacturers and trade.[12] To this day the organization created in 1987 to promote high-end French goods worldwide still acknowledges the central role of Colbert in building the reputation of France in the field of luxury, with a committee bearing the name of Louis XIV's minister: the Comité Colbert.[13]

Colbert had thought of Paris as the site for the spectacular glorification of the state, overseeing the construction of impressive new public buildings such as the Observatoire and the creation of the Louvre's Cour Carrée, as well as the founding of new academies for literature and architecture.[14] However, and to Colbert's dismay, the city was 'eclipse[d]' by Versailles when, in 1670, and after having regularly sojourned there, Louis XIV settled in the royal chateau that since the 1660s had been under redevelopment into a monumental palace.[15] Paris's Louvre was no longer the site of royal residence, and in 1683 both the government and the court definitively settled in the westerly seat.[16] Already a favorite location for the display of luxury before that date, Versailles gained a still stronger role in France's hegemonic hold over fashion, imposing itself the world over as an arena of ostentatious fashion and wealth, with the King spending ten times more on Versailles than he did on new buildings in Paris.[17] A few years after Louis XIV's death in 1715, the relation between fashion and Versailles' court society was made dashingly manifest in the figure of Marie Antoinette.

However, although France's rise to fame in the fields of fashion and luxury cannot be dissociated from Versailles and its court society, nor can it be split from Paris, for Louis XIV's use of fashion and luxury goods as a symbolic tool for the consolidation of royal and national power, like Marie Antoinette's own indulgences in sartorial display and pleasure, were dependent on the city as a site for their material production. Indeed, in the late seventeenth century Paris already occupied a central position in the French and international geographies of fashion, not least thanks to both the production and the consumption of fashion and luxury goods there, and the manufacture of the luxury goods at the heart of Louis XIV's hegemonic project was centralized in the city.[18]

In Paris's rue de la Coutellerie could be found Monsieur Charlier, silk mercer to the King in the 1670s.[19] Celebrated couturières such as, in the second half of the seventeenth century Madame Villeneuve and Madame Rémond, and, in the eighteenth century, Rose Bertin, famous for providing Marie Antoinette with a vast collection of beautiful dresses, were also based in Paris, with the rue Saint-Honoré increasingly famed, from the late seventeenth century on, along with the Place des Victoires, as a fashionable Paris quarter.[20] The Marais district, host to the nobility in the seventeenth century,[21] provided a nearby source of wealthy consumers. So did the Faubourg Saint-Germain, created in the early seventeenth century, home to Paris's *beau monde* and immortalized both in Balzac's novels[22] and in Proust's

A la Recherche du Temps Perdu as the consistently elegant quartier of the Parisian social nobility. A 'concrete reality', the Faubourg Saint-Germain also was a symbolic one, as epitomized by the use in the nineteenth century of the single term 'Faubourg' to refer to the elegant manners of the old traditional elite living there.[23] During the Regency (1715–23) the Palais-Royal also asserted itself as a fashionable quarter and a center of culture.[24]

Thus, as Jones observes, 'La mode's stage' extended beyond the confines of Louis XIV and his Versailles entourage to include various members of the Parisian elite and respond to gazes other than those of the King.[25] If in the seventeenth century fashion, as mentioned earlier, became, as *la mode*, synonymous with all things French, so it did with all things Parisian. A 'new discourse' was developed that celebrated the city 'as the fertile centre from which all fashions were born'.[26]

As a result of the centralizing in Paris of production and retail activities, the many people employed in the growing Paris-based fashion sector became 'an alternative source of knowledge' to that of Versailles, whilst Parisian figures such as courtesans, actresses, *grisettes* and *marchandes de mode* emerged as influential fashion trendsetters, their 'chic urbanity' embraced by the court of Louis XV.[27] Fashion gravitated further from Versailles in the eighteenth century after the court settled temporarily in Paris from 1715 to 1722, and by the 1789 Revolution fashionable figures, such as Parisian *marchandes de mode* and actresses, seriously rivaled the power of the king and the queen in setting trends.[28]

Supporting the aura of Paris fashion was the circulation of French fashion plates and fashion dolls documenting the style of fashionable ladies and promoting Parisian fashion to women throughout Europe. In the 1670s, Donneau de Visé's *Le Mercure Galant* featured engravings showing the latest fashions, although their inclusion in the newspaper proved too costly and he stopped using them.[29] However, it was soon realized that the dolls which had been used as models for the engravings could be dispatched to shops around the world, displaying for their customers the newest creations from Paris.[30] Moreover, although *Le Mercure Galant* was forced to abandon the use of engravings, the 1670s signals the beginning, in Paris, of 'the golden age of fashion plates' by celebrated illustrators such as the Bonnart brothers and Jean Dieu de Saint Jean.[31] At a time when fashion journalism was still in its infancy,[32] the eighteenth century saw both fashion plates and fashion dolls help consolidate the position of Paris as a fashion capital. In the late nineteenth century and throughout the twentieth and twenty-first centuries, fashion photography together with fashion writing

would further support the prestige and aura of Paris in the hierarchy of fashion cities, as I discuss in Part II.

During the first half of the nineteenth century and following the upheavals that redefined the Parisian and French socio-political landscape, the role of tastemaker extended far beyond the confines of court society to become the attribute, more generally, of Parisian figures, and, more precisely, its *beau monde*, found in 'le Tout-Paris'.[33] An expression invented around 1820, and still commonly used, 'Tout-Paris' refers to a fashionable elite of individuals who, contrary to what the expression might suggest, do not represent all of Paris but rather a very small, distinguished section of it.[34] In the nineteenth century this group included artists, writers, politicians, powerful businessmen, and newspaper professionals,[35] to which should be added, today, a string of various personalities from the world of television, cinema and fashion. However, since 'in France *tout Paris* is *tout*', as Lemert puts it,[36] it is a social constituency endowed with the power to set trends and define canons of tastes.

In the nineteenth century fashion established itself as a key Parisian trade, employing, in 1847, 'the greatest number of Parisian workers', with activities such as the manufacture of fabric and shawls and the milling of cotton amongst the most important Parisian industries.[37] The nineteenth century was also when the French field of fashion as we know it today was truly born. Kawamura notes that it signaled the birth of 'the modern system' of fashion more generally, for 'the French system', she observes, 'is still almost universally accepted as legitimate by designers and fashion professionals',[38] with Paris at its geographical center.

By 'field' I mean, as in Bourdieuian theory, a semi-autonomous structured space of positions defined by specific rules of functioning, values and principles, and the existence of consecrated institutions involved in the promulgating and legitimating of such rules and values.[39] Thus, central to the birth of the French field of fashion, and of the modern fashion system, was industrialization and the related rise of department stores and *confection* – the old term, until the late 1940s, for 'prêt-à-porter', from the American 'ready-to-wear'[40] – allowing, like the rapid growth of the fashion press, for the democratization of fashion.[41] However, also central to the making of the field was the creation of haute couture and the figure of the couturier, still at the heart of today's economy of fashion.[42] Indeed, although, as mentioned earlier, the seventeenth century already saw some *couturières* becoming famed for their work, it is in the nineteenth century that elite dressmakers became couturiers in the modern sense of the term:

fashion designers with the power to impose their taste and style on their clientele, as opposed merely to executing its desires.

This new creative power is generally acknowledged as being the invention of Englishman Charles Frederick Worth who in 1858 started his *maison de couture* in Paris, with Empress Eugénie, wife of Napoleon III as one of his most famous customers.[43] Worth's decision to settle in Paris is no mere coincidence, for as Waquet and Laporte note, 'In the Paris of the time, stability, economic and political power, authority, rhyme not only with the freedom to create, but with official support to innovate in fashion'.[44] That Paris was already celebrated as a fashion center also figured in Worth's decision to become a Parisian couturier.[45]

With Worth dressmakers no longer simply made dresses: they made fashion, now organized around new rituals and rules constitutive of the modern fashion system, including the seasonal presentation of his dresses to customers on live models, and the selling of exclusive creations, marked, like an artwork by a painter, by his signature sewn onto labels affixed to clothes.[46] In 1868 Worth also assumed the leadership of the 'Chambre syndicale de la confection et de la couture pour dames et fillettes', newly created the better to conduct the business of fashion and defend its interest in France and abroad. A set of principles and regulations were initiated, overseen by various ruling bodies that laid the foundations for French fashion as a highly regulated and organized field of practices revolving around the French capital.[47] At the time of its creation, the *Chambre syndicale* included both couture and *confection*. Indeed, at the beginning of the nineteenth century little distinction existed between the two.[48] The distinction became clear in 1910 when the *Chambre* was dissolved and *couture* became autonomous, giving way, in 1911, to the 'Chambre syndicale de la couture', also often referred to as 'Chambre syndicale de la haute couture'.[49] The *Chambre* instigated a strict calendar for the seasonal presentation, twice a year in Paris, of couture collections, which participated in the institutionalization of the city as the 'privileged place' for their display.[50] However, in the 1950s the split between haute couture and prêt-à-porter started to be bridged when couturiers began launching ready-to-wear collections to compete with the new crops of prêt-à-porter creations such as those of Lempereur and Chloé, for instance, whose younger and cheaper but nevertheless innovative styles were more in tune with the changing society.[51] In 1973 the relation between haute couture and high-end ready-to-wear was officialized with the creation of the 'Fédération française de la couture, du prêt-à-porter des couturiers et

des créateurs de mode' (hereafter *Fédération française de la couture*) bringing together the 'Chambre syndicale de la couture', the 'Chambre syndicale du prêt-à-porter des couturiers et des créateurs de mode' and the 'Chambre syndicale de la mode masculine'. Also federating French ready-to-wear companies albeit those situated at a lower level of the fashion hierarchy, are the 'Fédération française du prêt-à-porter féminin' and the 'Fédération française des industries du vêtement masculin'.

These organizations regulate the production, diffusion and promotion of the fashion they represent. They oversee relations with the fashion press, ensuring the adequate representation of designers and companies to a media whose role, as I discuss in part II, has been key to the making of Paris as a fashion city. Based in the capital they are also an instance of the centralization of French culture. At the end of the Second World War, for instance, the 'Chambre syndicale de la couture' organized a worldwide tour of French couture; that is, of Parisian couture, for in 1944 couturiers from the provinces were excluded from the *Chambre syndicale*.[52] Entitled *Théatre de la Mode,* and with sets designed by Christian Bérard and Jean Cocteau and Paris couture outfits shown on dolls, this 1945 fashion tour helped re-establish the French capital, weakened by the war, at the heart of the fashion map.[53]

Today the *Fédération française de la couture* still clearly signals its allegiance to the Parisian territory, as opposed to France more generally, by way of a website naming the capital in its title: 'www.modeaparis.com'. This naming of 'Paris' is part of a broader phenomenon, in the fashion press and the fashion industry, of capitalizing on the prestige and evocative power of the city, as I discuss in Part II. In 2002, the 'Fédération française du prêt-à-porter féminin' joined in the well rehearsed yet inconclusive debate on decentralization in France, stating that 'more power must be given to the regions',[54] thereby acknowledging that power lies in the hands of Parisian, as opposed to provincial, representatives of the industry. Thus in 2005, 'few are the companies [from the luxury sector] whose headquarters are far from the capital',[55] for in the French field of fashion as in French economic and cultural life more generally, authority and prestige is synonymous with Paris.

The concentration, in Paris, of the French field of fashion has also been supported by a series of practices and measures, both symbolic and material, which have helped sustain the aura of the French capital and its dominant position in the French hierarchies of fashion and culture. Fashion collections, for instance, have always been presented in Paris,

making the French capital an even greater center of attraction and media attention. Significant in this was the choice in 1982, under the instigation of then Minister of Culture Jack Lang, of the Louvre and its Cour Carrée as a location for the shows. A prestigious site of collective memory and artistic creations, its use as a space for the display of fashion has contributed to the latter's celebration as a national treasure, part of the nation's heritage. Similarly, 1986 saw the creation, in the Louvre, of the Musée des Arts de la Mode, inaugurated by President François Mitterand. In 1997 the museum – renamed Musée de la Mode et du Textile – reopened after two years of closure for redevelopment. A catalog was published with a contribution by fashion historian and curator Lydia Kamitsis that clearly underscored the role of Paris as a representative of France, and the role of fashion, or rather Parisian fashion, as expressive of French culture. She stated:

> When in 1982 Jack Lang, then minister of culture, announced the creation of the Musée des Arts de la Mode, he thereby asserted the State's will to give an activity particularly representative of the French art of living the status of a heritage, so true is it that vestimentary fashion has always been understood as a Parisian speciality.[56]

The 1980s stand out for the particular attention the French government paid to fashion – an attention that testifies to the importance of this sector in the French economy. Indeed, in 2005 it still represented 450,000 direct and indirect jobs with the 1,500 companies of more than 20 employees responsible for a turnover of 32 billion euros, with the fields of perfumery and luxury particularly strong.[57] Thus, in the 1980s, Parisian public displays of state support of fashion were numerous. Waquet and Laporte give examples of such consecration, and by the highest levels of government: fashion designers were given honorary decorations by the French president at the presidential l'Elysée palace, and by the Minister of culture in the Palais-Royal, a sign more generally of the good relations between the couture industry, politicians and the state; in 1984 a public organization aimed at promoting fashion, the DEFI, was created; in 1985, Edith Cresson, then Minister of Industry, together with Jack Lang, Minister of Culture, and François Mitterand's wife, Danielle Mitterand, inaugurated the Institut Français de la Mode, a high-profile postgraduate management school specializing in fashion, located in Paris's high fashion district, the 8th *arrondissement*; in 1986 a spectacular fashion show took place on the prestigious Avenue Foch for a fashion festival, and, a year later, in the Palais de Chaillot with the support of Paris's mayor Jacques Chirac, also Prime

Minister; in 1986, Danielle Mitterand presided over an evening of 'Oscars de la Mode' (Fashion Oscars) in the fêted Palais Garnier opera house.[58]

At the heart of these felicitous relations in the 1980s between state, politics, and fashion was Pierre Bergé.[59] His position as creator, with Yves Saint Laurent, of the couture house bearing the latter's name in 1961, and as founder and head, in 1973, of the 'Chambre Syndicale du prêt-à-porter des couturiers et créateurs de mode', as well as director of Paris's Opéra Bastille and intimate friend of both Mitterand and Lang[60] encapsulated this alliance of high fashion, state power and the arts, all based in Paris.

Subsequent governments have not embraced fashion with as strong a fervor as their predecessors. Local authorities have, however, capitalized on it as a way of promoting the city, further consolidating the construction of Paris as center of fashion. Witness the launch in 2000 of Paris City Council's operation *'Paris, capitale de la Mode'*, renamed in 2003 *'Paris capitale de la Création'* and aiming at promoting twice a year, in September and January, fashion, interior decoration and design. Thus, in his 14 January 2000 press conference for the launch of *'Paris, capitale de la Mode'*, Jean Tibéri, mayor of Paris at the time, declared that the event 'is the first global fashion rendezvous of 2000. It would have been unthinkable for it to take place elsewhere than in Paris [. . .] It is in this way that Paris will see its image in this domain further improved and will remain the uncontested capital of creativity and fashion.'[61] In 2003 the French newspaper *Le Figaro*, commenting on that year's edition of *'Paris capitale de la Création'* and mobilizing the myth of revolutionary Paris, stated that 'Paris truly is having a revolution, which suits it well. But it is a silent one, and, importantly, it does not have any victims . . . or just wounded pride in foreign capitals.' The city, the daily adds, epitomizing the success of the slogan in the French press, 'truly is *"la capitale de la création"'*.[62]

The City Council's initiative draws attention to the importance of culture and fashion in the promotion of cities. It must be seen in the light of other cities' struggles, across the world, for the title of cultural capital, and their strategies of insertion into a field of fashion that is now global. Indeed, this field has emerged as a key sector in the cultural economy of cities and their ability to accumulate symbolic, and therefore economic, capital.[63] As Gilbert notes, 'making a city fashionable (in both narrow and wider senses of the term) is now a common and often explicit aim of urban policy'.[64] Witness the many fashion weeks that are now taking place across the world, whether in Sydney, Hong Kong, or Copenhagen, to name but a few. Thus if Paris's hegemony over the rest of the world was long uncontested,

the second half of the twentieth century saw the rise, in the field of fashion, of competing cities and competing visions of fashion the press regularly comments on, as I further discuss in Chapter 4, with London, Milan and New York the three other most established and celebrated fashion cities.[65]

In the global field of fashion, French fashion is highly reliant on the mystique of Paris haute couture and the potency of its symbolic capital. Worth's creation, in Paris, of the first couture house, soon followed by the launch of more couture houses, from the late nineteenth century and early twentieth-century houses of Jeanne Paquin (1891), Jacques Doucet (1900), or Paul Poiret (1904) to today's Jean-Paul Gaultier Paris, have fed into the city's hegemonic hold on French cultural and economic life, as well as on the global field of fashion more generally. Paris remains the city French fashion is conflated with, not least by way of its high-end pole, haute couture and the prêt-à-porter of couturiers and créateurs de mode. Couture clothes, as is often noted, are bought by a handful of privileged customers only. However, the aura that haute couture continues to convey represents a powerful promotional tool for both the ready-to-wear lines and many derived products, such as cosmetics and accessories, that bear the name of couture houses, as well as for the lower end of the ready-to-wear sector,[66] which benefits from the 'Paris' cachet couture sustains. In the process the city is given more visibility on the global map. In Part II I return to this idea of the promotion of the city by way of its association with the field of fashion and fashion brands. Thus, as Scott observes, 'if the cultural economy of Paris faltered somewhat in the twentieth century, and especially in the second half of the century, it still functions as a major site for many kinds of cultural production' such as cinema and sound as well as fashion.[67] Haute couture offers exposure both to brands and to Paris, further emphasizing the central position of the city in the French field of fashion.

The centralization of French fashion in the capital has also been supported by the concentration in Paris of all major fashion exhibitions more generally. The collections are an example but so are the salons – trade exhibitions – that regularly take place in the city and its outskirts, drawing to the capital fashion professionals from all over the world. Amongst them is 'Prêt-à-Porter Paris', which, like the Fédération's website and many fashion companies, trades on the value of the French capital's name.

Both collections and salons are central to the worldwide promotion of Paris fashion and the production of the city's position as fashion capital, still seen by many fashion players as the obligatory stage for designers

to show their work if they wish to succeed and gain visibility.[68] This has been compounded by the fact that the label 'haute couture', like that of 'couturier', can only be acquired by following the regulations set by the Paris-based federation, and these include showing in Paris. Foreign designers such as Hanae Mori[69] have thus been dependent on the French capital to qualify as couturiers, allowing the city to strengthen its monopoly over luxury fashion and benefit from the worldwide publicity the twice-yearly couture collections generate.

In France, Paris is not only the location of choice for the revealing of new creations, but also for the display of past fashions, fashion's history and heritage. Although throughout the 1980s a series of museums of fashion and costume were created throughout France (60 all in all),[70] Paris still hosts the most famous museums and the most celebrated fashion exhibitions. The Louvre's Musée de la Mode et du Textile, mentioned earlier, is one, and another is Paris's Musée Galliéra.

Paris is also where the most prestigious French fashion schools are concentrated, including the Studio Berçot, l'Ecole de la chambre syndicale de la couture and the Institut Français de la Mode. One's chances of becoming a designer are highly dependent on one's initial move to the French capital; that is, one needs to become a Parisian before being able to take the title of couturier.

The concentration in Paris of major exhibition venues, museums and schools, then, has supported the construction of the capital as a fashion city, perpetuating its dominance over the rest of France. But so have the many sites and spaces which have been central to the display of fashionable attire as worn and sold, making of the French city, more than any other city in France, and, arguably, abroad, an environment favorable to the creation and display of fashion. As Gilbert points out, 'the continued cachet of the name "Paris"' is not simply dependent on advertising and the media's ability to build an attractive city, it is also an outcome of the city's 'credibility [. . .] as a centre of fashion consumption and particularly as an embodied experience of fashion'.[71] These spaces, however, cannot be thought of outside of the many texts that have brought them to the attention of the world, in the process participating in the construction of the Parisian geography of fashion and the city's consecration as a site of prestige and sartorial excellence, as I now discuss.

Parisian spaces of fashion:
A geography at the junction of the lived and the imagined

Fashion, Steele notes, 'can only exist and flourish in a particular kind of dramatic setting with knowledgeable fashion performers and spectators'.[72] The rise of Paris as a fashion center was dependent on it being able to stage fashion.[73] Steele contrasts American and French societies, with the former characterized until recently, she argues, by 'a "small town" ambiance and a fairly puritanical attitude towards fashion', and the latter by a more cosmopolitan, 'ritualized fashion display'.[74] A variety of sites and spaces have lent themselves to the Parisian 'drama of seeing and being seen', with places such as theaters, parks, racetracks, boulevards and department stores central, Steele writes, to the thriving of Paris's 'geography of fashion'.[75]

This is a geography that many French authors and artists have put into words and images, promoting to a French but also to an international audience of readers and viewers visions of Paris as a place of fashionable display. The material and the symbolic, I point out in Chapter 1, cannot be separated: they feed into each other. As Proust said: 'Women pass in the street, different from those of the past, since they are Renoirs, these Renoirs in which, in the past, we refused to see women'.[76] Painters, he writes, make us see the world differently: the world 'has not been created once, but as often as an original artist has appeared'.[77] In the same way that embodied practices and perceptions are shaped by the representations they also feed into, cities are both a discursive and a phenomenological reality. The creation, and consecration, of Paris as fashion city, then, is as much the product of the emergence of real material spaces and practices of fashion as the product of the many texts that have given such spaces and practices a worldwide resonance and auratic appeal central to the promotion of fashionable goods.

In the remainder of this chapter, I turn to some of the spaces that authors such as Steele and Martin-Fugier have shown were key to the making of Paris as a fashion city in the nineteenth century;[78] also to comment, as I do with more contemporary sites of Parisian fashion, on their putting into discourse. I thereby draw attention to the importance of both the real and the discursive in the making of Paris. I do not see painterly and writerly visions of the city simply as straightforward evidence of life in the capital at the time, but as selective and mediated accounts productive of a particular Paris that will have overshadowed alternative visions of the city. As Marchand notes, and it is a comment equally true of Proust, 'Stendhal's

or Balzac's novels almost only stage the superior classes of the Parisian society. These, however, were only a small portion of the population';[79] a portion that has nevertheless become central to the Paris myth.

In nineteenth-century Paris, the Opera, for instance, was a space where fashionable audiences could gather not only to admire the latest musical productions but also to lend an eye, and present a spectacle, to elegant crowds.[80] Like the Théatre-Italien, another stronghold for operas, a musical genre that since the late 1670s had gripped Parisian high society,[81] it was a place 'to see and be seen'.[82] In the first half of the nineteenth century dashing and celebrated balls were a key figure of elegant Parisian life.[83] Women's outfits, the decorations, the music were depicted by the press as a spectacle, with Parisian *badauds* gathering in the street to gaze at the beautiful crowds on their way to a few hours of sumptuous entertainment.[84] The Opera had been host to such balls since 1716, when the famous 'bal de l'Opéra' was created.[85] During the July Monarchy the Opera's *bals Musard* in particular, named after the conductor who directed them, were prestigious events that helped forge Paris's fame as the capital of dance.[86]

Located in rue Richelieu until 1820 and then rue Le Peletier, the Opera was destroyed by fire in 1871.[87] In 1875 a new edifice, Le Palais Garnier, named after its architect, was inaugurated, a jewel in the crown of Haussmann's Paris. In his detailed analysis of the archives of the building, Patureau insists on its significance as a tool for the celebration of national prestige, for the consecration of lyrical art in contrast with other musical forms, and as a space for the experience and display of the 'splendours of *la vie mondaine*' (high society life).[88] All three dimensions were clearly acknowledged as being the key missions of the building.[89] A forerunner to the *grands travaux* that, in the twentieth and twenty-first centuries, would come to characterize the French Presidents' relation to the capital as the site of the expression of national and personal prestige, the Opera was thought of as the place for the display of France by way of its social elite. Its location in an upmarket area also conveyed this message.[90] Thus, a preparatory report stated that the auditorium must 'present the spectators with conditions similar to those offered by a meeting in a salon; [because] everyone must have their role in the representation'.[91] Charles Garnier himself insisted on the importance of dress [les toilettes] in the making of a spectacle addressed to 'a crowd that observes and feels observed'.[92] The magnificence of the building as well as that of its visitors made it one of the most fêted opera houses.[93]

But the Opera is also the romanticized place of novels such as those of Balzac and Proust; a site of real practices from which literary creations took inspiration and which they documented, at the same time lending it an appeal and visibility which the evocative and enticing style of both writers helped consecrate in the collective imaginary.

With Proust, the Opera is where the narrator hears, for the second time, the celebrated Berma playing Phèdre. But it is also where various strands of Paris's social elite appear before his eyes, a space given to the observation and contemplation of the beautifully adorned audience. 'White goddesses' sit in the boxes, their 'feather fans' and 'crimson hair tangled in pearls' slowly emerging out of the dark as 'the show proceeded'.[94] The show is not simply that unfolding on the stage, but that played out in the boxes by the beautiful goddesses. '[T]heir radiant faces appeared', their 'limpid and sparkling eyes' could be seen. Surpassing them all in beauty is the princesse de Guermantes. '[T]he delicious and uncompleted line of her waist', Proust writes, 'was the exact point of departure, the unavoidable beginning of invisible lines one's eye could not keep from extending, marvelous, created around the woman like the specter of an ideal figure cast by the dark'.[95] Her box was like a 'painting', the princess at once the object of contemplation and the artist whose work one contemplates: 'like those artists who, instead of the letters of their name, place at the bottom of their canvas a shape beautiful in itself, a butterfly, a lizard, a flower, it was the form of a body and of a delightful face the princess appended at the corner of her box, showing that beauty can be the most noble of signatures'.[96]

The spectacle the Opera offers, Proust suggests, resides as much in the audience and its beautiful attendants as in the show itself. Indeed, '[a] certain number of orchestra stalls had been sold in the office and bought by snobs or nosey individuals who wanted to contemplate people they would have no other opportunities to see from close up. And it was indeed some of their society life normally hidden one could publicly observe.'[97]

Proust's Opera scene, and the play of gazes and displays he depicts, reminds one of Balzac's opening chapter of *Splendeurs et Misères des Courtisanes* 'A view on the opera ball', where the narrator observes the whirlwind of individuals attending the 1824 event. There, Balzac writes, 'the different circles which constitute Parisian society meet, acknowledge, and observe each other'.[98] The place and its social scenery can only be grasped through observation, looking and being looked at. Indeed, many participants are masked and hidden behind a domino – the 'illustrious black Venetian robe'[99] worn mostly by women at such an event – but their

social and personal situation can be guessed by reading off the surface of their bodies various signs and marks. The Opera as Balzac depicts it is nothing but a condensed version of the Parisian social scene, ruled, the writer implies, by appearances. 'Who has failed to notice that here as in all areas in Paris there is a way of being that reveals what you are, what you do, where you come from, and what you want?' Balzac asks.[100]

The desire to appear and be seen is also what chiefly interests the Parisian Foedora when in *La Peau de Chagrin* she attends an opera at the Théatre-Italien. 'She did not listen to the music', Balzac writes; rather she 'presented herself there like a show within the show. Her opera glass travelled incessantly from box to box: anxious, although calm, she was a victim of fashion.'[101]

It is with the writing of Balzac, Fortassier argues, that fashion entered French literature.[102] In his novels the personal, the social and the sartorial cannot be dissociated.[103] 'Dress', he writes in his *Traité de la Vie Elégante*, 'is the expression of society'.[104] Thus being a Parisian – as much a social as a geographical state, we saw in Chapter 1 – means looking like one; that is, not appearing provincial, the concern of Balzac's Lucien de Rubempré and Madame de Bargeton upon arrival in Paris.[105] For in Balzac's novels the distinction Paris/*province* is articulated along the lines of a discourse on fashion whereby Paris is synonymous with fashionability and *la province* with an unredeemable lack of fashion sense. 'Transported to Paris', he notes, 'a woman who passes for pretty in *la Province* does not get the slightest attention, for she is beautiful only according to the proverb: In the kingdom of the blind, the one-eyed man is king'.[106] In Chapter 5 I return to this idea of a distinction between provincial and Parisian women.

More than a century later, French writer Nicolas Fargues still mobilizes this theme of the socio-sartorial split of France into Paris and *la province*. In his 2002 novel *One Man Show*, the main protagonist, when planning his trip to the capital reflects anxiously on how best to dress so as not to appear too provincial. Conjuring up the memory of Parisian writers such as Hugo and Zola for reassurance about having left the capital, he states:

> Every time I returned to Paris I felt intimidated. I was thinking about all that might have happened while I was away, even though those very things are also what I had fled from by choosing to live in the provinces, without thinking that it would one day give me complexes, nevertheless, about no longer being up-to-date. But I quickly reassured myself by thinking that coming back to Paris as an exiled writer was even more Parisian than simply having remained a Parisian.[107]

Pondering what to wear for a meeting at a TV production company Fargues asks: 'Shirt-jeans-trainers or t-shirt-jeans-trainers? Does a thirty two year old provincial writer in trainers look naff or pseudo trendy?'[108]

The Opera was a site of fashionable display in the years of Balzac's and Proust's novels, but in the twentieth and early twenty-first centuries too it lent itself to the spectacle of fashion. In March 1929, for instance, the Palais Garnier hosted *le Bal de la Couture*, organized by the 'Chambre syndicale de la couture'. The event, a fashion show followed by dining and dancing, the newspaper *L'Illustration* tells its readers, has become 'one of the season's most sought after celebrations of elegance'.[109] A large illustration showing glamorously dressed models waiting their turn to present their outfits to the audience, with a view of a beautifully lit theater in the background, further cemented the status of the Opera as a site of elegance and prestige. Similarly, in 1986, as mentioned earlier, the French *Oscars de la Mode* took place in the Opéra Garnier, and in late 2007, in Wong Kar-Wai's promotional film for the launch of Dior's new scent 'Midnight Poison', actress Eva Green could be seen running up its impressive staircase and along its corridors in an evening dress by John Galliano. A spectacular gala had taken place there a few months earlier to reveal the film to the international press. In 1998 too Dior had appropriated the Palais Garnier to present the couture collections designed by Galliano. For, in Paris, fashion designers often hold shows in Parisian sites of prestige. The Carrousel du Louvre, the Ecole Nationale Supérieure des Beaux Arts, the Grand Palais, the Palais de Tokyo, and even the Sorbonne have all become stages for the collections, thereby consolidating the relation which has long existed between Paris high fashion and the field of art.[110]

If the locating of the Musée de la Mode in the Louvre is an instance of this positioning of fashion as a high art, so is the literary embrace and celebration of fashion by French authors, including Proust. In the writer's *A L'Ombre des Jeunes Filles en Fleurs*, for instance, Elstir praises the creations of Callot, Doucet and Paquin; the maid Françoise tastefully decorates her hat with details 'that would have been ravishing in a Chardin or a Whistler portrait'; Fortuny is described as 'an artist', who still has the fabrication secret of Venetian guipures.[111] For Proust, as Steele points out, 'Fashion is, potentially, a work of art'.[112] As in the French field of high fashion discussed by Bourdieu and Delsaut, in Proust's writing 'the references to noble and legitimate arts, painting, sculpture, and literature' provide fashion 'with most of its ennobling metaphors'.[113] By way of the literary celebration of the fashion that is created, shown and worn in Paris, and its legitimation

as high art, the Paris myth is given yet more resonance, the city once again aligned with all things superior and distinctive.

Proust's consecration of the Parisian art of fashion is all the more noteworthy in that not only is he one of the French writers most fêted in his country, but also, in France, writers are particularly valued. Their celebrating fashion is a significant act of ennobling which few other cultural practices could equal. Indeed, in the French cultural hierarchy, literature stands out for the high status accorded to it.[114] In France, mastery of the written word is a key component of one's cultural capital, a source of high symbolic capital.[115]

Proust's attention to dress and attire, and the ennobling of fashion such attention grants, is supported by the many other authors who have turned to the subject or written for the fashion press. Balzac is one of them, with his *Traité de la Vie Elégante* published in *La Mode* in 1830.[116] In 1874 Mallarmé went as far as to create a fashion magazine, *La Dernière Mode*, acting as its designer, editor and author.[117] There he endeavored to 'study fashion as an art',[118] devoting much space to 'fashion and Parisian taste', as announced on some of the covers of the magazine.[119] Colette and Louise de Vilmorin too have written on, and for, fashion.[120] More recently, so has author Amélie Nothomb who, in one of her editorials for *L'Officiel* compared Christian Lacroix to an artist.[121] Fashion, and in particular Paris fashion, and with it Paris, has thus been given a legitimating attention and prestige that has not yet been awarded to fashion in other cities.

If the Opera has been a privileged site for the spectacle of fashion, so have the many outdoor spaces that have brought Paris fashion to the public gaze, feeding into the construction of the Parisian geography as a geography of fashion, and that of the city as a fashion city. Amongst such spaces were gardens and parks, which, as with many Parisian sites of fashionable display, have found their way into literary and artistic visions of the city, and have thereby been further consecrated as key to the spectacle of fashion.

Thus, as the nineteenth century saw a trend for Parisian gardens fueled by the myth of the 'idyllic' countryside, spaces such as the Parc Monceau and the Jardin des Tuileries, for instance, became places of refuge within, and yet at the same time away from, the city.[122] The Tuileries garden was also where, upon arrival in the capital, Balzac's Lucien de Rubempré 'spent two cruel hours' discovering, in the light of 'the elegant crowd' promenading there, the inadequacy of his provincial attire.[123] More acquainted with the Parisian elite's code of fashion and 'the world of necessary superfluities',

he later goes back to the garden wearing an elegant outfit: 'There he took his revenge. He was so well dressed, so gracious, so beautiful, that many women looked at him.'[124]

Painters, too, have offered visions of the city's outdoor spaces as fashionable spaces. Sargent's 1879 painting *In the Luxembourg Gardens* (see fig. 2.1), for instance, shows an elegant couple promenading during the tranquil hours of a late afternoon in the garden that many nineteenth-century French poems have celebrated.[125] Sargent was only one of the numerous American painters who traveled or moved to the city to enjoy its pleasures, making of the French capital a favorite object of late nineteenth-century representation[126] and thereby further consolidating the position of Paris in the collective imaginary.

Fig. 2.1 John Singer Sargent. *In the Luxembourg Gardens*. 1879. Oil on Canvas, 65.7 x 92.4 cm. Philadelphia Museum of Art, Pennsylvania. The John G. Johnson Collection, 1917.

A celebrated place of elegant strolling was the Bois de Boulogne, in the west of the capital.[127] Initially reserved by the kings for hunting, in the late eighteenth century it became famed as a site where, during Holy Week, Paris's *beau monde* could be observed on its way to Longchamp's abbey, their journey there known as the 'défilé de Longchamp'.[128] In the early nineteenth century it was further established as a space for the parading of elegant Parisians. As Saiki notes: 'the religious destination soon became only a pretext to display "the new outfits and new fashions [...] of the great lords, the noble ladies and famous actresses"'.[129] Indeed, during the Restauration, Good Fridays were known as 'le beau jour' ('the beautiful day'), capturing the idea that on that day the promenade, on the Champs-Elysées, of elegant Parisians on their way to the Bois de Boulogne and Longchamp was particularly vibrant with fashion, hosting more strollers in their dashing outfits than on any other day.[130] Thus in his 1841 *Physiologie*

du Bois de Boulogne Edouard Gourdon notes that: 'Fashion has branches everywhere: in the Tuileries, in the theatres, on the boulevards, in the *Chateaux*: it reigns in the Bois de Boulogne'.[131] The Bois, as it is also known – for 'to say I am going to the Bois de Boulogne is provincial or ill-mannered; to say I am going to the Bois is to be a man who is well brought up' – is the 'temple' of fashion.[132] In the second half of the nineteenth century it was given a new impetus by Napoleon III who, with Haussmann, presided over its redesigning and embellishing, further anchoring it to the Parisian geography of fashionable strolling.[133]

Guidebooks supported the institutionalization of the Bois' position as a fashionable space by recommending it to visitors to the city, who could revel in the spectacle which finely dressed women promenading in their carriages presented to the gaze.[134] As with many Parisian sites of sartorial display, the Bois was also appropriated by literature to become a conspicuous space in mental maps of the city. Zola, for instance, sets the opening scene of *La Curée* in this location, the place of election for the promenade of the beautiful and elegant Renée.[135]

At the beginning of the twentieth century photographer Jacques Henri Lartigue captured, whilst at the same time further constructing it as such, this characteristic of the Bois as a space for fashionable strolling and the sighting of what in his journal he calls 'the lady in all her get-up; very fashionable, very ridiculous ... or very pretty, who knows?'[136] A series of pictures he began in 1910 shows women promenading in the Bois de Boulogne or in its avenue of approach, the Avenue du Bois de Boulogne, now called the Avenue Foch, between the Arc de Triomphe and the Bois.[137] One photograph from 1911 catches the web of gazes in which both the observer and observed were caught (see fig. 2.2). It shows three fashionable women strolling in the avenue. One of them, engaged in a conversation with her female companion, gazes at the lady walking in front of them as if this woman, or perhaps rather her dress, were the object of their discussion. However, they are themselves objects of a gaze: that of the man who follows them, his smile a sign perhaps of the pleasure the sight of these two fashionable women gives him.

Lartigue shared Proust's interest in the passing of time and its relationship to memory, and like him, albeit through a different medium, he helped immortalize Parisian spaces such as the Bois de Boulogne.[138] Indeed, the Parisian Bois is one of the fashionable backdrops for the promenading of the characters of *La Recherche*. 'It was the women's Garden' Proust wrote in *Du Côté de chez Swann*. Its *Allée des Acacias* had been 'planted for them

Fig. 2.2 'Avenue du Bois de Boulogne; Max de Cazavent suivant ses amours, Paris, 15 Janvier 1911' ['Avenue du Bois de Boulogne; Max de Cazavent following his lovers, Paris, 15 January 1911']. Photograph by Jacques Henri Lartigue © Ministère de la Culture – France / AAJHL.

with trees of one sole species', and was 'visited by the famous Beauties', such as Madame Swann, who went there almost every day and whom the narrator, Marcel, hoped to see pass by.[139]

A few years later Proust also recounts how people went to the Avenue du Bois de Boulogne to gaze at rich Parisians.[140] Standing at its entrance, once again, Marcel eagerly awaits Odette Swann, hoping to accompany her in her stroll on the avenue. Her appearance makes him delight in the contemplation of her outfit. Her dress is in tune with both space and the season; 'languorous and luxurious like the most beautiful flower', she wears it in a regal manner, with 'competence and force', followed by a court of men, 'profane', compared to Odette, in the art of fashionable display.[141]

The Bois is also the location where Maria Casarès in Robert Bresson's 1945 *Les Dames du Bois de Boulogne* is seen wearing her dark elegant gown (Schiaparelli and Grès were the costume designers), and French fashion journalist Laurence Benaïm evokes the film when in *Le Monde* she notes that during Yves Saint Laurent's March 1996 show 'one sees again the black and brilliant tones of the Dames du Bois de Boulogne, by Robert Bresson, on a background of sparkles and long floating crepe skirts'.[142] It was in

the Bois that Jean-Paul Gaultier staged '*ses Dames du Bois de Boulogne*' in his eponymous 2006 advertising campaign. In January 2006 John Galliano revealed his haute couture collection for Dior in a marquee erected in the Bois de Boulogne, as did Karl Lagerfeld for Chanel in July of the same year. In 2010 the Bois will yet again lend itself to fashion, and, more precisely, one of its most famous names and brands, with the creation of the 'Fondation Louis Vuitton', designed by Frank Gehry. 'Wearing', as French fashion magazine *Elle* puts it, 'a transparent dress placed on a wooden structure',[143] it will be devoted to contemporary art – further consolidating the relation between high fashion and high culture.

The horse races that had been taking place at the Longchamp and Auteuil tracks in the Bois de Boulogne since the second half of the nineteenth century were another opportunity for high society women to don fashionable dress.[144] The park that hosted such events, and the events themselves were, like the Chantilly races, among the first outdoor backdrops shown in fashion photography to display the stylish attire of elegant women. Indeed, during the first decades of the twentieth century the link between these spaces and fashion was further sealed with the photography of the Séeberger brothers.[145] In their work, published in fashion magazines such as *Les Elégances Parisiennes*, *Femina* and *Vogue*, the creations of Prémet, Madeleine Vionnet and Worth, for instance, are worn by bourgeois ladies strolling in the Bois and attending the races.

The fashionable spaces that appeared in the Séeberger photographs were Parisian spaces, except for those outside the capital occupied by the Parisian social elite during various high society events such as the Chantilly races, or visited during the winter and summer holidays. Views of Longchamp and Auteuil alternated, like the seasons, with views of Deauville or Biarritz, made visible by the visibility of those who, temporarily away from capital and the better to return to it, congregated in those most Parisian of non-Parisian resorts.

Races, gardens and parks were green enclaves of sartorial spectacle protected from urban chaos and the hectic pace of Parisian arteries. However, these arteries too were a stage for fashion displays, for, in the course of the nineteenth century, the city streets and boulevards became central hosts to the fashion culture that was increasingly becoming a visual and tangible feature of the French capital. Thus in her column for *La Presse* in 1837, Delphine de Girardin observes that 'the boulevards are in bloom', and they are in bloom because the fashion seen there is like a parade of colorful flowers. She writes: 'it's the season of pretty women, pretty dresses;

each costume is a bouquet; rose muslins, white *jaconas*, blue scarves, lilac taffetas please the eyes'.[146]

The Boulevard that, since the late seventeenth century, stretched between République and Madeleine on the old ramparts, had become fashionable around 1750, with the section known as the boulevard des Italiens, in particular, as we saw in Chapter 1, famed as a site of elegant strolling.[147] In this place, along with the adjoining boulevard Montmartre, Léon Gozlan wrote in 1834, are accumulated 'all the treasures of this goddess we worship there who has two faces: Fashion and Pleasure'.[148] However, a key moment in the fashion history of Parisian boulevards, as we also saw in Chapter 1, took place in the second half of the century when Haussmann presided over the reconfiguration of the capital, resulting in a controllable and spectacular Paris, a city enjoying itself in the midst of a profusion of goods and cafés as well as the terraces that, since the 1860s,[149] had started appearing on the Parisian pavement. The spectacle offered was that of consumption, now entrenched in the material make-up of the city, and, increasingly, its 'imagined geography'.[150]

At the heart of this redefined and spectacularized Paris of boulevards was fashion:[151] fashion as addressed to the gaze of those observers sitting at the terraces and café windows that paved Parisian streets and which today are still a central feature of Parisian culture, along with fashion as made available to purchase in the shops that were flourishing in the city. From the vantage point of the cafés, brasseries and restaurants, visitors to the city as well as inhabitants could observe and be observed, their clothes the object of attention of a scrutinizing urban gaze. The Surrealists, in particular, made Parisian cafés a recurring setting in their narratives. In the work of Breton, Aragon, Desnos or Soupault, for instance, 'It is a privileged site of observation: women passing by, consumers, the display of prices, the arrangement of curtains, everything is precious, everything signified the possible encounter with a woman, a play on words or an object'.[152] In Chapter 6 I return to the idea of the observation, in Paris, of women passing by.

Steele notes that '"Paris and the boulevards" conjure up a host of images for us [. . .] principally because so many artists depicted them'.[153] Similarly, nineteenth-century guidebooks were paramount to the celebration of the Parisian boulevards and the fashionable life that could be observed and experienced there. They may well have described an empirical reality, but their 'selective geography'[154] certainly contributed to selective visions of the city as the city of pleasure, luxury and appearance. Indeed, Hancock

shows that in the second half of the century, Parisian boulevards moved to the heart of tourist guides, taking over the Palais Royal in the 'Paris imaginary'.[155] They became the privileged recommended sites of *promenade*, a privileging which no doubt fed into practices of the boulevards as spaces of fashionable strolling. Where London often became associated with its docks and river in discourses creative of the city as city of business, Paris became assimilated with its boulevards and the pleasures and luxuries they were host to.[156]

Thus in *Les Plaisirs de Paris*, boulevards are the first promenade Delvau invites his readers to indulge in. In a statement reminiscent of Proust's remarks on seeing women via the eyes of Renoir, he discusses, invoking Balzac's work, the Parisian types one sees there: between 2PM and 6PM and then from 9PM until beyond midnight they are, he argues, a stage for 'the Parisian comedy, – that is nothing, after all, but Balzac's Human Comedy, which would make one think either that this great writer painted all his types according to nature, or that the types we see today have been formed according to his. Look, here is Esther giving Madame de Restaud her pitying smile', and the author later praises 'those devilish little *Parisiennes* of the boulevards, who have in their walk, their dress, their physiognomy, a provocative and irresistible *je ne sais quoi*'.[157]

Displayed on the bodies of the elegant crowds encountered on the boulevards, fashion could also be admired as showcased in the windows of the grand magasin (department store) that, in 1865, had opened on the boulevard Haussmann near the Opera, then under construction: the Printemps. The building was as much a spectacle as the products it displayed.[158] In 1923 it was adorned with a glass dome that has been much celebrated,[159] as has that completed in 1912 for the nearby Galeries Lafayette (founded in 1896).

The Printemps is one of the many department stores that flourished in the capital in the second half of the nineteenth century and made available to a broad range of consumers the pleasures of fashion and of a democratized luxury.[160] With an abundance of products sold across many floors, they were sites of architectural and technological modernity[161] that, like the boulevards, entered the Parisian imaginary and the definition of the city as the privileged center for the consumption of fashionable goods. Amongst them were le Bon Marché (founded in 1852); Au Coin de Rue (1864); La Belle Jardinière (1866); A la Ville de Saint Denis (1869); A La Samaritaine (1869); Le Bazar de L'Hotel de Ville (1871); Les Grands Magasins du Louvre (1877).[162]

In France, department stores were first a Parisian prerogative. As Gaillard observes: 'until the end of the century they flourished only in Paris because Paris was the only city in France offering enough concentration of bourgeoisie and desire to risk the sale of new goods on such a scale'.[163] Store catalogues,[164] however, allowed provincial women to delight in the goods they offered, further supporting the material and symbolic circulation of Parisian fashion and the relation between the city and the world of fashionable commodities. Today although many provincial cities harbor a department store, none have equaled the sheer volume and splendor of the Parisian originals.

The notoriety of the Parisian department stores has famously been supported by Zola's 1882 *Au Bonheur des Dames*, the name for the grand magasin he set his story around, and which was inspired by existing Parisian department stores.[165] Indeed, Jourdain, the architect involved in the redesigning of La Samaritaine at the beginning of the twentieth century, had sent Zola his plans for his dream store and the author drew on his ideas in his description of *Au Bonheur des Dames*.[166] The opulence, appeal and spectacle that department stores offered consumers[167] is given a lyrical and enticing quality in Zola's description of this store in the opening chapter. Denise, recently arrived from the provinces, soon discovers the *magasin* she will later work for: it 'filled her heart, held her back, moved, interested, and forgetful of everything else'.[168] 'She had never seen this, admiration held her riveted to the floor', it 'made her dizzy and attracted her' Zola also writes of 'this chapel built for the cult of woman's graces'.[169]

Another Parisian department store, Le Bon Marché, also made a literary character dizzy: Darling, in Christine Orban's 2002 chick lit-like novel *Fringues*. Looking to assuage her passion for shopping and fashion, Darling heads to Le Bon Marché, 'a best of all worlds', a 'paradise' that makes her head 'spin' as soon as she opens the door: 'It feels as though I have been grabbed by this cocooned universe full', she states, 'of such varied things to discover'.[170] After hours of frantic buying she leaves the store, grateful: 'this land of discovery has avoided my having to cross the channel to go to Manolo Blahnik'.[171]

At the beginning of the new millennium the power of attraction of Parisian department stores, which texts such as Zola's have helped cement, has remained unabated, with the Galeries Lafayette, for instance, visited by 80,000 people a day: 'around four times more than are attracted by the Eiffel Tower'.[172]

The geographical proximity of the Opera, Printemps, and Galeries Lafayette captures the spectacular culture of consumption that developed in nineteenth-century Paris, a culture of the arts conjoined with a culture of shopping, and which the addition, in the late twentieth century, of a shopping mall to the nearby Louvre also tellingly epitomizes.

The many fashionable boutiques that have flourished in Paris throughout the centuries have also been key to fixing the fashion map on that of the city. As DeJean argues: 'ever since the 1660s, no other city has been more visibly identified with the acquisition of all the categories of luxury goods that people collect and display'.[173] Visitors to the capital raved about the luxury and opulence encountered there.[174] In the 1660s, for instance, the Foire Saint-Germain, a fair in the heart of Paris devoted to the buying and selling of high-end goods, became famed as a site of elegant entertainment, fashionable display, and luxurious shopping.[175] By the end of the seventeenth century a series of luxury shops had gathered on the *rive droite* (right bank, on the north side of the river) around the Place des Victoires and the rue Saint-Honoré, still one of Paris's main fashion arteries.[176] Luxury jewelers were found near the Palais Royal, also the location of high-end hairdressers, and near the Place Vendôme.[177] The latter's appropriation by the most famous names in the field of luxury such as Chanel, Bulgari, Cartier and Boucheron, as well as the Ritz, has endured, responding to the contemplating gaze of the tourists who still wander there from the Opera through another stronghold of luxury goods: the rue de la Paix. Until recently the French Monopoly board's most expensive street (it was replaced at the beginning of the twenty-first century by the Eiffel Tower), it is also the street where, in 1858, Worth created the first Parisian couture house.

The lighting installations which, since the late seventeenth century and in the nineteenth century especially, had allowed visitors to the city to stroll through it more safely at night, also secured the relation between Paris, the street, and the dazzling spectacle of consumption. As Prendergast notes: 'Paris as illuminated "spectacle" is Paris offered for consumption, and nowhere, of course, did gas and electric lighting more directly contribute to the function of the city as dream-machine than in the glitter it conferred on the commodity'.[178]

By the end of the nineteenth century Paris's right bank was firmly established as the main fashionable area, with the rue de la Paix its 'central axis'.[179] The *rive droite* continued to dominate the Parisian geography of fashion until the second half of the twentieth century when a new crop

of *créateurs* and boutiques, including Jacqueline Jacobson for Dorothée Bis and Sonia Rykiel in the 1960s,[180] drew the fashion map south of the river. Bourdieu and Delsaut have discussed this movement of fashion through space.[181] They argue that it reflects the internal structure of the French field of fashion; that is, the relative positions of designers, the positioning of their styles in relation to each other and the different customers they are aimed at. In the early 1970s, at the time Bourdieu and Delsaut wrote their article, established designers such as Dior and Balmain were based in established areas and tending to the taste of the high bourgeoisie. However, newcomers such as Saint Laurent, whose avant-garde collections were aimed at a less conservative clientele, selected upcoming areas such as the Rive Gauche. Saint Laurent significantly named his new line Saint Laurent Rive Gauche. Today, the presence of a number of avant-garde designers and boutiques such as Isabel Marant and Colette on the right bank has arguably given this side a new lease of fashionable life, although both *rives* are now host to a multitude of trendy retail sites and sought-after labels.

Amongst the many guidebooks that have helped promote Paris across the world, and indeed supported its construction as an object of consumption, are those that have focused on the capital as a site of fashion and fashionable activities, helping visitors to the city as well as its inhabitants to keep abreast with its geography of fashion. *Paris Chic and Trendy* is one such book, published in 2006 by Parigramme. Based in Paris, this publisher specializes in books on the French capital, adding yet more texts to the already significant body of work on the city, and helping to promote it in the collective imaginary. All aspects of life in Paris, from its history and representation in various media to its gardens, façades and brasseries, are the subject of a large collection of texts that, like the physiologies before them, are attempting to make sense of the city, order it, categorize it, whilst hinting at its value as a never-ending source of wonder and fascination. Thus 'It is in Paris that fashion is played out' *Paris Chic and Trendy* states, and the guidebook talks about the city's 'elegant banks', adding 'there is, in Paris, a designers' fashion like there is a *cinéma d'auteur*'.[182]

Similarly, in 2003, French publishing company OFR started specializing in all things Parisian and, more significantly, fashionable, bringing to an audience of trendy consumers in France and abroad seductive images and writing on the capital. Their December 2005 guidebook covers various areas of Paris by way of short first-person narratives in French and English that are snapshots of the everyday life of a *Parisienne*; a life of fashion and consumption, for her journey across the city is also a journey across

its fashionable sites. The 'Grands Magasins, Martyrs' entry reads: 'I take Lou to school. Paris is peaceful, well-dressed moms and dads. I go down for breakfast at Andre's hotel (Hotel Navarin) [...] then down to the department stores [...] I check out the new designers on show, the beauty products, the tea rooms.'[183] Texts are interspersed with maps of the areas discussed, indicating the various shops, cafés and restaurants mentioned. The fashion press also regularly uses maps in its construction of Paris as fashionable, a commodified Paris, for, like guidebooks, it too has been central to the representation of the city as an object of consumption, an idea I return to in Chapter 4.

In the ever-changing Parisian geography of fashion, the Triangle d'Or (Golden Triangle) remains a central site of luxury fashion. It is the glamorous, spectacular and spectacularized face of Paris. So called since 1975[184] and stretching between the Avenue des Champs-Elysées, the Avenue Montaigne and the Avenue George V, in the 8th district, it hosts the most celebrated Parisian couturiers. Dior, Chanel, Ungaro, Cartier, Nina Ricci, to name but a few, have all grafted their names onto the Parisian façades that form the triangle. A magazine bearing the name of the area, and available for free in various luxury hotels and other high-end places of the Triangle d'Or, is devoted to this luxurious Parisian space, ensuring the promotion of the various companies present in its perimeter and, in the process, of the luxury face of the capital.

Referring to those areas of a city that attract, as part of their marketing, embassies, businesses, and luxury shops, Pinçon and Pinçon-Charlot talk about 'griffe spaciale'.[185] This notion aptly captures the relation, both material and symbolic that, in Paris, ties fashion and space together, for in French a 'griffe', in the language of fashion, refers to the designer's or company's name affixed to a product – a prestigious label – the equivalent, as Bourdieu and Delsaut have suggested, of the painter's signature in art.[186] The spaces which 'griffe spaciale' refers to form the desirable front of Paris, which the many tourists turn to when they come to the city and which film directors have brought to screens across the world, further enticing crowds to visit. The Place Vendôme, for instance, which Pinçon and Pinçon-Charlot cite as endowing institutions and goods with a 'griffe spaciale', has lent itself to an eponymous film by Nicole Garcia with the ultimate *Parisienne* Catherine Deneuve.[187] An early moment of the film shows a view of the square at night. Its lights conjure up the sparkle of precious jewelry linked to this part of the city, also invoking the perennial idea of *lumière* that Paris has been associated with. Luxury boutiques and

beautiful opulent interiors are the spaces which the elegantly clad Marianne (Deneuve) moves in.

Cinema has been central to the making of Paris as fashion city. Craik even contends that Paris really 'took off as the fashion heart because of Hollywood', thanks to the many films that employed Paris designers to dress actors.[188] Givenchy's collaboration with Audrey Hepburn is but one example, which, alongside the numerous films that have linked the city with the idea of fashion – most famously perhaps Donen's *Funny Face* with Hepburn but also *Falbalas* by Jacques Becker, or, as mentioned in Chapter 1, *Ninotchka* and *Le Divorce* – have helped forge its reputation as the capital of fashion. At the beginning of the twenty-first century, one of the most iconic television series, *Sex and the City*, participated in this construction when, in an episode set in Paris, the trendy Carrie botched her entry into the Dior boutique by falling flat on her face. 'I fell in Dior, so I decided that the more I purchased the less they'd think of me as the American girl who fell in Dior', she tells her lover.[189] What in New York used to be her confident demeanor turns into awkwardness and unease when staged in Paris, the city that can unsettle, the program suggests, conjuring up stereotypical representations of France versus America, even the most fashionable American woman.

However, away from the luxurious confines of the Triangle d'Or and Dior is le Sentier, the hidden face of Paris fashion, less spectacularized because less glamorous. Indeed, le Sentier, based in Paris's second *arrondissement*, is the place, emerging in the nineteenth century and consolidated in the 1950s,[190] where affordable ready-to-wear is manufactured, stocked and sold to French and foreign shops alongside fabrics and the various materials necessary for the manufacture of finished products. It is where garments are made or sourced from wholesalers before being sent elsewhere in the city, France or the world.

The Triangle d'Or and le Sentier are two spaces where Paris fashion is made; a making, however, akin to symbolic production in the case of the former and material production for the latter. Indeed, in areas such as the Triangle d'Or the material production of fashion is obscured in favor of the display and spectacularization of goods productive of Paris fashion as enticing and seductive, a Paris of consumption, pleasure and leisure. In contrast the Paris fashion of le Sentier is that of manufacturing and labor, and is less concerned with display and the aestheticization of fashion. This opposition between two versions of Paris fashion and of Paris more generally – one spectacular, polished to attract consumers, the other

unencumbered by the imperative to impress the consuming gaze, a Paris of sweatshops, workshops and unglamorized trade – conjures up Erving Goffman's notions of front and back regions.[191]

Indeed, in his *The Presentation of Self in Every Day Life* Goffman makes an analogy with dramaturgy to distinguish between the front and back regions of social interaction. While the former refers to the spaces for 'the presentation of idealized performances' aimed at impressing on 'the audience' a specific definition of the situation, the latter is 'where the impression fostered by the performance is knowingly contradicted as a matter of course'. Front regions are those where only 'end products [...] something that has been finished, polished, and packaged' are presented. In contrast, back regions are where the 'illusions and impressions' conveyed front stage are constructed in the open where, for instance, the 'dirty work', 'the long, tedious hours of lonely labour' concealed behind a front of ease, takes place.[192]

Moreover, a region, Goffman notes, is 'any place bounded to some degree by barriers to perception'. Thus various material partitions can isolate from sight diverse areas of an office. Boundaries are both inclusive and exclusive, and in the same way that partitions allow for the identification of a front region a performance will take place in, they also allow for the demarcation between back and front regions.[193]

Although Goffman is interested in performances of the self and organizational practices, his conceptual framework can also be applied to the staging of cities in the collective imaginary. Indeed, in representations of Paris, whether in the arts or literature, glamorous visions of the city too are partitions, symbolic rather than material but not less effective, splitting the capital into visible, showable areas – its 'polished' front region of 'finished', well 'packaged' goods and services – and obscured ones – its back region of unglamorized work and production such as the manufacturing and selling of commodities in le Sentier for instance. A specific, desirable vision of the city is thus impressed on audiences, which are thereby kept away from the capital's back region. Similarly, fashion magazines, as we shall see in Chapter 4, regularly anchor fashion to the most desirable and mythical Parisian spaces barring from sight less openly seductive areas of the city. Like the many books, films and paintings that have supported a spectacular vision of the city, they have promoted its front region – helped 'fix a kind of spell over it' to use Goffman's terminology – that is, the beautiful places where fashion and through it Paris is consumed and displayed, as opposed to the back region where 'the suppressed facts' of fashion manufacturing

and a less orderly and aestheticized Paris 'make an appearance' away from the audience of fashion consumers.[194]

However, before I comment on the Paris of the French fashion press, I would like to return to a notion that has informed much of my discussion so far, and that underpins my analysis, in Part II, of the French fashion media's representation of Paris: 'discourse'.

3
FASHION MEDIA DISCOURSE

In Chapters 1 and 2 I looked at the idea of the construction and celebration of Paris both as an empirical and a discursive reality. I commented on the putting into discourse of the French capital in a variety of texts such as novels and films, looking more specifically at the idea of Paris as a fashion city. In this chapter, and drawing on the writings of Pierre Bourdieu and Michel Foucault, I return to the idea of discourse, focusing specifically, and with a view to defining them, on the notions 'fashion discourse' and 'fashion media discourse'. I thereby establish the epistemological and methodological underpinnings of my analysis, in Part II of the book, of the discursive creation of Paris in the contemporary French fashion press.

Symbolic production

The material production of cultural objects, Bourdieu argues, is only one side of their production. The other side is symbolic production; that is 'the production of the value of the work or, which amounts to the same thing, of belief in the value of the work'.[1] Symbolic objects are artefacts in which beliefs are invested, and the role of the researcher, Bourdieu stresses, is to unravel the ideologies hidden behind them, such as the '"charismatic" ideology' of the creators as sole authors of their work.[2] This ideology is the result of symbolic production – a type of production which aims at 'ensuring the ontological promotion and the transsubstantiation' of the product of material creation.[3] The creation of the fashion label ('griffe') is an example of such a process of transsubstantiation.[4] The label transsubstantiates the material object it is applied to, which then takes on the high value attached to the name. The label does not change the materiality of the product,

but its social characteristics. It is 'the perceptible manifestation – like the signature of a painter – of a transfer of symbolic value'.[5]

An analysis of the symbolic production of culture as it takes place in discourses on cultural objects allows the researcher to understand this process of transsubstantiation. 'A rigorous science of art', Bourdieu notes, must 'take into account everything which helps to constitute the work as such, not least the discourses of direct or disguised celebration, which are among the social conditions of production of the work of art *qua* object of belief'. A variety of institutions – magazines, museums, education – Bourdieu also notes, participate in this process of symbolic production, a production which is also that of the 'universe of belief' which is attached to cultural artefacts. They are 'institutions of diffusion or consecration', whose role is to institute reality.[6] Thus 'Fashion discourse', Bourdieu and Delsaut argue, drawing on Austin's idea of performative utterances, is a particular case of 'celebratory discourse'.[7] So are publicity and literary criticism, and 'all such discourses share the feature of describing and prescribing at the same time, prescribing while appearing to describe, uttering prescriptions that assume the form of descriptions'.[8]

This book is concerned with such a discourse, and more specifically that taking place in the media, fashion media discourse, the discourse of institutions of consecration or 'specialists in symbolic production',[9] here the contemporary French fashion press, as invested with the power to create and consecrate a city: Paris. For, where in the above quotes Bourdieu focuses mostly on the idea of the symbolic production of cultural artefacts, his discussion can be extended to the many components of the field where such production takes place. In the field of fashion as defined in Chapter 2, such components include cities. Discourses of symbolic production are discourses not simply about fashion commodities but also about practices, individual agents such as designers and celebrities, and collective agents such as companies and also cities, as I show throughout Part II. Discourses of symbolic production are discourses about the very field they appear in and that produces them.

Moreover, symbolic production is not the outcome of one institution or one individual only, but of the field of production itself; that is, of the system of relations which exist between all the agents and institutions of consecration which compete for 'the monopoly of the power to consecrate'.[10] Discourses on fashion are structured by the history, specificity and organization of the field they circulate in. They make it at the same time as they are made by it. Discourses are field-specific. Thus by 'fashion dis-

course' I am referring to the discourses that are produced and reproduced in the specific field of fashion, and conveyed by its members, whether collective or individual, designers or fashion journalists, for instance, as Bourdieu and Delsaut note.[11]

Interwoven discourses

In the same way that Bourdieu draws attention to the central role of discourses in the symbolic production of culture, Michel Foucault insists on no longer 'treating discourses as groups of signs (signifying elements referring to contents or representations) but as practices that systematically form the objects of which they speak'.[12] Media discourses invest fashion – its products, practices and agents – with a variety of values whose 'truth' is as much part of the object of discourse as the material reality it refers to.

In Foucault's work a discourse designates an ensemble of statements that share properties, theories and rules of functioning, and sets parameters for what can be said; for what constitutes truth at a certain time and place. It is an ordered and ordering group of statements productive of knowledge. As for a statement, it is not necessarily a sentence or any specific linguistic unit or structure. Rather, it could be said, although the following definition will not do justice to the intricacy and complexity of Foucault's writing on the topic, that a statement is a proposition the researcher is left to decide 'make[s] sense'[13] as conveying the truth of the discourse it belongs to, therefore the truth of the object it speaks of, and constitutes. 'Paris: capital of fashion' is one such statement that is formative of fashion discourse's truth about Paris, as I discuss in Chapter 4.

Discourse is not text-specific. Rather, it cuts across texts and across fields. It does not originate in the voice of one particular author but passes through him or her:[14] It 'is not the majestically unfolding manifestation of a thinking, knowing, speaking subject [. . .]. It is a space of exteriority in which a network of distinct sites is deployed.'[15] The various members of the field of fashion formulate and exchange statements that are formed by, and are formative of, their field, but which also belong to a wider 'discursive formation'; that is, a 'large group [. . .] of statements' that might well be 'different in form, and dispersed in time' but which 'refer to one and the same object' and are linked around an 'identity and persistence of themes'.[16] These statements are formative, as mentioned earlier, of the objects of which they speak. A regular theme of discourses on Paris,

for instance, as I show in Part II, is the idea that the capital is an active agent in the making of the arts and fashion, a creative source whose spirit manifests itself in creators and their creations. This notion, spirit – *esprit* – is a recurring concept, a 'constant [. . .] of discourse'[17] on Paris.

Discourse, then, is a space of knowledge with porous boundaries, a wide constituency of layered nodes of ideas, themes and concepts that cut across disciplines and fields. This is why statements on Paris in the fashion media must be seen in the light of a discourse on the French capital that has been articulated in texts from various historical periods and discursive fields, including those of literature, the arts and cinema. Fashion discourse, and within it fashion media discourse, enunciates statements pertaining to a wider formation of texts including those of literature and the arts.

Foucault uses the notion of discourse in relation to both objects and bodies of knowledge. He talks, for instance, about 'discourse on sex', but also about economic and psychiatric discourses.[18] Where the former refers to statements on sexuality that cut across texts and disciplines, the latter suggests that Foucault also understands discourse in relation to specific fields of enunciation. The latter approach resonates with Bourdieu's field analysis and the notion of fashion discourse as discussed earlier in this Chapter in relation to his work.

When talking about 'fashion discourse' in this book, I am borrowing from the work both of Bourdieu and Foucault. With Bourdieu, I understand fashion discourse as specific to the field of fashion in that it is made up of a set of values, assumptions and rules that are dominant at a certain time and a certain place in the field they are produced and reproduced in. Foucault actually refers to such rules when he notes that 'in all societies the production of discourse is at the same time controlled, selected, organized and redistributed through a certain number of procedures whose role is to ward off its powers and dangers, to master its uncertainty, and to avoid its heavy, its fearsome materiality'.[19] Here, however, Foucault is insisting on the wider societal context of discursive production and not 'fields' in the Bourdieuian sense of the term: relatively autonomous spaces of social relations and forces defined by specific boundaries and rules of functioning. Bourdieu's notion of field is helpful to remind us of the specific local context of production in which discourses appear and circulate.

However, and following Foucault's *Archaeology of Knowledge*, I also see fashion discourse as made up of statements that extend beyond the confines of the field and belong to various discursive formations; the formation, for instance, which regulates discourses on Paris, but also that

which underpins discourses on femininity. In that respect, then, fashion discourse overflows the limits of the field it unfolds in. Indeed, fields are not purely autonomous entities. They are themselves shaped by, and dependent on, wider social forces and their relations with other fields.[20] The field of fashion for instance, and the discourses that circulate in it, is defined by its relation to the field of art, with designers often drawing on high cultural references to legitimate their practice.[21] Statements about fashion design in the field of fashion are informed by statements on the arts in the field of art. The values and concepts that fashion discourse conveys are part of a wider discourse on the creative process and the idea of the artist. Similarly, statements about femininity in the field of fashion are not particular to this field but more generally inform discourses on women in today's society. What is particular to fashion discourse, however, is the particular coming together of specific discourses, such as, in the case of the French fashion discourse, discourses on creativity, femininity, or Paris. Therefore by 'fashion discourse' I am referring to a meeting of statements pertaining to various discursive formations and shaped by various fields, but whose combination is specific to the field of fashion. It is a conglomerate of discourses whose coming together is structured by the particular field they appear in as conveyed by its members – designers and museums, for instance, but also the media, as mentioned earlier – and who by sharing the 'same ensemble of discourses' are able to 'define their reciprocal belonging'.[22]

Discourses and their statements, then, 'proliferate',[23] and the fashion press is one site where such statements 'breed and multiply'[24] to become part of what I refer to as 'fashion media discourse'. Fashion media discourse is a particular instance of fashion discourse. As such, it runs across various texts. It is, for instance, articulated in a set of different magazines, but also in the form of fashion features, fashion spreads, newspaper fashion reports or fashion advertisements. Similarly, it is also made up of statements, concepts and themes that run across various texts and fields, as is the case for instance with statements on *la Parisienne* as chic, creative and spirited, also iterated in novels and films. As Foucault notes of books, but in a comment equally true of fashion texts such as magazines or articles: 'the frontiers of a book are never clear-cut: [. . .] It is caught up in a system of references to other books, other texts, other sentences: it is a node within a network. [. . . The book] indicates itself, constructs itself, only on the basis of a complex field of discourse.'[25] It is such a layered formation of texts, statements and ideas on Paris I am also interested in unraveling

when looking at the discourse on Paris as articulated in the French fashion media.

This book, then, engages with two types of discourse: one as defined by its object, the discourse on Paris, the other by the field it is produced and reproduced in, fashion discourse, and more specifically, French fashion media discourse. Moving to and fro between genres of texts as well as historical times, for, as mentioned in the introduction, contemporary fashion discourse is a relay of signifiers in a chain of texts harking back to the past, Part II draws attention to the nodal characteristic of magazines and newspapers, the system of references their words and images belong to and the historical past they feed on.

Moreover, where Foucault talks about 'discourse in its material reality as a spoken or written thing', and where, talking about fashion discourse ('discours de mode'), Bourdieu and Delsaut refer mainly to written and spoken words, along with Macdonald, I understand discourse as extending beyond linguistic signs to incorporate visual culture.[26] Thus in the following chapters I look at the Paris of the fashion press in both words and images.

Fashion media discourse

Although in *Le Couturier et sa Griffe* Bourdieu and Delsaut talk about 'fashion discourse', only a few lines are actually devoted to the discourse of the fashion press, and only to point to its strategy of distinction or pretension. This strategy is objectified, according to their argument, in discourses that are read as the exact reflection of these magazines' positions in the French field of fashion magazines. Bourdieu and Delsaut are concerned with a discussion of the structural characteristics of fashion discourse, seen as a formal expression of different field positions. Though Bourdieu insists elsewhere on the importance of discourses as 'the privileged site for the affirmation of differences',[27] with Delsaut he focuses on the issue of the process of affirmation of difference, rather than the *substance* of the differences being affirmed.[28] Indeed, for Bourdieu more generally, 'few works do not bear within them the imprint of the system of positions in relation to which their originality is defined',[29] and it is on this imprint that he concentrates, unraveling the structure of the field in which works are produced rather than elaborating on and unpacking the meanings and values these works convey. Artworks are thus read as a direct reflection, an

objectification, of the position of these works and of their direct producers in the field of cultural production.[30] The content of the text is exhausted in the formal representation of its position in the field of cultural production. Textuality is reduced to positionality. Were the researcher to adopt Bourdieu's approach to texts in terms of field analysis s/he would be 'worn out', as Lahire puts it, 'by the time s/he reach[ed] the doors of the discursive palace'.[31] In contrast, Part II of this book is concerned with the values and meanings conveyed in discourse.

Similarly, Foucault's analysis of discourse does not aim at interrogating texts, which, he argues, should be left to hermeneutics.[32] He does not aim to produce literary commentaries, but an analysis of the possibilities of enunciations of texts, their 'conditions of possibility' and 'conditions of appearance', the 'how' of texts rather than their 'what'.[33]

Where Foucault and Bourdieu are interested in conditions of emergence, of fields and texts for the latter, of discourses for the former, and thereby to some extent remain at the periphery of the content of discourses, in *The Fashion System* Roland Barthes does enter the texts of fashion discourse.[34] Indeed, in this 1967 study, Barthes is interested in fashion as written and talks about 'written fashion' and 'written clothing' to refer to the sentences describing clothes as photographed, and whose code and signifying principles he sets out to understand and systematise. However, as befits such a project, the French semiotician is concerned with the content of texts on a purely formalist plane.[35] His is a structuralist approach to fashion discourse, informed by Saussurian linguistics and the desire to understand the logic, the rules of functioning of 'written fashion', rather than its meanings and values, which are left to a short section of his book entitled 'The Rhetorical System'. Texts, indeed units of meanings as small as sentences – fashion captions, for instance – are approached as discrete entities, isolated from their context of production and the many texts they relate to and whose ideas, concepts and images they share and reproduce. Barthes' analysis nevertheless offers useful conceptual tools for engaging with fashion as written in the media, and I will be appropriating some of his insights when looking at the French fashion press on Paris in Part II. In this book, however, I use the expression 'written fashion' to include all forms of fashion writings such as reports, profiles, short news stories, interviews and not just the short utterances describing clothes that Barthes looked at.

Moreover, I see the fashion press as comprising both fashion magazines and the fashion pages of newspapers and periodicals, and make a

distinction between fashion magazines and women's magazines. The line between the two is, however, very thin and often blurred, with fashion magazines often taken to be synonymous with women's magazines, and studies devoted to the latter often devoting space to their discourse on fashion and appearance.[36] Men's magazines, in contrast, are rarely referred to as fashion magazines.

The conflation of fashion magazines with women's magazines, and the related distinction between fashion titles and men's titles, is an outcome of the large amount of space devoted to fashion in women's magazines, itself rooted in the importance of appearance and dress in definitions of femininity and the feminine gendering of fashion. However, I understand fashion magazines as dominantly devoted to the field of fashion and beauty, whether for men or women, another reason why I do not conflate fashion magazines with women's magazines. Fashion magazines are of a high visual and textual quality, which the term glossies, often used to refer to them, conveys. Hermes, for instance, makes a distinction between 'domestic weeklies', 'young women's weeklies', 'glossies', 'feminist monthlies', and 'gossip magazines'.[37] In France, Jost makes a distinction within the feminine press between 'the fashion press, constituted of high-end magazines such as *Marie-Claire, Elle, Vogue, Biba, Cosmopolitan,* and the practical press, more working class, with titles such as *Prima, Modes et Travaux, Femme Actuelle, Avantages*'.[38] Similarly, Charon sees the French field of 'les féminins' (women's magazines) as divided between generalist titles ('généralistes'), which are addressed 'to the different social categories of women' and 'titles centred on fashion, and cooking, or that are an invitation to escape, to "dream"'.[39]

I concur with Charon and Jost in seeing fashion magazines as a subgenre of women's magazines, but I differ from them in that I see them as a subgenre of men's magazines too. Moreover, fashion magazines can be addressed to men or to women, but also to both at the same time, which places them outside the fields both of women's magazines and of men's. In English-speaking countries fashion magazines that mix genders are also often referred to as style magazines, perhaps to reassure readers by keeping at bay the negative connotation attached to the femininity that the word 'fashion' still evokes. In the UK and the US then, fashion magazines include titles such as *Vogue, Vogue Hommes International, Pop, Harper's, Nylon, In Style, Arena Homme Plus, Fashion, Glamour*. In France they include titles such as *Vogue Paris, L'Officiel, Jalouse, Elle, Numéro, Mixte, Crash*.

A small body of academic work has developed – albeit mostly constituted of independent articles scattered across journals, books and disciplines[40] – paying attention to the fashion media and its discourse. However, it has not yet done justice to its richness as a platform for interrogating the many themes and objects the fashion press engages with and produces, in the process producing various visions of society and feeding into the collective imaginary. Paris is one such object, and it is to it that I now turn in my discussion, in Part II, of the Paris of the contemporary French fashion press.

Part II

4
PARIS, *CAPITALE DE LA MODE*

In this chapter I comment on the discursive construction of Paris in the contemporary French fashion press, also moving, as I do in the subsequent chapters, to and fro both in historical time and between textual genres, to underscore the way the modern-day construction of the capital is informed by historical myths and discourses. I first discuss the representation of Paris as an active agent in the making of fashion, a creator endowed with *esprit* – spirit. I then turn to the idea of the crisis of Paris fashion to address the issue of the competition between cities for the status of fashion capital. Finally I comment on the idea of the commodification of Paris and its branding as a fashion city, also discussing the branding of fashion commodities by way of their association with city names.

In this chapter, as in the rest of the book, I focus on the French fashion press from the late 1980s on, and this includes magazines – *Vogue*, *L'Officiel*, *Elle*, *Stiletto*, *Numéro*, for instance – as well as articles from newspaper such as *Le Monde*. The French field of fashion magazines is a crowded one and recent years have seen the emergence of titles such as *Stiletto*, *Numéro*, or *Mixte*, while *Vogue*, *L'Officiel* and *Elle* are now established players. Although, as mentioned in the previous chapter, I see fashion magazines as including both magazines addressed to women and those addressed to men, in this book I focus on the former. This is where the researcher's private and academic lives intertwine: as a woman interested in fashion I have long bought women's fashion magazines, and this private interest has triggered my interest in them as a researcher, resulting in the present analyses. Men's fashion magazines represent a rich – and growing – body of texts, and other researchers will hopefully turn their attention to them.[1]

Paris fashion media

The Paris press was born in 1631 with Théophraste Renaudot's *La Gazette*.[2] A few decades later, in 1672, Jean Donneau de Visé created *Le Mercure Galant*, targeted at women and the first French paper to devote some space to fashion.[3] Renamed *Le Nouveau Mercure Galant* in 1677, it was controlled and censored by the King and acted as a promotional tool for his government and the glory of France.[4] Articles were published telling an imaginary woman from the provinces about Versailles and Paris fashions, balls, celebrations and other cultural events attended by members of the court.[5] However, soon the French capital superseded Versailles as fashion center, with the style of Parisian women reported in the press for both provincial and foreign readers.[6] With the early eighteenth-century *Mercure* (one of the names under which *Le Mercure Galant* reappeared), as Moureau observes, les provinciaux can acquaint themselves with 'the excellence of *bon ton*'; that is, Parisian *bon ton*, for, Moureau notes, '*l'air de Paris* [the Paris atmosphere] reigns over it'.[7]

The first half of the nineteenth century signals the true rise and expansion of the French fashion press,[8] with various magazines yet again promoting *le goût parisien* – also the title of a late nineteenth and early twentieth-century publication – and thereby compounding the proliferation of texts on Paris. These magazines incited women from *la province* as well as foreigners to come and visit various fashionable shops in the capital, then 'represented as the delightful fashion capital of the world'.[9] Amongst such magazines was *La Mode* – created in 1829, with fashion illustrations by Gavarni[10] and home, in 1830, to Balzac's *Traité de la vie Elégante*, as mentioned in Chapter 2. The magazine, Fortassier notes, defined itself as 'Parisian, fashionable [mondaine], aristocratic', with the collocation of the three adjectives illustrating the homology that exists between social and geographical spaces.[11] The late nineteenth century saw the creation of yet more titles devoting space to fashion, with one of them, *La Famille*, explicitly aimed at provincial readers and offering to purchase Parisian goods on their behalf.[12] More generally throughout the nineteenth century and up until the 1950s, Wargnier suggests that fashion can be considered 'an orderly pyramid which, based on the undisputed authority of Paris and its couturiers, progressively diffuses changes down the social scale'.[13] During this period the press taught readers how to reproduce Parisian dress patterns (*modèles parisiens*).[14]

Today the Parisian model is no longer conveyed through the principle of patterns to reproduce, but it is no less overt. In the French media, fashion

still means Paris. Regularly anchoring fashion to the Parisian territory, the media have long naturalized the signifying relation between the French capital and *la mode*; the centrality, in France, of Paris in all things cultural is further consecrated. The one television fashion program, for instance, that established itself in the 1990s as a dominant player was called 'Paris Modes' – the title clearly encapsulating the link that regularly binds the two signifiers 'Paris' and 'Mode' together, as in the title of another TV program 'Paris c'est la Mode', on the Paris Ile-de-France television network. Broadcast on the cable channel Paris Première – also a significant title once again associating Paris with all things advanced and superior – it reached a wide audience, with half of the subscribers, in 1995, from *la province*.[15]

In the nineteenth century numerous French fashion magazines' titles bore a reference to Paris. *Les Modes Parisiennes* (1843–85), *Le Paris Elégant* (1836–81), *La Toilette de Paris* (1858–74), *Paris-Mode* (1869–73) are but a few examples, with a section of various periodicals also bearing the name of the capital and devoted to the city's latest fashion and fashionable sites and events, as in *Le Miroir Parisien*'s 'Chronique Parisienne' in the 1860s or 'La Mode à Paris', in *La Femme Chic à Paris*, at the beginning of the twentieth century.

Today the two key institutions *Vogue* and *L'Officiel*, both launched in 1921, still carry in their mastheads the word 'Paris', encased, in the former, in the letter 'O'. Of all 17 national versions of *Vogue*, the French *Vogue* – *Vogue Paris* – is the only one bearing the name of a city. Through its very title, but also through the many articles that privilege Paris over the rest of France, *Vogue*, like other French fashion titles such as *L'Officiel*, *Jalouse* or *Stiletto*, contributes to the superior positioning of Paris in the French geography of fashion.

In 1996, for instance, a readers' page was introduced in *Vogue Paris*, which lasted until 2001. Situated at the beginning of the magazine the page offered an entry, both literally and metaphorically, to French *Vogue*. Through the selecting, editing, or even, some would argue, manufacturing of readers' letters, a publication chooses to represent a certain voice of a certain reader – a preferred one – and in the process also representing itself to its readership.[16] Barthes' contention that 'the text is a tissue of citations'[17] is here particularly pertinent, for a letters page is nothing but an assemblage of citations. And if citations can be seen as helping those who appropriate them to put their point across by invoking the words of another, the reader's words cited in a letters page can also be seen as allowing a monthly to represent itself; that is, in the case of *Vogue*, to

represent itself as Parisian, and thereby claim the high symbolic capital associated with this socio-cultural state of being in space.

Thus, what one reader calls 'Parisian elegance' (August 1998) contrasts with what 'Flora D. Tarquin' from Paris refers to as 'provincial naffness' (October 2001), the magazine also flagging its Parisian allegiance through the specification of the reader's geographical origins, with the capital being the most represented city (36 per cent of all letters). A letter published in the September 2000 issue illustrates the privation of fashion and culture which *la province* has been associated with, as noted in Chapter 1. The author notes: 'I live in the provinces [. . .] At the beginning of each month, seeing your magazine at my newsagent is a real pleasure. I need to catch up with all the new fashion of course, but also new beauty, culture, cinema.' To catch up with *Vogue* is to catch up with Paris and its culture. As another reader, from Mandelieu, puts it, 'I miss Paris a bit, and your magazine brings me "the breath of life", all the novelty I miss' (December 1999). Paris, through *Vogue*, the magazine thereby makes clear, brings life – fashionable and intellectual – to provincial existence.

In *Vogue* as in other magazines such as *L'Officiel, Jalouse* or *Stiletto*, many articles are devoted to the actuality of culture and fashion as taking place in the French capital, the 'Paris Parisien' as *Vogue* puts it on the cover of the November 1996 issue. *Vogue*'s section 'On y va' ('The places we go'/ 'Let's go'), for instance, is almost exclusively devoted to Parisian places (See *Vogue Paris* February 1996 to September 2001). Similarly, in a short but significant article on the opening of a Mary Quant boutique in Paris, a journalist writes 'we'll be able to grab, here in Paris her Eye Opener' (May 1997, p. 92). In *Vogue* 'here' means Paris – the city that imposes itself in one's mind when it comes to fashion, and does not need to be named.

This Parisianism of the French fashion press is rooted in the very spatial organization of the French field of fashion. The large majority of key fashion institutions, players and events, as mentioned in Chapter 2, are located in Paris, making that particular city more likely to be referred to than any other in France. As a consequence, however, this geographical concentration of fashion which the magazine reflects also finds itself endlessly reproduced. The aura of Paris is consolidated, which can only preclude the movement of French fashion towards *la province* and away from both the capital and the stigmas attached to *la province*. Material and discursive realities, as we saw in Chapter 1, feed into each other, sometimes leading to the maintenance of the existing order and the reproduction of the state of things. In France this means that Paris is set

to remain associated with fashionability and the provinces with the lack of it.

Moreover, Paris, according to the French media, is not simply the French capital of fashion but the fashion capital *tout court*, the *'capitale de la mode'* – (fashion capital) – as the daily *Le Monde* (13 October 2004) and the fashion magazine *Jalouse* (June 2004, p. 80), for instance, tell their readers. It is an expression that the media regularly mobilize. The spaces that cities are capital of are of course nations. But by claiming the ability to be the capital of a field of practices such as fashion, they are also claiming the ability to be the capital of the world, for such a field extends beyond national boundaries, conjuring up grand visions of the city and the nation which, on a more geographically real plane, it represents. Their hegemonic power is thus reasserted, as it is in slogans such as *'Paris capitale de la Création'*, discussed in Chapter 2.

'A specific form of globalizing boosterism', Short notes, 'can now be identified that is concerned with positioning the city in a global flow of urban images and discursive practices'.[18] Expressions such as *'capitale de la mode'* have now become a common trope of the global flow of images and words formative of fashion discourse. Like slogans, they boost visions of the city, here Paris, conjuring up its glorious history as a leading capital. Thus, for instance, an advertisement for L'Oréal in *L'Officiel* reads: 'For this spring-summer 2001, through their collections, designers translate Parisian chic with audacity, allure and impertinence. The French touch will gratify lovers of femininity . . . Paris, *capitale de la mode*, becomes centre of the world again' (April 2001, p. 75). Here, designers are depicted as mere translators of Parisian chic, as if the style unveiled during the collections was not so much the creation of the designers themselves as that of the French capital, as I now discuss.

Creative Paris

Gilbert evokes the organicism that informs the rhetoric of 'fashion culture'.[19] Fashion is depicted as inherently linked to urban life, fashionable styles as the city made visible. The many magazine pages devoted to straight-up images of fashionable individuals 'found' on the streets of various cities epitomize this take on fashion.[20] With city names often the only word in the caption, the identity of the person represented is reduced to her sartorial style and conflated with the city she lives in and is shown to stand for

and to embody. In such contemporary physiologies of urban fashionability the stylish city-dweller becomes 'Paris', 'London', or 'New York', her appearance a natural continuity and outcome of the city that has fashioned her.

Fashion designers often invoke the city they belong to when commenting on their collections. Fashion is discussed as intrinsically linked to urban space, one of its organic manifestations. A comment by Galliano for *Vogue Paris* (March 1996, p. 158) aptly captures this rooting of fashion creation in the city. At the time of the interview the British designer was both in charge of a collection bearing his own name, and the designer for Paris couture house Givenchy. The French brand, he observes, means 'a calm elegance, a reliable quality, the symbol of Parisian chic'. He adds:

> Everything that concerns Galliano is done in England. I absolutely need to go back to London to recharge my batteries, see some exhibitions, go to the concert, party [. . .]. The Givenchy collection, I think it, I construct in Paris. Thus it is the geographical difference that establishes a sure boundary between the two.

Styles of dress, according to Galliano, are renditions of city styles, with the designer the lens through which cities pass to find their visual translation.

A certain naturalization of fashion culture, then, is not confined to French fashion journalism on Paris. It is expressive of fashion discourse more generally. However, the idea that the city is active in the making of fashion resonates particularly with the French discourse on Paris. In literature, for instance, the city has long been celebrated as both an inspiration and an original creative source, 'the enormous tank in which the wine of the future fermented', 'this field of intelligence, so deeply ploughed, where the future grows', as Zola writes.[21] The French capital is also turned into a person, the main character in the many stories unfolding within its walls. Indeed, anthropomorphism underpins much of the literary discourse creative of the Paris myth.[22] In Balzac's *La Fille aux Yeux d'Or*, for instance, as we saw in Chapter 1, Paris is 'a great man, an incessantly creative artist'.[23] Balzac also notes in *Ferragus* that its streets have 'human qualities, and impress upon us through their physiognomy certain ideas against which we are defenseless'.[24] For the poet Breton, and in texts such as *Nadja* and *L'Amour Fou*, Sheringham observes that 'the great purveyor of materials for the processes of the psyche to derive energies and modes of representation is the city of Paris'.[25] One's subjectivity is correlated with the French

capital: Paris itself becomes subjectivity. Indeed, Sheringham talks about 'Paris-as-subjectivity'.[26]

Similarly *L'Officiel* notes that Paris 'sets the tone for fashion, and gives all *couturiers* talent' (May 1990, p. 97). Paris becomes the central character of the fashion stories journalists narrate: a thinking being, the ultimate creator of fashion. Thus the French *Elle* states that 'Paris, known for its experimental reflexions on fashion, didn't want to rush' (15 March 2004, p. 14); in *Vogue* French author Madeleine Chapsal states that 'It's Paris which dominates, simplifies, measures, decorates, balances Haute couture' (September 1989, pp. 236–237); and *Jalouse* notes that Paris 'taught everything' to the Taiwanese designers of Yufengshawn (November 2006, p. 74). Like an artist the French city has its 'muses', writes *Vogue* in reference to the women pictured modeling haute couture clothes (September 1995, p. 168), but it is itself also a 'muse', the magazine suggests, for 'it is Paris, the best perfumers say, that inspires them and breathes this spirit into them, this inimitable lightness' (November 1996, p. 154). One of them, Jacques Cavalier, is quoted as saying 'the city, itself, predisposes one to create', whilst in another issue photographer Henry Clarke notes that 'Paris has taught me everything, Paris has inspired my whole life' (August 1996, p. 147). Asked by *Marie-Claire* whether Paris 'inspires' her, Ivana Omazic, head of Céline, answers, invoking the figure of the *flâneur* I return to in Chapter 6: 'Enormously! It is one of the rare capitals I know that incites one to walking, to flânerie and to dream. These are privileged moments for they give me precious grounds of inspiration' (*Marie Claire 2*, Autumn-Winter 2006/07, p. 62).

L'Esprit de Paris

Bound to the city, designers' creativity is an outcome of Paris, of its *esprit* – spirit – a recurrent notion in discourses on the French capital. Indeed, *l'esprit parisien* – the Parisian spirit – has been perceived as the original creative source, 'the spirit of time that determines all things', as Stierle observes of the Paris of Mercier's *Tableau de Paris*.[27] Thus, in *Vogue*, for instance, the director of fashion house Christian Lacroix observes, conjuring up the recurring trope of 'l'air de Paris' (the Paris atmosphere) that 'the work of designers needs a kind of environment, a climate, something that may be in the *air de Paris* and must come from a heritage, a patrimony, a disposition of *esprits* [minds]' (April 1997, p. 147). 'Paris has a gift for

perpetual invention', French writer Louise de Vilmorin once argued in her fashion articles. 'Paris changes women', she continues, 'without ever changing its *esprit*'.[28]

The many connotations of the word 'esprit' – 'mind' but also 'wit', 'intelligence', 'spirit' (including in its sense of 'style') – are all present in its meaning, but they cannot be captured in a single equivalent English term. In France *l'esprit* has long been valued as a key feature of French social and cultural life, and more precisely as taking place in what has been constructed as its high-end pole, Paris. This valuing can be traced, for instance, in the French definition of the word 'culture', which, more than its English translation, and therefore to some extent a *faux ami*, often tends to refer to high culture only. Thus Gauthier distinguishes two definitions of the concept 'culture': one inspired by Anglo-Saxon anthropology which

> includes all that which participates in an ensemble of representations, images, symbols, myths, rules of social organization, practices of everyday life interiorised by the members of a same group. Another definition – which is actually a French particularity – sees culture as the set of products of the *esprit* [mind]. Thus the Ministry of Culture [...] reunites more or less the same activities that in the Fourth Republic used to belong to the department of Art and Literature. Add cinema (but not TV, an interesting prejudice), and a few scientific activities, and we get an idea of what Edgar Morin used to call pleasantly 'cultivated culture', that is the dominant representation of culture: what one needs to master to be cultivated.[29]

According to French author Jean-Louis Harouel, 'true culture is of course culture in its noble and classical sense'.[30] It 'carries the idea of the formation and the edification of the *esprit* [...] the health of its soul. This is the humanist conception of culture' whereby, in France, 'the products of the human *esprit*' are attributed a superior value.[31] In this country culture as high culture, or *'culture cultivée'*, has established itself as the dominant model.[32] However, since in France Paris is the place of concentration of cultural life, the thinking head of the nation, as discussed in Chapter 1, the true beholders of cultural capital and therefore *esprit* are often depicted as Parisians, whose sharp and informed mind can be displayed in the course of that institution of French socio-cultural life: *la conversation*.[33]

In the eighteenth century conversations flourished in the cafés and salons that had emerged on the Parisian scene,[34] with salons, in particular, still a central institution of *la conversation parisienne* in the nineteenth century.

Salons were spaces of 'sociability' led, from their homes, by women, and often including, for the most prestigious ones, celebrated politicians, writers and artists.[35] For instance, Delphine de Girardin's salon was attended in the first half of the nineteenth century by Hugo, Dumas, Balzac, Musset, Delacroix, Rossini, and the actress Rachel, to mention but a few of the famous names who socialized there along with 'foreigners of high repute' taken to the salon 'to show them what Parisian superiority was'.[36] Salons established themselves as key social gatherings amongst the Parisian *beau monde* for the display of one's *esprit*, expressed in the art of 'savoir-parler': *la conversation*.[37] For 'to be Parisian meant to converse' – an idea which still informs discourses on the Parisian identity.[38] 'In this capital', as Higonnet notes, 'to be worldly, to be intelligent, has always meant and still means to speak elegantly', and to speak elegantly means showing *esprit*.[39]

Proust most vividly brought to the attention of readers the role of the salon – and in particular that of la duchesse de Guermantes, held in her *hôtel particulier* on the Faubourg Saint-Germain – for the display of one's *esprit* in the course of quick-witted conversations. Not only is she 'the most elegant woman in Paris', she is also celebrated for, and prides herself upon, being the most *spirituelle*.[40] For 'what the Duchess prized above everything else', Proust writes, 'was not intelligence, it was – a superior form, according to her, more rare, more exquisite, an intelligence risen to a variety of spoken talent – *l'esprit*'.[41]

The celebration of *la conversation* as a central feature of Parisian life testifies both to the high value accorded to all things of the mind in French society, and to the consecration of *l'esprit* as a Parisian attribute. As Balzac once wrote about *la province*: 'there one's *esprit* [mind] degenerates', whilst in his eighteenth-century *Tableau de Paris*, Mercier praised 'the rapid electricity of the *esprits* [mind]' he saw as characteristic of Parisian communication.[42] Thus when *Vogue* notes that 'the Parisian spirit remains inimitable' (September 1989, p. 211) and French writer Irène Frain says in *L'Officiel* that 'In Paris, the libertine tradition allows all games of the mind ['jeux de l'esprit'], all games of the body' (May 1990, p. 111), the Parisian spirit which authors before them glorified is conjured up, and carries into the present day the discursive celebration of Paris and its *esprit*.

According to the French fashion press *'l'esprit de Paris'* is not only instrumental in the creativity of fashion designers, but also expresses itself in their creations. An *Officiel* cover, for instance, reads 'Fashion: the Left Bank spirit' (November 2001). At Chanel's show, French glossy *Stiletto* observes, conjuring up the theme of revolutionary Paris, 'rarely

has what defines Paris's atmosphere been better captured: a group spirit offset by a rebellious spirit [*esprit*]' (Autumn 2004, p. 133). According to *Elle*, during the spring-summer 2005 collections, 'Paris refocuses on the essential: making women elegant. In the program, an allure full of *esprit* [spirit]' (18 October 2004, p. 14). 'When Christian Lacroix unites brocade to embroidery', Madeleine Chapsal notes in *Vogue*, 'it's a "number" where Paris's spirit reintroduces balance' (September 1989, p. 237). Objectified in clothes, the city's spirit is made visible. Hedi Slimane, *Le Figaro* notes, has 'the Parisian spirit', and the designer is quoted as saying 'I've read two or three things to absorb the idea of Paris' (26 January 2001, p. 18). The spirit of Paris melds into that of designers to materialize as clothes, '*l'esprit parisien*' now synonymous with a fashionable style. As *Elle* writes, in a statement that captures this melding of identities – geographical, authorial, and visual – into one another: 'Couture is Paris. [. . .] The famous "that's Paris", no one can state as truly as a couturier on a catwalk' (24 January 2005, p. 42).

Paris's fashion veil

Barthes and Bourdieu have commented on the system of linguistic signs that come between fashionable goods and consumers. Barthes calls it a 'veil' and Bourdieu a 'screen'.[43] An abundance of words is uttered on fashion that contributes to its symbolic production and the universe of belief attached to it. In France it is the belief in Paris fashion as a high art. The commercial dimension of fashion is obscured in favor of a discourse that promotes 'the ideology of creation':[44] designers are likened to artists and poets, their collections given the magical aura of the work of art and detached from the 'vulgar' world of business.[45] The screen and veil Bourdieu and Barthes talk about also recall the 'barriers of perception' that Goffman argues, as we saw in Chapter 2, split areas of individual and organizational practices into front and back regions, here, respectively the mythical region of high culture and the artist in contrast with that, often derided, of commerce and business.

The anthropomorphizing of Paris that makes of the city a fashion creator participates in the veiling and screening that Bourdieu and Barthes discuss. It engenders a greater belief in the symbolic value of fashion as that which originates outside the rational world of commerce. Fashion is not the outcome of astute strategists and businessmen but that of the

intangible creative spirit of the city. It is not fueled by informed knowledge and commercial acumen but by the rather uncanny and magical power of the French capital and its 'atmosphere' – the *'air de Paris'* – and spirit. As Short notes, 'the use of natural analogies, such as revitalizing the heart of the city, not only dramatizes the endeavor but naturalizes it so that to argue against it would be unreasonable, beyond the reach of common sense'.[46] The construction and anthropomorphizing of the French capital as key maker of fashion is given an essential truth that contributes to mythologizing both Paris and the creative process.

This veiling of fashion serves the interest of the fashion business it renders misrecognizable. Indeed, a web of words covers fashion commodities, Barthes argues, for economic purposes:

> Calculating, industrial society is obliged to form consumers who don't calculate; if clothing's producers and consumers had the same consciousness, clothing would be bought (and produced) only at the very slow rate of its dilapidation; fashion, like all fashions, depends on a disparity of two consciousnesses, each foreign to the other. In order to blunt the buyer's calculating consciousness, a veil must be drawn around the object – a veil of images, of reasons, of meanings.[47]

The covetable commodity is only that which is *claimed* to be so, for the desire it triggers pertains to the 'simulacrum of the real object' born out of discourse rather than to the object itself.[48] As Barthes puts it, 'it is not the object but the name that creates desire'.[49]

The media discourse on *la mode*, then, is also a discourse on Paris, and in the same way that the process of symbolic production of fashion entails a production of the value of designers and their creations,[50] it entails the production of the symbolic value of Paris. Absorbed, like its derivative 'Parisian', into the fashion rhetoric, the word 'Paris' no longer simply refers to a geographical origin. Rather, it is turned into a fashion signifier whose value resides in its power to evoke the world of fashion, and, more precisely, a world of 'elegance' and 'chic': two recurring terms in discourses on Paris fashion.

The fashion competition: A tale of four cities

The anthropomorphizing of Paris also adds to the news value attributed to fashion events such as the collections. Like the many organic metaphors and anthropomorphisms that underpin the literary discourse on Paris, it endows fashion with 'an emotional charge'.[51] This is the 'charge' pertaining to the unifying and uniting power which the conjuring up of the nation through Paris evokes. Fashion, according to the media, involves a whole capital, and, implicitly, through the capital, a whole nation, as is made clear in *Le Figaro*: 'Threatened by Milan and Hanover', the daily writes, 'Paris fights to remain the capital of fashion [in textiles]: the French unite against Italy' (*Le Figaro Economie*, 24 January 2001, p. 5). *L'Officiel*, however, reassures readers: 'the other fashion capitals seem pale' compared to Paris (May 2001, p. 103), and *Le Monde* invokes 'the battle of Paris' (7 July 2001, p. 22), announcing a year later that 'men's fashion shows consecrate the French capital before Milan' (6 July 2002, p. 24).

In the early twentieth century, Wargnier observes, the French press '"produce[s]" fashion as a collective phenomenon', the outcome of a zeitgeist incarnated in the Parisian dress patterns.[52] In the contemporary press, as the examples I have just mentioned suggest, fashion is still given a collective spirit, one situated in time but also anchored in place: Paris. Thus if fashion journalists draw on high cultural references to legitimate fashion in the hierarchy of cultural productions,[53] reference to the collectivity, invoked in the traits of Paris, also contributes to this process of legitimation. As Bourdieu and Delsaut note, 'fashion discourse' is a 'technical language which, when it is addressed to the outside, by journalists, becomes a purely decorative discourse that contributes to the imposition of legitimacy'.[54] No longer derided as what is often seen as an individualistic and narcissistic practice, fashion's status is raised to that of representative of a collective being, a matter of collective pride. The spirit of competition that has informed cities' quest for visibility on the global map is thus conveyed in the discourse of fashion journalism, bringing to mind Bourdieu's analogy with sport in his conceptualizing of the field of cultural production. Fields, he argues, are made up of various individual and collective agents – he calls them 'players' developing various 'strategies' in a 'game' – who compete for the dominant position.[55] There are established players and newcomers. In discourses on fashion, cities are represented as such players, with the fashion press regularly commenting on their movement and position in the field, and their struggle for the title of fashion capital.

Thus, a recurring theme in the French media is that of the crisis of Paris high fashion and the challenges to the city's ability to hold onto this coveted title. Dominant until the 1960s, Paris fashion has since seen its hegemonous position shaken by the emergence and consolidation of new fashion cities, most notably London, New York and Milan, as mentioned in Chapter 2. The fragile position of Paris on the global map, which contrasts with its mythical status as a leading capital, is brought to the attention of the reader in a string of articles that alternate between celebratory announcements of the return of Paris as '*capitale de la mode*', and concerned writings about the prospect of such a position, which the repeatedly heralded death of haute couture would signify.

French daily *Le Monde* is one of the sites where the highs and lows of Paris by way of the high fashion industry are regularly commented on. In the mid-2000s the tone is celebratory, with the newspaper announcing in 2005 that 'Paris wins hands down the title of capital of fashion' (6 October 2005). However, a somber mood informs many mid-1990s articles, when Paris fashion was said to be experiencing yet another crisis. In January 1996 the paper notes, commenting on Parisian haute couture, that it 'does not escape the turbulences of the time' and 'each season makes one fear the death of this luxury in the French way' (22 January 1996, p. 11). However, the reprinting a few days earlier, on 18 January (p. 23), of an article from the January 1946 edition still allows the newspaper to celebrate the city. It reads:

> It is in Paris, always in Paris, that not only French fashion but also international elegance incessantly revive themselves. The love of woman and the exaltation of *l'esprit* are, I think, in the area of taste, the main reasons for our privilege; Paris thereby becomes the capital of new ideas, of charming inventions, where the present enriches the past through a perpetual contradiction.

After commenting on the fashion trends of the time, the author commends the industry's post-war effort to reconsolidate the position, shaken by the war and the occupation, of Paris on the international fashion map:[56] 'Thus, in spite of the events and difficulties, Paris carries on giving birth to all the most varied creations'.

According to the paper the mid-1990s crisis of Paris fashion can be blamed partly on new practices, in particular as espoused by the Americans and the Italians. 'The word "internet"', writes *Le Monde*, which condemns the subservience of fashion to the realm of images, 'has become the taboo

of fashion: it provokes recoil and suspicion, isolating once more Paris in its splendour against the commercial and media offensive of Milan and New York' (24 March 1996, p. 24). The newspaper supports the statement with a quote from the head of Thierry Mugler, Didier Grumbach, who argues that 'Paris has become the *bureau de style* [fashion trends office] of the whole world. Designers are plundered before shop owners order their clothes.' 'Some creators', the newspaper writes a few months later, 'the blood sucked out of them by the vampires of Italo-American marketing and the success of Prada, Gucci, Calvin Klein, Donna Karan, end up their first victims. Arrogantly, they push lines and colours to excess.' (19 October 1996, p. 29) Thus, 'to the serialized woman of Milan, Paris opposed its chameleon woman' (19 March 1996, p. 26) and 'defying the limits of the international Italo-American good taste, Paris lays claim to its difference through authorial collections' (24 March 1996, p. 24). America, notes *Le Monde*, mobilizing the recurring theme in the French media of American imperialism, 'imposes once more its standards: the clean, the beige, and the irreproachable', as is the case with Oscar de la Renta, who 'presented a historically correct collection' (29 January 1996, p. 20). In 2005 the French daily reiterated its lack of enthusiasm for American fashion when praising the work of Alber Elbaz for Paris couture house Lanvin. The designer, the paper wrote, 'brings in an absolute refinement to American vestimentary clichés' (28 January 2005).

In *Le Monde*, as with much of the French discourse on American versus French identity, Anglo-Saxon culture, along with Italian fashion, is depicted as a commercial culture, antithetical to the art and tradition of French culture, of which Paris high fashion, the newspaper is suggesting, is an example. Thus, 'the art of the finish so dear to Christian Dior', the daily argues, commenting on Paris haute couture, 'seems very little compared to this amazing pressure that turns the businessman into the new judge of taste and transforms *couturiers* into the sales reps of their make' (22 January 1996, p. 11). The journalist asks: 'is haute couture becoming, like French cinema, an *"exception culturelle"*?'; '*exception culturelle*' referring to the French debate on the protection of French cultural production from the forces of globalization, most specifically as driven by America.[57]

Similarly, in her 2004 'interview in the form of a conversation' in French fashion magazine *Inoui*, Paris boutique owner Maria Luisa states that 'Paris seems to me to be a "very luxury" city', and, contrasting the French capital with New York, that is, art with commerce, adds:

Paris allows itself to choose: in Paris, one does not want things that can be found in London or New York and whose lifespan will not extend any longer than a few weeks. [...Paris] does not develop this systematic hysteria for the new. Parisian luxury feeds on discretion, a certain nonchalance, nuance. The city itself is everything but showy, its architecture and urbanism have a great elegance, a relaxing classicism, a rare harmony. (June-August 2004, pp. 7–8)

Parisians 'do not want ostentatious luxury', Maria Luisa continues, mobilizing the rehearsed theme of *l'esprit de Paris*, whereas in New York 'incomes stand for genealogical trees, for intelligence, for talent, for everything... In France, *l'esprit* still is a passport'.

Fashion-branding the city and city-branding fashion

Gilbert draws attention to the spatial disconnection characteristic of many goods branded as being made in a city such as Paris.[58] The relation between the city and the product that bears its name is often hard to establish. Fashion images are a visual manifestation, and reproduction of, this disconnection between city names and physical space. Indeed, 'Paris' has become so highly evocative a sign that magazines often do without actually representing Parisian spaces in fashion spreads themed on the city. Readers are left projecting onto the monochrome background of visuals bearing the name of the French capital their own vision of this city.[59] In its September 2006 issue devoted to Paris, fashion magazine *Numéro*, for instance, opens its series of fashion stories on the French metropolis with a spread entitled 'Noir de Paris', a nod, perhaps, to Bourjois's 1863 scent 'Soir de Paris'. A model is shown against a series of backgrounds in various shades of white and grey. These backdrops become a screen that can be filled with the Parisian images the reader will have accumulated throughout their encounter with various texts – films, advertisements or novels for instance. Lingering among the visuals are the ideas of elegance, chic and fashionability which the enunciation of the word 'Paris' conveys. A single word is enough to fill the image with meaning and shift the products represented to the apex of fashion. Indeed, as Gilbert also observes, 'certain cities are among the strongest and longest-established of global brands' and city names themselves have become 'an integral part of branding'.[60] Amongst them is Paris, the oldest city-turned-fashion brand, whose citing on a product or an advertisement is central to the promotion of commodities.

A *L'Officiel* feature on luxury fashion shops captures this relation between fashion, the city and the branding of both fashion and the city. It reads: 'L'Officiel's Paris: the mood of the time and of fashion, trends, Parisian symbols, and capital institutions from the right bank to the left bank are to be discovered throughout these pages in the form of an address book, like a very official guide' (May 1990, p. 33). *L'Officiel* guides the readers through Paris streets. Only, the symbols mentioned are not major historical sites as in traditional tourist guides but shops, for 'L'Officiel's Paris' is here reduced to a series of luxury brands highlighted throughout the article like the word 'Paris' repeated across the page. The profusion of the signifier 'Paris' echoes that of the brands cited in the text, the plurality of Paris only that of the signs of luxury, its diversity reduced to an abundance of designer brands.

In fashion magazines, brands and city names are placed on the same plane: signs of fashion, fashionable logos, that add value to the object represented. As one flicks through a magazine, the flow of images is punctuated by a succession and profusion of recurring words, key signifiers that stand out and float across pages the same way they float from one fashion commodity to the next. Chanel, Paris, Dior, Gucci, New York, Hermès, Milan merge into one another to become the very signs of fashion, the names by which objects and the visuals they are anchored to can be reinjected with a sense of fashionability and exclusivity.

The inscription of the French capital in the world of commerce through its assimilation with a brand is also supported by the construction of Paris as commercial realm. In the French media, not only is Paris promoted as the center of elegance, but it is also turned, like the metropolis Wilson discusses, into a 'vast department store',[61] the best French department store. Such a vision of the city as a space reduced to a site devoted to commerce has long informed discourses on the city. Indeed, by the late 1890s, Paris, Wilson notes, had turned into a 'consumerist mecca in the twentieth-century sense', a 'dream world of mass consumption' the 1900 *exposition* epitomized and celebrated, and, similarly, one of the literary metaphors associated with the French capital was that of 'a brilliant emporium (or, alternatively a brawling marketplace)'.[62] This subsuming of the city in the world of commerce and its comparison with a commercial space is captured and reproduced in the many pages devoted, in magazines such as *L'Officiel*, *Vogue* or *Elle*, to Parisian retail sites. The French capital is constructed as a land of plenty, a never-ending source of fashionable goods and profuse spaces of consumption.

Thus enjoying Paris has become synonymous with enjoying *consuming in* Paris. In a June–July 1990 article in *Vogue* entitled 'Paris is always celebrating', for instance, the author takes the reader through a promenade across various areas of the capital. S/he writes: 'One cannot forget the splendors of the Place Vendôme. Those of its present jewels, those from jewels of the past' (p. 27). The pleasure that is gained from walking through historical landmarks is firmly linked, the magazine suggests, to the pleasure experienced during one's encounter with various boutiques. Indeed, as Gilbert observes, tourists often visit famous shops for themselves rather than to buy the goods they display.[63] In Paris, retail spaces such as the Galeries Lafayette have now become a requisite stop in one's touristic journey across the capital, to the point where, as mentioned in Chapter 2, the department store is more visited than the Eiffel Tower. In features such as *Vogue*'s, the history of Paris is fused with its fashion geography. Its richness is equated with the luxurious shops and brands that constitute the glamorous and desirable face, according to fashion media discourse, of the French capital.

For, in magazines such as *Vogue*, the Parisian fashion geography is often narrowed down to its front region, its luxurious side, epitomizing the 'processes of urban "editing"' that Edwards argues also informed British *Vogue* in the 1930s.[64] Paris becomes a city entirely geared towards pleasure, a fashion city absolved from pain and misery, as I also discuss in Chapter 6. This is captured in the many fashion spreads set in luxurious Parisian spaces. Paris is reduced to a series of glamorous hotels, chic cafés, elegant avenues, and beautiful outdoor sites. In such spreads, the Ritz, the Place de la Concorde, the Jardin du Luxembourg, the Café de Flore or Les Deux Magots, for instance, form the Parisian territory of the French city as fashioned by the media.

The now defunct magazine *Bag* – Beautiful Address Guide – captured the subsuming of the French capital into the world of pleasurable consumption. Also signaling a blurring of the distinction between fashion magazines and tourist guides, it evidenced – and reinforced – 'the close relationship between shopping and urban tourism'.[65] As *Bag* put it, Paris is the 'capital of fashion and tourism' (Issue 1, Winter 2004, p. 30). Launched in 2004, the magazine guided readers through Paris's fashionable shops and goods. The French capital, like a fashionable commodity, was permanently updated, forever made new. Some texts were translated into English, the 'lingua franca' of the transnational field of fashion, promoting the goods mentioned throughout the magazine, and, in the process, Paris, to foreign

tourists/consumers. A whole section – 'Shopping route' – was devoted to maps allowing readers to locate the stores whilst also highlighting possible shopping breaks. These included what the magazine called 'arty breaks' (See Issue 2, Spring 2004, p. 141; Issue 3, Summer 2004, p. 120), during which 'the ultra contemporary artistic heritage Paris abounds in' (Issue 3, Summer 2004, p. 120) could be uncovered. An editorial read: 'because shopping is not simply "buying". Because it is not necessarily futile.' (Issue 2, Spring 2004, p. 6) Small maps were also provided next to some of the products photographed. To find them, just 'follow the map', as the magazine put it (Issue 3, Summer 2004, p. 28). Paris's geography became indissolubly linked to a set of fashionable objects and retail sites. Thus, in issue three's 'shopping route' section, the Paris maps were laid out over close-up pictures of the fabric of diverse fashionable items (see fig. 4.1). A visual metaphor was created that turned the fabric shown into that of Paris, as if the French capital were made of fashion, its streets and buildings sewn together like the diverse fragments of a piece of clothing, the pattern they form akin to the motifs on a garment.

Fig. 4.1 The Fabric of Paris. 'Le Marais.' *Bag*. Issue 3. Summer 2004.

Fig. 4.2 'Green spring in Le Marais.' French *Elle*. 7 November 2005. © Elle.

Fashion magazines regularly feature maps of Paris in articles devoted to the capital's fashionable sites of consumption. However, if fashion is the thread that links its parts together, unifying it into a fashionable whole, the city as fashioned by magazines is also characterized, like the world of fashion more generally, by a seeming diversity: that pertaining to the ideology of choice that consumer culture nourishes. Paris becomes an assemblage of distinct areas, split, defined along the lines of different fashionable styles and sites. In November 2006, for instance, *Elle* devoted three pages of '*news beauté*' to 'our best addresses in Paris'. In the center of each page is a map of three different Paris areas, with the pages labeled in relation to them, that is, 'VIP square in Montorgueil', 'green spring in Le Marais' (see fig. 4.2), and 'fashion spot in Saint-Germain-des-Prés'. The numbers on the maps coincide with the images of beauty products and spas displayed next to them. In the same way that fashion commodities form part of various segmented markets, so does the Parisian geography as redefined by fashion discourse. The Parisian market of fashion pages offers consumers a choice of goods, places and spaces that, as with the guidebook discussed by Hancock[66] (see Chapter 1), draws attention to the spectacularization of the city by way of its commodification. Accessing the various addresses that magazines recommend, and acquiring the goods they sell, is accessing Paris, acquiring a small parcel of the capital. Barthes wrote that 'one of the functions of all commercial activities is to tame space; selling, buying, exchanging: it is through these simple acts that men really dominate the wildest places, the most sacred constructions'.[67] Fashion magazines, as Edwards also observes of British *Vogue* in the 1930s,[68] participate in this taming of the city through practices of consumption. Their maps are not simply those that guide fashionable readers through the city but those that allow one ultimately to possess it.

However, in the French fashion media's construction of Paris as the pleasurable land of fashionable consumption, commerce is once again hidden from view. Like Poe's 'Purloined Letter',[69] so visible that one fails to see it, commerce so pervades fashion magazines that it can also vanish from sight. Fashion spreads in particular are at the same time full of commodities and devoid of signs of commerce. Whilst being promoted as a desirable site of consumption, indeed as the object itself to be consumed, the city of fashion imagery, its landscape, has largely been cleared of one of the most visible references to the world of commerce: advertisements. This world, though the motive for fashion spreads, is somehow brushed out of the visuals. The real city of logos, clashing colors and all the associated

trappings of commercialism is often refashioned into a surface free of commercial marks. Yet commerce is reinscribed in its representation not only in the captions that indicate brands and sometimes prices but also on the bodies of models. For in fashion spreads the principal site of commercial exchange and promotion is fashionable bodies, which carry on their surface the desirable goods of the fashion economy, as I also discuss in Chapters 5 and 6.

Thus, fashion magazines and fashion journalists are 'cultural intermediaries'[70] who participate, alongside advertising,[71] in the symbolic production and branding of cities. They turn Paris, to borrow from Miles and Miles, into 'an image designed to foster consumption of the city itself'.[72] Through a reading/writing of the city that reduces its many layers into two-dimensional street maps, journalists facilitate readers' access to different kinds of goods, including not only those laid out in the various stores magazines recommend, but also the reified Paris commodified into a landscape of shopping sites and fashionable objects. The Paris brand is strengthened, helping to sell both commodities and the city itself.

The relation between fashion, the city, and the branding of both fashion and the city, then, is articulated at various levels that feed into each other, and to which fashion journalism contributes. This interplay, at the level of branding and promoting, between fashion and the city can be captured by two processes I call fashion-branding the city and city-branding fashion. Whilst the former refers to the idea of selling and promoting a city by way of developing and promoting fashion and fashion-related activities, the latter refers to the idea of promoting fashion products and brands by way of their association both with the idea of the city and with specific cities.

The field of fashion, we saw in Chapter 2, has emerged as central to the positioning of cities on the global map. The fashion press participates in such fashion-branding of cities. Through the representations of Paris in fashion images, and the many reports and captions bearing the name of the capital, the city is given a potent presence in visual culture, not least with regard to French titles, in magazines such as *Vogue Paris*, available throughout the world. Fashion magazines promote cities and they promote them, in the case of the French capital, as discussed earlier, as brands, written signs on a par with other key signs of fashion discourse such as company names and logos.

Cities, Gilbert notes, are both 'the physical context for fashion' and 'the objects of fashion'.[73] Like fashionable styles, they are subject to trends; they lose and gain value in the currency of fashionable places, appear

and disappear as 'visual accessories in fashion's iconography'.[74] The branding in the fashion press of cities as signs of fashion and fashionable signs feeds into this construction of cities as objects of fashion, which the creation of events such as 'fashion week', or, in Paris, '*Paris capitale de la Création*', also supports. Global cities such as Paris 'are enacted, performed and spectacularized',[75] and this includes their representation in fashion images, their naming in fashion spreads and reports, the grafting of the geography of fashion onto that of the city. In Chapter 7 I return to this idea of the spectacularization and symbolization of the city in fashion visuals by focusing on one key sign of Paris turned fashion sign: the Eiffel Tower.

But the fashion press is also central to city-branding fashion; that is, to tightening the relation between fashion and urban culture, and also between fashionable goods as well as labels, and city names. The frequent representation of fashionable attire in an urban environment, together with the regular conjoining of names such as Paris, New York or London with fashion labels, draws attention to the importance of space – here urban space – in the selling of fashion. Indeed, fashion and the city have emerged as coterminous spaces of experiences and practices, their modernity indissociable, as I also discuss in Chapter 6; the thrill, edge, fast pace and spectacular dimension of urban spaces that of fashion, and vice versa. In this association between the sartorial and the urban a few cities have stood out whose own history and mythology have supported, and been supported by, the field of fashion. Like Paris, New York, Milan and London have acquired a high currency in the symbolic production of fashion, with the names of those cities incorporated, as mentioned earlier, in the branding of fashion goods. Fashion reports and fashion spreads feed into such branding, also made manifest in the many shopping bags bearing the name of both brand and city, and which, as Gilbert notes,[76] are often as treasured as the goods themselves. 'Paris' has long been a recurring sign in this symbolic spacialization of commodities, in the fashion press, on packaging, but also on goods themselves. Perfumes such as 'Soir de Paris', mentioned earlier, are an example but so are the many commodities that have been given the name of the French capital's female inhabitants, *les Parisiennes*. For in the economy of fashion, Parisian women, like the city they live in, have become signs of fashion, as I now discuss.

5

LA PARISIENNE

La Parisienne is as much an imagined as a living reality. Indeed, French writers, painters, and film directors have appropriated this figure, feeding into her status as an iconic model of femininity. Today's *Parisienne* of discourse is nourished by a past whose many interwoven layers of textual representations have sedimented into her contemporary value as a sign and symbol. Linking these layers together is the idea that a fashionable appearance and creative spirit is her key defining trait. Books, paintings, films have celebrated this feminine archetype and so has the French fashion press, with contemporary fashion images and writings regularly devoting space to *la Parisienne*.

This chapter starts with a brief history of the discursive *Parisienne* and some of her many incarnations, then focuses on her presence in the key fashion magazine *Vogue Paris*. At once a dominant institution in the international field of fashion and a periodical that has frequently referred to *la Parisienne*, *Vogue* constitutes a rich platform for a discussion of the discursive construction of this female figure and its celebration as an icon of fashion.

La Parisienne in fashion

The putting into discourse of the French capital has been paralleled by a putting into discourse of its female inhabitants, *les Parisiennes*, and in the same way that in the nineteenth century the French capital was 'magnified',[1] so was *la Parisienne*. Numerous painters, for instance, chose her as the subject of their art. In their work, the relation between the city, fashion and femininity is underscored in visions of fashionable Parisian womanhood.

In Monet's 1866 painting of his Parisian lover Camille (see fig. 5.1), for instance, sartorial elegance is lusciously represented, infusing the dress and its wearer with an auratic presence drawing on fashion plates, for such plates often served as an inspiration for the outfits and feminine bodily poses exhibited in his work, as they did in the painting, more generally, of Realists and those of the Impressionist circle.[2] Indeed, away from the confines of the high cultural space of the painter's canvas, *la Parisienne* had already become a figure of popular images, with plates and caricatures helping to define and create, as Steele notes, 'new and contemporary ideals of feminine beauty as part of a chronicle of modern urban life'.[3] Amongst such images were those of Gavarni, whose work could be found in various fashion magazines, such as the *Journal des Dames et des Modes* or *La Vogue*.[4] Gavarni, as Steele observes, was better known for his contributions to the physiology genre, which, we saw in Chapter 1, flourished in the 1840s, and was part of an attempt to make sense of Parisian life and Parisian figures. Monet's portrait of Camille, like Renoir's 1867 *Lise*, his 1874 *La Parisienne* and Manet's 1875 *La Parisienne*, was intended to be an archetype of *la Parisienne*, and can therefore be seen as a continuation, albeit in a high art form, of the physiologists' attempt to capture Parisian types.[5]

Fig. 5.1 Claude Monet. *Camille*. 1866. Oil on Canvas, 231 x 151 cm. Kunsthalle Bremen. Germany.

If French painters such as Monet, Renoir and Manet have been key to bringing *la Parisienne* to the attention of the world, so have the many Americans who, in the second half of the nineteenth century, attracted by the cultural and artistic dynamism of the French capital, took up residence there, turning it and its inhabitants into a favored representational subject.[6] Sargent's 1883–4 painting of the chic *Parisienne* Madame X (Madame Pierre Gautreau, see fig. 5.2), for instance, shows her standing next to a delicately carved table, her pale skin contrasting with the black fabric of her beautiful dress, two fine straps adorning her milky shoulders with a perlescent and golden shimmer. A minute diadem subtly adorns her head, exquisite

Fig. 5.2 John Singer Sargent. *Madame X* (Madame Pierre Gautreau). 1883–4. Oil on Canvas, 208.6 x 109.9 cm. The Metropolitan Museum of Art, New York. Arthur Hoppock Hearn Fund, 1916 (16.53). Image © The Metropolitan Museum of Art.

Fig. 5.3 *Les Parisiennes* by Kiraz. Cover of the Artist's *Je Les Aime Comme Ça* [That's the way I like them], a collection of *Parisiennes* drawings. First Published in 2000. © 2000 Éditions Denoël, Paris, France.

detail on a highly distinguished allure. The painter, Hirshler writes, 'represented Mme Gautreau as she wanted to be seen – as a quintessential *Parisienne*, sophisticated, perfectly groomed, elegantly dressed, urban and independent'.[7]

In the second half of the twentieth century, *la Parisienne* became further entrenched in French popular arts with Kiraz's short comic strips 'Les Parisiennes' for the weekly *Jours de France*. Beautiful, frivolous young women, Kiraz's *Parisiennes* live a life ruled by fashion and the pursuit of love (see fig. 5.3). Over the several decades – from the late 1950s to the 1980s – during which the artist collaborated with the magazine, *la Parisienne* further established herself in the nation's collective imaginary, with this figure also consecrated in a 2005 exhibition at Paris's Galeries Lafayette, entitled '*Kiraz, Les Parisiennes et la Mode*'.

In the late twentieth and early twenty-first centuries *la Parisienne* moved further away from the traditional canvas of the painter to appear on the visible surface of the very city she engaged with: Paris's walls. In 1985 a graceful and glamorous female silhouette began to adorn the streets of the city. Appearing in various sites – the corner of a building, above the façade of a restaurant – these *pochoirs* (stencil graffiti) represented a young woman almost invariably wearing a black dress and stiletto heels. They were signed Miss.Tic (see fig. 5.4). Coming across them at unexpected times became a feature of one's walks in the streets of the capital, this fleeting vision of sexy

Fig. 5.4 A stencil by Miss.Tic. Paris, 13th *arrondissement*. 2007. Photograph Agnès Rocamora.

femininity as much a part of the city's make-up as its fleshly inhabitants. Aphoristic observations – 'that which catches our eyes makes us blind', 'do free actions have a price?', 'ethics are internal aesthetics', for instance – gave the visuals a reflective mood for the passers-by to engage with. Modeled on the street artist Miss.Tic herself, these silhouettes officially entered the long history of iconographies of Parisian women when, in late 2006, a book of her street art entitled *Parisienne* was published in conjunction with an exhibition held at Paris's Lélia Mordoch gallery. In her introduction to the book, the gallerist writes:

> We are *parisiennes* and the whole universe knows it [. . .]. All dressed in black, their lips painted red, their eyes glowing, they [Parisian women] move forward, victors and seducers, in the grace of a freedom they wear every day like a shining armor to conquer the world [. . .] it's well known, *les parisiennes* are elegant without even trying to be, we are born in fashion, in Paris fashion.[8]

As well as being a figure of art, a fashionable model in the work of visual artists, *la Parisienne* is also a literary character in the many physiologies and novels that have put her into words, praising the distinctive elegance of her allure. Thus although in his 1841 *Physiologie de la Parisienne*, Taxile Delord notes that '*la Parisienne* is a myth, a fiction, a symbol', he nevertheless states that she can be encountered in 'all the places where women show themselves': 'balls, theatres, concerts, promenades'.[9] *La Parisienne*, Delord suggests throughout his physiology, is first and foremost a character defined by her ability to appear and be seen, and fashion is her realm of election. *Les Parisiennes*, he writes, 'carry on the great mission of the national spirit; they enlighten all fashion subjects by appropriating them'.[10] Similarly, in Léon Gozlan's 'Ce que c'est qu'une Parisienne' ('What a Parisienne is'), published in the 1845 collection of Parisian physiologies *Le Diable à Paris*, with illustrations from Gavarni, *la Parisienne* is she who sets trends and give the clothes and accessories she consumes 'the consecration of taste, the baptism of fashion'.[11]

Novels have significantly compounded the role of physiologies and paintings in cementing the mythical status of *la Parisienne*, carrying her into the twenty-first century and across national borders. And in the same way that the writing of Balzac has been key to the discursive construction of Paris, it has also been key to the figure of the Parisian woman. A recurring character in his writing, she can be an aristocratic woman (in *La Duchesse de Langeais*, for instance), a mysterious stranger (in *La Fille aux*

Yeux d'Or), or a courtesan (in *Splendeurs et Misères des Courtisanes*), but beautiful she always is. The duchesse de Langeais is 'supremely woman and supremely coquetish, *Parisienne* above all'; the mysterious *Fille aux Yeux d'Or* is 'the person who is the most adorably woman' that the main character, Henri de Marsey, has ever come across, and the courtesan Coralie is 'the salt Rabelais enchanted and which, thrown onto matter animates it and raises it to Art's marvelous regions: her dress unfolds extraordinary magnificence, her fingers drop their gems in time, like her mouth its smiles; [...] her language sparkles with sharp remarks'.[12] As Balzac wrote in his physiology *La Femme de Province*: 'there are in Paris many types of women, all different: there is the duchess and the businessman's wife, the ambassadress and the consul's wife, the minister's wife and the wife of the man who is not one; there is the proper woman from the right bank and that of the Seine's left bank'.[13] At the heart of the differences Balzac evokes, however, are details of dress only – 'charming distinctions' such as 'hats that are more or less open [...] old laces on young bodies, [...] precious jewels destined to hide or reveal works of art'[14] – for these women fundamentally belong to the same socio-geographical category, *la Parisienne*, varied in appearance but unique and singular in her sartorial skills.

As for the provinces, Balzac notes, 'there is one woman only, and this unfortunate woman is the woman from the provinces; I swear to you, there are not two'. And the author adds:

> Let's be clear! France in the XIXth century is split between two large zones: Paris and *la province*; *la province* jealous of Paris, Paris thinking of *la province* only to ask for money. In the past, Paris used to be the first provincial town, and the Court dominated the City; now Paris is the entire Court, and *la Province* is the entire City. The woman from *la province* is therefore in a permanent state of blatant inferiority.[15]

'*Une Parisienne!*', Taxile Delord exclaims, 'this word is an abyss in which the imagination of provincial women loses itself'.[16] One remembers the provincial Madame Bovary losing herself in the 'immense name' 'Paris', 'repeat[ing] it softly to herself, for the pleasure of it: it rang in her ears like the great bell of a cathedral, it flamed before her eyes even on the labels of her pots of ointment'.[17] Thus, as Delord notes, although *la Parisienne* might well be of provincial origins, her coming to Paris allows her to reach a perfection she would never have attained had she stayed in *la province*. In moving to the capital, she has been 'refined' by it. 'Yes', Delord writes,

'the earth turns, and provincial women have grace and spirit . . . providing only that they don't live in *la province*'.[18]

With Proust, as with Balzac, *la Parisienne* can equally be a courtesan or an aristocratic woman. She is Odette for instance, or the Duchess de Guermantes, both admired, confident in their beauty and the mastery of the art of dress.[19] The ultimate incarnation of fashionability, *la Parisienne* is the woman who, as in Feydeau's 1898 *La Dame de chez Maxim*, sets trends and embodies Parisian distinction.[20]

The putting into literature of *la Parisienne* is not confined to the nineteenth and early twentieth centuries. In the twenty-first century she still forms the matter of novels, as in Gilles Martin-Chauffier's *Une Vraie Parisienne*, for instance, where the Parisian Agnès de Courroye is depicted throughout the book as beautiful, fashionable, and elegant. She is 40, the author writes, 'except that as a true *Parisienne*, she looked ten years younger'; 'at the age of 40', he adds, in a statement redolent of the celebratory tone of many texts before it, '*les Parisiennes* annihilate the rest of the world. They have found their hairstyle, their couturier, their tone and they hunt at an age when others clutter the grannies department.'[21]

La Parisienne also appears in the traits of statues: for instance, the one that greeted visitors to the 1900 *Exposition Universelle* from the top of the Monumental Gate. On her head rests a ship, the symbol of Paris. Sculpted by Moreau-Vauthier, she is again linked to the realms of fashion and appearance: her gown is modeled on a design by Paquin, as were most of the clothes for his miniature bronze sculptures which fashionable Parisian women displayed in their salons after the exhibition.[22] In Paris's Petit Palais today a *Parisienne* statue also greets visitors to the gallery (see fig. 5.5). Exhibited by Emile Chatrousse during the 1876 Salon and wearing the latest fashion, it is, the notice reads, 'one of the first large scale sculpted representations of an unknown contemporary'. Next to her, in 2007, were two more *Parisiennes*: the *Femme aux gants*, known as *La Parisienne*, painted by Charles Giron in 1883 (see fig. 5.6), and Carolus Duran's 1889 *Portrait de Madame Edgar Stern* (see fig. 5.7). Wearing a beautiful black dress embroidered with shimmering lace and adorned with the sparkle of a necklace and earrings, the Parisian *Femme aux Gants* recalls Sargent's *Madame X*. Like her she is wearing a luxurious, dark, but resplendent, dress, and like her she stands next to a delicate table, her head gracefully turned to the side to display her elegant profile.[23] *Madame Edgar Stern*'s red evening dress contrasts with that of the *Femme aux Gants*, but she too is beautifully adorned, offering the observer a vision of *la Parisienne* as existing in a

world of luxury and sophistication. The fur coat that rests nonchalantly on her shoulder, like Sargent's *Madame X*'s evening gown and delicate crown, seem to announce the imminent pleasures of a Parisian night at the Opera, an elite ball, or perhaps a dinner with the Parisian *beau monde*.

Besides paintings, literature, and sculpture, *la Parisienne* has also appeared in cinema. In René Clair's 1955 film *Les Grandes Manoeuvres*, set in 1913/14 France, *la Parisienne* is Marie-Louise Rivière (actress Michèle Morgan), recently divorced and just arrived in *la province*. In this film, the Parisian woman is yet again linked to the field of fashion: it is as a milliner that she settles in her elected town.

Fig. 5.5 Émile François Chatrousse. *Une Parisienne*. 1876. Plâtre patiné. Musée des Beaux Arts de la Ville de Paris, Petit Palais. © Petit Palais/Roger Viollet.

Fig. 5.6 Charles-Alexandre Giron. *Femme aux Gants (La Parisienne)*. 1883. Oil on Canvas. Musée des Beaux Arts de la Ville de Paris, Petit Palais. © Petit Palais/Roger Viollet.

Fig. 5.7 Charles Carolus Duran. *Madame Edgar Stern*. 1889. Oil on Canvas. Musée des Beaux Arts de la Ville de Paris, Petit Palais. © Petit Palais/Roger Viollet.

One of the most famous Parisian women of cinema is Catherine Deneuve. With films such as Buñuel's 1967 *Belle de Jour*, Truffaut's 1980 *Le Dernier Métro* or Nicole Garcia's 1998 *Place Vendôme*, Deneuve's face has superimposed itself onto that of the anonymous *Parisienne*, in the process cementing the actress's position at the junction of both the imagined and the lived. For Catherine Deneuve, by virtue of living in Paris, *is* a *Parisienne*, whilst at the same time her identity cannot be dissociated from the glamorous fictional images – the imagined Parisian women that have made her famous the world over. And in the same way that Audrey Hepburn has famously been associated with the idea of Parisian chic by way of her on- and offscreen cooperation with designer Givenchy, so has Deneuve asserted herself as an icon of Paris fashion by way of her cooperation with French couturier Yves Saint Laurent, who famously dressed her for *Belle de Jour*.

It is in the fashion press, however, that the relationship between *la Parisienne* and fashion has most consistently been sealed. From past centuries' fashion plates and fashion journals[24] to today's fashion photography and writing, *la Parisienne* has been a recurring figure of the fashion media, and, in contemporary France, of one of the most influential fashion magazines in particular: *Vogue Paris*. She fronts the August 2006 cover, the strapline announcing: '*La Parisienne*: her 80 looks, her beauty circuit, her audacities

Fig. 5.8 'La Parisienne. Ses 80 Looks.' *Vogue Paris.* August 2006. Photograph Mario Testino. © Vogue Paris.

of style' (see fig. 5.8). Both a noun and an adjective, the word '*Parisienne*', like the word 'Paris', has been appropriated by fashion discourse to signify fashion, or, as Barthes puts it of 'written clothing', 'to convey a message whose content is: *Fashion*'.[25] With this figure a staple of magazines, la *Parisienne* has been ensured a continuing visibility in late twentieth and early twenty-first century discourses on the capital and on fashion, indeed on the capital as fashion city.

In *Vogue*, as in the discourse on *la Parisienne* more generally, not only are Parisian women women of fashion, but they are the very essence of female fashionability, the apex of alluring womanhood. *Vogue* quotes perfume maker Guerlain, for whom *la Parisienne* is 'a strange mixture of mischievousness, assurance and elegance that is for me the height of femininity' (November 1996, p. 134). '*La Parisienne*', the French glossy also writes, 'is the most beautiful mistress of haute couture' (September 1995, p. 168). The magazine also invokes 'the preciousness of Parisian elegance, the classic eternal feminine' (August 2003, p. 137), whilst an editorial reads: the new season 'will be chic. But a sublimated and never immediate chic. A symbol of that elegance captured through the prism of idealization: *la Parisienne*.'(Cahier 2, February 2000, p. 3) Such statements recall Uzanne's 1894 assertion that 'In every class of society, a woman is more *femme* in Paris than in any other city in the universe'.[26] In 1841 Taxile Delord referred to 'the supremacy which the trip to the capital gives women', whilst a few years later Gozlan posed the rhetorical question: 'isn't *la Parisienne* the woman *par excellence?*'[27] Similarly, in the May 1990 (p. 111) issue of *L'Officiel* writer Irène Frain describes *la Parisienne* as 'the quintessence of womanhood'. *La Parisienne* is perceived as the ultimate fashionable woman because Paris is seen as the ultimate fashion capital – 'a woman's paradise', as Flaubert put it,[28] mobilizing an expression many before him had also drawn on.[29] His own fashionable *Parisiennes* Madame Moreau and Rosanette, from *L'Education Sentimentale*, were to make an appearance in November 1997's *Vogue* by way of a comic strip on contemporary fashionable life in Paris (pp. 144–5).

A fashion trade

La Parisienne, then, has been depicted as stylish and alluring, with fashion her field of expertise and knowledge: her trade. Indeed, for many Parisian women fashion has not been confined to practices of the self. It has been

the very core of their professional life. In 'Paris, capital of fashion', fashion is a way of living because it also is the means by which one makes a living. As Emmeline Raymond put it in her 1867 text 'La Mode et la parisienne': 'In Paris, half the female population lives off fashion, while the other half lives for fashion'.[30] In the nineteenth as in the eighteenth century, the large number of women employed in the fashion industry could be seen as 'a daily visible reminder to Parisians of the connection between women and clothing production',[31] and, more specifically, between Parisian womanhood and fashion.

An empirical reality, women who have made a profession of fashion have become a central figure of discourses on the French capital. Amongst them is the *grisette*, the object of an 1841 physiology by Louis Huart illustrated by Gavarni, and an entry, in the same year, by Jules Janin in *Les Français Peints par Eux-Mêmes*.[32] Dating from the second half of the seventeenth century, the term *grisette* refers to a grey cloth worn by shop girls that became a fashionable trend adopted by Court women.[33] It was subsequently used to refer to the girls themselves and 'entered Parisian folklore during the 1820s and 1830s'.[34] The *grisette*, Janin writes, is a 'Parisian product'. A worker in the Paris fashion trade, she is 'a girl who is good at everything, who knows everything, who can do everything'. She is an 'artist'.[35] However, although the fashionable apppearance of rich women depended on her skills, she was badly paid. And so was that other figure of the nineteenth-century Parisian fashion trade, the *trottin*, a young *grisette* whose duty was to go and buy things for milliners and deliver their hats,[36] and could therefore be seen 'trotting' along the Paris pavement. In spite of being poor, *la grisette* was well dressed and fashionable, and Janin praises her beauty, youth, and cleanliness.[37] As in the discourse on *la Parisienne* more generally, her appearance is celebrated. Like the *lorette*, however, named in 1841 by Nestor Roqueplan after the many prostitutes seen in the Notre-Dame-de-Lorette area,[38] she was said to have loose morals.[39] Thus Huart, for instance, notes that *la grisette* 'almost always goes off track as soon as she takes her first step in the career of life' and 'doubtless many a grisette turns into a Lorette, but at least this is only around twenty-two or twenty-three years of age'.[40]

La grisette's appearance was praised, but her virtue was questioned, not unlike another key female Parisian figure whose trade too, albeit of a different type, resided in the realm of appearances: the courtesan. She did not work in the field of fashion, but an attractive allure was central to the potential profit she could make from exhibiting and negotiating over her looks and body on Paris's fashionable scene. A woman of fashion, whose

style was celebrated, she was often more stylish than the bourgeois women she mixed with,[41] whether at the Opera, the theater or the various balls she attended, as mentioned in Chapter 1. Thus Worth, for instance, was a couturier not only to high-ranking women but also to courtesans, with the former undeterred by the idea of sharing a fashionable address with the latter.[42]

This meeting of courtesans and high society ladies on the plane of fashion is brought vividly into literature in Zola's *La Curée*, where the rich Aristide Saccard gives his wife Renée a set of diamonds which his courtesan mistress Laure D'Aurigny had put on sale. When Renée first wears them at a dinner party she is hosting her female invitees, although aware of the necklace's provenance, marvel at its splendor. But they also complain that 'these girls took the most beautiful things, soon there wouldn't be any diamonds left for honest women. And in their complaint', Zola continues, 'could be heard the desire to feel on their naked skin one of those jewels *tout Paris* had seen on the shoulders of an illustrious impure woman'.[43]

In Balzac's *Splendeurs et Misères des Courtisanes* the beautiful and fashionable courtesan is most notably Esther, traded on the Parisian social market to serve the ambition of her lover. With Zola, she is Nana, the courtesan actress who seduces the many respectable bourgeois men she mingles with. 'The prodigious thing', Zola writes, is that:

> this large girl, so awkward on stage, so funny as soon as she wanted to play the honest woman, played in town the role of seductress without effort. It was the fluidity of a snake, a skilful negligee, as if by chance, exquisitly elegant, the distinction of a pedigree cat, an aristocracy of vice, superb, outraged, stepping on Paris as an all-powerful mistress. She set trends, society ladies imitated her.[44]

With the rise, in the twentieth century, of women in the business hierarchy, a new type of fashion worker has taken over from *la grisette* in discourses on Parisian women of fashion – including that of *Vogue*. In the French magazine, the women from the fashion trade are not poorly paid employees but, as befits its readership, powerful company directors, influential stylists and other women ranked high in the hierarchy of fashion. The January 1990 section 'Femme en *Vogue*', for instance, introduces Isabelle D'Ornano, head of beauty company Sisley. 'In her office on Avenue George-V', the magazine notes, she is 'the most elegant, the most rigorous businesswoman'. The April 1990 'Femme en *Vogue*' is Catherine Canovas, head of finances for interior decoration company Manuel Canovas. 'Although she willingly

talks about her *provençales* origins, Catherine obstinately and passionately says she is a *Parisienne*.' 'In Paris', the magazine continues, 'she lightens up [her] strict grey or navy Yves Saint Laurent jackets [...] with some fresh, bright, and sophisticated accessories'. The fashionable appearance of these *Parisiennes* of fashion stands as evidence of their success in the industry. For *Vogue*'s world is a world of prestige and luxury. Situated at the high end of the field of fashion and that of class, it is addressed to readers with the economic capital necessary to acquire the high-fashion goods promoted.

The presence in *Vogue* of these *Parisiennes* who live '*off* fashion' is legitimated not only by their high position in the Parisian fashion industry, but also by their sartorial know-how, also displayed, along with that of those *Parisiennes* who live '*for* fashion', in sections such as 'Fille en Vogue' and 'Une fille, un style'. There la *Parisienne* features in the form of women from the capital having their style unveiled to the readers. They are the holders of a high 'cultural capital',[45] a fashion capital consisting of knowledge, with tips and addresses shared, but also possessions – they display their favorite items. Appearing in images alongside pages featuring professional models, they are turned into models in their own right, like them posing in fashionable clothes, their presence in *Vogue*, the high point of the French fashion media, legitimated by their prominent position on the French fashion map. These *Parisiennes* are represented as tastemakers because living in the French capital of taste, fashion models because the inhabitants of the model fashion city.

Thus Deneuve might well be a famous actress, but it is her Parisian quality the magazine highlights in an article entitled 'Itinerary of a Chic Parisian' (December 2003, p. 193). Similarly the French *Elle* places the two positions – celebrity and *Parisienne* – on equal terms when, in an article promoting ayurvedic therapy, it observes that not only have celebrities adopted it but so have '*les Parisiennes*' (8 November 2004, p. 187). In both magazines celebrities and *Parisiennes* are given equal status – that of models to be emulated.

The *Parisienne* tastemakers are featured in *Vogue* to convey their knowledge to women deprived of so solid a fashion capital, including the absent other of the fashion press, la *Provinciale*, and initiate them into the secrets of a life of fashion and a fashionable allure. The notions of 'tips', 'addresses', and 'secrets' have thus become a staple of fashion features, as the titles of sections such as 'L'Agenda Perso' (Perso diary) in 1998 and 'ABC. Carnet d'adresses' (ABC. Address book) in 1989 illustrate.

These notions have also come to form the substance of the many contemporary guidebooks on Paris fashion; guidebooks that have helped reproduce the mythical status of the city and its female inhabitants. *Paris Chic and Trendy*, for instance, evokes *la Parisienne*'s 'indefinable chic', her 'real eye for trends' and her 'femininity captured with grace'. *Chic in Paris: Style secrets and Best Addresses*, by Susan Tabak, promises readers that it will unlock the 'mystery' of *'la femme parisienne'*'s sexiness, 'elegance, grace, and classic chic'. In Hélène and Irène Lurçat's *Comment Devenir une Vraie Parisienne*, becoming a *Parisienne* means looking like one. However, the book tells the readers 'it is best, of course, to have a trustworthy address book: [. . .] the references of the "Parisianly correct" are elementary landmarks'.[46]

Similarly, in February 2006 French *Elle*, informing readers about the launch of a new website, www.amieparisienne.com, wrote:

> This site offers a personalized highend service for provincial or foreign customers who do not know the good Parisian addresses. During the day, a founder of the site accompanies them on a trendy, chic and slightly underground circuit. As if a hip friend was giving them their best addresses. Shopping in the designers's boutiques, trendy cooking lessons, previews, fashionable eateries: only the tips of ultra privileged in-the-know people. (6 February 2006, p. 148)

Locating *la Parisienne*: The universal woman

Regularly featuring alongside *la Parisienne* in the pages of *Vogue* is *la Française*, who the magazine attempts to define in various articles. However, in such pages Parisian women are recurrently singled out, as if they were the best representatives of the French identity under discussion. In line with discourses on Paris, *la Parisienne*, the high point of fashion, is not only the essence of French femininity but also a superior being whose identity resides in her belonging to the Parisian territory and places her above the nation.

In a 'special French woman' issue, for instance, the author Laure Adler 'paints the portrait of the young French woman' (September 1996, p. 45). 'Sit at the terrace of one of St Germain's cafés and watch girls passing by', she suggests. 'In this territory, which remains the symbolic heart of an intellectual and creative France, girls like, precisely, to wander.' The French women she looks at are Parisian women, the freedom, 'rebellious *esprit* [spirit]' and 'irony' she praises best encapsulated in the 'symbolic heart'

of France, Paris, embodied in *les Parisiennes*. The representational status of *la Parisienne* as the epitome of French womanhood is also highlighted in a small article on a sculpture by Elie Nadelman, entitled 'La Femme Française'. 'This sculpture, the idealised portrait of a young *Parisienne*', the magazine writes, 'symbolised, in its spirit, the French woman' (September 1996, p. 95).

Vogue's discourse on *la Parisienne* reflects the exceptional status of Paris, at once the epitome of France and so French, but also, and in its claimed superiority to *la province*, above France, somehow detached from it. As in discourses where the French nation is associated with, but also, and in the process, reduced to, the capital, the shift from *la Française* to *la Parisienne* can be seen as expressive of the privileging of the latter over the former, with the most accomplished version of French women Parisian women. Indeed, by being singled out repeatedly from other Frenchwomen, distinguished from them, *la Parisienne* further emerges as a figure of distinction. As the American author Richard Bernstein contends, 'to be Parisian is to have an identity that transcends social class, economic distinction; it is to belong to a world apart, to an intellectual and moral category, not of class, race and gender, but of a qualitative difference from the rest, an essential worldliness'.[47]

This translates into the figure of the Parisian foreigner that has long informed discourses on Parisian women. In the Goncourt brothers' work, for instance, Fortassier notes, *la Parisienne* 'can equally well be a foreigner: freed from the provincial ties all French women have, she will the more easily be a fully-fledged Parisian'.[48] In Balzac's *La Peau de Chagrin*, Foedora is 'the most beautiful woman of Paris' but also 'a half-Russian Parisian, a half-Parisian Russian!' For Taxile Delord, 'the most distinguished Parisian women are Russian women'. However, he adds, 'an English woman will never become a *Parisienne*, nor will a German woman; a Spanish woman will be able to become so in the third generation'. *Les Parisiennes*, according to Théodore de Banville's 1881 *Le Génie des Parisiennes* (The genius of *Les Parisiennes*), are 'women born or living in Paris'. Tétart-Vittu notes that the periodical *La Vie Parisienne* (1889) described 'the ideal society woman' as 'not always French, but almost always Parisian, or she has become so very quickly. She is even sometimes born a *Parisienne* on the other side of the ocean.' In 1932 writer Léon-Paul Fargue wrote that '*Parisiennes* can be the colour of milky coffee, like Joséphine Baker, or Jewish like Sarah Bernhardt. Here is a first point: *la Parisienne* is well able to come from Moscow, from the Sugar Islands, or from Castelsarrasin.'[49]

Similarly, if for *Vogue la Parisienne* is the ultimate French woman, she is not necessarily French, for one can be 'Parisian by birth or at heart' (November 1996, p. 95) as the magazine puts it, describing Hiroko Matsumoto as 'the most Parisian of Japanese women' (December 1994, p. 102), and Minami Goto as 'the most Parisian woman from Osaka' (September 1994, p. 280). Thus the magazine asks: 'how does the American Nan Legeai dress to be, from morning to evening, the quintessence of a *Parisienne* in the Céline style?' (August 1990, p. 128) also invoking 'a borderless chic seriously redolent of *la Parisienne*' (November 1999, p. 93). As the French newspaper *Libération* puts it in reference to Parisian women: '[there is] no need to be born in the capital to personify the spirit of the city' (27–8 January 2001, p. 41).

La Parisienne is impervious to borders because Paris itself, according to discourses on the French capital, is borderless, open to all. Mercier, for instance, in his *Tableau de Paris*, refers to 'this reputation for affability that distinguishes us [Parisians]', and speaks of 'all the peoples of Europe arriving at this principal destination [Paris]', whilst in 'Ce que c'est qu'une Parisienne' Léon Gozlan argued that it is a mistake to think that *la Parisienne* is born in Paris, for 'Paris is primarily everybody's city'.[50] It is the universal city of universal values as discussed in Chapter 1, a 'cosmopolitan' city and capital (March 1992, p. 224; September 1994, p. 272), *Vogue* notes, also talking about 'a cosmopolitan tout-Paris' (November 1996, p. 132).

The abstraction of *la Parisienne* from national rootedness is also emphasized through the parallels the magazine often makes between Paris and other capitals, as well as other big cities in various nations. From one issue to the next, from one page to the next, readers hear about women from Paris, but also from Los Angeles, Milan, or Tokyo. *Les Parisiennes* featured in 'Une fille, un style' alternate with fashionable women from cities across the world but no French provincial ones. *La Parisienne*, according to *Vogue*'s geography of fashion, has more in common with women from other capitals than with *les provinciales*, whose rare presence in the pages of *Vogue* reflects their exclusion from the realm of fashion. Inscribed in a chain of capitals and major cities from various nations, Paris is further detached from France, lifted off the French map and reinserted into a supranational order of urban places that *Vogue*'s *Parisienne* encounters through her fashionable journeys. For not only is she borderless, but so is the space she moves across.

Glossies such as *Vogue* have long been key in constructing cities as world cities and the fashion geography as 'an international stage', as Edwards's

study of 1930s British *Vogue* on London suggests, although she also notes that, compared with the British and American editions, the French 'was much more insular' and 'largely concerned with Paris'.[51] Today, whilst the French magazine still celebrates Paris as the capital of fashion, it regularly pays attention to other fashion cities from various nations, also frequently referring to the supranational geography of fashion through the use of expressions such as 'from Paris to Los Angeles' (March 2007, p. 291). Such expressions emphasize the commonality between fashion cities and their positioning, above the national, in the cross-border space of the global field of fashion. As Short notes, 'cosmopolitanism is concerned with unbounded space, similarities and shared global connections. The truly cosmopolitan city is tied as much into the space of global flows as national networks, more part of a global society than a national order',[52] and so is the fashionable *Parisienne* as depicted in *Vogue*.

Thus, Carine Roitfeld, editor of the magazine since 2001, states that: 'we talk to *la Parisienne* as we imagine her [. . .]. A sparkly woman with a personality, who follows fashion, and easily leaves for New York or Berlin. Through our choices, it is a universe we create and which we make alluring.'[53] The territory of *Vogue*'s *Parisienne* stretches across nations. A woman of fashion and a fashionable woman, her occupation and interests take her through the extended space of the transnational field of fashion. No longer limited to the local streets that the *grisettes* could be seen walking along, her path follows the global trajectories of planes. In 1990 *Vogue* noted that the American Parisian Nan Legeai, CEO of French luxury fashion company Céline, 'goes around the world twice a year, and takes a plane at least once a week' (August 1990, p. 128). A September 1997 (p. 198) feature reads: 'the address book of seduction: a woman's best friend? her caterer, her masseur and her make-up artist. A hotel on the sea, for the duration of an escape; the address for having a drink in all the capitals of the world.' The escape is away from Paris and towards fashion cities in other countries, for *la province*, it is implied, cannot be the fashion destination of *la Parisienne*. Rather, as Taxile Delord wrote in 1841, it is her 'martyrdom', the place she is forced to move to if she loses her beauty: 'boredom will dig her grave, and her mirror will tell her every day: Sister, you must die!'[54]

In the zone of 'time-space compression'[55] that *Vogue*'s *Parisienne* inhabits, movement is instantaneous, weightless, unencumbered by boundaries. As Barthes writes of the fashion press: 'the rhetorical activity of Fashion escapes time',[56] and it also escapes space, as structured by fashion magazines such as *Vogue*. Thus, in a similar vain, *Stiletto* notes, also invoking Buñuel's film,

that 'Belle de jour lives between Paris, London, Geneva and New York [. . .]' (Spring-Summer 2006, p. 7), and in *Jalouse* Céline's art director Ivana Omazic states: 'today the Céline woman is the incarnation of sophistication, a mixture between the Left Bank *Parisienne* and "Park Avenue princesses" [. . .] I will perpetuate the image of this sophisticated woman, but it will be nearer *la Parisienne* than the New-Yorker because I am European at heart. The Céline woman will be an active, cosmopolitan woman' (October 2005, p. 84).

Vogue's *Parisienne*, like that of *Stiletto* and Céline, is part of the 'global elite' that Short discusses, and which participates in 'the production and consumption of the global city'.[57] Comprising transnational professionals and 'consumerist elites', its 'migration flows', he writes, 'link together global and globalizing cities in a space of flows that reproduce their cosmopolitan interests and practices. They are mobile, global and cosmopolitan. [. . .] They both embody and represent globalization.'[58] This embodiment is made manifest on the body of *Vogue*'s *Parisienne* through the various commodities acquired in the course of her movement across the transnational space of global fashion, and which are revealed, like the 'secret' addresses they can be seen at, to the readers of the magazine. 'Social power', Pinçon and Pinçon-Charlot note, 'is also power over space',[59] the power *Vogue*'s *Parisienne* has freely to move between cities as if the world was but a stream of fashionable haunts. As the magazine puts it: 'From Milan to Tokyo through New York and London, *Vogue* travels in the borderless land of ideas, fashions and creation' (October 1989, p. 187).

Naming *la Parisienne*

The idea that *la Parisienne*'s defining trait is her fashionable appearance suggests that such an appearance should allow one to distinguish her easily, in the pages of *Vogue* for instance, from other fashionable women. However, her frequent return to such pages also sees her allure changing repeatedly, with the lack of continuity in visual styles rendering it useless to ask the question 'what does she look like?' Thus, for instance, in a story entitled 'Les Nouvelles Parisiennes' [the new *Parisiennes*] in February 2002 *Vogue* tells us she is 'typically urban [. . .] active, wearing a quickly but beautifully applied make-up', but also 'a chic hippy [. . .] a daughter-of-the-sun type, from San Francisco to Saint-Tropez. A fresh complexion', as well as 'neo sophisticated [. . .] sexy and audacious, this is the Saint Laurent

woman as reinvented by Tom Ford'. In February 2004 *la Parisienne* is poetic as well as rock'n'roll, in the image of Agathe Buchotte's Paris boutique 'imagined', the magazine notes, 'like the wardrobe of a true *Parisienne*': it 'astutely mixes everyday clothes with the trendiest designer creations. Isabel Marant, Cabane de Zucca, for the most famous, but also the poetic creation of Robert Normand, Dragovan's high heeled eccentricities, Oggi Person's rock'n'roll belts and T-shirt' (February 2004, p. 84). In the August 2006 special issue on *la Parisienne*, she dons 80 styles, including a black sleeveless Louis Vuitton overall; a bright blue 1920s-like Roberto Cavalli silk dress; lurex tights with a grey Ralph Lauren cashmere cardigan embroidered with gold leaves; and a short asymmetrical Miu Miu dress with a blue, white and yellow print (see fig. 5.9). The diversity and multiplicity of styles labeled '*Parisienne*' makes it impossible to identify this figure through her sartorial envelope.

Vogue's variety of fashionable *Parisiennes* seems to support those authors who have suggested, like Fargue, that 'there are all kinds of *Parisiennes*' or, like Delord before him, that 'there are so many varieties, so many surprises, so many contrasts among Parisian women'.[60] For both authors,

Fig. 5.9 Some *Parisienne* looks. *Vogue Paris*. August 2006. Photograph Mario Testino. © Vogue Paris.

however, as for Balzac, discussed earlier, the distinctive trait common to the many versions of *Parisiennes* is their allure and fashionable style, which also distinguishes them from women from Paris, for – as Delord also notes – 'not all women from Paris are *Parisiennes*'.[61] According to Fargue, too, *Parisiennes* and 'women from Paris', are 'not exactly the same thing'.[62] If it rains, Delord writes, the woman from Paris opens an umbrella, not *la Parisienne,* as 'A pretty woman with an umbrella is like a pretty rhyme that is false [...] The woman from Paris takes care of her health, *la Parisienne* takes care of forms. One is a woman, the other is a poet.'[63] *La Parisienne* is a woman from Paris who knows how to adorn herself. Being a *Parisienne* is looking like one.

In *Vogue*, however, not only are all women from Paris fashionable and skilled in the art of adorning themselves, but so are all the women featured in the magazine. For beauty and fashionability is the common denominator of femininity according to *Vogue*. In this magazine, as in most fashion magazines, model women stand out through their highly distinguished, yet ultimately homogenizing because normalized, beauty. The project of separating *la Parisienne* out from other women, which the variety of styles she is seen donning somehow renders highly hypothetical, is made even more unrealizable by the fact that in *Vogue* she is just one of many stylish and fashionable women. Her looks continually renewed, she sinks into the beautiful mass of fashionable *Vogue* women, whether from Paris or not, whether the character in a '*Parisienne*' fashion spread or not.

Thus in many articles and images the one thread that links the different versions of *Parisiennes* together and truly distinguishes this character from other fashionable women is the word '*Parisienne*' itself. So potent has this word become in fashion discourse that its simple evocation, like that of the word 'Paris', suffices to affect the meaning of a sentence or image, and anchor it to the realm of all things fashionable and desirable. As Taxile Delord wrote in his physiology: '*Parisienne*. The word says it all.'[64] In fashion magazines such as *Vogue* the Parisian woman is often *Parisienne* by name, or more exactly by naming, rather than by appearance.

In the same way that 'a garment can signify because it is named'[65] so can a fashionable type such as *la Parisienne*. Thus, referring to the name attributed to various pieces of clothing, Barthes talks about species, that is, 'names for clothing'. He gives the example of the 'twin set', observing that 'in order for [it] to signify, it is enough that it asserts its species'.[66] In the same way that there are species of clothes, in fashion discourse there are species of fashionable women, including *la Parisienne*, and in the same way

that it is enough for a clothing item to signify 'Fashion' through assertion,[67] so is it for species of women such as *la Parisienne*. 'What signifies', Barthes continues, insisting on the role of language in the making of fashion – for 'to name is always to make something exist' – 'is never the materiality of the species, but rather its affirmation'.[68] In images of *la Parisienne* it is the very mention of the word that brings the various styles together to create the impression of unity and make *la Parisienne* exist.

Thus '*Parisienne*' as noun and adjective infuses the woman referred to and the clothes she is wearing with a meaning that transcends their material and objective qualities. Like 'Paris', but also 'Dior', 'Chanel' or 'Gucci', it anchors them to an imaginary realm of glamor, fantasy, and desire – all meanings and values the former words have long carried with them. 'The "speech" (of the magazine)', Barthes also writes, 'seizes upon insignificant objects, and, without modifying their substance, strikes them with meaning, gives them the life of a sign; it can also take this life back from them, so that meaning is like a grace that has descended upon the object'.[69] The term '*Parisienne*' is one element of the speech, one constituent of fashion discourse, that gives meaning to the objects it 'touches [. . .] at a distance',[70] whilst also creating continuity and coherence amongst them. For, as Barthes also notes:

> the very aim of the Fashion system is this difficult reduction from the many to the one; for, on the one hand, it must preserve the garment's diversity, its discontinuity, and the profusion of its components; and, on the other hand, it must discipline this profusion and impose a unified meaning under the various species of a unique aim.[71]

'*Parisienne*' disciplines the multitude into an ordered whole that creates the illusion of identity without which objects and styles would be devoid of meaning and value.

Thus if images are central to the symbolic production of fashion, so are words. Discourses, we saw in Chapter 3, are made up of both linguistic and non-linguistic signs, and their values feed into each other. The word *Parisienne* inflects the meaning of visuals, whose slick content and polished form in the pages of *Vogue* will ultimately feed back into the word, injecting it with yet more potency and the power to continue adding value to more images and the styles they depict. As Barthes puts it: 'the word transforms the object into a force, the word itself becomes a force'.[72]

Rarely then, can *la Parisienne*'s fashionable style mark her out from the other fashionable women that grace the pages of the French magazine,

seemingly diluting her visual distinctiveness into a parade of undifferentiated beauty and fashionability. Just as mentioning the word '*Parisienne*' disrupts this standardized parade, so does the mobilization of a recurring set of iconic and linguistic signs which *la Parisienne* has become associated with. Indeed, although, as discussed above, the '*Parisiennes*' of fashion spreads are often Parisian by naming alone rather than by appearance, a few sartorial signifiers, both linguistic and non-linguistic, exist that have commonly been associated with this figure. Amongst them are *le tailleur* (skirt-suit) and *le trench* (trench-coat).

The editorial of the September 1989 issue of *Vogue* announces the advent of 'a new *Parisienne*'. In a fashion spread, a model is photographed walking in 'old Paris' wearing a *tailleur* in a fashion story devoted to this piece of clothing. An August 1991 fashion spread shows the image of a model wandering through Paris streets wearing a trench-coat (p. 119). The October 1995 section 'Elles portent toutes' ('They are all wearing') is devoted to an exhibition in the Paris department store Le Bon Marché, organized in conjunction with *Vogue,* and entitled 'Portraits of Left Bank Women as seen by *Vogue*'. The section features four pages of 'Our selection of basics from the Bon Marché' including *tailleurs* and *trenchs*. A *tailleur* once again adorns the body of a model on the November 1996 cover entitled 'The Parisian Paris', and although in October 1998 *Vogue* had written that 'the cliché of the *Parisienne* wearing a little *tailleur* is over, this elegant woman is plural and her look, like Paris, is coded by districts' (p. 143), the *tailleur* returns to the cover of the magazine's August 2006 issue on *la Parisienne*.

First appearing in the eighteenth century, the *tailleur* was more widely appropriated by Parisian women at the end of the nineteenth century.[73] Although initially a product of the English tailoring tradition, it was consecrated, in the first half the twentieth century, by Parisian designers such as Lelong, Schiaparelli and Dior, and came to 'symbolise the quintessence of *la Parisienne*'s style and taste'.[74] A British invention, then, it has been given a Parisian identity by way of its legitimation by Parisian couturiers and its appropriation by, and representation of, Parisian women. A sartorial sign of authority, independence, and rationality born of its association with the masculinity of modernity, it has lent itself to the production, since the nineteenth century, of *la Parisienne* as a symbol of modern femininity defined as active, urban and emancipated. For in the nineteenth century, *la Parisienne*, the female inhabitant of the modern city *par excellence*, is celebrated as 'an icon of modernity'.[75] She is depicted, for instance, in the traits of a 'lionne', that other nineteenth century female

type standing for women eager to take up new sports and share Parisian pleasures and manners normally reserved for men.[76] Manet's painting of *la Parisienne* (see fig. 5.10) was also to help cement her status as modernity made flesh by giving her, thanks to the new modern technique and the play of color and light that inform the representation of her fashionable attire, 'a new, modernized image'.[77] Similarly, in the 1920s she features in the work of the Delaunays, a symbol of modernity and the visual exponent of the simultaneous art they advocated.[78]

Like the *tailleur*, the trench-coat, also a British invention, was initially a masculine garment.[79] It was worn by soldiers during the First World War, and as with the *tailleur*, this masculine attribute has helped convey the idea of *la Parisienne* as an exponent of modernity. The garment has become linked to visions of Parisian women in *Vogue*, as mentioned earlier, as it has in fashion discourse more generally. One of the visuals for Gérard Darel's 2006 advertising campaign, for instance, shows French actress and singer Charlotte Gainsbourg wearing a trench-coat. Commenting

Fig. 5.10 Edouart Manet. *La Parisienne*. 1875. Oil on Canvas. © The National Museum of Fine Arts, Stockholm.

on the campaign in a short article entitled 'the *Parisienne Chic* style' and illustrated with the visual, French fashion magazine *Elle* writes that the actress 'displays the unique relaxed chic of the *Parisienne* style' wearing, amongst other things, 'an obligatory trenchcoat' and, 'in the end, a "French look", a mixture of fashion, natural style and glamour we all dream of' (30 January 2006, p. 117).

La Parisienne, Paris and the creative spirit

In contrast with *les provinciales*, Parisian women have been endowed with a creativity that, already in the eighteenth-century French fashion press, was said to be one of their main attributes. The *Cabinet des Modes*, for instance, Jones observes, 'perpetuated the notion that the creativity of the fashionable women of Paris remained fecund and abundant and constantly praised the "riens" [little nothings] that the women of Paris had created'.[80] In Rousseau's 1761 *La Nouvelle Eloise*, Saint-Preux writes that, of all women, Parisian women are:

> the least subservient to their own fashions. Fashion dominates *les provinciales*, but *les Parisiennes* know how to turn it to their advantage. The former, *les provinciales*, are ignorant and servile copyists who even copy spelling mistakes; the others are authors who are master copyists, and know how to correct bad lessons.[81]

Echoing the late nineteenth-century construction, in commercial literature, of *la Parisienne* as artist with fashion her art,[82] Banville wrote that Paris 'is the artist and poet city *par excellence*; but the greatest artists and the greatest poets of Paris are *les Parisiennes*'. Theirs is the art of 'translating general ideas into fashion'.[83] Similarly, nineteenth-century journalist, writer and *communard* Jules Vallès praises Parisian women's 'genius for grooming', whilst at the beginning of the twenty-first century Rustenholz celebrates *Parisiennes* in his eponymous book, stating that 'each day she [*la Parisienne*] reinvents herself'.[84]

In *Vogue*, too Parisian women appear as creative. The *Parisiennes* of 'Une fille, un style' are presented as individual and original, as the title of the section also makes clear. '[Masako] mixes styles, juggles with the basics' (March 2003) the magazine writes, also noting, for instance, that Clarisse likes 'scrambling the signals' (May 2003) and Laurence customizing her t-shirts (April 2003). Like De Certeau's hero of consumer culture,[85] *Vogue's*

Parisienne is an everyday artist who, at once consumer and author, has mastered the art of consumption. Perfumer Jean Guichard tells the glossy that *la Parisienne* 'knows better than any other women in the world how to wear the most extravagant, the most sophisticated perfumes. She wears perfume like she wears clothes: with imagination and fantasy' (November 1996, p. 154).

However, although *la Parisienne* is a creator, she is the creator Paris makes her, for it is Paris, as discussed earlier, that is the source of all inspiration, the 'artist', according to Taxile Delord, who 'incessantly finesses with the hammer of the *esprit* [mind]' the 'marble blocks' that 'the world sends it'.[86] *Vogue* depicts journalist Claire Chazal as being 'a pure product of the 16th' [*arrondissement*] (May 1991, p. 22). The Favier sisters have 'a 16th *arrondissement* side' (August 1996, p. 59) whilst actress Anouk Aimée, photographed at a café terrace, 'is Left Bank, at the Deux Magots' (August 1994, p. 118). Physically located there, she also incarnates Paris's Left Bank: she *is* Left Bank, her identity indissociable from that of a part of Paris.

The idea that it is Paris that gives Parisian women their identity is best illustrated in an October 1998 feature on *la Parisienne* where images of models walking down the catwalk are shown with their faces covered with a blank oval of the same white as the *arrondissements* on the Paris map reproduced next to them (see fig. 5.11). The women's individuality is 'a pure product' of the *arrondissements* they inhabit. Commenting on the work of the French poet Réda on Paris, Sheringham notes that 'the city manifests itself in endless traits which confer on it, by analogy, certain kinds of personality but do not alter its profound anonymity';[87] an idea conveyed, in the feature discussed, through the representation of faceless, that is, anonymous, models. The women's identity – their name – is only that which Paris gives them. They are, the subhead tells us, *la Parisienne*, sole concession to their singularity. The singular form of the noun itself, a form frequently used in discourses on Parisian women, brushes aside essential differences in favor of formal, here sartorial, variations. 'This elegant woman is plural', *Vogue* writes in the feature. But *la Parisienne* is first and foremost a 'she', not a 'they', the ultimate woman who stands in for the others, as in Breton's *Nadja*, where, Sheringham notes, 'woman' is 'incarnated by the generic "Parisian woman"'.[88]

Thus although many authors have argued, along with Fargue, as cited earlier, that 'there are all sorts of *Parisiennes*', this figure is often referred to in the singular form, not least by Fargue himself whose reflections on Parisian women is entitled *'la Parisienne'*. Grammar lends itself to

the discourse on such women by subsuming, as befits the construction of mythical figures and ideals, their possible diversity into a widely encompassing and singular whole, a unique repository of meaning and collective imaginary.

The women's look, their 'plastic self' then, to borrow Jenkins' expression,[89] is expressive of a wider collective self; that of Paris, whose spirit manifests itself through its female inhabitants. 'In Tokyo, in New York', for instance, *Vogue* writes, Isabelle d'Ornano 'is the spirit, the chic of Paris' (December 1989, p. 142), whilst 'the spirit of these two Parisians by adoption [Alaia and the model Farida], as Parisian as you can get, suggests there's no need to despair of the future: Paris will always be Paris. It must be the climate' (June–July 1990, p. 56).

After the Industrial Revolution, according to Richard Sennett, fashions in cities assumed the role of 'direct expressions of the "inner" self ...

Fig. 5.11 *La Parisienne* is Paris. *Vogue Paris.* October 1998. © Vogue Paris.

Fig. 5.12 'Haute couture, L'Esprit Parisien.' *Vogue Paris.* September 1989. Photograph Peter Lindbergh. © Vogue Paris.

guides to the authentic self of the wearer',⁹⁰ an idea I return to in the next chapter. But in the contemporary fashion press, fashion is also seen as an expression of a collective self, that of cities, conducted on the body of city-dwellers. The self of the wearer is a situated self, Paris's spirit melding with that of its inhabitants, Parisian women, who do not simply *habitent à Paris* – live in Paris – but *habitent* Paris – inhabit Paris.

The virtue *la Parisienne* has of embodying Paris's spirit was already conferred on her toy version, the *poupée de mode* (fashion doll), aptly known throughout the nineteenth century as *Parisienne* or *Poupée Parisienne*.⁹¹ As Peers observes of an 1867 Rochard doll: it 'perform[ed] most clearly a duty that Octave Uzanne devolved to all living *Parisiennes*: to be specifically fashionable and thus to represent "the spirit of Paris"'.⁹² Similarly, referring to Catherine Deneuve in *Le Dernier Métro* in his book *Parisienne(s)*, Rustenholz asks: 'is it a coincidence that Catherine Deneuve was never more *Parisienne* than in this parable on *la Parisienne* as an inspired "medium"?' '*La Parisienne*', he adds 'is the spirit of the place'.⁹³ Thus on a *Vogue* September 1989 cover entitled 'Haute couture: l'esprit parisien' (see fig. 5.12), which also reproduces, as in many other issues (see, for instance, June–July 1990; March 1991; September 1995), visions of the French capital as a city of cafés and terraces, the two models are shown walking briskly past Paris café Les Deux Magots. Haute couture, the cover line says, stands for *l'esprit parisien*, both incarnated in the two models: the women, high fashion and the Parisian spirit becoming one.

Paris, then, expresses and incarnates itself in *la Parisienne*. Indeed, whether a fashion doll in past centuries, a statue on the Paris 1900 exhibition gate, or, more recently, a naked woman, as in Michael Ackerman's 1999 'Paris, France' photograph (see fig. 5.13), Paris is a she, to the point, some have argued, that it brings femininity out of its inhabitants. In his 1953 *Psychanalyse de Paris*, for example, 'Frédéric Hoffet argued that the very femininity of Paris had turned men into a kind of woman'.⁹⁴ In Leduc's *La Batarde* 'the city is feminized and feminizing' and its 'landscape becomes "a seductive and mysterious woman"'.⁹⁵ *La Parisienne* is 'the woman who is the most woman', Jean-Louis Bory writes in his text for Paris's Musée Galliéra 1958 exhibition *Les Parisiennes*, 'since she is a citizen of the most woman city in the world'.⁹⁶ In a 2006 article on the Parisian woman for French daily *Libération*, author and journalist Philippe Lançon also sees the capital as a woman, indeed a *Parisienne*, with its streets and monuments her body, anatomical metaphors having long informed the Paris myth.⁹⁷ He writes:

La Parisienne

Fig. 5.13 'Paris, France.' 1999. Photograph Michael Ackerman. © Michael Ackerman/Agence Vu.

La Parisienne holds the street and this street changes. It regenerates itself through silhouettes. [...] The new spine of *la Parisienne* lays down Vendôme going north. A tropical and Commune sun illuminates it. It's *rue de* Belleville: a long and supple neck, almost straight but not entirely, haughty and sensual, with an aggressive joy and debauched by a hem of custard.[98]

A comment by Bernstein in his 1991 book *Fragile Glory* reproduces this gendering of the capital as feminine. He asks 'what makes a Parisian a Parisian?' 'Perhaps', he ventures, it is 'this old bourgeois couple sitting at a café terrasse', or this sales assistant selling cheeses and talking about them as if they were artworks. 'Or perhaps', he also suggests:

> Paris is represented by a young woman, very casual in a black skirt and a silk blouse with a scarf, having dinner with a somewhat older man in some classic café, [...], and looking as though she could transform a cowgirl's outfit into an instance of haute couture, because in her case, it is not the clothes that make the woman but the Parisian woman who makes the clothes.[99]

Martin-Chauffier, in *Une Vraie Parisienne*, also makes the city a woman in the following, where, in the original French, the adjectives are given the feminine gender: 'Paris is beautiful, small, refined, of a human size, disorderly in appearance and very organized in reality, quite homogenous in the end; centuries pass and its inhabitants always construct the same city'.[100]

Vogue too asserts that 'Paris is a woman' (November 1996, p. 161), quoting Malcolm McLaren, for whom 'Paris is a female city' (September 1994, p. 218). 'Paris boring?' *Vogue* asks with the adjective in the feminine, 'Don't even think about it. Cheerfulness is Parisian above all' (April 1995, p. 161). Thus in spite of Higonnet's contention that in the nineteenth century Paris became 'the masculinized capital of the Republic of Letters', and that 'Nowadays, of course, Paris is masculine',[101] the feminine gender is still often mobilized in reference to the French capital.

A feminine city, then, and a city of pleasure, as we saw in Chapter 1, Paris is that which gives pleasure, not least to the many male painters and writers who have represented it. For its nineteenth century putting into discourse was primarily a male putting into discourse, the city an attractive woman who men embraced. For the Parisian *flâneur*, Balzac writes in *Ferragus*, the city is 'the head of the world [. . .] a creature; each man, each parcel of a house is a foil of this great courtesan's cellular fabric, and with whose head, heart and whimsical habits they are perfectly acquainted. Thus they are Paris' lovers.'[102] In the 1958 'Les Parisiennes' exhibition in Paris's Musée Galliéra, *la Parisienne* still appears as a male creation and fantasy. Out of 91 painters and sculptors featured, only four are women. Of the 15 writers contributing to the catalog, only one is a woman – Irène Lebar. As Delord puts it '*La Parisienne* is an *homme d'esprit* [a sharp-witted man]'.[103] Delord's reference to a masculine intellect was intended to emphasize the supremacy of the type, but his statement also captures its characteristic as a creation mostly of men. From Balzac, Flaubert, Zola or Manet to Buñuel or Kiraz, for instance, the pleasure which *la Parisienne* evokes is that of men who have made the city and its women theirs. As Conrad writes of the painter who, in Zola's novel *L'Oeuvre*, 'envisions Paris as a female nude . . . "The city of passion" can only be embodied by his flagrant, resplendent, sexually available model'.[104]

This association between the city and a sexually available woman, both appropriated by men, is captured in the female figures that, as mentioned in Chapter 1, have personified Paris: the prostitute and, as in the above quote by Balzac, the courtesan, two figures which also draw attention to the representation of Parisian women as sexually promiscuous. 'When the painter James Tissot [. . .] chose England for ten years, no matter what he did', Rustenholz writes, 'the *Spectator* saw women in his portraits as "undeniably Parisian". It was not a compliment; it meant, reading another periodical, the *Graphic*, that his style was "full of barely decent innuendos".'[105] In 1885, the painter exhibited in Paris 15 paintings of

Parisian women. Set in the city's public spaces – 'the boulevards, parks, balls, shops, theatres and salons for which Paris had become famous' – they depicted a femininity closely associated with the notions of display and adornment and also of consumption, the high status men could afford and show off on the body of their female companion.[106] The woman herself, no longer envisioned simply as a mother or wife confined to the private sphere, represented the very luxury displayed.[107] At the time, visions of *la Parisienne* as 'commodified femininity' were a well-rehearsed trope of print culture.[108] 'Posing for public acclamation of her physical charms, or selling something', Garb writes, 'the slippage between the merchandise on sale and the woman herself' was 'easy to make'.[109] Buñuel's famous Parisian *Belle de Jour*, in which Deneuve plays a prostitute, certainly contributed to the production of the Parisian woman as a figure of sexual consumption, here also straying from the traditional bonds of married life. In 2004, this figure yet again informs cinematic visions of Parisian womanhood in Anne Fontaine's *Nathalie*, where Emmanuelle Béart plays *entraineuse* Marlène/ Nathalie, whom the bourgeois Catherine (Fanny Ardant) pays to have sex with her husband (Gérard Depardieu).

Fig. 5.14 'Nocturne Parisien.' *Vogue Paris*. August 2006. Photograph Mario Sorrenti. © Vogue Paris.

In the August 2006 issue devoted to *la Parisienne*, *Vogue* also refers to the figure of the Parisian prostitute. A spread entitled 'nocturne Parisien' reads 'when Paris goes to sleep, all desires awake' (see fig. 5.14). It shows a model at night scantily dressed in various Parisian streets, her body often leaning against a wall or other prop in a suggestive pause evocative of stereotypical visions of prostitutes waiting for a potential customer to pass by. One picture shows a man walking past as if about to proposition her, his gaze lingering on her body while she sits on the front of a car, her hair slightly disheveled. In the image that follows, he is standing next to her, having approached (see fig. 5.15). Prostitution is cleared of any negative connotations. Glamorized, it is reduced to a simple law of temptation and attraction. In line with discourses on *la Parisienne*, the prostitute emerges as a seductive temptress, a tantalizing and manipulative object of male desire. As Steele notes, in the nineteenth century 'behind the image of the femme fatale, the irresistably attractive woman who leads men to destruction, lurked the specter of the fashionable Parisienne'.[110] In contemporary fashion visuals, however, it is the specter of the femme

Fig. 5.15 'Nocturne Parisien.' *Vogue Paris*. August 2006. Photograph Mario Sorrenti. © Vogue Paris.

fatale and seductive temptress that lurks behind images of fashionable *Parisiennes*.

Visions of Paris as feminized, and informed by the notions of desire, pleasure and consumption, serve the interest of *Vogue* in its role as a tribune for the promotion of consumer goods. For such notions are the backbone of fashion discourse and that on consumption. Not only do they underpin visuals inspired by the theme of the prostitute, but they also underpin those also set in the French capital, illustrating fashion stories as love stories, for 'the erotic myth that was Paris'[111] is also a myth of love. For instance Esther, the Parisian courtesan of Balzac's *Splendeurs et Misères des Courtisanes*, dies for the love of Lucien. Kiraz's *Parisiennes* spend the majority of their time thinking about shopping and fashion but also love, the *raison de vivre* of another frivolous Parisian woman, Michel Boisron's Brigitte in his film *Une Parisienne*. In Miss.Tic's street *pochoirs* the aphorisms that caption images of her *Parisiennes* are often reflections on love. As gallerist Lélia Mordoch puts it in the introduction to the book on Miss.Tic, 'It is known the world over, *les Parisiennes* are in love'.[112] Thus, in

Fig. 5.16 Paris and the myth of love. *Vogue Paris*. May 1991. Photograph Christian Moser. © Vogue Paris.

Vogue, male models have appeared in fashion spreads conjuring up visions of (heterosexual) love and romance, as in the May 1991 issue, for instance, where a couple is represented enjoying an evening out in Paris's Brasserie Lipp (see fig. 5.16).

La Parisienne, then, stands as the material embodiment and personification of the French capital, of its *esprit*, and, in the same way that the spirit of Paris has been celebrated, so has that of its fleshly manifestation. Not only does *la Parisienne* distinguish herself through appearance, according to discourses on this female figure, but her *esprit* is also a distinctive trait. Banville, for instance, praises the celebrated Parisian actress Rachel: in her eyes can be seen 'the subtle flame of the *esprit* [mind]'.[113] As Delord before him wrote, 'the gaze of women from Paris is always *spirituel* [witty]'.[114] More recently, in *Comment devenir une vraie Parisienne*, Hélène and Irène Lurçat note that *la Parisienne* 'a de l'esprit' ('has wit').[115] One of the defining traits of French women, according to *Vogue*, is their spirit: 'Women's *esprit* [spirit]: it's known, French women are racy, talented and amazingly classy. With rigour and grace they naturally win the top prize for excellence' (September 1995, p. 194). However, since *la Parisienne* is perceived as the ultimate incarnation of *la française*, she is also the best representative of this spirited womanhood, the 'speciality' of Parisians being, according to *Vogue*, 'de faire de l'esprit' [to display wit] (April 1990, p. 120), a statement that recalls Vilmorin's '[in Paris] nothing is done without *esprit* [wit]'.[116] According to the magazine 'the ideal *Parisienne*', Inès de la Fressange, is 'an ideal of the active, elegant, *spirituelle* [witty], ardent French woman'; that is, a Parisian ideal (September 1995, pp. 164, 167).

This ideal was nourished, at the same time as it was institutionalized, in the Paris salons that flourished in the eighteenth century, and where, as discussed in Chapter 4, one's *esprit* could be put to the test and displayed through various *bons mots* and quick-witted comments. Noting in 1932 that true *Parisiennes* were dying out, Fargue categorized them as those women from Paris able to 'wear to their advantage furs and jewelry' as well as 'say things newspapers would quote'.[117] Being a *Parisienne* meant having 'a natural distinction, an *esprit* that borrowed from exhibitionism when it failed to manifest itself through conversation'.[118] An alert and lively spirit together with a distinguished sense of dress is what allows Parisian women to stand out.[119]

Rustenholz, unlike Fargue, does not believe that true *Parisiennes* are disappearing, and still celebrates their *esprit*. Drawing on a metaphorical link with fashion to describe Paris, he writes:

And, behind, as a set, is Paris, its Seine scarves and stone laces, the Eiffel Tower's diminutive fishnet . . . On the Parisian stage, with Montmartre on the garden side and Montparnasse on the courtyard side, the Louvre and the docks as a backdrop, Bastille and the Sentier descending from the flies, *l'esprit* continuously issues from the prompt box. *La Parisienne* is her interpreter. To be a *Parisienne*, no need to be born in Paris, it is enough to be there.[120]

He notes that the *charme* of *la Parisienne* lies in the fact that she is 'animated by *l'esprit* [the mind]. Let's say [. . .] that she is silhouetted by a stroke of *esprit* [spirit]'. Her 'body [is] shaped by *l'esprit* [the mind]'.[121]

La Parisienne, then, is quick witted and spirited. According to Adler in *Vogue*, she has an 'esprit frondeur' (a rebellious mind). Here the French author is mobilizing the myth of revolutionary Paris, for the adjective *frondeur* comes from the 1649 and 1652 Parisian uprisings known as the *Fronde*, after a Y-shaped catapult,[122] a myth the magazine often invokes, not least when celebrating *les Parisiennes*' rebellious spirit. Thus frequent use is made of various adjectives and nouns conjuring up the idea of revolution and the related notions of irreverence, freedom, and independence, as in this quote by Jean-Paul Guerlain, mentioned earlier, and according to which '*la Parisienne* is a strange mixture of mischievousness, assurance and elegance that is for me the height of femininity' (November 1996, p. 154). According to *Vogue* Guerlain's perfume 'Champs-Elysées' 'is the perfume of an independent, joyful and terribly Parisian woman who walks in triumph up the most famous of avenues' (November 1996, p. 159). Later in the article the magazine also mentions 'Rive Gauche', 'a joyous and feminist perfume dedicated to the unpredictable and liberated women: *les Parisiennes*'.

Such reference to the freedom of Parisian women is a common theme of discourses on *la Parisienne*. Rustenholz, for instance, talks about 'this emancipated *Parisienne*'.[123] The author cites the names of Réjane, Mistinguett, and Arletty as archetypes of this figure.[124] Indeed, these women are often associated with a well-rehearsed vision of the French capital: a romanticized traditional 'old' Paris as conveyed, for instance, in films such as Jeunet's *Amélie* starring Audrey Tautou. Like Edith Piaf, the subject of a 2007 French biopic, they stand for a nostalgic vision of the city frozen in time. However, famed for their *franc-parler*, their *gouaille* (a frank, cheeky verve), they also stand for visions of *la Parisienne* as outspoken and bold, thereby feeding into discourses on this figure as open minded, *un esprit libre* (a free spirit), in line with discourses on Paris as revolutionary. Thus in

Paris Chic and Trendy, Ribes-Tiphaine notes that *la Parisienne* is defined by a 'freedom of spirit'.[125] To quote Lélia Mordoch again, on the work of Miss. Tic: 'All dressed in black, their lips painted red, their eyes glowing, they [Parisian women] move onward, victors and seducers, in the grace of a freedom they wear every day like a shining armour to conquer the world'. 'On the wall', she also notes, 'Miss.Tic opens a window onto freedom. Here died for the liberation of Paris this citizen that will soon be forgotten [. . .] Paris starts singing the revolution, elegance and love at the crossroads of all possibilities.'[126]

References, in texts such as *Vogue*, to the revolutionary spirit, and to Parisian women's ability to stand out, serve representations of *les Parisiennes* as icons of fashionability. For what else is fashion than the permanent taking over of past ideals, their questioning and replacing with ever-new standards and rules? *Les Parisiennes'* revolutionary spirit is legitimated as the bedrock of fashion innovation and suggested as one of the reasons for Paris's status as *'capitale de la mode'*. As Gladys Perrint Palmer puts it in her fashion illustration for *L'Officiel*: 'this year, there is no French revolution, only fashion evolution' (February 1990, p. 150).

It is also because *la Parisienne* is free and independent, according to the discourse, that she, like Paris, has frequently been associated with the idea of sexuality. In visions of the capital and its female inhabitants an emancipated spirit also means an emancipated sexuality. As Irène Frain puts it in *L'Officiel*: '[Paris is] the international pole for intelligence and pleasure. In Paris, the libertine tradition allows all games of the mind ['jeux de l'esprit'], all games of the body' (May 1990, p. 111). Rustenholz also argues, once again using the metaphor of fashion that 'in Paris emancipated morals ['liberté des moeurs'] are a (couture) workshop practice in the vicinities of (artists') workshops, one that is not without elegance'.[127] Agnès de Courroye, the main protagonist in Martin-Chauffier's *Une Vraie Parisienne*, declares: 'I am a true *Parisienne* – in the odious sense of the term: cultivated, mocking, chatty, who likes a drink, and is, perhaps, a manhunter'. The man who falls in love with her sees in 'her very pale skin and dark eyes, her dark hair and her pure smile, her elegant outfit, her remarks rarely proper [. . .] a sample of the Parisian killer grace'.[128]

According to Wilson, one can find in the Parisian landscape material traces of the politically and sexually revolutionary spirit of the city. Paris, she notes, hosts an 'astonishing number' of statues of women, and in them 'sexual freedom and [. . .] political revolution' are joined.[129] This lends weight to the representation of *la Parisienne* as emancipated both spiritually

and bodily. Thus for Fargue famous Parisian women such as Lucie Mangin and Liane de Pougy 'were Parisian because they considered that life should be exclusively devoted to pleasure, frivolity, snobism, rapture and uproar'.[130] In *Vogue*'s fashion story 'Les Nouvelles Parisiennes', mentioned earlier, the 'neo-sophisticated' *Parisienne* is 'sexy, bold' (February 2002, p. 214), whilst on the August 2006 cover devoted to *la Parisienne* the model looks defiantly at the reader, her lips parted to reveal her pink tongue (see fig. 5.8). The color of her lipstick, the tongue is slightly stuck out in a sassy, sexy manner that conjures up the proverbial sauciness and free-minded spirit of the Parisian woman. Her jacket is unbuttoned, her hand holding it as if about to reveal her naked body underneath.

Consuming *la Parisienne*

Spirited, emancipated and fashionable, *la Parisienne*, according to discourse, is an ideal of femininity. But this ideal, according to *Vogue*, is not unattainable to the reader. It can be appropriated through the purchase of various commodities, allowing consumers to fashion themselves as *Parisiennes*. In *Vogue*, and to borrow Hughes' comment on Leduc's character Hermine in *La Batarde*, readers are 'seduced into embracing Parisian feminine selfhood – a selfhood that is very much for sale'.[131]

On the pages devoted to the 'Portraits of Left Bank Women' exhibition by *Vogue* and Le Bon Marché, mentioned above, a selection of clothes and accessories are laid out in a manner recalling cut-out paper dolls (see fig. 5.17). However, the doll is not shown, only referred to as a 'femme Rive Gauche'; a *Parisienne*. It no longer exists in the form of an actual doll as in the nineteenth century, but in the no less powerful form of a category of the mind whose simple evocation brings about the idea of ultimate fashionability. A background photograph shows Paris and its rooftops, another recurring image of the Paris myth that conjures up the idea of *'le charme de Paris'*[132] in French art from literature[133] to cinema. Prime examples are Clair's celebrated opening shot for *Les Toits de Paris* or that of Klapisch in his *Riens du Tout*, and in the field of fashion Yves Saint Laurent's 2006 advertising campaign. Projecting their own bodies onto the pages, readers can visualize themselves not only wearing the clothes but wearing them in the French capital, becoming *Parisiennes* by inhabiting a Parisian look. *La Parisienne Rive Gauche* is assimilated into a doll's outfit, the doll the reader herself.

Fig. 5.17 'Portraits de Femmes Rive Gauche vues par Vogue.' *Vogue Paris*. October 1995. © Vogue Paris.

Vogue draws on the analogy with dolls and costumes through the repeated use of the word *'panoplie'*, the French term for a doll's outfit or a child's costume, as in the section 'Une fille, un style', for instance (see April 2003; August 2003; September 2003; February 2004). Of Masako Kumakura, who lives in Paris and Tokyo, *Vogue* writes that she 'keeps a little girl's spirit, and functions through *panoplies*'. Kumakura is quoted as saying 'I compose my look as though with a Barbie doll' (March 2003, p. 195). A fashion story is entitled 'Paris, France: [. . .] jewelry, accessories, the *panoplie* of *la Parisienne*' (September 1995, p. 222) while a fashion spread entitled '*La Parisienne*' reads, also referring, as in an October 1998 fashion story, to illustrator Kiraz: 'frivolous and sublime, *les Parisiennes* sketched by Kiraz have become a legend. With a spontaneous elegance, they adopt the new everyday *panoplies*' (April 1995, p. 143). *Vogue*'s parallel between the world of fashion and that of childhood play; that is, between femininity and girlishness, is also epitomized in a September 1989 spread drawing on the pictorial conventions of cut out doll books (see fig. 5.18). Paper dolls replace real models. The reader is invited to project herself into these

Fig. 5.18 Vogue fashion dolls. *Vogue Paris*. September 1989. © Vogue Paris.

inanimate versions of an ideal self as if playing the game she will have encountered in her youth. In *Vogue*, 'the work of femininity' – the 'creative work' women execute on their appearance – is turned into the playful experience of the feminine 'masquerade',[134] which the appropriation of the *Parisienne*'s *panoplie* enables. The *Parisienne* identity is attainable through 'performative' enactments, in Butler's sense of the word, 'fabrications manufactured and sustained through corporeal signs and other discursive means',[135] here the signs conveyed through the goods promoted in *Vogue*. In the section 'Une fille, un style' such goods are also juxtaposed with pictures of the selected *Parisiennes*, again like paper clothes next to a paper doll. Laid out beside the woman, they become associated with the identity of their wearer, whilst at the same time the woman herself becomes reified into goods that objectify her.

This take on femininity is not particular to *Vogue* but characterizes fashion media discourse and consumer culture more generally. Central to it is the idea that consuming clothes is a serious matter because of its signifance as a tool for the fabrication of the self – consuming clothes means constructing oneself – and also that consumption, although crucial to self-construction and expression, should be playful. As Betterton notes, drawing on the work of Bowlby, in the late nineteenth century women began to be addressed as consumers.[136] They were offered 'sexually attractive images of themselves'.[137]

This suggested that one's identity could be altered whilst at the same time limiting the possibilities for change by 'substituting a series of products for a truly different self-image'.[138] Thus although a shift occurred in the 1970s, with fashion magazines veering away from perceiving readers as uncritical towards seeing them as actively engaged with fashion in a theatrical game of role-play,[139] in advertising and the fashion media, as Betterton observes, 'Women are sold their images in the form of commodities'.[140]

In the 1970s *Vogue Paris*, too, was embracing a vision of fashion as a theatrical, playful game. Indeed, with the rise of popular culture in 1960s and 1970s France, and the related increasing success of prêt-à-porter, a style of fashion more affordable than haute couture established itself, addressed to young consumers. *Vogue* regularly reported on the style, mobilizing a playful visual and written tone. Fashion was constructed as entertaining in line with the 'fun morality' – 'the imperative to enjoy oneself' – that, Baudrillard argued in 1970, characterize consumer culture.[141] Today the French fashion media still convey such a morality of fun-fashion whilst at the same time constructing dress as a serious matter because key to the fabrication and expression of the self. However, as in the texts examined by Betterton and Rabine, the feminine self that French fashion magazines promote is ultimately reduced to a series of fashionable goods, the identity of women that of the commodities on display, both objects of fashion.

Thus in *Vogue*, actress Lou Doillon is described as 'a prototype of the undergound *Parisienne*. Cigarettes, whisky and reggae: the *coup de coeur* [the selection] of the magazine' (November 1998, p. 141). Doillon's object-like quality – she is a prototype – is also established in the expression '*le coup de coeur*', usually applied only to objects and frequently used by French fashion magazines to draw consumers' attention to the products they favor. Doillon's identity is reduced to the one that journalists have selected – have had a *coup de coeur* on – as they would with any (other) fashionable object. In *L'Officiel* too a parallel is made between women and objects, whose kinship resides in their susceptibility to the vagaries of fashion. The May 2006 issue, for instance, features a section entitled 'the bag of the month'. A few pages further, another section reads: 'the girl of the month'. The 'girl' and the bag are the two elected objects of the magazine, their value lying in their aesthetic appeal and novelty. But as with most fashion goods their worth will fast expire, lasting, the magazine suggests, for the duration of a month only, until *L'Officiel* elects new fashionable objects, including 'girls'.

Alongside the *femme fatale*, the *garçonne* or the *femme active*, la *Parisienne* is one of the feminine identities on offer in the fashion press. Turned into a fashion category, *la Parisienne* is the outcome of a process: categorization. Such a process, Jenkins suggests, 'may be more significant for categoriser(s) than for categorised';[142] that is, for the fashion industry selling images of fashion and their related products. 'In our contemporary consumer society', Finkelstein notes, 'women's identities have been fractured, divided, redivided and newly created in order to multiply the opportunities and niche markets for fashion driven products'.[143] The commodification, in *Vogue*, of *la Parisienne* is only one instance of a 'fabricated femininity' that since the nineteenth century[144] has reached across various sectors from Yves Saint Laurent's '*Parisienne*' handbag to Vosges' chocolate drink 'Couture Cocoa *la Parisienne*'. 'Myth', Caillois writes, 'belongs by definition to that which is collective. It justifies, supports and inspires the existence and action of a community, of a people, of a profession ['corps de métier'] or a secrete society.'[145] The Paris myth, of which the myth of *la Parisienne* constitutes an element, has been appropriated by the fashion profession the better to promote its goods and commodities.

However, as Finkelstein also argues, drawing on the work of Rabine, 'to enjoy the moment when fashionable clothing and a well-groomed style give one a sense of being attractive is also to be aware of having failed to replicate the perfection displayed in the fashion photograph. The perfect image can never be achieved.'[146] This quest for perfection sustains the fashion industry. It ensures a future not only for its many commodities but also for the magazines that promote them by promoting the idea that amidst their pages are the recipes for the fashioning of a perfect visible self. The *Parisiennes* featured in the pages of *Vogue*, then, can only be unattainable models – 'inimitable to the point of irreality' as Rabine puts it.[147] The attainment of the *Parisienne* identity that the appropriation of goods is said to enable is ultimately denied by the very nature of the media that celebrate them. Paris, through *la Parisienne*, remains anchored to the sphere of all things superior. The aura of the city is further strengthened. Its dominance over the rest of France is further legitimated.

6

PASSANTE DE MODE

A une Passante
La rue assourdissante autour de moi hurlait.
Longue, mince, en grand deuil, douleur majestueuse
Une femme passa, d'une main fastueuse
Soulevant, balançant le feston et l'ourlet;

Agile et noble, avec sa jambe de statue.
Moi, je buvais, crispé comme un extravagant,
Dans son œil, ciel livide où germe l'ouragan,
La douceur qui fascine et le plaisir qui tue.

Un éclair . . . puis la nuit! – Fugitive beauté
Dont le regard m'a fait soudainement renaître,
Ne te verrai-je plus que dans l'éternité?

Ailleurs, bien loin d'ici! trop tard! jamais *peut-être!*
Car j'ignore où tu fuis, tu ne sais où je vais,
Ô toi que j'eusse aimée, ô toi qui le savais!

To a Woman passing by
The deafening street roared around me.
Tall, slender, in deep mourning, majestic grief,
A woman passed, and with a stately hand
Lifting, swinging the scallop and the hem;

Agile and noble, with her leg like a statue's.
As for me, I drank, tensed like a lunatic,
From her eyes, livid skies brooding hurricanes,
The tenderness that fascinates and the pleasure that kills.

Bolt of lightning . . . then night! – Fugitive beauty
Whose gaze suddenly brought me back to life,

Will I never see you again before eternity?

Elsewhere, far from here! Too late! *Never* perhaps!
For I do not know where you are fleeing, you do not know where
I am going,
Oh you whom I would have loved, Oh you who knew it!

(Baudelaire 1991 [1860])[1]

Fashion, we saw in Chapter 2, was born in Europe in the fourteenth century, with a key moment in its history taking place during the Industrial Revolution, which allowed, thanks to the emergence of new technologies, the acceleration of fashion's cycles and the democratization of its products.[2] Fashion became inextricably linked to that figure of modernity: the city. Indeed, 'modernity', the French poet Baudelaire famously said, 'is the transitory, the fugitive, the contingent'; a definition which, Evans observes, underpins numerous discourses on the 'city as a space of flux and unpredictability'.[3] But the modernity characteristic of the city – transitory and contingent – is characteristic of fashion too.[4] Thus in Baudelaire's work, as Berman notes, 'modern life appears as a great fashion show, a system of dazzling appearances, brilliant façades, glittering triumphs of decoration and design'.[5] Put into prose by the poet in the nineteenth century,[6] fashion is intrinsically linked to modern urban experiences. It is in the city that both – fashion and modernity – see their accomplished version making of all three – the city, fashion and modernity – the intertwined elements of a meeting of space, aesthetic practice and time. Indeed, 'by emphasising the seductiveness of the new and deriding the past', as Finkelstein notes, 'fashion becomes synonymous with the urban and the modern'.[7]

Vestimentary styles are also the means by which, in the chaos and anonymity characteristic of city life, strangers who pass each other by in the street create sense and meaning by seeing clothes as a legible surface that can reveal the other's personality. Thus in *The Fall of Public Man* Sennett analyses dress as a response to the urban scene and a tool for practicing the city.[8] In the eighteenth century, it became a means by which the new urban landscape and its growing concentration of individuals who are alien to each other was given a sense of coherence. It was perceived as bringing order to the modern urban chaos, materially marking recognizable social and professional positions. In the nineteenth century, however, Sennett argues, dress in public was no longer conceived as an 'arbitrary marking of where you stood in society'.[9] Rather, it was perceived as a sign

of personality, a material exteriorization of the inner self. An expressive symbol, dress became the way in which the many strangers that saw each other in city streets could define and comprehend each other by capturing the reified indices of their personal identity.

Thus, according to Sennett, the eighteenth and nineteenth centuries signal the appearance of an activity specific to the city, and more precisely metropolises such as Paris and London: the observation of the actors on the urban stage. In the modern city, exchanging words between strangers is perceived as improper. An 'invisible wall of silence' is created, which preserves 'a right to be left alone'.[10] The gaze imposes itself over speech as a tool for knowledge in public; observing becomes a dominant way of practicing the city, thus 'marked', as Simmel also notes, by a 'preponderance of the activity of the eye over the activity of the ear'.[11] For instance, Wilson notes that in Poe's short story 'The Man of the Crowd' 'it is the silent gaze that typifies city life'.[12] Dress and fashionable attire lend themselves to this 'new stress on display and the visual – on looking' characteristic of the modern metropolis.[13]

However, the various urban practices of fashion born of modernity, including the observation of strangers as spectacle, are differentiated practices. Indeed, the game of the gaze directed at others or received by them is a gendered game, for men and women do not inhabit the street in the

Fig. 6.1 *Passantes de mode.* Numéro. August 2006. Photograph Sofia Sanchez and Mauro Mongiello. © Numéro.

same way, as two central figures of the modern urban landscape make clear: the *flâneur* and the *passante* (the female passer-by), respectively subject and object of the gaze. But whilst many studies have been devoted to the former,[14] cultural analysts have tended to ignore the latter. In that respect Claude Leroy's 1999 study of *Le Mythe de la Passante* (The Myth of the Passante) stands out in the academic field, and I will be returning to it throughout the chapter.[15] Indeed, this chapter focuses on this figure, and more specifically *la passante parisienne*, as visualized in contemporary fashion images (see fig 6.1). I start with a discussion of the notions of the *flâneur* and the *passante* to then move on to the appearance, in fashion photography, of women in city streets. I then further investigate the idea of urban femininity by way of an interrogation of French fashion magazines' visions of *passantes* in Paris.

Walking the city: *Flâneurs* and *passantes*

'The street', according to Finkelstein, 'is where modern classifications and claims to identity are now staged'.[16] Amongst these is the *flâneur*, a wandering city-dweller and modern urban '*promeneur*', whose mind delights in the seductive objects the street offers his contemplative gaze.[17]

A recurring figure of nineteenth-century literature, the *flâneur* can be found, for instance, in the *Nouveaux Tableaux de Paris* of 1828, where a chapter devoted to 'La Journée d'un Flâneur' narrates his marveling at the 'living panorama' and 'distractions' on offer on the Paris boulevards.[18] In his 1833 *Ferragus*, Balzac, too, as we saw in Chapter 5, evokes the *flâneur*. The story opens with a comment on Paris's ability to trigger thoughts in the mind of those who wander through its streets; that is, in the mind, more precisely, of 'these men of study and thought, of poetry and pleasure who know how to harvest, during their flânerie in Paris, the mass of delights, floating, at all times, between its walls'.[19] The *flâneur* is also the subject of an 1841 physiology by Huart, in which the writer starts his humoristic account of *flânerie* as an 'agreeable art' by noting that 'Man rises above all the other animals solely because he knows how to *flâner*'.[20]

With the writing of Baudelaire, where he appears in his 1863 portrait of the 'Painter of Modern Life', followed by that of Benjamin in his reflections on Paris and on the French poet, the *flâneur* became consecrated as a key figure of modernity and its space of expression: the city, and most especially Paris.[21] For the *flâneur* has often been represented as a 'quintessentially

Parisian character'.[22] Indeed, living outdoors, enjoying the city streets and its spectacles in the course of one's *flânerie*, many nineteenth-century guidebooks claimed, was a Parisian characteristic contrasting with a more domestic English life and the hurried walk of busy Londoners in the city of work and business.[23] It has been argued that Haussmann's Paris, in particular, with its 'scenic boulevards',[24] represents the 'heyday' of the *flâneur*, the stage *par excellence* for the practice of the gaze, and which the spectacle of fashion nourished. The *flâneur* is the modern inhabitant of the capital of the nineteenth century, whose profusion of lively and colorful arteries, arcades and visual pleasures lend themselves to his love of the street and his inquisitive and meditating gaze. Thus Paris, Benjamin wrote, 'created the type of the flâneur'.[25]

With Benjamin, it has been argued, this type has come to be seen 'as a bygone figure'.[26] However, writings such as White's 2001 *The Flâneur*, and, more recently, Clerc's 2007 *Paris, Musée du XXI Siècle* – two literary excursions through the streets of Paris and the history and thoughts they bring out – suggest that *flânerie* has persisted across the twentieth and twenty-first centuries as a resonant and significant mode of engagement with urban space, and Paris in particular.[27]

With the *flâneur* the solitary practices of walking and looking support and stimulate each other to form a way of being in the modern city that turns it into a 'pure spectacle', an 'aesthetic object'[28] and rich resource for the imaginary and the mind. Urban space belongs to the *flâneur*, feeding his connoisseurship and mastery of the modern city but also supporting his creativity as a poet of modernity.[29] *His* creativity it is, for the *flâneur* is a man – as Tester also notes: 'much, if not indeed all, of Baudelaire's work presupposed a masculine narrator or observer'[30] – a bourgeois figure whose masculine gender allowed him to freely enjoy the city streets in a state of detached and distanced immersion in urban pleasures.[31] For although some cultural commentators have argued that in the nineteenth century women, too, indulged in *flânerie* within, for instance, the secure confines of 'public-private liminal spaces' such as department stores and galleries,[32] in Baudelaire's day – and even often today[33] – streets lent themselves more unequivocally and safely to men's *flânerie* than to women's. Wolff even contends that 'For women in the city negotiating the geography and architecture of public space in the early twentieth century, the role of flâneuse remained unavailable'.[34] Indeed, the public sphere was dominantly coded as a masculine realm.[35] Proper femininity and the idea of the street could only be seen as antithetical, as expressions such as, in

English, 'streetwalker', but also, in French, 'fille des rues' (woman/girl of the street) show. As Perrot also puts it, talking about the French language, it is 'telling that it opposes the *"femme publique"*, a horror, to *"l'homme publique"*, an honour'.[36]

When Madame Bovary, sitting in her provincial house, traces with her finger her journey through a Paris reduced to the flat surface of a map, it is not only her longing for the big city and its pleasures that is expressed but also, perhaps, the impossibility of her roaming freely through public space. Her *flânerie* can only take place in a mental realm; her body is firmly removed from public attention, confined to *la province* and the private sphere, both locations the spatial translation of a perceived exclusion.

Today, although *flânerie* has become an activity that women can indulge in, their presence in the street is still fraught with potential tensions and the menace of verbal or physical harassment, making of the female's *flânerie* an experience never totally akin to that of men. As Gleber notes:

> Women's specific use of space has historically been marked by anxieties and limitations that make them go about their daily matters in a more cautious fashion than men, assuming fewer, less expansive spaces to be open to their gaze and presence at any time. [...] This epistemological awareness is fundamentally inscribed as an anxiety into women's experience of public spaces and remains a scarcely changing constant, a continuing 'containment of women' that curtails their access to and movement in the street.[37]

Like the *flâneur*, in the literature of modernity *la passante* came into its own under Baudelaire's pen and his attention to the expressions and incarnations of modernity in urban space. Indeed, although *passantes* did 'not wait for Baudelaire to take a walk in the street, nor *flâneurs* to be moved by their sight or their gaze', as Leroy observes, in a statement also identifying the two poles of a gaze pertaining to the city, *le flâneur* and *la passante*, Baudelaire's 1860 sonnet 'A une Passante' is nevertheless the text through which the myth of the female passer-by established itself.[38] Leroy notes, in a comment that also draws attention to the interplay between representational and phenomenological practices of space, that 'since the sonnet was published'

> *Passantes* no longer pass by in the same way, and those who watch them no longer observe them with the same eye. The word *passante*, Baudelaire did better than invent it. By signing it with a sonnet, he appropriated it [...].

With Baudelaire, love encounters have been enriched, to quote Aragon, with a 'new vice': the overwhelming feeling the fugitive apparition of a forever-unknown woman triggers in the *extravagant* in a big city.[39]

A seductive apparition, and the object of the gaze of a poet-*flâneur* such as Baudelaire, *la passante* is a figure of the city. 'There is her territory':[40] 'the deafening street' that 'roared around' the poet.[41] Her fugitivity echoes that of modernity and its urban frame, whilst her characteristic as a 'forever-unknown woman' – 'Will I never see you again before eternity?' Baudelaire asks – makes her a quintessential creation of the city, the milieu, *par excellence*, of strangers.

Being a passer-by is not the exclusive preserve of women, and like *la passante*, *le passant* also features in the nineteenth-century literary discourse on the French capital. He appears, for instance, as Stierle observes,[42] in the work of Balzac, whose Lucien de Rubempré, in *Les Illusions Perdues*, reached literary fame through a physiology of *passants*. But as Stierle notes, it is with '*Les Passants à Paris*' (Passers-by in Paris), written by Hetzel in 1845 under the pseudonym J.-P. Stahl, that one can find the first theory of passers-by, also a 'theory of the city'.[43] A central element of the Paris myth, the *passant* contrasts with the *flâneur* in that the former 'has no gaze for the city'. The *passant* 'is no longer a type or a personality', Stierle adds, 'but only an abstract, fugitive element of the city itself', and more precisely of Paris.[44]

However, Bowlby draws attention to the importance of gender in visions of *passants*. Indeed, Baudelaire's sonnet signaled a consecration of female, as opposed to male, passers-by.[45] Thus the *passante*, Bowlby argues, has something the *passant* lacks: her status as a romantic and fugitive apparition, the object, as in the work of Baudelaire and Proust, of a desiring look. Similarly Wolff observes that *la passante* is one of the many female urban figures that appear in Baudelaire's writing, but who never, she writes, 'meet the poet as his equal. They are the subject of his gaze, objects of his "botanising"'.[46]

La passante is an urban apparition whose sighting triggers in her observer – the *flâneur* – desire and passion, an erotic impulse that will not, however, be satisfied. Indeed, unlike that other female city-dweller, the prostitute, *la passante*'s body is situated at the immaterial level of an apparition – 'Bolt of lightning ... then night!' Baudelaire writes – a visual pleasure and erotic promise never to be translated into sexual proximity. As Antoine Pol puts it in his poem 'Les Passantes', made famous, as a song, by Georges Brassens:

> One thinks, with a hint of desire
> About all those glimpses of happiness
> About the kisses one did not dare take.
>
> [...]
>
> One cries over the absent lips
> Of all those beautiful *passantes*
> One was unable to retain.[47]

Disappearance is always already part of *la passante*'s appearance. It is a corollary to the power of her evanescent beauty, the power her ephemerality grants her.[48] Its promise of 'unknown pleasure', as Proust writes of the *passantes* who have crossed his path, is forever imprinted in the observer's mind because never captured and realized.[49] Thus Benjamin insists on the importance of elusiveness in Baudelaire's writing on the encounter with *la passante*, and the fascination such elusiveness exercises on the poet.[50] 'The delight of the city-dweller', he notes, 'is not so much love at first sight as love at last sight'.[51] Some authors have written about the erotics of the city as a feature perceived as typical of nineteenth-century Paris and the *flâneur*'s engagement with the capital.[52] The prostitute clearly captures this idea of 'the sexualisation of flânerie',[53] and so does *la passante*.[54] But where the former can be approached and possessed, the latter is forever distant, lost almost as immediately as she is sighted, but also loved as immediately as she is lost, for the longing she triggers is 'a longing for the impossible'.[55]

Simmel has commented on the indifference that reigns in the city and that acts as 'a protective device without which one would be mentally ground down and destroyed in the metropolis'.[56] But in the sighting of *la passante* and the amorous feeling she triggers in her observer, indifference and modern anomy are superseded by the *flâneur*'s imaginary. The banal passing-by of a stranger typical of city life is turned into an extraordinary encounter. *La passante* represents a fantasy of proximity in a space that has created social distance. The city street of Baudelaire's *Tableaux Parisiens* (Parisian scenes) is hostile and aggressive, but its gift of *la passante* to the *flâneur* is a remedy to such hostility and the *flâneur* is born again following his sighting of *la passante*.[57] Thus *la passante* is not 'simply a woman who passes by'.[58] She is a beautiful apparition, at once marvelous, magical and miraculous, a muse who inspires in her observer creative thoughts and the delight of love at first – and last – sight.[59]

However, whilst the *flâneur* strolls in a leisurely manner through the city streets, absorbed as he is in his observation of the urban spectacle, *la*

passante hurries; she does not take the time to contemplate the pleasures the city offers the gaze. 'In 1839', Benjamin writes, 'it was considered elegant to take a tortoise out walking. This gives an idea of the tempo of flânerie in the arcades.' Higonnet also reminds us that the poet *flâneur* Gérard de Nerval 'strolled through [the arcades] with a lobster on a leash'. Baudelaire's *passante*, in contrast, is a 'Fugitive beauty'. She 'has no time to take on a name'. Sternberg in his short story 'Les Citadines' writes that *passantes* are 'always in a hurry'. Proust notes that 'the charms of *la passante* generally are directly related to the rapidity of their passing'. In an image reminiscent of Baudelaire's sonnet, he talks about 'a fragmentary and fugitive *passante*'. Pol's and Brassens's *passante* is 'nimble', and, with her 'shapely silhouette ... graceful and slender' 'vanishes' as soon as she is sighted. In Dominique Sylvain's 1998 thriller *Travestis*, the Parisian '*passante* of the docks', whom inspector Clémenti observes from a café, 'walked hastily'.[60]

Thus *la passante* hurries not least because the street, as mentioned earlier, is not equal for men and women. *La passante*'s fugitivity, a sort of feminine urban 'habitus'[61] made manifest through her hurried walk, is a fugitivity her feminine state imposes on bodily movement. In a hurry she is, in a hurry she has to be, so as not to be mistaken for that other feminine figure of the street, the prostitute.[62] 'Ambiguity is rarely absent. This woman offered by the street', Leroy asks, 'what if she was of the street?' 'This gaze from which comes lightning', he adds, 'what if it revealed the art of a woman who likes to set men on fire [an *allumeuse*]?'[63]

Thus, the ambiguity born of the idea of a feminine presence in the street is compounded by the evocation of her *regard* (gaze), a gaze, moreover, that might have met that of the poet. The notion that it brought him back to life suggests as much, as does, Wolff observes, the last line of the poem: 'Oh you whom I would have loved, Oh you who knew it!'[64] This raises the issue of the social origins of Baudelaire's *passante*, for it is questionable, as Wolff also notes, whether at the time a '"respectable" woman' would have returned the gaze of a stranger encountered in the street. However, it might well be that *la passante*'s gaze, which Baudelaire put into words, and which, he wrote, 'suddenly brought me back to life', was only a glance frozen in time by his poetry. Baudelaire's words can indeed be compared to a camera box. At a time when photography was emerging as a central way of capturing the modern city,[65] his writing can be read as replicating the freezing of time and urban evanescence characteristic of photography. Indeed, his poems were *Tableaux Parisiens*, snapshots of modernity in the making, fugitivity arrested in time. A transient moment is turned into

eternity; a furtive glance becomes a fixating glaze. The contemplative walk of women across a city's streets, gazing in a leisurely way at its spectacle and dwellers will really have to wait until the twentieth century to truly be accepted and acknowledged as a legitimate feminine practice of the city.

Different city figures, then, the *flâneur*, the *passante* and the prostitute, represent different ways of walking the city, different ways of being in it that draw attention to the gendering of urban space and the embodied experience of gender in space. Where the street allows the *flâneur* to stroll through the wonders of the city, desiring both its goods and its women, it forces *la passante* always to embrace a pace that will clearly differentiate her from that of the prostitute, inviting and slower, the proper tempo to meet the gaze of the *flâneur*.

However, in the city's gardens and parks, *la passante* can slow down her walk to adopt the leisurely movement of the *flâneur* during a *promenade*, her slow pace now legitimated by the status of such spaces as proper places for women to wander round. Where *flânerie* is mostly seen as the attribute of the male city-dweller and passing-by a translation into time and space of women's constrained movement in the public sphere, *la promenade* is where femininity, the city and the outdoors are reconciled in the urban realm. In such green urban oases, the city is kept at bay, nature moves to the foreground, the proper environment of a proper femininity, as in the parks painted by Renoir, and which, Prendergast notes, were akin to 'an Arcadia in which women and children are supposed to appear as the embodiment of prelapsarian innocence'.[66]

After Baudelaire, *la passante* became a recurring character of literary discourse,[67] not least that of French authors, for whom she resonates as a central figure of the city – Paris, in particular. Indeed, although *passantes* can be encountered in many cities across the world, in both reality and fiction, like the *flâneur*, she stands out as a Parisian type. As in Baudelaire's work, she is the character of '*Tableaux Parisiens*'. In René Fallet's *Paris au Mois d'Août*, for instance, *la passante* is the beautiful woman in a red dress – a 'mirage' – whose sight filled the main character, Plantin, with 'an unexpected softness', 'the Mallarmean softness of a Parisian summer'. 'She passed in front of him, a metre from him, so close', Fallet writes, 'that he could smell the sour fragrance of forbidden fruits': 'She was not for him. Too beautiful'.[68] *La passante* also features in the writing of the surrealist Soupault, for whom the enigma of the anonymous *passante* echoes that of *les mystères de Paris*. In his *Les Dernières Nuits de Paris*, *la passante* is Georgette, whom the narrator follows through Paris streets.

When she stands before the protagonists, 'Paris was before our eyes'.[69] 'Each passer-by', Stierle notes, 'is a trajectory across the city, whose line disappears into the unknowable',[70] and *la passante* in particular is the city made flesh; the living surface where the *flâneur*'s love of the city and of Woman is crystallized. As Leroy observes, also arguing that *la passante* is 'at the crossroads of the myth of love and of the Paris myth': 'the love for *la passante* and the love for the city function as mirrors of each other'.[71]

La passante also appears in cinema, in the films of Agnès Varda, Eric Rohmer and François Truffaut, among others. With Varda, *la passante* is Cléo from *Cléo de 5 à 7*, who walks through the streets of Paris followed by the eye of the camera.[72] With Rohmer, the *passantes* are those of *L'Amour l'Après-Midi*, whom the main male protagonist cherishes. 'What in my eyes gives so much value to the streets of Paris', he says, 'is the constant and fleeting presence of these women passed by every second, whom I am almost certain never to see again'. His active imagination projecting onto Paris streets 'those beauties who pass by', a magical pendant he daydreams about allows him to possess them, in a fantasy world, by breaking the rule of silence that underpins interaction between strangers in big cities.[73] In Truffaut's *L'Homme qui Aimait les Femmes*, the *passantes* are the many women the narrator sees on the street and cannot refrain from desiring and falling in love with. He asks: 'But what do they have those women, what more do they have than all the women I know? Well, precisely, what they have over other women is that I do not know them.'[74]

La passante in fashion

A recurring figure in literary and cinematographic discourses, *la passante* appears in fashion discourse in the twentieth century in the many fashion images addressed to the readers of the fashion and women's press. Object of the male gaze, source of desire whose appearance seduces he whom she passes, the figure of *la passante* has been appropriated by fashion discourse to attract another observer, the female reader of fashion magazines, offering to her gaze the newest creations, and an ideal and idealized image of women's presence in the city. By appropriating her, magazines have appropriated her central defining traits: appearance, movement, modernity and urbanity. Before I discuss this appropriation, however, I would first like to comment on the appearance of women on the streets of fashion imagery.

Images of women at the height of fashion have long adorned the pages of magazines and newspapers, with fashion photography one of its main modes of representation. Concerned primarily, according to Hall-Duncan, 'with the styles of dress rather than the sitter', fashion photography emerges around the 1850s and 1860s.[75] However, it was not until 30 years later, in the 1890s, that it was more widely appropriated by the written press as a way of promoting fashion goods, in titles such as, in France, *La Mode Pratique*.[76] Early fashion photographs closely followed the representational conventions of fashion plates and portraiture, with models often selected from the aristocracy, for an association was often made between professional models and prostitution.[77]

In the early twentieth century, with the first outdoor fashion photographs emerging from the studios of the firm Ed. Cordonnier, and, soon after, the Séeberger brothers, women began to be photographed at the seaside, in the parks, at the races and winter sports locations.[78] The valuing, at the beginning of the twentieth century, of a modern life of speed and freedom, and of a dynamic femininity, also represented an opportunity for photographers such as Martin Munkacsi in the early 1930s to show active women in sports clothing in an outdoor environment,[79] whilst a photograph Jean Moral took in 1932 of Lillian Farley walking near the Arc de Triomphe is an early example, Harrison argues, of a model shown 'on the move and on the street'.[80] In the early twentieth century Ed. Cordonnier, too, had produced fashion photographs of women in Paris's streets,[81] but one really has to wait until after the Second World War to see the generalization in the fashion press of images of women in movement in city streets.[82] With dynamic poses becoming more firmly established as a feature of fashion photography,[83] fashion photography comes to occupy urban space more systematically, freeing itself from the shackles of the studio[84] as well as of a culture that had tightly controlled women's access to the public stage. The way was thereby paved for a proliferation of *passantes* in contemporary fashion imagery (see fig. 6.2).

Both fashion and *la passante*, as discussed earlier, find their expression in the urban realm, with the former made manifest on the body of the latter. *La passante* is an 'apparition', a word whose close relative, 'appearing', also draws attention to one of her defining traits: her appearance. Not only is she an urban figure, she is also a figure of fashion, as expressed in the many writings and films where her silhouette and the allure of her outfit are brought to the attention of readers and viewers.

Fig. 6.2 *Passante Parisienne. L'Officiel.* September 1990. Photograph Peter Hönneman. © L'Officiel.

In his sonnet, Baudelaire notes 'the scallop and the hem' that *la passante*, 'tall, slender', lifts and swings 'with a stately hand'. Dominique Sylvain's *'passante* of the docks', mentioned earlier, has hair 'the colour of honey' that 'shone in the sun. She was wearing high heels' and 'a light suit'. *La passante*, according to Breton, is 'coquette'.[85] In *Cléo de 5 à 7*, she is beautiful and elegant, her striking polka dot dress marking her out from the urban crowd she moves through. Followed, at a distance, by a camera that has turned film viewers into observers tracking her steps in the city, as if they were spying on her, she is seen delighting in her own reflection in the mirror of a milliners shop she has stopped by. The sable coat of *La Passante du Sans-Souci* catches the eyes of Kessel's narrator,[86] and it is again appearance that stands out as the defining character of Truffaut's *passante* in his *L'Homme qui Aimait les Femmes*. The main protagonist categorizes them into types based on their silhouette: *'les petites pommes'* – the little apples – and *'les grandes tiges'* – the long stems. Images of beautiful *passantes* in Rohmer's *L'Amour L'Après Midi* are interspersed with an image of a model on the cover of a glossy magazine – *Votre Beauté* – seen on a street stall. The *passantes* shown are like fashionable models on a Paris asphalt turned fashion stage, with the cinematic sequence of 'those beauties who pass

Passante de Mode 139

Fig. 6.3 'Une Fille à Paris.' *L'Officiel.* August 2005. Photograph Élina Kéchicheva. © L'Officiel.

Fig. 6.4 'Filature.' *Stiletto*. Spring/Summer 2005. Photograph Benoit Peverelli. © Stiletto.

by' before the gaze of film viewers like the pages of a fashion magazine unfolding before the eyes of a reader.

A fashionable figure, *la passante*, like the beautiful women one encounters in fashion magazines, is a model to follow. Films and authors have consecrated this model position, but so have fashion magazines, through the many visuals that have featured woman walking briskly through a city street, the eye of the *flâneur* that of the camera that freezes her movement, as well as that of the reader who contemplates her stylish allure. French fashion magazines such as *L'Officiel* and *Stiletto*, for instance, have made of the figure of *la passante* a recurring feature of their fashion pages. *L'Officiel* features her in a section entitled 'Une Fille à Paris' – a Girl in Paris – and *Stiletto*, tellingly, in one called 'Filature'; that is 'shadowing/tailing' (see figs. 6.3 and 6.4). In August 2005, the 'girl in Paris' is Maria Jurado, 'whose silhouette strolls through the streets of Paris, where she's recently been residing'. 'For a whole day' *L'Officiel* adds, 'we followed this

(above) **Fig. 6.5** The street as catwalk. *Vogue Paris.* March 1991. Photograph Alistair Taylor-Young. © Vogue Paris.

(left) **Fig. 6.6** 'Toutes en scènes.' *Vogue Paris.* March 1991. Photographs Claus Ohm, Piero Biasion. © Vogue Paris.

Spanish woman whose allure is chic and rock'n'roll [. . .] trying to decipher a lifestyle'.

In pages where images from the collections are shown next to those of various actresses photographed simply walking down a street, the magazine *Elle* supports the construction, mentioned earlier in relation to *L'Amour l'Après-Midi*, of the street as fashion stage, of *passantes* as models, here incarnated in the figure of the famous women caught in the seemingly anonymous conduct of a mundane act (8 October 2007, p. 80). In such images, a staple of the fashion press, the street is to the *passantes* what the catwalk is to models: a space where their beauty and allure is offered to the scrutinizing gaze of others. It is a space, such shots suggest, for an encounter with the spectacular, that provided by the sight of fashionable women walking in the street, this arena, therefore, as rich a setting and legitimate a backdrop for fashionable display, according to the fashion press, as official catwalk presentations.

Similarly the succession in a March 1991 issue of *Vogue Paris*, first of two fashion stories, one showing a model walking in Paris streets during the day, the other representing two models walking in the street at night, and then of catwalk images, collapses by the flick of a page the street and the catwalk into one another. A close-up image of women's legs strutting down a pavement is echoed in the subsequent photographs of models' legs strutting down a catwalk stage (see fig. 6.5 and fig. 6.6). The mixture of full-length images of models and the focus on legs reinforces the continuity, the visuals segueing into each other.

In magazines such as *Vogue* and *Elle* space is compressed into an unending fashion stage that bridges the extraordinary realm of the catwalk and the everyday space of urban life; the performative and exuberant quality of staged fashion is extended to the public sphere, women's appearance on the street one more moment of a continual fashion show.

The playing of the soundtrack from *L'Homme qui Aimait les Femmes* during Sonia Rykiel's autumn-winter 2006–7 collection[87] equally brings to mind this parallel which fashion discourse often makes between *passantes* and models, the street and the catwalk. So does French company Comptoir des Cotonniers's Autumn–Winter 2006–7 fashion show.[88] At the beginning of the show the models walked on a catwalk styled as a zebra crossing that stretched across the arena of Paris's Cirque D'hiver.

In his 2006 article on the Parisian woman for French daily *Libération*, French author Philippe Lançon, mentioned in Chapter 5, discusses the *Parisiennes* one sees in the streets of Belleville: 'transfixed by desire', he

notes, 'men with convex gazes undergo the force of the défilé'.[89] In French 'défilé' means 'parade', but also 'fashion show'. The use of this word is telling, once again evoking the association between the realm of the street and its *passantes*, and that of the catwalk and its models, both perceived as geared towards the scrutinizing and desiring gaze of the onlooker.

Like the women Lançon discusses, *Stiletto*'s and *L'Officiel*'s *passantes* are Parisian *passantes*. Indeed, as mentioned earlier, this figure has been perceived as a Parisian figure. If *la passante* is the urban manifestation of the city she belongs to, and Paris, according to French fashion discourse, the ultimate French city and the capital of fashion, then the Parisian *passante* stands out as the ultimate incarnation of both *la passante* and Paris's fashionable icon, *la Parisienne*. Thus where *la Parisienne* is a recurring sign in discourses on fashion, so is her manifestation in the traits of a *passante*. Sheringham notes that in the work of Breton, for instance, as we saw in Chapter 5, women are 'incarnated by the generic "Parisian woman" constituted by women glimpsed in the streets'.[90] One of them is named Parisette.[91]

L'Officiel also mobilizes the theme of the Parisian *passante* when observing that *'la Parisienne* has chic [. . .] Heads turn when she passes by [. . .] she *is* fashion' (May 1990, p. 101). In *Vogue* Helmut Newton is quoted as saying: 'the beautiful girls one comes across on the pavements are always the best memories I bring back from Paris' (November 1996, p. 135). Similarly French actor Lambert Wilson celebrates the Parisian *passante* when in an interview with French fashion magazine *Elle* he evokes the *Parisiennes* he 'eyes up' while riding his scooter. He states:

> I look rather than being looked at. I live on my scooter, and from my scooter, protected by my helmet, I eye up. I actually want to defend the myth of *la Parisienne*. It is in Paris that one can still see charming women, dressed up for a beautiful rendezvous, simple and joyous. [. . .] Here, women are not as vulgar as in other countries. They don't all think that to be desirable they must be full of sexual signals. From my scooter, it seems I can see a certain sophistication. (26 September 2005, p. 98)

Rustenholz also evokes the *Parisienne* as *passante* when, in his *Parisienne(s)*, he singles out her way of walking the city. He writes: 'the *Parisienne* walks fast, taking big steps. She's alluring [. . .]. Attracted by her charm, one follows the Parisian woman; one follows her because one cannot catch up with her.'[92] Rustenholz's book draws attention to the relation between *la*

passante and *la Parisienne*, the street and the catwalk, but also Paris and fashion when, in the early pages, he refers to four particular types of *Parisiennes*: the nineteenth-century *grisette*, *trottin* and *midinette*, who could be seen walking between fashion houses, and also the contemporary fashion model as seen walking down the catwalk.[93] A parallel is made then between the world of fashion and that of urban life, models and *passantes*, all brought together through ways of walking the city, that of Parisian women.

Thus in his *Le Génie des Parisiennes* Banville notes that even in the rain 'the great *Parisienne* goes out on foot'. 'She goes out with an assured, rhythmical, glorious, adorable step', he writes, adding: 'Her irreproachable shoe ravishes our eyes and she shows, but not too much or without decency, enough to assert her divine race, a svelte, proud, superb leg imprisoned in tights pulled up with genius'. This is why, he argues, Paris in the rain 'is the triumph of woman [. . .] and for the same reason, it is the paradise of the dreamer who follows women'.[94] Laird Borrelli notes Kiraz's claim that he is 'inspired by women', 'particularly Parisian women', who, she quotes him saying, 'are always in a hurry, they take tiny steps', and 'he likes to pass time in cafés watching them go by'.[95] *L'Officiel* also mobilizes the theme of the swift Parisian *passante* when stating:

> vivacious allure, long silhouette, sparkling gaze, *la Parisienne* is chic and racy. Heads turn when she passes by. Whether blond or a brunette, she is unique and her elegance, her finesse make one dream. She moves across ages knowing instinctively what suits her. Pretty, inimitable, she has the sense and love for details. She is fashion. (May 1990, p. 101)

Thus '*la Parisienne* according to Nina Ricci', the magazine tells the reader, quoting the French company's art director, is 'a woman with a long, moving silhouette, sensual and romantic, urban and poetic, but determined, who walks fast and in high heels' (February 2001, p. 96). Similarly, shots such as *Vogue*'s, mentioned in Chapter 5 (see fig. 5.12), showing models taking long strides in the streets of Paris also conjure up the proverbial swiftness of Parisian women.

The Parisian *passante* walks fast because she might want to fend off obtrusive gazes, but she also walks fast because, and especially as women progressed further into the twentieth century, like her male counterparts she might be living a fast life, punctuated by swift movements between her home and her work. Her hurried walk, even if objectified by observers, city-dwellers and magazine makers as well as readers, can therefore stand as a sign of modernity, power and independence, qualities *la passante* in

her status as a *Parisienne* figure grants her. Her putative superiority to *la provinciale* is further built into celebratory discourses on the French capital, for as Vigarello notes, the fast *Parisienne* has implicitly been contrasted with the slow *provinciale*.[96] *La Parisienne* hurries, according to the discourse, because she can, because her long, lean, elegant body allows her a movement which a heavy, indolent, that is, provincial, body, precludes.[97] As Balzac notes: '*esprit* rusts as much as the body, if it is not renewed in the Parisian *milieu*; but what defines provincial life most is bodily gesture, gait, the movements that lose this agility Paris incessantly communicates'.[98] 'The genius of gait belongs to the woman of Paris', he also exclaimed in *Les Français Peints par Eux-Mêmes*.[99] Similarly, *la Parisienne* on a trip to the provinces, according to Delord, can always be distinguished from *la provinciale*: she 'passes by' he writes, and 'The first man who sees her, even if he has never left his *province*, even if he is the village's school teacher, or the prefect of the district, turns around and says: This is a *Parisienne*. The *Parisienne* does not walk, she undulates.'[100] The agile and rapid steps authors and fashion magazines say are a characteristic of Parisian women are invoked as bodily evidence of the Parisian distinction, Paris yet again legitimated as the sphere of all things superior.

But it is not simply because *la passante* distinguishes herself through her appearance that she is an appropriate figure of fashion discourse. Her status as the object of a fugitive encounter captures the ephemerality of both fashion and modernity, making her one of their ideal symbols. Like *la passante*, Leroy notes, citing Baudelaire, 'modernity is fugitive [. . .] and it is in the fantasies of female fashion that one must attempt to pierce the mysteries of "this fugitive, transitory element"'.[101] On the body of *la passante* and through her hurried walk fashion, modernity and urbanity intertwine to find their materiality and incarnation.

The very experience of the fashion magazine reproduces this evanescence particular to fashion and *la passante*. The reading of fashion magazine pages, rapidly flicked over, offering a procession and succession of images to the reader's gaze, captures, at the same time that it reproduces it, the furtive passing of fashion and *la passante*, whilst the periodicity of the magazine too echoes their transitory character.

La passante de mode and the gaze: Watching women in the city of fashion

A fashionable figure, then, *la passante* stands out through appearance. In that respect she also emerges as a figure for the female identity. Indeed, femininity has long been constructed as defined through appearance, as governed and legitimated by the eyes of men.[102] On it depends women's assurance of being cared for and loved, and of their life's being deemed successful. As Berger famously observed: 'how [woman] appears to others, and ultimately how she appears to men, is of crucial importance for what is normally thought of as the success of her life. [. . .] men act and women appear'.[103] Varda's *passante* Cléo says: 'Being ugly, that's what death is, as long as I am beautiful I am alive'.

The figure of the female passer-by captures particularly well the dependence of female identity on men, for *la passante* exists solely through their eyes. 'For a woman to become a *passante*', Leroy points out, 'there needs to be a promeneur, and just one gaze suffices to elect her amongst a crowd and appropriate her'.[104] *La passante*'s identity is the outcome of her appearance in the *flâneur*'s gaze, it can only exist as realized by his eyes. What defines her is not so much a way of being as a way of being seen – not a doing, but an appearing.

Aragon's words clearly translate the opposition object/subject; passive/active which structures the game of the gaze between *passante* and *flâneur*, and more generally, the construction of the relation between men and women. He notes: 'instead of concerning yourself with the conduct of men, you should rather look at women passing by'.[105] The association conduct/men, passing/women, captures, at the same time as it reproduces it, the social construction of gender.

Moreover, the female gaze, it has been argued, is nothing but a male gaze internalized, a way of seeing ruled by male references and values that women have made their own.[106] Thus in fashion images, according to Winship, 'it is "the man" who, in a manner of speaking, occupies the space between model image and woman reader'.[107] An ideal and idealized object of the male gaze, *la passante*, in her status as a femme 'fatale'[108] who attracts and seduces men, is also an ideal and idealized object of the female gaze. In the fashion press, she is a model to follow, precisely because followed by the male gaze, whether it be that of the men sometimes photographed near her (see fig. 6.7), their eyes lingering on her body, that of the man taking the picture and whose perspective the gaze of the readers will travel through,

Fig. 6.7 The male gaze. French *Glamour*. April 2006. Photograph Peter Stanglmayr. © Glamour.

or the gaze, invisible but nonetheless imposing, that female readers and photographers might have internalized.

Adopting the traits of a model in the glossy pages of fashion magazines, *la passante* is turned into a fashion intermediary, passing fashionable commodities across to the desiring gaze of the reader. A celluloid *marchande de mode*, she has entered the fashion system to promote its products. It is by copying her silhouette, and through the acquisition of the goods the model-*passante* carries elegantly on her body, that the female reader too will make heads turn, and will thus accomplish herself as a woman. Indeed, feminine identity has long been conceived as formed and expressed through the consumption and imitation of cultural icons such as models and celebrities.[109] *La passante* is one of those icons turned fashion sign, her anonymity[110] allowing readers easily to appropriate her traits. Like the fashion models Winship discusses,[111] she is a nameless face others can project themselves onto, a vacant body shaped by various commodities.

But the reader's desire to see herself in this attractive body is bound to remain unsatisfied. *La passante*, Leroy notes, is 'untouchable'.[112] Her glossy incarnation is an appropriate visual metaphor for this unreachability of the female passer-by. To quote Rabine again, fashion images are often 'inimitable to the point of irreality'.[113] The irreal nature of fashion images feeds into that of *la passante*, whose perfection, like that of fashion images,

will never be reproduced. She is the one who 'evades and excludes'[114] not only the *flâneur*, but the reader too.

However, a distinction should be made between photographs set in a studio and those taken in urban space. Fashion images are given a realist slant when staged in a city street; a truth and immediacy that the fictional props or colorful backdrops of studio sets deny to studio images. The very construction, in a studio, of an environment and place the reader will never occupy draws attention to the artificial and fictional character of the fashion photographic *mise en scène*, thereby allowing for a possible demystifying distance from the represented scenes. Transposed into urban space the model-*passante* becomes the point where the idealized and the lived meet to enjoin the readers to reproduce in their everyday life that, unreal and flawless, of models.

Thus the *passantes* of fashion pages invite the readers to conform at all times and in all places, the street included, to the rules of fashion and the gaze. Although they can provide a vision of women as active and independent in a public place, thereby legitimating their presence in a space they have long been excluded from, they also remind women that they 'are always on stage',[115] that their position is that of objects continuously being observed, and who, as a consequence, must always observe themselves. The street is not a simple passageway, a path from one place to the next, but an end in itself, a stage offered to fashion and the full accomplishment of a feminine identity reduced to its condition of an object defined through its sartorial envelope.

Images showing *passantes* photographed from behind, unaware of the gaze that follows and evaluates them, capture particularly well the panoptic strength of the gaze, whilst also reproducing it.[116] Evans and Thornton argue that the picture of a woman walking away from the camera – by virtue of showing her in action – 'walking' – shows an 'active subject'.[117] They call such a *passante* of fashion imagery, also invoking Baudelaire's sonnet, 'the disappearing woman'. 'Showing her walking away', they continue, 'underplays the objectification of the model, of women'.[118] Yet back shots of *passantes* also conjure up the invisible yet powerful presence of the gaze, thereby inviting women to continuously obey the conventions of appearance by reminding them of their status as 'object and prey', to cite Bartky.[119] When the female reader looks at a woman being looked at, it is also herself she's looking at and surveying, for as Berger notes 'the surveyor and the surveyed' are the two constituents of the feminine identity.[120] The reader 'can "become" this woman who walks away and attract oneself or

attract another's gaze', as Evans and Thornton argue,[121] but in so doing the female reader also becomes this woman whose identity constantly passes before the gaze, whether it be hers or that of an implied other.

Back shots of fashionable *passantes* are also a fitting visual metaphor for fashion itself, with the similarity between the two captured in the idea of following. One follows fashion, the expression goes, and one also follows *la passante*, either with the gaze, or by chasing her steps in the city. As Aragon writes, 'one follows in her the passing of seasons, of fashion'.[122] A September 1989 *Vogue* fashion story features a woman walking in the street. In the first image she is shown moving away from the viewer, whose eyes are thus invited to linger on the back of her silhouette (see fig. 6.8). The caption reads 'supple, airy, she follows the course of fashion, fur: a glamorous allure and extremely long legs, this is the great show of the cold'. The idea of following fashion is articulated in the representation of *la passante* – '*Elle*' (She). '*Elle*' is the stylish woman in the spread, who follows fashion, her fashionable attire and the caption suggest. But '*Elle*' is also the implied reader, who follows, not only fashion, by virtue of reading the magazine, but the model-*passante* too, through the visual angle and point of view the photograph provides her with. Similarly, an *Officiel* November 2007 spread shows a woman in various Parisian locations: stepping out

Fig. 6.8 'Fur Play.' *Vogue Paris*. September 1989. Photograph Wayne Maser. © Vogue Paris.

of Café Marly, in the Tuileries, at Louvre Rivoli, in the Opera area. The section is entitled 'Style à suivre...' (Style to follow). A picture of the model moving away from the camera lends visual weight to the section's title. Readers are invited to follow the woman's path – her style – through her Parisian journey, which they can track by flicking through *L'Officiel*'s pages, by strolling through the magazine, turning into *flâneurs* who can delight in the fashionable spectacle offered to their gaze.

If women are looked at, then, they are also those who look at – themselves, but also other women, the *passantes* of fashion pages, for instance, whom they can contemplate, taking up the position of the voyeur. The female reading experience can indeed be inscribed in a dialectic of the gaze characteristic of women's relation to images of femininity,[123] and positioning them at the same time as exploiting subject – the voyeur – and exploited object – the observed woman, passive *passante*, for instance – offered to the gaze of others.

This dialectic is also articulated in the space of images of *passantes* when their gaze is shown fixing that of the reader. Arrested in time by the immobilizing power of the photograph, what might have been a furtive glance is turned into a fixating and confident gaze. Caught in her own game, the female reader is thus offered an active vision of herself in the figure of a *passante* given the power to look and return the voyeur's inquisitive gaze in a game of looking now shared.

This power that fashion images give to *passantes* hints at the idea of women possibly taking up the pleasures of *flânerie*, including the confident observation of urban spectacles. For with women's presence in city streets having become an increasingly common feature of life in most capitals, *la passante* has been allowed to slow down her pace and embrace *flânerie*. A *passante* she might be, for always possibly the object of the desiring gaze of those she passes by, but a *flâneuse* too she can become, for she is now able to lose herself in urban crowds and actively enjoy the city streets. Contemplating the urban scenery, looking at others and returning gazes is now part of women's ways of practicing urban spaces, even if insistent looks might sometimes force them to revert to *la passante*'s non-staring gaze and hurried walk, for, as mentioned earlier, female and male *flânerie* are unlikely ever to become one.

French handbag company Lamarthe's short 2006–7 promotional Internet film[124] captures this tension that women walking in city streets might find themselves caught in between the positions of *flâneuse* and *passante*, a tension between their position as both subject and object of the gaze. Shot

in black and white and reminiscent of *Nouvelle Vague* cinema, 'Elettra dans la Ville' (Elettra in the City) tells the story of a beautiful young woman – 'rebellious [frondeuse] and light, devilishly *Rive gauche*, pretty to die for, with *esprit* to spare', the titles read – who finds herself the object of love of a mysterious man who follows her around the streets of Paris, the film also conjuring up the myth of Paris and *les Parisiennes* as a myth of love. His shadowy presence always looming over her steps, Elettra constantly feels observed even when she realizes that the man – never shown on screen – is not following her. Thus whilst she is able to *flâner* through the city and enjoy its pleasures, she also feels oppressed by this evasive yet intrusive male gaze, an adequate expression for the two positions which women today move through while moving through urban space: that associated with the *flâneur* – leisurely, detached and confident – but also that invoked by the figure of *la passante* as a woman observed and followed by the eyes of men, a position of acute self-awareness constrained by the gaze. The narrator tells the viewer: 'Even when one is not followed one feels followed', which conjures up Berger's comment that 'the surveyor and the surveyed' are the two components of the feminine identity.

One day the man stops following Elettra, but she begins to miss his panoptic presence, the film thereby intimating that being the object of the gaze is indeed central to the making of one's femininity. Being deprived of this experience, it suggests, deprives women of their plenitude. Thus longing to be looked at and loved – longing to assert herself as a woman – Elettra sets out to find the man who followed her. In doing so, however, she herself becomes the one who follows, following the men who might have been her admirer. She in turn is the subject of the gaze, once again having reverted to a position more akin to that of the *flâneur*, empowering, than to that of *la passante*, objectifying.

Throughout the short film female viewers might take up the position of the woman followed and relate to the oppressive feeling evoked, whether it be the one associated with the pervasive presence of an intrusive gaze or that triggered by its absence. But, as with the fashion photographs mentioned earlier, they can also take up the empowering position of the voyeur who observes a woman being observed: by a mysterious man as well as by a loving camera. As with one's reading of fashion magazines, they can thus indulge in the pleasures such a position triggers.

Not only do fashion images offer female readers the pleasures involved in embracing the voyeur's position, but they also offer, by virtue of projecting oneself onto the figure of *la passante*, the pleasures involved in

imagining oneself in the clothes she is wearing. Indeed, Bruzzi questions cultural analysts' reading of the female cinematic gaze as internalized male gaze by reminding us that 'the act of looking at a garment, whether in a magazine or on the screen, frequently has nothing to do with any sexual desire (for the wearer of the garment at least) and much more to do with an attraction to the clothes'.[125] Numerous, for instance, are the fashionable styles shown in magazines, and taken up by female consumers, that have parted with conventional visions of femininity – I am thinking about, for instance, the work of Rei Kawakubo for Comme des Garçons, a telling name (in English, literally, 'like boys') – and been valued and praised for their ability to give the course of fashion a new impetus. The enjoyment involved in engaging with such clothes surely partakes of the enjoyment that comes from knowing about fashion design, of one's love for, and familiarity with, creativity in fashion as well as the skills such creativity necessitates and demonstrates. In that respect enjoying the clothes might also mean showing and sharing knowledge, to and with other women for instance, who, also, might be able to appreciate the quality, visual and tactile, of the clothes involved. As Craik observes: 'despite the rhetoric that women dress to please men, other evidence suggests that women primarily dress to please other women. Further, there is no clear pattern as to whose "eyes" women view other women through.'[126]

However, Bruzzi's comment on one's attraction to clothes fails to acknowledge that this attraction might also reside in perceiving the clothes as able to allow for the construction of a certain version of femininity still dependent on the male gaze, because seen as attractive to men. Similarly Craik's idea that women dress to please other women does not preclude the fact that the female gaze they're addressing themselves to, and incorporating into their practice, might ultimately be structured by male ways of seeing and by male values.

Bruzzi's and Craik's statements on ways of looking at women's attire also draw attention to the emphasis that has been placed on fashion as belonging to the realm of appearance only – appearing to others – and the idea of clothes as symbolic and signifying tokens, at the expense of an understanding of their specificity as material objects interacting with real bodies as opposed simply to one's gaze. When looking at fashion images of a female passer-by, the female reader is looking at a woman she might see herself in, but she is also looking at the clothes *la passante* is wearing; fabrics, colors and shapes which, set in an urban environment, are given an empirical reality that might become hers, a sensual dynamism that the movement

of the bodies photographed gives to the clothes while bringing them alive. Thus brought out, the corporeality of the reader is reminded of the materiality of fashionable clothing in the promise of future tactile pleasures. As Rabine observes, 'the fantasies generated by fashion magazines (or videos) do not confine themselves to the page (or screen). They are actually acted out by readers on their own bodies.'[127] This reality of the body is part of the real world referred to by Kaplan when, drawing on the work of Eagleton, she advocates a return in academic engagement with images to the materiality of the world they refer to and influence.[128] This is the materiality readers experience through their engagement with fashion not simply as a system of signs[129] devoid of physical content and detached from all referents, but as a physical reality addressed to a tangible corporeality, and which fashion images bring before the tactile memory of consumers.

Fashion consumption is a 'continuum' of pleasures located at both the level of fantasy and that of lived everyday interaction, and which makes the opposition between the real and the unreal, the external and the internal redundant.[130] They are the pleasures derived from one's engagement with the fantasy world of images, but also the pleasures born of one's actual recreation and physical appropriation of the admired styles that form part of this fantasy world. Pleasure in looking at fashion images, then, cannot be separated from that experienced in one's actual engagement with the real objects – clothes in their materiality – that such images refer to.

Finally, the female reading experience as an experience of the tension I have discussed, between the positions of observing subjects and observed objects – for, however tactile it may be, it is at least potentially also that – also enables women to give way to the fantasies of submission and objectification which form part of the female imaginary, and are a source of pleasure.[131] As Grimshaw observes: 'it is perfectly possible to agree "in one's head" that certain images of women might be reactionary or damaging or oppressive, while remaining committed to them in emotion and desire'.[132] Images of *la passante* invite the reader to experience a fantasy safely – that of an objectified woman as evoked in the figure of the passive *passante* – by projecting herself into a cityscape protected from a real inquisitive gaze by the boundary of the fictional world of the fashion pages. Ballaster *et al.* talk about 'the pleasure in safety' that readers can experience when reading women's magazines, where the private sphere is safe and warm, unspoilt by the threats of the outside world.[133] In fashion magazines, the public sphere is also safe. In that respect such magazines also convey a utopian vision of the city. Its streets are no longer a place where women risk having

to confront the symbolic and physical violence announced in some gazes, but an imaginary space wholly devoted to fashion and its pleasures. Urban reality and presence in the street are thus reinvented, contributing to the definition of the city as 'a spectacle of commercial culture'.[134] Emptied of dissonances and asperities, the street becomes a smooth surface, a comfort zone the reader can occupy in the reassurance provided her by the idealizing order of fashion.

Barthes notes that the rhetoric of fashion rids 'human activity of its major scoria (alienation, boredom, uncertainty, or more fundamentally: impossibility)' to focus solely on pleasing and reassuring experiences.[135] Shopping, for instance, is never limited by constraints of time or money, possible tiredness or disappointment. Rather it is entirely directed towards 'the promise of beauty, the thrill of the city, and the delight of a perfectly idle super-activity'.[136] Fashion images are often a textual expression of this clearing of impossibility by fashion discourse. In visions of *passantes*, danger, tensions and anxieties are kept at bay by the aestheticizing veil of 'the euphoria of Fashion'.[137]

Fig. 6.9 'La Nouvelle Parisienne.' French *Elle*. January 2005. Photograph Alexia S. © Elle.

A fashion spread published in *Elle* in January 2005, for instance, shows different models incarnating 'La Nouvelle Parisienne' (see fig. 6.9). They are standing in the middle of the street in the midst of Parisian traffic, unfazed by the many cars that shoot past them, as if oblivious to the possible danger such cars might represent. The visuals seem to suggest that the beauty of the models is providing them with a protective aura, a magical power conveyed by the blurred images of the cars around them; images that contrast with the clarity of the *passantes Parisiennes*, lending them an air of controlled focus. Similarly, a *Vogue* August 1992 fashion spread shows a model moving confidently through a street, her movement impeded neither by crowds nor traffic, nor by the vertiginously high heels she is wearing (see fig. 6.10). As the subheading puts it: 'up and down the city with coats or jackets of a slightly savage vigor, to wear freely and in all casualness with platform shoes'. *La passante*'s visibility on the street of magazine city is spectacular and assured, endowed with a power and freedom real ordinary *passantes* might be devoid of. This illustrates the split between signifying systems which, Rabine argues, the feminine body is caught in: at once free, as staged in the pages of fashion magazines, and constrained and controlled outside those pages.[138]

Fig. 6.10 'Extérieur, jour.' *Vogue Paris*. August 1992. Photograph William Garrett. © Vogue Paris.

Moreover, in this invented urban fashion space human difference is reduced to sartorial distinction. The differentiated landscape characteristic of urban life is homogenized, normalized, with the norm that of fashion discourse: city streets are peopled by beautiful, young and, generally, white city-dwellers. They are turned into a homogeneous whole of unbridled normative beauty. The ordinary and the extraordinary collapse into one another to form a third space of extraordinary normality, a 'hyperreal'[139] world inhabited by glamorous confident women, and lending itself unproblematically to the spectacle of fashion.

Contradictions are the stuff of fashion magazines, where disempowering and objectifying visions of femininity are produced on the one hand along with empowering ones on the other.[140] Visions of Parisian *passantes* are caught in this web of contradictions. The French city is at the same time a space where women are always reminded of the importance of appearance in the making of their identity and a safe beautiful space open to the confident walk of Parisian women along its streets. On the one hand Parisian women are once again reduced to the realm of appearance, objectified into individuals whose identity resides in their sartorial envelope and the consumption of goods, as also discussed in Chapter 5. On the other hand, the *Parisienne*'s silhouette and body are not impeded by urban chaos and tensions; rather they are always lithe and agile, elegant and fashionable, lending further weight to visions of the city as a space of choice for the unbridled display of fashion.

Reading both written words and images is not a fixed process, nor is discourse something that imposes itself unequivocally onto individuals. Rather, many cultural analysts have shown that texts are open to appropriation and negotiation.[141] In the course of their engagement with a whole magazine or a single image, readers might occupy varied positions,[142] taking on different gazes, often contradictory and conflicting but nevertheless not exclusive of one another in their formation of the reading experience. As Radner notes of images of the *Single Girl* in the 1960s, fashion photography is contradictory, bringing together 'spectacle and activity'.[143] This is also the case with images of fashionable *passantes*, through which are articulated various ways of seeing women, various positions, in tension, on their presence in urban space. These are ways of seeing readers will shift through and urban presences they will see themselves in during their multi-layered engagement with the city and the woman of fashion magazines.

7
THE EIFFEL TOWER IN FASHION

'Paris' and *'la Parisienne'* are key signs of French fashion discourse, which contribute to the construction of Paris as fashion center and capital of fashion. So does the Eiffel Tower, for the monument has long been used as a symbol of Paris. This chapter investigates French fashion discourse's appropriation of the monument to unravel its relation with fashion. It looks at its presence in the work of French authors and artists, and the recurring metaphor of fashion used to depict it. It then interrogates the tower's relevance to fashion discourse in fashion images, and its role in the promotion of the French capital. A monument is always already a network of meanings, and to be appropriated successfully by fashion discourse it has to be amenable to a fashion statement, in this case one about the role and position of Paris as fashion capital. The Eiffel Tower is not simply an index of Paris; it is an index of a certain Paris and a certain discourse on Paris fashion. Bringing the monument into fashion visuals means bringing in its symbolic and material dimensions, and, consequently, lending the brands and products for which it is a backdrop the values that have been attached to it. But it also means bringing Paris into the picture, giving it certain meanings and attributes, and, in the process, contributing to visions of the city.

Iconic tower

In 1886, to celebrate the 100th anniversary of the 1789 French Revolution the French Ministry of Commerce and Industry initiated a competition for the construction of a 300-meter (1,000 foot) tower in iron. The tower would stand on a square base with each side 125 meters long, at the heart of the May 1889 *Exposition Universelle* in Paris's Champ-de-Mars,

and would constitute its main attraction.¹ The competition was won by Gustave Eiffel – who had been involved in the design of Le Bon Marché – and his associates, with their plan for an A-shaped tower. Its 18,000 parts and 2,500,000 rivets were assembled in just over two years – from January 1887 to March 1889 – in time for the exhibition.²

Iron had been used in architecture since the 1870s, following the generalization in France of the use of metal in various projects earlier in the nineteenth century, including, in Paris, the 1803 Pont des Arts, the 1853 Halles de Paris and the internal structure of the Opéra Garnier.³ However, Eiffel's tower stood out, literally and metaphorically, for its prowess of engineering design and as a visual feast of 7,300 tonnes of iron rising in a grid-like pattern on the Paris skyline. It quickly attracted many visitors: during the 173-day-long *Exposition Universelle* 1,953,122 tourists rose through its structure – on foot, for the most daring ones ready to brave the 740 steps leading to the second floor, or, for the less fit, with the help of a lift.⁴

This popularity of the tower stood in stark contrast to the virulence of the attacks it was at first the object of. A letter was famously published in *Le Temps* on 14 February 1887, and signed by the likes of Charles Garnier, Guy de Maupassant, Alexandre Dumas and Leconte de Lisle, who despised what they saw as a temple to 'modernizing technocracy' and called for the rejection of the plans.⁵ The letter condemned the 'wild [. . .] mercantile imaginations of a machine builder', who had produced a structure that was 'useless and monstrous', a threat to 'art and [. . .] French history'. It would profane Paris, a city, they described as 'without rival in the world', and the repository of 'the soul of France'. Even 'the commercial America would not want it'.⁶

For the poet François Coppée, who had also signed the letter protesting against Eiffel's project, the tower, under construction at the time of his writing, is 'hideous', a 'monster', 'A symbol of useless strength/And the triumph of brutal fact'.⁷ Once built, the tower found itself at the receiving end of yet more damning comments. In his 1889 'Le Fer' (Iron), J.-K. Huysmans, for instance, laments the use of iron in architecture, arguing that it is inferior to stone. He writes that the tower looks like 'the chimney of a factory under construction'. It reveals 'an absolute lack of sense in art'; it is 'of a disconcerting ugliness and [. . .] not even enormous'. The monument, he adds, is 'absurd'.⁸ Similarly, Guy de Maupassant, who in *La Vie Errante* writes that 'I left Paris and even France because in the end the Eiffel tower irritated me too much', calls it an 'inelegant skeleton'.⁹

Although in 1887 Eiffel had been promised the right to make use of the tower for two decades, granting it therefore at least that many years in the Parisian skyline, it was decided in 1894 that the architects of the 1900 *Exposition Universelle* would be able to modify or even destroy it.[10] The tower's place on Parisian soil was therefore fragile at first, and the many verbal offenses it had to endure did not help guarantee its permanency in the material make-up of the city. The tower's attackers were particularly critical of its apparent uselessness, with no function to redeem its perceived ugliness. It stood, as Higonnet notes, 'as a splendid rebuke to the utilitarian myths of its day'.[11] To counter this criticism, in a letter published, like the collective protest, in *Le Temps* on 14 February 1887, Eiffel promoted the tower as 'the glaring evidence, in this century, of the progress made by the engineers' art', and praised its potential value for astronomy, meteorology, and physics. 'During wartime', he also contended, 'it will allow Paris to be permanently connected to the rest of France'.[12] Various purposes were improvised – a meteorological station, a radio mast – which helped justify its continuing presence in the Parisian landscape.[13] In 1903 it was finally agreed that the tower would not be destroyed, and in 1964 it was 'registered in the Inventory of historical monuments' under the instigation of André Malraux.[14] It has since become one of the most appreciated Parisian monuments, with 6,400,000 people visiting it in 2005, and is also replicated, albeit in smaller sizes, in cities such as Liverpool, Las Vegas, Tokyo, and Shenzhen in China.[15]

The object of much condemnation, the tower did, however, also find itself an object of praise and celebration, with a key moment in its history taking place between the two world wars. During the First World War the tower had proved its usefulness as a radio mast, guiding planes defending Paris and intercepting enemy messages, lending it the attribute of Paris's 'female warder' and renewing confidence in its value and quality.[16] Contemporary discourses on the tower still invoke this protective role. In *Le livre de la Tour Eiffel*, a 1996 book aimed at introducing the tower to young French readers, the authors inform them that 'As soon as a violent storm descends on Paris, the tower attracts lightning'. 'In Paris', they write, 'it replaces the tower of the village church'.[17]

But this post-war seal of confidence in, and love of, the tower, which to this day has not waned, must also be seen in the light of the many literary and artistic works that have celebrated the monument, legitimating its presence in the French fields of art and literature, and ennobling it in the collective imaginary. Indeed, in the first decades of the twentieth century

Paris's claim to fame was supported by a strong contemporary art scene that embraced the tower's aesthetic, with painters and writers such as Chagall, Delaunay, Dufy, Vuillard, Apollinaire, Cocteau, Soupault and Fargue[18] all turning to Eiffel's monument for their visual and literary creations and consolidating 'the myth of the Tower'.[19]

For Apollinaire, for instance, the tower lends itself to his 'affirmation of solidarity with the brave new world of steel, electricity and rapid motion'.[20] His collection *Alcool* opens on a poem, 'Zone', whose first lines are devoted to the tower, a tower/bergère (shepherdess), Apollinaire writes, 'tired of this ancient world [...] You have had enough of living in Greek and Roman antiquity'.[21] But for Apollinaire the tower is also defiant, lending its shape to a *calligramme* celebrating the French victory over Germany. Words and letters laid out in the shape of the monument read: 'Hello world I am the eloquent tongue that your mouth oh Paris sticks out and will always stick out at the Germans'.[22] For Soupault on a stroll in the Trocadéro, 'the Eiffel Tower was taking on a passionate aspect and was becoming an act of bravery and pride'. Its 'character' and 'silhouette' could change depending on where it was admired from. Gracious, it is 'a vertical friend, alive and almost cheerful' who gives strength to the writer and becomes the object of his esteem, for 'only she could struggle with the night whom she could defeat in the end since she seemed higher, more majestic in the shade and the wind of the sky'.[23]

The tower features more recently in the work of French artist Sophie Calle. In her 2002 performance art 'A Room with a View' part of the tower's fourth floor is temporarily turned into a bedroom into which the artist invites visitors to tell her stories to keep her awake. The tower no longer simply enters the artwork, but the artist herself enters the tower turned, with Calle, into the very work of art. Of the installation, she says: 'I asked for the moon, I got it: I SLEPT AT THE TOP OF THE TOWER. I watch out for it, and if I pass by it at the bend of a street, I salute it, I tenderly look at it. High up there, at 309 meters, it's home in some way.'[24]

In cinema, too, the tower has made regular appearances. From René Clair's 'Paris qui Dort' to Eric Rochant's *Un Monde sans Pitié*, Eric Rohmer's *Les Rendez-Vous de Paris* or Christian Volckman's *Renaissance*, it has become a permanent fixture of the mediascape, also celebrated in the work of photographers such as André Kertész, Robert Doisneau, Winnie Denker, and Catherine Orsenne.[25]

The Eiffel Tower, then, overcame dissent and opposition to establish itself as an iconic building, celebrated and legitimated by many artists.

Its metallic structure is now firmly established in the Parisian landscape, its iron part of the permanent material make-up of the French city. In his *Arcades Project*, Benjamin stresses the shift of this metal away from transient to permanent uses. Iron, he notes, was first used for transitory constructions – in the building, for instance, of covered markets or exhibitions.[26] It was given a utilitarian function tied to economic life. However, at the time of his writing, in the first half of the twentieth century, it followed 'an altered tempo' to become 'formal and stable'.[27] So did the tower, its stability residing in the strength of its formal quality. Thus the tower, as Barthes writes in *La Tour Eiffel*, is 'determined simply to persist, like rock or a river, it/she is literal like a natural phenomenon'.[28]

Barthes' essay on the tower was first published in France in 1964 as a complement to André Martin's black and white photographs of the monument. In this book Barthes is both the semiotician who unravels the meaning of the tower, and the mythifier who participates in the building of its mythical status.[29] Indeed, as Loyrette argues, with this text the building was given 'the Barthian seal of approval', which, he continues, 'was more effective than all the long eulogies of engineers and architecture historians'.[30]

Barthes' essay is preceded with a quote from the letter of protest against the tower, its shaky beginnings on Parisian ground thereby invoked. However, the tower, Barthes writes 'is there', its existence cannot be denied.[31] This irrefutability of the tower in the French and Parisian landscapes is a manifestation of its appeal, which resides in its very lack of utilitarian and rational attributes. The tower, Barthes notes, has asserted itself against the 'rationality' and 'the empiricism of the great bourgeois undertakings' to emerge as a powerful receptacle and vehicle for what he says is 'the great imaginary function', without which human beings would not be 'properly human'.[32] What some have argued to be a useless metallic structure is the crystallization of 'a shift of the imaginary' away from the world of stone towards that of iron and the related mythology of fire and energy; that is, away from the realm of 'immutability', 'permanence' and eternity towards that of constructive strength and lightness but also human work and the mastery of nature and its forces by human beings.[33]

The tower allows one's imagination to naturalize Paris.[34] Through the panoramic vision it offers the visitors, the city is turned into a landscape of ant-like individuals, a human space lending itself to people's gaze in the same way as other natural spaces such as oceans, mountains or rivers.[35] This panoramic vision also enables the tower's visitors to imagine the

'*histoire*' of the city; its story and history embraced and pinned down, like its geography and social make-up, into 'a continuous image of Paris'.[36] For if the tower is the object of the gaze it is also that which looks at Paris when visited; it is both seen and seeing,[37] a seeing of Paris as panorama.

Indeed, the tower possesses one key function of which, to this day, its many visitors have not tired: the embrace of Paris by a sweep of the eyes. Following in the footsteps of eighteenth-century panoramic representations of space, the tower offered a vantage point from which to see the whole of Paris. However, unlike the panoramic representations of the time, the view provided was not mediated. For when on the tower, not only are the viewers the subjects of the contemplating gaze, but they are also immersed in the very space contemplated. As Prendergast notes: 'the city seen from the point of view of the panorama was the city evacuated of obstructive challenges to understanding, the city perceived from a position of mastery, confirming an "identity" at once of the viewing subject and the object viewed'.[38] As with the panoramas, viewers are in control of the city, but unlike with the panoramas, they are also part of it, tied to it in a symbiotic relation formative of identity.

This detached, controlling yet belonging presence was captured by director René Clair in his 'Paris qui Dort'.[39] In this short film, after a night spent sleeping in the tower the night guardian wakes up to find the city at a standstill. He has been unscathed by a mysterious ray that has put the city to sleep but has failed to reach the top of the tower. Whilst on a stroll in the dormant capital he meets a group of five people who were also spared the effects of the ray as they were far above ground in a plane. The protagonists observe a Paris without movement, and decide to enjoy its pleasures, offered to them free of constraint for no one can stop them in their journey through the city. 'All Paris belongs to them', the film tells the viewers. They help themselves to bottles of alcohol in a restaurant in which they spend time in the company of guests silenced and immobilized by the ray. They head for the shops of the French capital, and unscrupulously appropriate many goods before returning to the protective – shepherdess – tower and enjoying their mastery of a city they can gaze at at will. The Paris depicted is a Paris open to consumption, possessed by way of a possession of the goods found in its confines, a Paris of commodities and pleasures, as in many representations of the city. But it is also a Paris possessed by way of the panoramic controlling gaze that their position on top of the tower affords them. From the tower they dominate the capital as if it were an inanimate object, a whole reduced to an entity one can easily master, their

vantaged gaze akin to the ray that has tamed the city's disorder and taken over its rules and controlling forces.

Barthes discusses the panoramic quality of the gaze enacted from the tower.[40] Like the 'panoramic gaze' more generally, it is an 'intellectualist' gaze that manifests a new imagining of the city, a new mode of engagement with space: 'concrete abstraction'.[41] It already informed, he argues, albeit as a 'fantasy', Hugo's *Notre-Dame de Paris* and Michelet's *Tableau de la France*, where a panoramic view of, respectively, the French capital and France is put into words, and, in the process, the world organized and made readable at a distance.[42] But with the tower such a literary 'imagination' is materialized and Paris, deciphered by the gaze, is transformed into an abstract yet material whole graspable as a functional and intelligible structure.[43] The city is turned into an 'abstract map', truly heralding new ways of seeing urban space which will come to inform the vision of various artists.[44]

The tower enables one to make sense of Paris, it 'attracts meaning', Barthes writes, 'like a lightning conductor does lightning; [...] it plays a prodigious role, that of a pure signifier, that is to say, of a form men continuously put meaning into (which they supply at will from their knowledge, their dreams, their history) without this meaning ever being ended or fixed'.[45] Here the semiotician in Barthes is at work, seeing in the tower a sign, one that is never fixed and can always be appropriated; a receptacle for the *imaginaire* that Barthes says allows human beings fully to be humans. Thus the tower can be represented in metaphor as a plant, an animal, or a human.[46] Cendrars, for instance, called it a 'gracious palm tree', but also a 'Giraffe/Ostrich/Boa', and the Goncourt brothers talked about 'the spider web-like architecture of the Eiffel Tower'.[47] But the tower also stands first and foremost for Paris. It has asserted itself as a sign of the capital: 'Its very emptiness', Barthes writes, 'designated it to the symbolic, and the first symbol it was to create, through logical association, could only be that which was "visited" at the same time as the tower, that is, Paris: The tower became Paris by metonymy'.[48]

Paris as a tower

The tower means Paris, and the Paris it means is that encapsulated in the values the monument was constructed to convey and represent, such as modernity, both technological and political. For the tower is the outcome

of an engineering project and an aesthetic whose revolutionary character echoes that of the Revolution of which the tower is a celebration. This is also signified in its location, Paris's Champ-de-Mars, where revolutionary struggles and festivities took place. A tribute to the *République*, it is also a tribute to scientific progress and secular ideas,[49] in contrast with the clericalism materialized in Notre-Dame and other churches such as the Sacré-Coeur. As Zola writes about the Montmartre edifice, which, he argues, is a 'colossal mass' and 'monstrous flourishing' that mars the Paris skyline and stands against the revolutionary project and reason:

> France was stricken by the defeat because it deserved to be punished. It was guilty, today it must repent. What of? Of the Revolution, of a century of free thinking and science, of its emancipated reason, of its seminal and liberating activity, spread across the four corners of the world... This is the real mistake, and it is to make us expiate our great labour, all the conquered truths, the improved knowledge, the now approaching justice, that they built the gigantic block Paris will see from all its streets, and it will be unable to see without feeling unknown and insulted, in its effort and in its glory.[50]

Eiffel defended the modernity of the tower, insisting on its revolutionary inheritance and celebrating it as a manifestation of the industrial age. The tower, he argued, 'can seem worthy of personifying the art of the modern engineer but also the century of Industry and Science we live in, whose paths have been prepared by the great scientific advance of the end of the eighteenth century, and by the Revolution of 1789'.[51] The tower stood as a material manifestion of a modernity made visible in the physical make-up of the city. With it, Benjamin writes, the 'heroic age of technology found its monument'.[52]

It is precisely this modernity that artists appropriated and signified by bringing the tower into their work, also thereby clearly marking out their departure from established artistic conventions and practices. Celebrating the tower meant celebrating new visions of art, as in Clair's 'Paris qui Dort', a film that Conley describes as 'devoted to the modernity of the city', or Truffaut's 1959 *Les 400 Coups*, where the tower, featured at the beginning of the film, is a symbol for the director's split with cinema's *anciens*.[53] It will reappear some years later in his 1968 *Baisers Volés*, for instance, as well as on the poster for his 1988 *Vivement Dimanche*; a nod towards the director's love for the monument.[54]

The tower is also a recurring figure of modernity in the paintings of Robert Delaunay, acting as a 'trademark' for the artist's promotion of, and engagement with, simultaneity.[55] Its presence in his portraits of Madame Mandel and Sonia Delaunay, both fashionably attired, also supported the painter's depiction of the Parisian woman as a picture of modern femininity.[56] Similarly Barthes' deciphering of the tower is also a deciphering of the city and its modernity, a celebration of the capital by way of one of its monuments and the signifieds it conveys: 'functional beauty', 'technique', 'creative audacity', 'pure spectacle'.[57] Thus, 'opposed, uncertain', as Loyrette observes, the tower 'has managed to become the very image of modernity', one of 'the treasures of modernity' as French journalist Michel de Jaeghere also argued recently in his introduction to *Le Figaro*'s special issue on the tower.[58]

But the tower has also been seen as a visual metaphor for the enlightened universalism Paris has been associated with, the 'symbol of the City of light', 'the worthy heir of the enlightenment' as Lemoine puts it.[59] The magazine *Tour Eiffel 1889–1989*, published for the centenary of the tower, also invokes the tower as 'symbol of light' in the 'city of light'.[60] For the tower's characteristic as a monument to the Revolution and the Enlightenment thought it developed out of, and its association, like that of the city, with the idea of light, are inscribed in its very structural make-up.

In 1925, it was fitted with 200,000 lights and 90 kilometers of electric cables, allowing it to glow in the night.[61] The subsequent years have seen various new lighting installations, as in 1937 when the tower became visible from a distance of 250 km.[62] For the celebration of the new millennium, a system was installed allowing the lit-up tower to scintillate at night. Until 2013 it will do so for ten minutes on the hour until one in the morning in winter and two in summer.[63]

Thus not only can the tower be seen from many places in Paris – Maupassant famously enjoyed eating in its restaurant as it was 'the only place in Paris where I cannot see it'[64] – but, like a lighthouse, it can also be seen at any time. Indeed, the monument was also 'an answer', Loyrette observes, 'to a nineteenth century obsession' with the idea of 'the lighthouse that guides and spreads light',[65] whilst in that century images of Paris as 'lighthouse' and 'lodestar' to the world became a recurring feature of the literary discourse constitutive of the Paris myth.[66] The tower, therefore, stood as a material metaphor for Paris as a guiding light. At the beginning of the twenty-first century two rotating light beams of 80 kilometers were added to the top of the monument.[67] This visual innovation has

compounded its association with a lighthouse, with the term appropriated on the tower's website to celebrate the monument's role as a 'symbolic and universal landmark'.[68]

The tower, then, guides Paris, as it does – and as, through it, does the capital – the French nation as well as the rest of the world. A 'worthy heir of the enlightenment', it is also heir to the universalism that underpinned it, and which the *Expositions Universelles* celebrated. Thus in 1889 French politician and philosopher Jules Simon declared: 'Here, there are no more differences of opinion and nationality. We are all citizens of the Eiffel Tower.' In the same year French diplomat and author Eugène-Melchior De Vogüé has the tower tell Notre-Dame: 'I represent universal strength, disciplined by arithmetic. Human thought runs through my limbs. My forehead is covered with lightning stolen from the sources of light. You are ignorance, I am Science. You made man a slave, I make him free. [. . .] My unlimited power will recreate the universe.'[69]

Barthes, too, celebrated the tower's universalism. Not only is it 'present to the whole world as a universal symbol of Paris' and as such part of 'the universal language of travel', but it transcends its association with Paris alone to reach 'the most general human imaginary'.[70] This ability to elevate itself above particulars of place, Barthes argues, arises from 'its simple matrix-like shape' which 'gives it the vocation of an infinite number: in turn, and depending on one's imagination, a symbol of Paris, of modernity, of communication, of science or of the XIX century, rocket, stem, derrick, phallus, lightning conductor or insect, in front of dream's great itineraries, it is the unavoidable sign'.[71] In his 1989 tribute to the tower French author Paul-Loup Sulitzer also praises the tower's universalism, observing that 'Eiffel intended to construct a temporary edifice which wouldn't survive the Universal Exhibition of 1889; but it is the exhibition that will turn out to be temporary and the tower which became universal'.[72] Similarly, in her 2005 book on the tower photographer Catherine Orsenne celebrates its universalism calling it 'a universal lighthouse'.[73]

This grand ambition attributed to the tower is echoed in its ambitious size, its 'arrogant verticality', to borrow an expression from Henri Lefebvre on skyscrapers – he also talks about their 'phallic verticality'[74] – a telling visual and material rendering of France's universalistic and dominating project. Prudhomme, who had signed the 1887 letter against the tower, later changed his mind to celebrate its 'imperious size' as well as to praise the presence, at its top, of the French flag. Located there it acts as 'an emblem for the homeland's invincible aspirations'.[75] For writer Jean

Giraudoux, too, the tower is an emblem of the nation's *grandeur*. In 1923 he wrote:

> I thus have before my eyes five thousand hectares where, of all places in the world, there has been the most thought, the most discussion, the most writing. The planet's crossroads that has been the most free, the most elegant, the least hypocritical. This light breeze, this emptiness below me, are the stratifications, the accumulated scheme, of *l'esprit* [the mind], reasoning, taste.[76]

For both authors, as in much of the discourse on the tower more generally, the monument means not simply Paris but France. Indeed, on 31 March 1889 Eiffel and his collaborators erected a French flag on top of the tower to mark its completion, whilst the *Exposition Universelle*, of which the tower constituted the main attraction, was a tool, as with all such *Expositions*, not only for the promotion of industry and the arts but for that of the nation too.[77] Thus Léon-Paul Fargue, in his 1939 text on the tower, notes that it 'is the Parisian's panache', but also that 'there is something of national union about it', his writing taking the form of the tower and using the colors of the flag.[78] Similarly the magazine *Tour Eiffel 1889–1989*, created for the centenary of the tower, states:

> Paris is known across the world as the city of the Eiffel Tower. [...] and why not another architectural or historical site? Because France's warmth, magnificence, and creative tradition are incarnated in its prominent building: 'The Eiffel Tower'. Work of art, vision of the future, and absolute symbol: A century after its creation the Eiffel Tower remains a question mark in the sky of the city of light and independence. [...] The whole world is at its feet.[79]

Le Figaro praises the tower as one of 'the 7 wonders of French Genius', whilst Sulitzer notes that although one cannot dissociate the tower from its Paris location, it is also seen as 'the most universal symbol of France'.[80]

However, in spite of its frequent association with France as opposed simply to Paris, the tower nevertheless makes manifest the perceived superiority of the French capital over the nation it belongs to. Once again tension is expressed between the idea of Paris as part of France but also above and superior to it – in this case in the very materiality of the tower. Indeed, its height is a material feature that lends itself to the idea that Paris

is the high symbolic point of France, the place one aspires to. 'Going up the Tower to contemplate Paris', Barthes writes,

> is the equivalent of that first trip whereby *le provincial* 'was going up' to Paris to conquer it [. . .]. The city, a sort of superlative capital, calls for this ascending movement towards a superior order of pleasures, values, arts and riches; it is a sort of precious world whose knowledge makes one a man, marks the entry into true life of passions and responsibilities; it is this myth, probably very old, that the trip to the Tower still suggests.[81]

The ascension of the tower is an appropriate metaphor for the many stories of those who have moved to the city in the hope of ascending the social hierarchy. In that respect the tower also stands as a symbol of social ascent for those who have 'made it' to Paris.

Praised as a symbol of modernity, universalism, and enlightenment, the tower has also been celebrated as a woman, its metallic structure and appearance likened to a stylish dress in discourses that have drawn on the metaphor of fashion to celebrate it. In French, 'tower' – *la tour* – is a feminine noun. Discourses on Eiffel's monument, however, have compounded its feminine gender, also transcending its quality as an inanimate object by anthropomorphizing it, for it has been attributed values and adjectives with which only a real fleshly woman could be qualified literally. In French the tower is no longer an 'it', but a 'she'. Thus the monument has been described as 'la belle' and 'la grande dame', for instance.[82] For De Vogüé the tower has 'the charm of those women who are often looked at and deeply loved'. Fargue calls it 'the Venus of iron and azure', and Lemoine 'La Grande Demoiselle'.[83] In his 2001 *Spleen de Paris* Deguy mobilizes the theme of *la Parisienne* and Paris as courtesans. His Tower is a cocotte (a demi-mondaine): 'Even the tall cocotte, the Eiffel kid, cannot scintillate all the time', he writes, 'She is not employed by the Lido 24 hours out of 24. This week, low clouds envelop her; she wraps herself in fog. She is not entertaining, she is in her dressing gown.'[84] One of Delaunay's numerous portraits of the tower, *La Femme et la Tour* (see fig. 7.1), shows a naked woman standing next to it and, caught in the simultaneous brush of the artist, apparently merging with the monument; the tower and the naked female form, the drawing intimates, a single body. The Eiffel Tower, Cendrars wrote, 'played the coquette' with him and Delaunay,[85] as in another work by Delaunay, *La Ville de Paris* (see fig. 7.2), where three naked women are standing in the foreground. Holding one anothers' arms, they

(left) **Fig 7.1** Robert Delaunay. 'Femme et la Tour.' 1925. © L&M Service B.V. The Hague 20080309.

(below) **Fig 7.2** Robert Delaunay. 'La Ville de Paris.' 1910. © L&M Service B.V. The Hague 20080309.

are Three Graces fused with the Parisian landscape. Their voluptuous shape is made of facets and angles that echo those of the tower the women are juxtaposed with. Split into three parts that conjure up the three female bodies, the tower is in effect the fourth grace – or maybe three graces fused into one – in this vision of Paris where womanhood, tower and city meld.

As in discourses on femininity, the tower's appearance is a defining trait, with references to the monument in terms of fashion and dress mobilized regularly in discourses about it. In her 1980 collection of texts on the tower Hamy notes that: 'there is an Eiffel style like there is a Chanel style. An

outfit the dark colour of "ferrubrou", made from chrome yellow and iron oxide. Renewable every 5 or 6 years.'[86] For the celebration of the Chinese new year the tower's website ran a headline announcing that 'the Tower dresses in red', the text also drawing attention to 'this new outfit of light'. Similarly, Sulitzer notes: 'New lighting adorns it with a dress of luminous beauty worthy of haute couture'. 'Spotlights and multicolored fairy lights', Lemoine also writes in his book on the monument, 'strangely give the Tower, timeless during the day, a period style during the night. She only follows fashion in an evening gown.' For Louis Aragon, in his poem dedicated to Delaunay and his towers, the tower is 'the great blue female/ the dame with a jalousie bodice/she is tender she is new/her laughter is fires'.[87]

The tower's metallic structure is often likened to lace, with Lemoine, for instance, talking about 'iron lace'.[88] When lit it is frequently likened to sparkling jewelry, as, for example, on the monument's website, where its scintillating is compared to that of a diamond. The tower, according to Pierre Mac Orlan, is adorned with a 'set of diamonds, rubies and emeralds'. It 'is inseparably linked to Paris', because, Sulitzer notes, 'it is set in the capital like a rare and strange stone, with Paris serving as the jewelry case. Spurning the tower', he adds, 'means rejecting Paris'. The tower, all such quotes suggest, is as precious as the most precious jewelry.[89]

Robert Delaunay's association, in his *Portrait of Madame Mandel*, between the tower and a woman wearing simultaneous fashion[90] also conjures up the link that has been built, throughout the years, between the Paris monument, fashion and femininity. Similarly, Gronberg draws attention to an advertisement for Sonia Delaunay's fashion and textiles in 1925/26 showing the silhouette of a woman, a dress fanning out and the name 'Sonia Delaunay' all merging into the form of the tower, the woman and the monument a single entity.[91] A sign of Paris, a symbol of elegance and femininity, but also modernity, the tower might well be the ultimate *Parisienne*, one more monument to a feminine Paris, alongside the many Parisian statues of women referred to earlier, and which can be seen as expressive of the city as female.

Metaphors of fashion, then, have been mobilized in celebrations of the tower. Conversely, the tower has entered French fashion discourse in the form of an image in the many fashion spreads and advertisements that have used it as a backdrop for the promotion, in the fashion press, of various brands and products, not least those associated with Parisian makes. In the process, certain visions of Paris have been circulated that have contributed

to the promotion of the city not only on the French fashion map but also on the global one. Indeed, French magazines such as *Vogue Paris* in which visuals representing the tower can be found are distributed worldwide and therefore looked at by a readership extending beyond the confines of France and French readers. Moreover, many fashion advertising campaigns that have used the monument to anchor the French goods and brands advertised to Paris are international campaigns, with the visuals therefore appearing in a range of magazines in various nations and once again reaching an audience of both French and non French readers.

Thus in the remainder of the chapter I discuss various fashion images in which the tower has featured. I look at how its material and symbolic qualities can be seen as appropriate to the promotion of fashionable goods and comment on the 'Paris' that the tower's presence in fashion visuals has helped to convey and promote.

Fashion discourse and the tower

In 1989, for the centenary anniversary of the monument, a spectacular fashion show was organized on the terraces of the Palais de Chaillot, with many of the most famous fashion designers taking part.[92] Both the monument and fashion were celebrated during an event that further enhanced their role at the heart of visions of the capital and the nation it represents.

Fig 7.3 Lisa Fonssagrives on the Eiffel Tower wearing a Lucien Lelong dress. 1939. Photograph Erwin Blumenfeld. © ADAGP, Paris and DACS, London 2007.

The tower's most noticeable association with fashion and its discourse, however, lies in the media, with the monument a recurring feature of both fashion spreads and fashion advertisements. An early instance of the staging of a fashion shoot on the Eiffel Tower is Erwin Blumenfeld's famous 1939 picture for *Vogue* (see fig. 7.3). The photograph shows a woman wearing a Lucien Lelong dress, her left hand and foot keeping her precariously yet confidently anchored to the tower whilst her body hovers over Paris from the top of the tower. Her dress sweeps through the air, its pattern reminiscent of the tower's grid. The casual ease with which she leisurely stands at the edge of the tower, seemingly undaunted by its height, also recalls the playful presence of Clair's characters on the monument in 'Paris qui Dort'. In the film the actors can be seen at the top of the tower resting on its beams – playing cards, picnicking – as casually as if they were on the ground. None of them were doubled by stuntmen/women.

In fashion advertisements, too, the tower has been conspicuous (see figs. 7.4 and 7.5). From shoes to perfume and hair styling or jewelry, it has featured in visuals for Yves Saint Laurent, Jean-Paul Gaultier, Nina

Fig 7.4 2007 advertisement for Repetto. © Repetto.

Fig 7.5 1997 advertisement for 'Paris', by Yves Saint Laurent. © Yves Saint Laurent/Gucci Group.

Ricci, Christian Dior, Repetto, Morgan, Jean-Louis David, Charles Jourdan, Chloé, Et Vous, Givenchy and Fred Joaillier, to name but a few French brands, also lending non-French makes such as Laurèl and Kallisté that Parisian quality that has long been valued in all things pertaining to the field of fashion.

The city as a whole does not actually need to be represented, only its monumental symbol. For the tower, having been established across the world as the recognizable sign of Paris, acts as its 'geographical signature'.[93] At a time when fashion brands and companies belong to multinational groups and fashion products are designed and manufactured by multinational teams, attributing a clear geographical identity to goods is not always straightforward. However, in the global economy, place, as Scott observes, 'is still uncontestably a repository of distinctive cultural conventions and traditions'.[94] Rooting commodities in place at the level of their symbolic production – in advertisements, for instance – can help infuse objects with a range of values and meanings – the power the evocation of the French capital has to conjure up notions of fashionability, desire and romance, for instance – central to consumers' engagement with these commodities. The tower's presence in the global flow of fashion visuals allows the goods promoted to travel through space whilst at the same being anchored in place; a place – Paris – with a high currency in the economy of fashion and its signs.

However, appropriating the tower in fashion images means appropriating both its symbolic and its material identity. There is the grid pattern of the tower, reminiscent of checked fabric, as in the Blumenfeld picture, but also, for instance, as in a 1998 advertisement for fabric company Manuel Canovas. The image shows the tower wrapped in fabric, in the manner of Christo's wrapping of Paris's Pont Neuf in 1985 and the Reichstag in 1995. The monument is given a new set of girders and angles by way of the fabric's grid-like pattern.

Lace, we saw earlier, is often invoked when talking about the tower. Conversely the lace like quality of the tower is reinvested into fashion discourse to support the representation, and promotion, of lace. In a 2005 advertisement for Paris's 'Salon International de la Lingerie' (see fig. 7.6), for instance, the tower's silhouette, a feature frequently invoked in discourses on the monument, is turned into a corset of lace, the intricate network of iron grids – its 'guipures' as Cocteau calls them[95] – now the tightly woven threads of the female garment, the monument yet again associated with femininity.

The Eiffel Tower in Fashion

As a construction often praised for its ornamental quality, the tower lends itself to fashion discourse and that of consumption to promote visions of fashion and femininity as ornamental. Its gendering as a woman reinforces such visions, with the monument and fashionable women often echoing or melding into each other in fashion images in a manner reminiscent of Delaunay's *La Femme et la Tour*, mentioned earlier. A 1987 *Vogue Paris* fashion spread featuring Uma Thurman (see fig. 7.7), for instance, shows the then model wearing a Nina Ricci fur coat squatting facing the camera. Behind her is the Eiffel Tower, partly hidden by Thurman and as if rising out of her body, which, together with her coat spreading out in an A-line shape, is superimposed onto, as if to become part of it, the base of the tower. In such an image, as in many visions of the monument such as Delaunay's, tower and woman fuse.

Similarly a 1995 advertisement for Jean-Paul Gaultier (see fig. 7.8) conjures up the painter's *La Ville de Paris*. It shows three women standing

Fig 7.6 2005 advertisement for the Salon International de La Lingerie, Interfilière. © Salon International de La Lingerie.

Fig 7.7 The tower as a woman. *Vogue Paris*. September 1982. Photograph Arthur Elgort. © Vogue Paris.

Fig 7.8 1995 advertisement for Jean-Paul Gaultier.

next to each other, the shape of their dress similar to the shape of the tower they are juxtaposed with, the tower in effect the fourth woman in the picture. The link between the tower and the models is affirmed through the shimmer of the dresses, which recalls that of the tower's lights, and the sparks of fireworks at its summit reminiscent of the feathery hats the women are wearing. Like the tower, the women, the image suggests, shine and sparkle, the brand advertised allowing them to radiate an auratic glow of dazzling beauty, as dazzling as the city of light and its tower. Nina Ricci's 2004 advertisement for the perfume 'Love in Paris' (see fig. 7.9) similarly plays on this association of the tower and women by choosing to show the monument lit. Set at night, it shows a blonde woman holding in her arm a large bottle of the perfume. In the background stands a sparkling tower. The golden glow that emanates from it recalls both the golden hair of the model and the golden color of the scented liquid in the bottle. Both the tower and the woman, like the latter's dress of shimmering fabric, are radiant: *lumineuses*. The parallel between the monument and femininity is yet again asserted, as in a visual for Yves Saint Laurent's 2005 advertising campaign (see fig. 7.10). In a manner that brings to mind the merging of a woman with the monument in Delaunay's *La Femme et la Tour*, the model is juxtaposed with the illuminated monument, the blurred outline of her silhouette suggesting she is emanating from the tower, as if model and monument formed a single entity: a fashionable woman.

But it is also in its being an instance of architectural design that the tower's value as a sign for fashion media discourse resides. A parallel is

The Eiffel Tower in Fashion 175

Fig 7.9 2004 advertisement for 'Love in Paris', Nina Ricci. © Parfums Nina Ricci. All rights reserved. © Tour Eiffel – Illuminations Pierre Bideau.

Fig 7.10 2005 advertisement for Yves Saint Laurent. © Yves Saint Laurent/Gucci Group.

made between fashion and architecture that places the two on the same plane: the studied construction of matter and its display for practices of everyday life and the interaction between bodies in space. Quinn has drawn attention to the link that exists between 'the shapes of fashion' and architecture, as has Breward, who sees 'fashion joining architecture and other material artefacts as a form of urban biography'.[96] In the nineteenth century Balzac argued in preparatory notes to the *Traité de la Vie Elégante* that 'Almost all the rules of architecture apply to dress. Indeed, dress, in a way, is the architecture of the individual.'[97]

Not only cultural commentators have made a parallel between fashion and architecture, but so have fashion images, appropriating the tower to support the architectural quality of fashion. A *Vogue* August 1995 fashion story entitled 'Paris desert' is subheaded: 'Princess-like white and queenly

176 Fashioning the City

simplicity for outfits with a modern architecture thanks to their perfect proportions'. The second page of the spread shows a woman stepping over a small hedge. In the background is the tower. The caption reads: 'the body in a straight line'. The model is wearing a white suit that emphasizes her lean figure turning her into a long smooth line, a phallic body the fleshly echo of the tower's phallic shape and its 'perfect proportions'. Her legs form an A-shape reminiscent of the tower that stands behind her, only slightly shorter than the model, thanks to the photographic perspective. The modern architecture of fashion is affirmed by that of the tower, the feminine silhouette of the model echoes the shape of the monument, its female gendering is further consecrated.

The monument's value as a sign of architecture can also be seen as an ennobling presence. Still situated higher than fashion in the hierarchy of culture, architecture, when referred to, infuses the fashion it is related to with a legitimacy pertaining to its status as an art, which many cultural commentators[98] and observers are reluctant to attribute to fashion.

Fig 7.11 1992 advertisement for Dentelle de Calais. Reproduced with the kind permission of Fédération Française des Dentelles et Broderies.

This legitimating presence of the tower informs a 1992 promotion for Dentelle de Calais (see fig. 7.11). It reads:

> Woven with the Leavers loom, unique in the world, the Calais Lace is an inimitable woven art which only masters in lace still know how to create. The inheritors of an ancient art and of a technique transmitted as a secret through generations, they have forever renewed the creations of great French lace making. Counterpoints made of threads and nets, rosettes and volutes inspire haute couture and the spirit of lingerie. Subtle touches of shade and light reveal an eternal femininity.

The text is drawing attention to lace's being the product of a longstanding artistic and craft tradition in France. But it is also a subtext on the tower, firstly because the representation of the lace-like monument in the image means the text can be read as comment on it, and secondly because the registers of art and technology that are drawn on to talk about lace in the text have often been mobilized in discourses on the tower. Eiffel, for instance, as cited earlier, saw the tower as 'worthy of personifying the art of the modern engineer but also the century of Industry and Science we live in'. In his letter of February 1887 he also claimed beauty, elegance, utility and science as attributes of the monument.[99]

The text imposes itself as a subtext on the tower whilst actually referring to lace. The fabric further takes on the values traditionally associated with the tower, through a process that sees a conflation of signifiers, iconic (the visible shape of the monument), and linguistic (the words lace, nets, rosettes and volutes), which their visual merging also suggests. Moreover, the artistic value it has taken on because artists have celebrated the tower is here transferred to the lace, in line with French discourses on fashion as a high art, as discussed in Chapters 2 and 4, lending the fabric the aura and high value accorded to high cultural productions.

The text in the Calais advertisement also draws attention to another value of the tower as sign in fashion images: time. A symbol of modernity rooted in the history of Paris, the tower signifies the past whilst also being indissociable from the ideas of the avant-garde and innovation, the developments, political, technological and aesthetic, which the tower materialized and still carries with it as a 'lieu de mémoire'.[100] Past and future converge into the present of the monument, whose mobilizing in fashion images thereby allows for the articulation of the tension between the idea of Paris fashion as a fashion of tradition and history, and that of its

status as a leader and forerunner in the field and therefore turned towards the future.

Christian Volckman's 2006 animation movie *Renaissance* conjures up this ever-lasting modernity of the tower – what some might call, in the context of the film, its high modernity or post-modernity. The sharp metallic lines of the tower, contrasting with the transparency of the void they frame whilst also rendering it visible, form a graphic composition that supports, at the same as it is supported by, the striking black and white postmodern landscape the film depicts. Still dominating the capital's buildings in this Paris of 2054, the tower, the film suggests, is not out of place in urban architecture of the future. In an early scene, a digital billboard advertizes the merits of Avalon, a company selling 'health, beauty, longevity'.[101] The tower featured in the background lends weight to the eternal youth which the Avalon advertisement, not unlike the Calais lace advertisement, promotes.

Eiffel's monument is at the junction of the past and the future in a present permanently consisting of both, stretching between them never to settle into real time. As Barthes notes the tower is both 'very old' and 'very modern'. 'It has no age', he adds, 'it accomplishes the feat of being like a sign void of time'.[102] The monument's presence in fashion images endorses the representation of Paris fashion and the brands and goods it is conjoined to, as equally situated at this junction between times, timeless. When appropriated by fashion advertisements, the monument is used to say that such goods and brands are not 'now' but 'always', that these are not 'in' commodities that are bound to disappear as quickly as they have appeared, but 'forever' products that will be as eternal as the tower and the *Paris éternel* it signifies – what fashion discourse calls classics.

That the tower was erected at around the same time that Paris haute couture emerged also makes the monument significant in the construction of Paris fashion as part of the nation's heritage, an idea that French fashion discourse often invokes. The tower's iconic presence in fashion images suggests that Paris fashion – Yves Saint Laurent, Dior, Givenchy, for instance – is a seminal modern gesture, as central to the nation's *patrimoine* (heritage) as Eiffel's monument.

A December 1990 *Vogue* promotion for shoe company Charles Jourdan also trades on the tower's reference to past and future. The photograph, reproduced on the cover of this book, shows the legs of a woman running on the place du Trocadéro, the Eiffel Tower clearly visible in the background. The following captioned the visual:

Time does not alter that which is pure. The Charles Jourdan 1921 collection is eternal because it is simple and never outdated. A permanent collection that can be found in all Charles Jourdan boutiques, in never ending variations of materials, heel heights, and colors.

Such a statement could equally be seen as a statement on the tower, as its presence in the image intimates. Indeed, it is because the tower has survived time, its modernity still celebrated, that it represents a useful iconic metaphor for fashion: tradition, the past, the present and the future are all inscribed in it, part of its make-up, in the same way that they are part of the make-up of Charles Jourdan shoes, the promotion suggests.

The tower was erected during the century that won Paris the title of 'capital of the nineteenth century' and at the advent of a *Belle Époque* that was to last until the First World War. Its emergence and early consecration in the Parisian landscape took place during a high point of the city's history in the collective imaginary. The monument's vertiginous height claimed, asserted and celebrated this high position. It has since been relativized, we saw earlier in the book, not least by the rise and assertion of other cities in fields Paris used to dominate, such as the fields of arts and fashion, with, for instance, New York and London both host to strong fashion and art scenes, and both, like Paris, objects of fascination and attraction. Indeed, New York is often referred to as the 'capital of the twentieth century'.

However, monuments, Stierle notes, 'maintain the presence of the past, which, because of their material stability, they are intended to transmit to the ever new present of the city'.[103] The past becomes a permanent, ever-present fixture of the city, the city always new, yet, at the same time, forever anchored in the past, its present somehow timeless. By frequently mobilizing the tower as a sign of Paris in fashion images, the fashion industry conjures up the city's history, the time when the tower emerged and asserted itself, carried into the present by the monument's repeated presence in the French and international 'mediascapes'. A glowing picture of the city is presented, underlined by the fact that the images used of the tower frequently show it sparkling. Paris as *ville lumière* is put at the forefront of visions of the city, covering up its more nuanced and contrasted reality. Fashion magazines, as discussed in Chapters 2 and 4, bring to the fore, and, in the process, further anchor in visions of the city, the 'front region' of Paris fashion, its ideal and idealized space. The tower is one such space, a favorite site of fashion discourse because a favorite image of Paris.

The Paris thereby foregrounded is the spectacular Paris of the Eiffel Tower, admired, dominant, a flamboyant Paris, as radiant as the lights that glow on the tower, a *Paris éternel* unscathed by history, outside time. Quinn notes that 'as a system of symbols, the architecture represented in fashion photography continues to be infused with symbolic and allusive values that construct place as abstracted, distant and romanticized'.[104] This is particularly true of the tower's sign value in fashion discourse's vision of Paris. For the tower is an aesthetic abstraction, and this abstract quality fittingly captures the tower's ability to abstract itself from the now. Its present is split between past and future, as mentioned earlier. Impervious to time, timeless, the tower encapsulates a Paris equally detached from the historical present of the city, abstracted from it. The French city as encapsulated in the tower is reduced to an immutable object of envy, a Paris longed for rather than a lived, everyday Paris.

Thus, Michel de Jaeghere invokes the Paris of 1900, a time, he notes, which represents 'a high point' for both the city and France. 'It is not without melancholy', he adds 'that we have dedicated to them this seventh issue [of *Le Figaro Collection*] on the treasures of the French heritage'.[105] When the tower is mobilized in fashion images, so are Paris's golden days. This is a desirable Paris, one of memory and souvenirs, indeed itself a souvenir, like the miniature towers tourists bring back from the capital as a way of taking with them a small piece of Paris.

The Paris featured in fashion images by way of the tower, then, is an object of desire, like the commodities it is juxtaposed with, a city entirely geared towards consumption – indeed a city to be consumed. Appropriating the goods advertised, the visuals suggest, is appropriating the French capital. But whilst the Paris of the tower injects the commodities and brands promoted with the city's mythical qualities, conversely, fashionable goods and desirable brands feed into the city's stock of desirable features.

The conspicuous presence of fashion advertisements featuring the tower in magazines across the world supports the construction of the French capital as the capital of fashion, a feminine capital, as glamorous as the many female models who have been photographed near the tower. Yves Saint Laurent's 'Paris je t'aime' advertisement for the fragrance 'Paris', for instance, – a declaration of love that has long informed the Paris myth, as mentioned in Chapter 1 – trades on the capital's association with love to build desire for the product as a scent signifying, emanating love. At the same time, the capital's status as the city of love is reasserted, its depiction as an attractive woman – the beautiful model standing in the foreground

The Eiffel Tower in Fashion 181

Fig 7.12 1990 advertisement for 'Paris', Yves Saint Laurent. © Yves Saint Laurent/Gucci Group.

(see fig. 7.12) – endorsed. In this 'economy of desire',[106] tower, city, model – and by implication the consumer who will be wearing the fragrance – and commodity all become desirable. Le Corbusier once declared that 'the Tower is in everybody's heart, a sign of Paris loved, a loved sign of Paris'.[107] Fashion companies such as Yves Saint Laurent have certainly appropriated, and reproduced to effect, such a vision of the tower – a vision of the French capital.

In a series of 2006 advertisements for French shoe company Charles Jourdan too, the city and its tower emerge as object of desire (see fig. 7.13). The tone is lighthearted and humorous, allowing the company to show a knowing distance from mythical representations of Paris by way of the tower, the city's status as an image, an object of longing and fantasizing. Yet rather than breaking away from the myth and glamorous visions of Paris, the visuals further reinforce Paris's status as a desirable place by way of an ironic tone that lends the tower and the city it represents a cool edge appropriate to the selling of fashionable goods. The symbolic capital

Fig 7.13 2006 advertisements for Charles Jourdan. Photograph Bettina Rheims. Agency: Wolkoff et Arnodin. Courtesy Wolkoff et Arnodin.

attributed to Paris is strengthened, supporting its position as a fashionable place.

Other iconic buildings have entered the visual discourse of fashion. Bringing monuments from other nations into fashion imagery means bringing alternative cities into the competition for the status of fashion capital; asserting their position in the global field of fashion. DKNY, Carolina Herrera and Burberry have all made use, in their advertisements, of this strategic appropriation of monuments; New York's Empire State Building for the first two and London's Big Ben for the third. The importance of such buildings in fashion advertisements also testifies to the importance of the idea of urbanity and urban spaces in the promotion of goods. The edge attributed to city life is grafted onto the products and brands advertised, giving them an edge central to the logic of fashion and its appeal to consumers.

Impressive buildings have long been used as a way of promoting cities on the global map, and to enhance their visibility and status in the mediascape.[108] The construction of the Eiffel Tower was itself the outcome of a predating interest in tall, grand monuments as an expression of grand

cities and nations. It was superseded by Van Alen's 319 meter Chrysler Building in 1930, itself beaten shortly after in the race for the tallest construction, by Johnson's 449 meter Empire State building (antenna included) in late 1930. High-rise towers and spectacular buildings are still at the heart of the power struggles between large cities, all eager to benefit from what has been dubbed, in relation to Bilbao's success in attracting visitors following the opening in 1997 of its new museum of art: the 'Guggenheim effect'. In 2009 it will be Dubai's turn to qualify for the title of city hosting the world's tallest building with its Burj Dubai edifice. Having already reached 688 meters whilst under construction in September 2008, once completed it will officially assume the laurel, beating Taipei's 508 meter tall 101 building.[109]

In this struggle, the Eiffel Tower is the one Paris building that French fashion brands have most persistently returned to for their advertisements – returning, in the process, to a favored vision of the French capital. They are presenting to the world of media readers the city's beautiful and desirable face by way of its iconic monument, the original tall building, which higher Parisian constructions such as the Montparnasse tower have not supplanted in the production, and reproduction, of the Parisian myth. Mobilizing the tower in fashion advertisements means reasserting the city's position as a key contender in the geography of fashion, a long established one, as established as its iconic monument. With the tower, such visuals suggest, Paris is visibly on the fashion map, spectacularly so, regardless of any possible crisis in Paris haute couture or the rise of other fashion cities.

A recurring figure of literature, the arts, cinema and fashion imageries, the tower has also been established on the global scene of iconic monuments by way of the many objects of commerce it has appeared as, and been proliferated through. 'Yesterday's emblems', Evans notes, 'have become tomorrow's commodities'.[110] So has the emblematic tower. In the very early years of the monument, for instance, the Printemps acquired bits of metal discarded from the construction site to convert them and sell them as miniature towers.[111] From small souvenir replicas to patterns on plates or various functional and even edible objects, the tower can now be consumed in many guises. As Loyrette notes, it is easily reproducible – 'two legs, often heavy, an arch, an arrow topped by a lantern, the whole thing streaked by the more or less tight network of the metal beams'[112] – and it certainly has been reproduced a great number of times. The field of fashion has noticeably participated in this proliferation and fetishization – a fetishization of Paris – with the tower turned into an object of fashion,

a fashionable one. Indeed, added to the stock of fashion images is a long list of fashion commodities that have borne either an image or pattern of the tower, or taken its shape. In the 1930s for instance, Schiaparelli used it as a motif on her silk prints. It has also appeared on a sweater designed by Sonia Rykiel, a dress by Jean Paul Gaultier and in the form of pendants and charms, some of them created by companies such as Louis Vuitton.

The regular appropriation of the tower by a diversity of makes and its juxtaposition with an endless series of new products, then, carries into the up-to-the-minute present pertaining to fashionable goods, the tower, and, with it, Paris. Always the same yet constantly renewed by virtue of the new commodities and models it is related to, the Paris of the tower is forever fashionable and covetable. The monument has been integrated into a flow of fashionable objects and clothes that have turned it and in the process Paris, into a sign of fashion, a fashionable sign, one whose value has long sustained the selling of commodities that have in turn supported the mythical status of the city. Paris promotes fashion, but fashion also promotes Paris, and the presence of the tower in fashion images draws attention to this concordance between discourses on the city and discourses on fashion.

CONCLUSION

Since Paris was put into words in the fourteenth century in the work of Jean de Jandun, the layers of texts on the city have grown, making the French capital a highly visible object of discourse, both written and visual. Amongst such texts are those of the contemporary French fashion press, whose images and words have carried into the present mythical visions of the city; a city endowed with *esprit* and agency, active in the creation of fashion and fashionable beings, *les Parisiennes*, a city synonymous with prestige and distinction, superior to the provinces but also to the rest of the world, the 'center of the world, as *Vogue*'s editor put it in the April 1997 issue (p. 107). Images of the capital by way of its symbol the Eiffel Tower have compounded its high visibility and centrality in the French and international landscapes of imagined cities, bringing into these landscapes desirable visions of Paris – indeed, visions of the capital as object of desire, like the commodities the tower has been juxtaposed with. For the Paris of the fashion press is also a commodified Paris, a city reduced to a series of fashionable haunts and goods in the same way that its symbol, the Eiffel Tower, has been reduced to a pattern one can display on one's dress, or a piece of jewelry one can harbor around one's neck or wrist.

In fashion discourse and the fashion press 'Paris' has risen above the referent it relates to – the physical material city – to enter the realm of the imagined, and become synonymous with fashionability and desirability, a sign of fashion on a par with other fashion signs such as brands. Appropriated by fashion discourse, and with the force also imparted it by the many texts – books, paintings, films, for instance – that have mythologized the city, Paris has been abstracted from physical place and its differentiated and varied realities to become an ideal and idealized space, one more tableau to have bathed the capital in the 'gilded atmosphere' that Emma Bovary daydreamed about.[1] To quote Bourdieu and Delsaut again,

'fashion discourse' is a 'technical language which, when it is addressed to the outside, by journalists, becomes a purely decorative discourse that contributes to the imposition of legitimacy';[2] the legitimacy of Paris as fashion city, indeed as capital of fashion.

'The geography of Fashion', Barthes writes, 'marks two "elsewheres"; a utopian "elsewhere", represented by everything that is exotic, exoticism being an acculturated geography; and a real "elsewhere", which Fashion borrows from outside itself – from an entire economic and mythic situation of contemporary France'.[3] Barthes gives the example of the Riviera, but in the geography of fashion as defined by contemporary fashion discourse this is also true of Paris, the 'elsewhere' of France by virtue of its superior positioning to *la province*, of its status as the place of ascent and prestige. Discourses on the capital, including that of the French fashion media, have helped transport it to this 'elsewhere', the sphere of all things glamorous and fashionable. Yet it has also become a point of reference, the model precisely because distanced and distinguished from the nation it belongs to; a space the collectivity has been defined through and projected into at the same time as it has been split into two socio-geographical entities: Paris and *la province*.

The city as imagined, however, is no less real than the material city. It cannot be discarded as simply 'words' and 'images', an invention at the periphery of the reality of material, political, and economic life and of the city as phenomenological space, for the symbolic is always incorporated into practices: ways of being are also ways of seeing, and experience at the junction of the imagined and the lived. As Lefebvre notes, 'a society is a space and an architecture of concepts, forms and laws whose abstract truth is imposed on the reality of the sense, of bodies, of wishes and desires'.[4] Paris is a reality that stretches across geographical and mental spaces, and this is why approaching it, understanding it, must include approaching and understanding the many texts that have constructed it, imposing their truth on the bodies and desires of viewers and readers. In this book I have focused on the contemporary French fashion press, insisting on its resonance with past visions of Paris. But with the fashion media landscape reaching new platforms such as the worldwide web, yet more fashion texts are being created that are compounding the visibility and aura of the French capital in the collective imaginary, and its celebration as a fashion city and *'capitale de la mode'*. Numerous French fashion blogs and Internet fashion magazines are anchored to the city – including Café Mode, Deedee, and Cachemire et soie, for instance[5] – their authors reporting on all things

fashionable, all things Parisian. Researchers will hopefully turn to such texts the better to interrogate contemporary constructions of the French capital and the truths that have informed, and will continue to inform, our engagement with it.

ENDNOTES

Introduction

1. Mistinguett 'Ça, c'est Paris', in http://www.paroles.net/pages/print=12135. 1927 (Accessed 28 April 2008).
2. See, for instance, R. Alter, *Imagined Cities: Urban Experience and the Language of the Novel* (London: Yale University Press, 2005); J. Donald, *Imagining the Modern City* (London: The Athlone Press, 1999); M. Sheringham, 'City Space, Mental Space, Poetic Space: Paris in Breton, Benjamin and Réda', in M. Sheringham (ed.) *Parisian Fields* (London: Reaktion,1996); K. Stierle, *Le Mythe de Paris: La Capitale des Signes et son Discours* (Paris: Ed. de la Maison des Sciences de L'Homme, 2001).
3. See, for instance, P. Bourdieu & Y. Delsaut, 'Le Couturier et sa Griffe: Contribution à une Théorie de la Magie', *Actes de la Recherche en Sciences Sociales*, 1 (1975), 7–36; D. Gilbert, 'Urban Outfitting: The City and the Spaces of Fashion Culture', in S. Bruzzi & P. Church Gibson (eds), *Fashion Cultures: Theories, Explorations and Analysis* (London: Routledge, 2000); Y. Kawamura, *The Japanese Revolution in Paris* (Oxford: Berg, 2004); A. McRobbie, *British Fashion Design: Rag Trade or Image Industry?* (London: Routledge, 1998).
4. On Paris designers, see, for instance, E. Charles-Roux, *Chanel* (London: Collins Harvill, 1990); C. Morais, *Pierre Cardin: The Man who Became a Label* (London: Bantam Press, 1991); A. Rawsthorn, *Yves Saint Laurent: A Biography* (London: Harpers Collins, 1996). On the history of Paris fashion, see for instance, J. Jones, *Sexing* La Mode*: Gender, Fashion and Commercial Culture in Old Regime France* (Oxford: Berg, 2004); V. Steele, *Paris Fashion: A Cultural History* (Oxford: Berg, 1998); V. Steele, 'Femme Fatale: Fashion and Visual Culture in Fin-de-siècle Paris', in *Fashion Theory*, 8 (3) (2004), 315–28; D. Veillon, *La Mode sous L'Occupation* (Paris: Payot, 1990).
5. Steele, *Paris Fashion*, 136.
6. R. Barthes, *The Fashion System* (Berkeley: University of California Press, 1990 [1967]).
7. C. Evans, *Fashion at the Edge: Spectacle, Modernity and Deathliness* (London: Yale University Press, 2003), 12.
8. G. Flaubert, *Madame Bovary* (Paris: Gallimard, 2001 [1856]). My translations adapted from Flaubert, G. *Madame Bovary*. Translated by Geoffrey Wall (London: Penguin, 2003).

9 A. Appadurai, *Modernity at Large: Cultural Dimensions of Globalization* (Minneapolis: University of Minnesota Press, 1996).
10 P. Bourdieu, *The Field of Cultural Production* (Cambridge: Polity, 1993).

Chapter 1: Paris, France

1 For a concise history of the city see, for instance, S. Prigent, *Paris en Dates et en Chiffres* (Paris: Editions Jean-Paul Gisserot, 2005) and, for more developed accounts, A. Hussey, *Paris: The Secret History* (London: Viking, 2006); and C. Jones, *Paris: Biography of a City* (London: Penguin, 2006).
2 See Jones, *Paris*.
3 Jones, *Paris*, 199–204.
4 P. Higonnet, *Paris: Capital of the World* (London: Belknap Press, 2002).
5 Jones, *Paris*, 204.
6 Higonnet, *Paris*, 7; Jones, *Paris*, 199.
7 C. Prendergast, *Paris and the Nineteenth Century* (Oxford: Blackwell, 1992), 104.
8 P. Deyon, *Paris et ses Provinces* (Paris: Armand Colin, 1992).
9 Prendergast, *Paris*, 14.
10 Deyon, *Paris*, 7; R. Chartier, 'Trajectoires et Tensions Culturelles de l'Ancien Régime', in Burguière, A. & Revel, J. (sous la dir. de) *Histoire de la France* (Paris: Seuil, 2000).
11 Montaigne, cited in Stierle, *Mythe*, 52.
12 A. Corbin, 'Paris-Province', in Nora, P. (sous la direction de) *Les Lieux de Mémoire*. Vol. 2 (Paris: Gallimard, 1997), 2858.
13 Corbin, 'Paris-Province', 2858; Deyon, *Paris*, 32–3.
14 Corbin, 'Paris-Province', 2859.
15 Corbin, 'Paris-Province', 2865.
16 Ibid.
17 Jones, *Paris*, 69.
18 J. George, *Paris Province: de la Révolution à la Mondialisation* (Paris: Fayard, 1998), 257.
19 Corbin, 'Paris-Province', 2878; Deyon, *Paris et ses Provinces*, 148.
20 J. François-Poncet, *Rapport D'Information No 241*. Sénat. Paris: Délégation du Sénat à l'Aménagement et au Developpement durable du Territoire (2003), 44.
21 George, *Paris Province*, 243.
22 Corbin, 'Paris-Province', 2872.
23 Ibid.
24 J. Scheibling, 'La France. Permanences et Mutations'. http://pweb.ens-Ish.fr/omilhaud/scheibling.doc. 2007 (Accessed 30 April 2007).
25 Deyon, *Paris*, 148.
26 Ibid.
27 Corbin, 'Paris-Province', 2862.
28 O. Ihl, 'Les territoires du Politique', in *Politix*, 21 (1993), 7–14.
29 *Le Temps*, cited in Ihl, 'territoires', 29.

30 Ihl, 'territoires', 29.
31 Sénat, 'Banquet Républicain', in http://www.14juillet.senat.fr/banquet2000/banquet.html. 2007 (Accessed 6 February 2007).
32 Ihl, 'territoires', 31.
33 Deyon, *Paris*, 34.
34 Ihl, 'territoires', 28.
35 Ibid.
36 Ibid.
37 Jones, *Paris*, 156.
38 J. DeJean, *The Essence of Style: How the French Invented High Fashion, Fine Food, Chic Cafés, Style, Sophistication, and Glamour* (New York: Free Press, 2006), 213.
39 See also C. Hancock, 'Capitale du Plaisir: the Remaking of Imperial Paris', in Driver, F. & Gilbert, D. (eds) *Imperial Cities: Landscape, Display and Identity* (Manchester: Manchester University Press, 1999), 65–6.
40 Higonnet, *Paris*, 351–4.
41 See, for instance, S. Rice, *Parisian Views* (London: MIT Press, 1997).
42 Rice, *Parisian Views*, 40.
43 Ibid.
44 Rice, *Parisian Views*, 9, 38.
45 Hancock, 'Capitale', 68; Rice, *Parisian Views*, 68.
46 Higonnet, *Paris*, 172.
47 B. Marchand, *Paris, Histoire d'une Ville* (Paris: Seuil, 1993), 157.
48 Marchand, *Paris*, 96.
49 L. Bernard, *The Emerging City: Paris in the Age of Louis XIV* (Durham: Duke University Press, 1970), vi.
50 Hussey, *Paris*, 156.
51 Bernard, *Emerging City*; Hussey, *Paris*, 156.
52 See, for instance, T.J. Clark, *The Painting of Modern Life: Paris in the Art of Manet and his Followers* (London: Thames and Hudson, 1985), 41; Hancock, 'Capitale du Plaisir', 64; Prendergast, *Paris*, 103.
53 W. Benjamin, *The Arcades Project* (London: Belknap Harvard, 2003), 12.
54 Clark, *Painting of Modern Life*, 41.
55 Hancock, 'Capitale', 67; see also Clark, *Painting of Modern Life*, 63.
56 Hancock, 'Capitale', 68.
57 Marchand, *Paris*, 88.
58 George, *Paris Province*, 85.
59 See G. Poisson, *Les Grands Travaux des Présidents de la Ve République* (Paris: Parigramme, 2002).
60 Poisson, *Grands Travaux*, 6.
61 J.R. Short, *Global Metropolitan: Globalizing Cities in a Capitalist World* (London: Routledge, 2006), 76.
62 Short, *Global Metropolitan*, 76.
63 Higonnet, *Paris*, 46, 243.
64 Jones, *Paris*, xvii. See P. Nora (sous la direction de) *Les Lieux de Mémoire*. Vol. 1 (Paris: Gallimard, 1997); P. Nora (sous la direction de) *Les Lieux de Mémoire*.

Vol. 2 (Paris: Gallimard, 1997); P. Nora (sous la direction de) *Les Lieux de Mémoire*. Vol. 3 (Paris: Gallimard, 1997).

65 M. Deguy, *Spleen de Paris* (Paris: Galilée, 2001), 28–9.
66 Scheibling, 'La France'.
67 Ibid.
68 See P. Citron, *La Poésie de Paris dans la Littérature Française de Rousseau à Baudelaire*. Vol. 1 (Paris: Minuit, 1961a).
69 See also Steele, *Paris Fashion*, 74.
70 See J-F. Gravier, *Paris et le Désert Français en 1972* (Paris: Flammarion, 1972).
71 See, for instance, P. Bourdieu, *La Misère du Monde* (Paris: Seuil, 1993), 161.
72 George, *Paris Province*, 7.
73 A. Corbin, 'De l'Histoire des Representations à l'Histoire sans Nom', in *Politix*, 21 (1993), 7–14, 11.
74 Higonnet, *Paris*, 312.
75 Louis Veuillot, cited in Marchand, *Paris*, 125.
76 Corbin, 'Paris-Province', 2852. See also George, *Paris Province*, 135–6.
77 Corbin, 'Paris-Province'; I. de Courtivron, '"Never Admit!": Colette and the Freedom of Paradox' in Chadwick, W. & True Latimer, T. (eds) *The Modern Woman Revisited: Paris Between the Wars* (New Brunswick: Rutgers University Press, 2003), 57; Higonnet, *Paris*, 313.
78 Corbin, 'De l'Histoire'', 12.
79 See also C. Charle, *Paris fin de Siècle: Culture et Politique* (Paris: Seuil, 1998), 37.
80 Bourdieu, *Misère*, 162.
81 Ibid.
82 Corbin, 'De l'Histoire', 11.
83 Corbin, 'Paris-Province', 2851.
84 Corbin, 'De l'Histoire', 11.
85 *Le Petit Larousse* (Paris: Larousse, 1994), 832.
86 Corbin, 'Paris-Province', 2851.
87 A. Martin-Fugier, *La Vie Elégante ou la Formation du Tout-Paris: 1815–1848* (Paris: Points, 1990), 284.
88 *Le Petit Larousse*, 748.
89 Corbin, 'Paris-Province', 2858.
90 See also Hussey, *Paris*, xviii.
91 See also Donald, *Imagining*.
92 Citron, *Poésie* (1), 21.
93 Guillaume de Villeneuve, cited in Stierle, *Mythe*, 42.
94 L-S. Mercier *Le Tableau de Paris* (Paris: La Découverte, 2000 [1781–8]).
95 Stierle, *Mythe*, 88.
96 See E., Texier *Tableau de Paris*. Tome Premier (Paris: Paulin et le Chevalier, 1852); J. Vallès, *Le Tableau de Paris* (Paris: Berg International, 2007 [1882–3]).
97 D. Hansen, 'The portrait as a Work of Art', translation of 'Das Portrait als Kunstwerk', in *Monet und Camille* (Kunsthalle Bremen: Hirmer, 2005), 2; Higonnet, *Paris*, 380–83.
98 Corbin, 'De l'Histoire', 13.
99 Prendergast, *Paris*, 2.

100 Rice, *Parisian* Views, 36, 37, drawing on Benjamin, see W. Benjamin, *Charles Baudelaire* (Paris: Payot, 2002 [1938–9]), 60–61.
101 Rice, *Parisian Views*, 36–7.
102 Stierle, *Mythe*, 193–218.
103 H. de Balzac, *Physiologie de l'Employé*, in *Traite de la Vie Elégante. Physiologie du Rentier de Paris. Physiologie de l'Employé. Les Boulevards de Paris* (Paris: Bibliopolis, 1911 [1841]); *Physiologie du Rentier de Paris*, in *Traité de la Vie Elégante. Physiologie du Rentier de Paris. Physiologie de l'Employé. Les Boulevards de Paris*. Paris: Bibliopolis. Also published as *Monographie du Rentier* in *Les Francais Peints par Eux-Mêmes*. Vol. 3 (Paris: L. Curmer éditeur, 1911 [1841]); *Physiologie de la Toilette*, in *Traité de la Vie Elégante. Physiologie de la Toilette. Scènes Eparses* (Paris: Nouvelle Société D'Edition, 1946 [1830]); *Histoire et Physiologie des Boulevards de Paris*, in *Le Diable à Paris* (Paris: J. Hetzel, 1846).
104 *Français Peints par Eux-Mêmes (Les)* (Paris: L. Curmer éditeur, 1841).
105 Citron, *Poésie* (1); P. Citron, *La Poésie de Paris dans la Littérature Francaise de Rousseau à Baudelaire*. Vol. 2 (Paris: Minuit, 1961).
106 R. Caillois, *Le Mythe et l'Homme* (Paris: Gallimard, 2002 [1938]). See Citron, *Poésie* (1), 252.
107 Citron, *Poésie* (2), 74.
108 Citron, *Poésie* (1), 250.
109 Stierle, *Mythe*, 192; Citron, *Poésie* (2), 189.
110 C. Hancock, *Paris et Londres au XIX Siècle: Représentations dans les Guides et Récits de Voyages* (Paris: CNRS Editions, 2003), 200.
111 C. Arnaud, 'Les Grands Boulevards', in *Paris Portraits* (Paris: Gallimard, 2007), 40.
112 V. Hugo, *Les Misérables*. I (Paris: Gallimard, 1995 [1862]); *Les Misérables*. II (Paris: Gallimard, 1995 [1862]). See Citron, *Poésie* (1); P. Parkhurst Ferguson, *Paris as Revolution: Writing the Nineteenth-Century City* (Berkeley: University of California Press, 1994); Prendergast, *Paris and the Nineteenth Century*.
113 Higonnet, *Paris*, 59.
114 H. de Balzac, *La Fille au Yeux d'Or*, in *Ferragus. La Fille aux Yeux d'Or* (Paris: Flammarion, 1988 [1834–5]), 263, see also Jones, *Paris*, 318; E. Zola, *Paris* (Paris: Gallimard, 2002 [1898]), 416, 440.
115 Marivaux, cited in Jones, *Paris*, 204; Charles de Peyssonel, cited in Jones, *Paris*, 204; Mercier, cited in Citron, *Poésie* (1), 275.
116 Higonnet, *Paris*, 15.
117 W. Benjamin, 'Paris, the Capital of the Nineteenth Century', in Benjamin, W. *The Arcades Project* (London: Belknap Harvard, 2003 [1935]).
118 Charle, *Paris*; Hancock, 'Capitale', 69; Higonnet, *Paris*, 346, 351.
119 See DeJean, *Essence of Style*, Ch. 10; Jones, *Paris*, 327.
120 Prendergast, *Paris*, 32. See also Citron, *Poésie* (1), 273.
121 See Citron, *Poésie* (1).
122 A. de Vigny, 'Paris', in *Poemes Antiques et Modernes* (Paris: Hachette, 1914 [1831]), 233, cited in Citron, *Poésie* (1), 271; Texier, *Tableau*, i, cited in Prendergast, *Paris*, 6–7.
123 Heine, cited in Stierle, *Mythe*, 157.

124 Rice, *Parisian Views*, 19.
125 Stierle, *Mythe*, 31.
126 P. Pons, 'A Tokyo, le luxe européen à la folie', in *Le Monde* (19 February 2005).
127 See Marchand, *Paris*, 161–71.
128 Corbin, 'Paris-Province', 2881; George, *Paris Province*, 254–5.
129 Corbin, 'Paris-Province', 2881.
130 Sheringham, 'City Space', 88.
131 M-C. Bancquart, *Paris des Surréalistes* (Paris: La Différence, 2004), 155.
132 Bancquart, *Paris des Surréalistes*; Sheringham, 'City Space'.
133 See M-C. Bancquart, *Paris dans la Littérature Française après 1945* (Paris: La Différence, 2006).
134 Higonnet, *Paris*, 333–7.
135 DeJean, *Essence of Style*, 16–17, 210; Higonnet, *Paris*, 30.
136 DeJean, *Essence of Style*, Chapter 10.
137 Higonnet, *Paris*, 30.
138 See Alter, *Imagined Cities*, 8.
139 Hancock, 'Capitale', 71; Hancock, *Paris et Londres*.
140 Hancock, 'Capitale', 70.
141 Higonnet, *Paris*, 291.
142 Galignani, *Galignani's New Paris Guide* (Paris: A. & W. Galignani and Co., 1862), 474.
143 Galignani, *Galignani's New Paris Guide*, iii.
144 Balzac 1988b, 'La Fille aux Yeux D'Or', 209, cited in Prendergast, *Paris*, 56.
145 Galignani, *Galignani's New Paris Guide*, 13.
146 A. Delvau, *Les Plaisirs de Paris* (Paris: Achille Faure, 1867), 64, cited in Hancock, 'Capitale du Plaisir', 71. See also Hancock, *Paris et Londres*, 22.
147 Galignani, *Galignani's New Paris Guide*, 486.
148 Martin-Fugier, *Vie Elégante*, 325.
149 Hancock, 'Capitale', 64, 69, 69.
150 Higonnet, *Paris*, 314.
151 Flaubert, *Madame Bovary*, 96.
152 Flaubert, *Madame Bovary*, 111.
153 Flaubert, *Madame Bovary*, 112.
154 Flaubert, *Madame Bovary*, 111.
155 Higonnet, *Paris*, 304.
156 Prendergast, *Paris*, 136. But see also Alter, *Imagined Cities*, 5; Citron, *Poésie* (2), 11–12; Higonnet, *Paris*, 10, 99; Hussey, *Paris*.
157 See, for instance, Citron, *Poésie* (2), on the image of Paris as courtesan in the Paris of literature.
158 Delvau, *Plaisirs*, 263, 267.
159 Delvau, *Plaisirs*, 267.
160 Delvau, *Plaisirs*, 272, 260.
161 Michelin, *Guide de Tourisme. Paris* (Paris: Pneu Michelin, 1994).
162 Prendergast, *Paris*, 28. But see also Donald, *Imagining*.
163 Parkhurst Ferguson, *Paris as Revolution*.
164 Citron, *Poésie* (1), 256.

165 See, for instance, Clark, *Painting of Modern Life,* on 'Manet and his followers'.
166 T. Gronberg, 'Sonia Delaunay's Simultaneous Fashions and the Modern Woman', in Chadwick, W. & True Latimer, T. (eds) *The Modern Woman Revisited: Paris between the Wars* (London: Rutgers University Press, 2003), 116.
167 Gronberg, 'Sonia Delaunay', 116.
168 See, for instance, K. Adler, E.E. Hirshler, H.B Weinberg, D. Park Curry, R. Rapetti, C. Riopelle, *Americans in Paris: 1860–1900* (London: The National Gallery Company Ltd, 2006), for an account of the paintings of Americans in Paris during the second half of the nineteenth century).
169 Rice, *Parisian Views,* 48.
170 See also N.T. Binh, *Paris au Cinéma* (Paris: Parigramme, 2005), 107–8.
171 N.T. Binh, 'Paris, a cinephile dream', talk delivered at the Institut Français (London, 4 February 2007).
172 Binh, 'Paris, a cinephile dream'. See also Binh *Paris,* 11; Film France, *Répartition Géographique des Tournages Cinéma et Télévision en 2005* (Film France, Commission Nationale. Paris. 2005).
173 See Citron, *Poésie* (2), 64, on the Paris of literature.
174 See, for instance, Dupuy-Berberian, *Monsieur Jean, L'Amour, La Concierge* (Paris: Les Humanoïdes Associés, 2005); R. Multier & G. Tévessin, *Un Taxi Nommé Nadir* (Paris: Actes Sud BD, 2006); J. Tardi Tardi, *M'As-tu Vu en Cadavre? D'après le roman de Léo Malet* (Casterman, 2000).

Chapter 2: Paris, Fashion City

1 C. Breward, *Fashion* (Oxford: Oxford University Press, 2003) 23; Steele, *Paris Fashion,* 17.
2 Breward, *Fashion,* 24; DeJean, *Essence of Style*; Steele, *Paris* Fashion, 20–24.
3 DeJean, *Essence of Style,* 36.
4 *Lettres d'un Sicilien,* cited in Stierle, *Mythe,* 57.
5 Jones, *Sexing* La Mode, 9.
6 Jones, *Sexing* La Mode, 4.
7 Jones, *Sexing* La Mode, 2–3.
8 D. De Marly, *Louis XIV & Versailles* (London: B.T. Batsford Ltd, 1987), 46; Jones, *Sexing* La Mode, 9.
9 De Marly, *Louis XIV,* Ch. 3.
10 See also DeJean, *Essence of Style*; Kawamura, *Japanese Revolution*; De Marly, *Louis XIV.*
11 Colbert, cited in Steele, *Paris Fashion,* 21.
12 De Marly, *Louis XIV.*
13 See also L. Bergeron, *Les Industries du Luxe en France* (Paris: Editions Odile Jacob, 1998); Kawamura, *The Japanese Revolution in Paris,* 48–9.
14 Bernard, *Emerging City,* 10; Jones, *Paris,* 115, 184.
15 Jones, *Paris*; Bernard, *Emerging City*: 10–11; DeJean, *Essence of Style,* 187.
16 Jones, *Paris,* 195.
17 De Marly, *Louis XIV*; DeJean, *Essence of Style*; Jones, *Paris,* 196.
18 See also Kawamura, *Japanese Revolution,* 25.

19 De Marly, *Louis XIV*, 49.
20 DeJean, *Essence of Style*, 40–41.
21 M. Pinçon & M. Pinçon-Charlot, *Sociology de la Bourgeoisie* (Paris: La Découverte, 2003), 56.
22 See Bernard, *Emerging City*, 8, 24; Martin-Fugier, *Vie Elégante*, 24.
23 Martin-Fugier, *Vie Elégante*, 109–10.
24 D. Waquet & M. Laporte, *La Mode* (Paris: Puf, 1999), 90.
25 Jones, *Sexing* La Mode, 41.
26 Jones, *Sexing* La Mode, 4.
27 Breward, *Fashion*, 25; see also Jones, *Sexing* La Mode, 74.
28 Jones, *Sexing* La Mode, 73–4.
29 DeJean, *Essence of Style*, 63.
30 DeJean, *Essence of Style*, 63–5; Steele, *Paris*, 25.
31 DeJean, *Essence of Style*, 68–70; De Marly, *Louis XIV*, 53.
32 Steele, *Paris Fashion*, 25.
33 H. Hahn, 'Fashion Discourses in Fashion Magazines and Madame de Girardin's *Lettres parisiennes* in July Monarchy France' (1830–1848) *Fashion Theory*, 9 (2) (2005), 205–28, 209–10; Martin-Fugier, *La Vie Elégante*.
34 Martin-Fugier, *Vie Elégante*, 25; Higonnet, *Paris*, 316.
35 Martin-Fugier, *Vie Elégante*, 23.
36 C.C. Lemert, *French Sociology. Rupture and Renewal Since 1968* (New York: Columbia University Press, 1981), 5.
37 N.L. Green, *Ready-to-Wear, Ready-to-Work: A Century of Industry and Immigrants in Paris and New York* (London: Duke University Press, 1997), 2; H. Hahn, 'Fashion Discourses', 207.
38 Kawamura, *The Japanese Revolution in Paris*, 35.
39 See, for instance, Bourdieu, *The Field of Cultural Production*.
40 Green, *Ready-to-Wear, Ready-to-Work*, 101.
41 P. Perrot, *Les Dessus et les Dessous de la Bourgeoisie* (Paris: Editions Complexe, 1984); N.J. Troy, *Couture Culture: A Study in Modern Art and Fashion* (London: The MIT Press, 2003), 13.
42 See Breward, *Fashion*; D. Grumbach, *Histoires de la Mode* (Paris: Seuil, 1993), 193; Troy, *Couture Culture*, 18.
43 See D. De Marly, *Worth: Father of Haute Couture* (London: Elm Tree Books, 1980).
44 Waquet & Laporte, *La Mode*, 92–3.
45 De Marly, *Worth*, 10.
46 De Marly, *Worth*; F-M. Grau, *La Haute Couture* (Paris: Puf, 2000), 34; Grumbach, *Histoires*, 19.
47 See also Grumbach, *Histoires de la Mode*; Kawamura, *Japanese Revolution*, for a history and discussion of the responsibilities of various ruling bodies.
48 Grumbach, *Histoires*, 24.
49 Grumbach, *Histoires*, 25, 31.
50 C. Barrère & W. Santagata, *La Mode* (Paris: La Documentation Française, 2005), 72.
51 Grumbach, *Histoires*.

Notes to pages 30–36

52 Grumbach, *Histoires*, 29.
53 M. Delpierre, *Le Costume: La Haute Couture 1945–1995* (Paris: Flammarion, 1997), 12; Kawamura, *Japanese Revolution*, 47; Steele, *Paris Fashion*, 269–70.
54 *Fédération française du prêt-à-porter féminin*, cited in *Valeurs Actuelles*, 'Prêt-à-porter. Paris sort ses Griffes' (30 August 2002).
55 Sessi, *La Mode en Chiffres* (Edition 2005. Service des Etudes et des Statistiques Industrielles. Ministère de L'Economie des Finances et de l'Industrie. Paris, 2005).
56 L. Kamitsis, 'La Mode au Musée, Paradoxe et Réalités', in *L'Album du Musée de la Mode et du Textile* (Paris: Union Centrale des arts Décoratifs, 1997), 11.
57 Barrère & Santagata, *La Mode*, 17; A.J. Scott, *The Cultural Economies of Cities* (London: Sage, 2000), 196.
58 Waquet & Laporte, *La Mode*, 110–12.
59 Waquet & Laporte, *La Mode*, 112.
60 Ibid.
61 J. Tibéri, 'Paris, Capitale de la Mode, "Think Fashion"', Conférence de Presse. Intervention de Paris. Dossier de Presse, Mairie de Paris (Friday 14 Jan. 2000).
62 D. Savidan, 'La Création en Capitale', in *Le Figaro* (23 January 2003).
63 Gilbert, 'Urban Outfitting', 20; D. Hesmondhalgh, *The Cultural Industries* (London: Sage, 2002), 14; Scott, *The Cultural Economies of Cities*.
64 Gilbert, 'Urban Outfitting', 20.
65 See Steele, *Paris Fashion*, Chapter 14.
66 See also Scott, *Cultural Economies of Cities*, 198.
67 Scott, *Cultural Economies of Cities*, 188.
68 See also Kawamura, *Japanese Revolution*; Waquet & Laporte, *La Mode*, 102–3.
69 Kawamura, *Japanese Revolution*.
70 Waquet & Laporte, *La Mode*, 111–12.
71 Gilbert, 'Urban Outfitting', 9.
72 Steele, *Paris Fashion*, 135.
73 Ibid.
74 Steele, *Paris Fashion*, 290.
75 Steele, *Paris Fashion*, 8, 135–6.
76 M. Proust, *Le Côté de Guermantes* (Paris: Gallimard, 2000 [1920]), 317.
77 Proust, *Côté de Guermantes*, 317.
78 See Martin-Fugier, *Vie Elégante*; Steele, *Paris Fashion*.
79 Marchand, *Paris*, 28.
80 P. Barbier, *A L'Opéra au Temps de Balzac et Rossini* (Paris: Hachette, 2003); Martin-Fugier, *Vie Elégante*; Steele, *Paris Fashion*, 154–6.
81 Bernard, *Emerging City*, 99–101; Higonnet, *Paris*, 2002.
82 Martin-Fugier, *Vie Elégante*, 217.
83 Barbier, *A L'Opéra*; Martin-Fugier *Vie Elégante*.
84 Martin-Fugier, *Vie Elégante*, 125.
85 Martin-Fugier, *Vie Elégante*, 134.
86 Martin-Fugier, *Vie Elégante*, 134–5.
87 Barbier, *A L'Opéra*, 20; Martin-Fugier, *Vie Elégante*, 311.

88 F. Patureau, *Le Palais Garnier: Dans la Société Parisienne 1875–1914* (Liège: Mardaga, 1991), 10.
89 Patureau, *Palais Garnier*, 11–14.
90 Patureau, *Palais Garnier*, 13.
91 Report cited in Patureau, *Palais Garnier*, 13.
92 Garnier, cited in Patureau, *Palais Garnier*, 15.
93 Patureau, *Palais Garnier*, 12.
94 Proust, *Côté de Guermantes*, 33, 34.
95 Proust, *Côté de Guermantes*, 35.
96 Proust, *Côté de Guermantes*, 36.
97 Proust, *Côté de Guermantes*, 32.
98 H. de Balzac, *Splendeurs et Misères des Courtisanes* (Paris: Gallimard, 1999 [1843–7]), 39.
99 Balzac, *Splendeurs*, 38.
100 Balzac, *Splendeurs*, 39.
101 H. de Balzac, *La Peau de Chagrin* (Paris: Gallimard, 1999 [1831]), 195.
102 R. Fortassier, *Les Ecrivains Français et la Mode* (Paris: Puf, 1988).
103 See also Fortassier, *Ecrivains*; Steele, *Paris Fashion*, 58.
104 H. de Balzac, *Traité de la Vie Elégante* (Paris: Arthème Fayard, 2002 [1830]), 48.
105 H. de Balzac, *Les Illusions Perdues* (Paris: Le Livre de Poche, 1983 [1837–43]), 138–43; see also Steele, *Paris Fashion*, 59–62.
106 Balzac, *Illusions Perdues*, 140.
107 N. Fargues, *One Man Show* (Paris: Gallimard, 2002), 69.
108 Fargues, *One Man Show*, 74.
109 *L'Illustration*, 2 March 1929.
110 See Troy, *Couture Culture*.
111 M. Proust, *A L'Ombre des Jeunes Filles en Fleurs* (Paris: Gallimard. 1997[1919]), 462, 218, 460; see also Steele, *Paris Fashion*, 215.
112 Steele, *Paris Fashion*, 208; see also Fortassier, *Ecrivains*, 154–5.
113 Bourdieu & Delsaut, 'Le Couturier et sa Griffe', 16; but see also Troy, *Couture Culture*, for a discussion of Paris high fashion couturiers' appropriation of the discourse of high culture to construct themselves as artists.
114 See also P. Parkhurst Clark, *Literary France: The Making of a Culture* (Berkeley: University of California Press, 1991), 9.
115 Parkhurst Clark, *Literary France*, 27.
116 Balzac, *Traité*.
117 P.N. Furbank & A.M. Cain [Trs.], *Mallarmé on Fashion* (Oxford: Berg, 2004), 4.
118 *La Dernière Mode*, cited in J-P. Lecercle, *Mallarmé et la Mode* (Librairie Séguier, 1989), 144.
119 See Furbank & Cain [Trs.], *Mallarmé on Fashion*.
120 See Fortassier, *Ecrivains*; L. de Vilmorin, *Articles de Mode* (Paris: Le Promeneur, 2000).
121 *L'Officiel*, (March 1999).
122 Higonnet, *Paris*, 82; Martin-Fugier, *Vie Elégante*, 330.
123 Balzac, *Illusions*, 142–3; see also Martin-Fugier, *Vie Elégante*, 330; Steele, *Paris Fashion*, 60–1.

124 Balzac, *Illusions*, 144, 163; see also Martin-Fugier, *Vie Elégante*, 330.
125 See Citron, *Poésie* (2), 168.
126 See Adler *et al.*, *Americans*.
127 See for instance, Martin-Fugier, *Vie Elégante*, 331–2; Perrot, *Les Dessus*, 308–10; Steele, *Paris Fashion*.
128 S. Saiki, *Paris dans le Roman de Proust* (Paris: Sedes, 1996), 168; Martin-Fugier, *Vie Elégante*, 331.
129 Saiki, *Paris*, 168, citing Hillairet.
130 Martin-Fugier, *Vie Elégante*, 331.
131 E. Gourdon, *Physiologie du Bois de Boulogne* (Paris: Charpentier, 1841), 37.
132 Gourdon, *Physiologie*, 48, 37.
133 See Higonnet, *Paris*, 115; Saiki, *Paris*, 168; Steele, *Paris Fashion*, 137, 171; E. Wilson, *Adorned in Dreams: Fashion and Modernity* (London: Virago, 1987), 134.
134 G.M. Thomas, 'Women in Public in the Parks of Paris', in D'Souza, A. & McDonough, T. (eds) *The Invisible Flâneuse?: Gender, Public Space, and Visual Culture in Nineteenth-century Paris* (Manchester: Manchester University Press, 2006), 41–3.
135 E. Zola, *La Curée* (Paris: Le Livre de Poche, 1996 [1871]).
136 Lartigue, cited in C. Chéroux, 'Jacques Henri Lartigue: The Memory of the Instant', in D'Astier, M., Bajac, Q., Sayag, A. (eds) *Lartigue. Album of a Century* (Hayward Gallery Publishing, 2004), 23.
137 See K. Moore, *Jacques Henri Lartigue: The Invention of an Artist* (Princeton: Princeton University Press, 2004), 111.
138 Chéroux, 'Jacques Henri Lartigue', 24–5.
139 M. Proust, *Du Côté de chez Swann* (Paris: Gallimard, 1999 [1913]), 410, 410, 409.
140 Proust, *A l'Ombre*, 204.
141 Proust, *A l'Ombre*, 205, 206.
142 *Le Monde* (19 March 1996), 26.
143 *Elle* (9 October 2006), 22.
144 Perrot, *Dessus*, 306–7; Steele, *Paris Fashion*, 167–70.
145 See S. Aubenas & X. Demange (eds) (2006) *Les Séeberger: Photographes de L'Elégance 1909–1939* (Paris: Seuil); N. Hall-Duncan, *The History of Fashion Photography* (New York: Alpine Book Company, 1979), 30.
146 D. de Girardin, *Lettres Parisiennes du Vicomte de Launay*. I (Paris: Mercure de France, 2004 [1836–40]), 145, cited in Hahn 'Fashion Discourses', 222.
147 Martin-Fugier, *Vie Elégante*, 326.
148 Cited in Citron, *Poésie* (1), 355.
149 See Jones, *Paris*, 218.
150 Gilbert, 'Urban Outfitting', 18. See also M. Berman, *All that is Solid Melts into the Air* (London: Verso, 1997), 151.
151 J. Gaillard, 'Préface', in Zola, E. *Au Bonheur des Dames* (Paris: Gallimard, 1980), 20; Gilbert, 'Urban Outfitting', 18; Steele, *Paris Fashion*, 143–5.
152 Bancquart, *Paris des Surréalistes*, 11.
153 Steele, *Paris Fashion*, 145.
154 Hancock, *Paris et Londres*, 56.

155 Hancock, *Paris et Londres*, 92
156 Hancock, *Paris et Londres*.
157 Delvau, *Plaisirs*, 21, 22.
158 C. Billot & C. Rey 'Le Printemps', in *les Cathédrales du Commerce Parisien* (Paris: Action Artistique, 2006).
159 Billot & Rey, 'Le Printemps', 72.
160 R.H. Williams, *Dream Worlds* (Berkeley: University of California Press, 1991).
161 B. Marrey, *Les Grands Magasins: des Origines à 1939* (Paris: Librairie Picard, 1979).
162 See Marrey, *Grands Magasins*.
163 Gaillard, 'Préface', 18.
164 See F. Falluel, 'Les Grands Magasins et la Confection Féminine', in *Au Paradis des Dames* (Paris: Paris- Musées, 1990); F. Tétart-Vittu 'Le Catalogue', in *Au Paradis des Dames: Nouveautés, Modes et Confections, 1810–1870* (Paris: Paris-Musées, 1992); Waquet & Laporte *La Mode*, 96.
165 Gaillard, 'Préface'. See also Steele, *Paris Fashion*, 147–9.
166 Gaillard, 'Préface', 10.
167 Falluel, 'Grands Magasins', 80.
168 E. Zola, *Au Bonheur des Dames* (Paris: Gallimard, 1996 [1882]), 30.
169 Zola, *Bonheur*, 32, 33, 45.
170 C. Orban, *Fringues* (Paris: Albin Michel, 2002), 154, 155, 156.
171 Orban, *Fringues*, 164.
172 D. Gow, '£2bn deal ends family feud', in *Guardian* (30 March 2005).
173 DeJean, *Essence of Style*, 233.
174 Bernard, *Emerging City*, 4.
175 DeJean, *Essence of Style*, 235–41.
176 DeJean, *Essence of Style*, 12–13, 40–41.
177 DeJean, *Essence of Style*, 26–7, 9.
178 Prendergast, *Paris*, 34.
179 Steele, *Paris Fashion*, 138.
180 Grumbach, *Histoires*, 213–14.
181 Bourdieu & Delsaut 'Le Couturier'.
182 A. Ribes-Tiphaine, *Paris Chic and Trendy* (Paris: Parigramme, 2006: 7).
183 Ofr, 'Rue des Martyrs', in *Guide Paris* (Paris: Ofr, 2005), 93.
184 Waquet & Laporte, *La Mode*, 98.
185 Pinçon & Pinçon-Charlot, *Sociologie*.
186 Bourdieu & Delsaut 'Le Couturier'.
187 N. Garcia, *Place Vendôme* (Artificial Eye, DVD, 1998).
188 J. Craik, *The Face of Fashion* (London: Routledge), 75; Gilbert, 'Urban Outfitting', 18.
189 *Sex and the City*, Episode 17, in The complete season 6, disc Five (HBO, 2004).
190 See Green, *Ready-to-Wear*; N. Vasseur, *Il Etait une Fois le Sentier* (Paris: Liana Lévi, 2000).
191 E. Goffman, *The Presentation of Self in Everyday Life* (London: Penguin). But see also C. Breward, 'Fashion's Front and Back: "Rag trade" Cultures and Cultures of Consumption in Post-war London *c.* 1945–1970', in *The London Journal*,

31 (1) (July 2006), 15–40, on the front and back regions of post-war London fashion.
192 Goffman, *Presentation*, 45, 114, 52, 114, 53, 52.
193 Goffman, *Presentation*, 109, 109, 115.
194 Goffman, *Presentation*, 126, 114.

Chapter 3: Fashion Media Discourse

1 Bourdieu, *Field*, 37.
2 Bourdieu, *Field*, 76.
3 Bourdieu & Delsaut, 'Couturier', 28.
4 Bourdieu & Delsaut, 'Couturier', 23.
5 Bourdieu & Delsaut, 'Couturier', 21, 23, 22.
6 Bourdieu, *Field*, 35, 15, 133.
7 Bourdieu & Delsaut 'Couturier', 25; J.L. Austin, *How to Do Things with Words* (London: Oxford University Press, 1971).
8 Bourdieu & Delsaut 'Couturier', 25.
9 M. Featherstone, *Consumer Culture and Postmodernism* (London: Sage, 1994), 10.
10 Bourdieu, *Field*, 78.
11 Bourdieu & Delsaut, 'Couturier', 23.
12 M. Foucault, *The Archaeology of Knowledge* (London: Routledge, 1989), 49.
13 Foucault, *Archaeology*, 86.
14 M. Foucault, *L'Ordre du Discours* (Paris: Gallimard, 1999), 28.
15 Foucault, *Archaeology*, 55.
16 Foucault, *Archaeology*, 35, 32, 35.
17 Foucault, *Archaeology*, 62.
18 M. Foucault, *The History of Sexuality*. Volume 1 (London: Penguin, 1990), 24; Foucault, *Archaeology*, 108.
19 Foucault, *Ordre*, 10–11.
20 See, for instance, Bourdieu, *Field*.
21 See, for instance, A. McRobbie, *British Fashion Design: Rag Trade or Image Industry?* (London: Routledge, 1998); Troy, *Couture Culture*.
22 Foucault, *Ordre*, 44.
23 Foucault, *Ordre*, 10.
24 Foucault, *Archaeology*, 100.
25 Foucault, *Archaeology*, 23.
26 Foucault, *Ordre*, 10; Bourdieu & Delsaut, 'Le Couturier'; M. Macdonald, *Exploring Media Discourse* (London: Arnold, 2003), 3.
27 P. Bourdieu (with L. Boltanski, R. Castel & J-C. Chamboredon) *Photography. A Middle-Brow Art* (Cambridge: Polity Press, 1996), 63.
28 See also P. Crowther, 'Sociological Imperialism and the Field of Cultural Production: The Case of Bourdieu', in *Theory, Culture and Society*, 11 (1994), 155–69, for a similar argument on Bourdieu's analysis of the field of art.
29 Bourdieu, *Field*, 118.
30 See, for instance, Bourdieu, *Field*.

31 B. Lahire, 'Champ, Hors-champ, Contrechamp', in Lahire, B. (sour la dir. de) *Le Travail Sociologique de Pierre Bourdieu. Dettes et Critiques* (Paris: La Découverte, 1999), 48.
32 Foucault, *Archaeology*, 162.
33 Foucault, *Ordre*, 56, 62–3.
34 Barthes, *Fashion System*.
35 See also F. Dosse, *Histoire du Structuralisme* I (Paris: la Découverte, 1992), 99; P. Jobling, *Fashion Spreads: Word and Image in Fashion Photography since 1980* (London: Routledge, 1999); A. Milner, *Contemporary Cultural Theory* (London: UCL Press, 1995), 84–5.
36 See, for instance, R. Ballaster, M. Beetham, E. Frazer, S. Hebron, *Women's Worlds: Ideology, Femininity and the Woman's Magazine* (London: Macmillan, 1991); J. Winship 'What's Wrong with Images of Women?', in Betterton, R. (ed.) *Looking On: Images of Femininity in the Visual Arts and Media* (London: Pandora, 1987).
37 J. Hermes, *Reading Women's Magazines* (Cambridge: Polity, 1995), 164–165.
38 H. Jost, 'Economie de la Presse de Mode', in Richoux-Bérard, S. & Bonnet, F. (eds) *Glossy* (Marseille: Images en Manoeuvres Editions, 2004), 36.
39 J-M. Charon, *La Presse Magazine* (Paris: La Découverte, 1999), 59.
40 See, for instance, L. Borrelli, 'Dressing Up and Talking about It: Fashion Writing in *Vogue* from 1968 to 1993', in *Fashion Theory*, 1 (3) (1997), 247–60; B. Conekin & A. de la Haye (eds), 'Vogue', in *Fashion Theory*, 10 (1/2), Special Double Issue (March/June, 2006); Hahn, 'Fashion Discourses'; Jobling, *Fashion Spreads*; B. Moeran, 'A Japanese Discourse of Fashion and Taste', in *Fashion Theory*, 8 (1) (2004), 35–62; L. Rabine, 'A Woman's Two Bodies: Fashion Magazines, Consumerism, and Feminism', in Benstock, S. & Ferriss, S. (eds) *On Fashion* (New Brunswick: Rutgers University Press, 1994).

Chapter 4: Paris, *Capitale de la Mode*

1 But see T. Edwards, *Men in the Mirror: Men's Fashion, Masculinity and Consumer Society* (London: Cassell, 1997); Jobling, *Fashion Spreads*, for some discussion of fashion in the men's press.
2 P. Albert, *La Presse Française* (Paris: La Documentation Française, 2004), 183.
3 DeJean, *Essence of Style*, 46–7; Jones, *Sexing* La Mode.
4 De Marly, *Louis XIV*, 60; F. Moureau, *Le Mercure Galant de Dufresny (1710–1724) ou le Journalisme à la Mode* (Oxford: The Voltaire Foundation, 1982), 7.
5 De Marly, *Louis XIV*, 60; Jones, *Sexing* La Mode, 26–7.
6 Jones, *Sexing* La Mode, 181–2.
7 Moureau, *Mercure*, 85.
8 Hahn, 'Fashion Discourses'; J-P. Vittu, 'Le Printemps de la Presse Mode', in *Au Paradis des Dames* (Paris: Paris-Musées, 1992).
9 Hahn, 'Fashion Discourses', 208; A. J. Greimas, *La Mode en 1830* (Paris: Puf, 2000), 7.
10 Steele, *Paris Fashion*, 100.
11 Fortassier, *Ecrivains*, 45; Bourdieu, *Misère*, 160.

12 A. Barbera, 'Des Journaux et des Modes', in *Femmes Fin de Siècle* (Paris: Paris-Musées, 1990), 103, 109.
13 S. Wargnier, 'Eloge de l'Intermédiaire', in *Glossy* (Musée de la Mode de Marseille: Images en Manoeuvres Editions, 2004), 15.
14 Wargnier, 'Eloge', 15.
15 George, *Paris Province*, 251.
16 L. McLoughlin, *The Language of Magazines* (London: Routledge, 2000), 56; A. Davis, *Magazine Journalism Today* (Oxford: Focal Press, 1994); J. Morrish, *Magazine Editing: How to Develop and Manage a Successful Publication* (London: Routledge, 1996), 135; McLoughlin, *Language*, 3.
17 Barthes, cited in A. Compagnon, *Le Démon de la Théorie* (Paris: Seuil, 1998), 53.
18 Short, *Global Metropolitan*, 84.
19 Gilbert, 'Urban Outfitting'.
20 A. Rocamora & A. O'Neill, 'Fashioning the Street: Images of the Street in the Fashion media', in Shinkle, E. (ed.) *Fashion as Photograph: Viewing and Reviewing Images of Fashion* (London: I.B.Tauris, 2008).
21 Zola, *Paris*, 500, 510; see also Stierle, *Mythe*, 236, 406.
22 Citron, *Poésie* (1); Stierle, *Mythe*,18.
23 Balzac, *La Fille au Yeux d'Or*, 30.
24 H. de Balzac, *Ferragus*, in Balzac, H. de, *Ferragus. La Fille aux Yeux d'Or* (Paris: Flammarion, 1988a [1833]), 79.
25 Sheringham, 'City Space', 95.
26 Sheringham, 'City Space', 96.
27 Stierle, *Mythe*, 92.
28 Vilmorin, *Articles*, 27.
29 G. Gauthier, 'Culture et Citoyenneté', in Lecourt, D., Nicolet, C., Perrot, M., Poulat, E., Ricoeur, P. *Aux Sources de la Culture Française* (Paris: La Découverte, 1997), 114.
30 J-L. Harouel, *Culture et Contre-Cultures* (Paris: Quadrige/Presses Universitaires de France, 1998), 21.
31 Harouel, *Culture*, 21; M. Fumaroli, *L'Etat Culturel: Essai sur une Religion Moderne* (Paris: Fallois, 1991), 33.
32 E. Morin, *L' Esprit du Temps 1. Névrose* (Paris: Grasset, 1982), 20; see also B. Rigby, *Popular Culture in Modern France* (London: Routledge, 1991), 4; P. Yonnet, *Jeux, Modes et Masses: 1945–1985* (Paris: Gallimard, 1985).
33 M. Fumaroli, *Trois Institutions Littéraires* (Paris: Gallimard, 1994).
34 Higonnet, *Paris*, 31; Jones; *Paris*, 214, 216.
35 Martin-Fugier, *Vie Elégante*, 92.
36 Martin-Fugier, *Vie Elégante*, 282–3, 99.
37 Higonnet, *Paris*, 32; Martin-Fugier, *Vie Elégante*, 174–8.
38 Higonnet, *Paris*, 33.
39 Ibid.; Fumaroli, *Trois Institutions*.
40 Proust, *Côté de Guermantes*, 465.
41 Proust, *Côté de Guermantes*, 446.
42 H. de Balzac, *La Femme de Province*, in Balzac, H. de *La Muse du Département*

(Paris: Gallimard, 1984 [1841]), 305; Mercier, cited in Stierle, *Le Mythe de Paris*, 94.
43. Barthes, *Fashion System*, xi; P. Bourdieu, 'Haute Couture and Haute Culture', in Bourdieu, P. *Sociology in Question* (London: Sage, 1993b), 138.
44. Bourdieu, 'Haute Couture', 138.
45. See also A. Rocamora, 'Le Monde's *Discours de Mode*: Creating the *Créateurs*', in *French Cultural Studies*, 13 (1) (2002), 83–98; Troy, *Couture Culture*.
46. Short, *Global Metropolitan*, 85.
47. Barthes, *Fashion System*, xi.
48. Barthes, *Fashion System*, xii.
49. Ibid.
50. See Rocamora, 'Le Monde's *Discours de Mode*'.
51. Stierle, *Mythe*, 18.
52. Wargnier, 'Eloge', 15.
53. Rocamora, 'Le Monde's *Discours de Mode*'.
54. Bourdieu & Delsaut, 'Couturier', 27.
55. See, for instance, Bourdieu, 'Haute Couture'.
56. See Grumbach, *Histoires*, 37; Veillon, *La Mode*.
57. See S. Collard, 'The Elusive French Exception', in Godin, E. & Chafer, T. (eds) *The French Exception* (Oxford: Berghan Books, 2004).
58. Gilbert, 'Urban Outfitting', 9.
59. See also Rocamora & O'Neill, 'Fashioning', for a similar argument about the key fashion signifier 'street'.
60. Gilbert, 'Urban Outfitting', 9, 14.
61. E. Wilson, *The Contradictions of Culture: Cities, Culture, Women* (London: Sage, 2001), 65.
62. E. Wilson, *The Sphinx in the City* (London: Virago, 1991), 60; Williams, *Dream Worlds*; Alter, *Imagined Cities*, 5.
63. Gilbert, 'Urban Outfitting', 11.
64. B. Edwards, '"We are Fatally Influenced by Goods Bought in Bond Street": London, Shopping, and the Fashionable Geographies of 1930s *Vogue*', in Conekin, B. & de la Haye, A. (eds) '*Vogue*', in *Fashion Theory*, 10 (1/2), Special Double Issue (March/June, 2006), 82.
65. Gilbert, 'Urban Outfitting', 21.
66. Hancock, 'Capitale'; Hancock, *Paris et Londres*.
67. R. Barthes, *La Tour Eiffel*, photographies d'André Martin (Paris: CNP/Seuil, 1989 [1964]), 15.
68. Edwards, 'We are Fatally Influenced', 80.
69. E.A. Poe, 'The Purloined Letter', in *The Fall of The House of Usher and Other Writings* (London: Penguin, 1986).
70. P. Bourdieu, *Distinction: A Social Critique of the Judgement of Taste* (London: Routledge, 1986), 359.
71. Gilbert, 'Urban Outfitting', 13–14.
72. S. Miles & M. Miles, *Consuming Cities* (New York: Palgrave, 2004), 52.
73. Gilbert, 'Urban Outfitting', 19.
74. Gilbert, 'Urban Outfitting', 8.

75 Short, *Global Metropolitan*, 12.
76 Gilbert, 'Urban Outfitting', 11.

Chapter 5: *La Parisienne*

1 G. Vigarello, *Histoire de la Beauté* (Paris: Seuil, 2004), 149.
2 Hansen, 'The portrait as a Work of Art'; Steele, *Paris Fashion*, 125–31.
3 Steele, *Paris Fashion*, 100; see also A. Solomon-Godeau, 'The Other Side of Venus: The Visual Economy of Feminine Display', in de Grazia, V. *The Sex of Things: Gender and Consumption in Historical Perspective* (London: University of California Press, 1996), 117.
4 Steele, *Paris Fashion*, 100.
5 Hansen, 'The portrait', 1–3.
6 K. Adler, '"We'll Always Have Paris": Paris as Training Ground and Proving Ground', in Adler, K., Hirshler, E.E., Weinberg, H.B., Park Curry, D., Rapetti, R., Riopelle, C., *Americans in Paris: 1860–1900* (London: The National Gallery Company Ltd., 2006).
7 E.E. Hirshler, 'At Home in Paris', in Adler, K. *et al.*, *Americans*, 79.
8 L. Mordoch, Introduction to Miss.Tic, *Parisienne* (Diffusion Alternatives, 2006).
9 T. Delord, *Physiologie de la Parisienne* (Paris: Aubert et Cie, Lavigne, 1841), 9.
10 Delord, *Physiologie*, 71.
11 L. Gozlan, 'Ce que c'est qu'une Parisienne', in *Le Diable à Paris* (Paris: Hetzel, 1845), 51.
12 Balzac, *Duchesse*, 88; Balzac, *La Fille aux Yeux d'Or*, 236; Balzac, *Splendeurs*, 51.
13 Balzac, *Femme de Province*, 302.
14 Ibid.
15 Balzac, *Femme de Province*, 302, 303–4.
16 Delord, *Physiologie*, 21.
17 Flaubert, *Madame Bovary*, 110.
18 Delord, *Physiologie*, 10, 13.
19 See Proust, *A L'Ombre*; Proust, *Swann*; Proust, *Côté de Guermantes*.
20 N. Heinich, *Les Ambivalences de l'Emancipation Féminine* (2003), 30; Marchand, *Paris*, 148–9.
21 G. Martin-Chauffier, *Une Vraie Parisienne* (Paris: Grasset, 2007), 35, 197.
22 Higonnet, *Paris*, 362; Steele, *Paris Fashion*, 149.
23 See also Hirshler, 'At Home in Paris', 79.
24 See, for instance, F. Tétart-Vittu, 'Le Chic Parisien', in *Femmes Fin de Siècle, 1885–1895* (Paris: Editions Paris-Musées, 1990) on the late nineteenth century.
25 Barthes, *Fashion System*, 8.
26 Uzanne, cited in Steele, *Paris Fashion*, 73.
27 Delord, *Physiologie*, 11; Gozlan, 'Ce que c'est qu'une Parisienne', 66.
28 G. Flaubert, *Dictionnaire des Idées Reçues* (Paris: Mille et Une Nuits, 2000), 73.
29 See Citron, *Poésie* (1).
30 E. Raymond, cited in Higonnet, *Paris*, 117.
31 Jones, *Sexing* La Mode, 81.

32 L. Huart, *Physiologie de la Grisette* (Paris: Lavigne, 1841b); J. Janin, 'La Grisette', in *Les Français Peints par Eux-Mêmes* (Paris: L. Curmer éditeur, 1841).
33 DeJean, *Essence of Style*, 52.
34 Steele, *Paris Fashion*, 68.
35 Janin, 'La Grisette', 9, 10, 16.
36 A. Rustenholz, *Parisienne(s)* (Paris: Parigramme, 2001), 6.
37 See also Steele, *Paris Fashion*, 69.
38 Martin-Fugier, *Vie Elégante*, 341.
39 Citron, *Poésie* (1), 379; Steele, *Paris Fashion*, 69.
40 Huart, *Physiologie*, 60, 48.
41 Perrot, *Dessus*; Steele, *Paris Fashion*, 159, 170; Steele, 'Femme Fatales', 318.
42 S. Aubenas, 'Grands Couturiers: Figures du Chic', in Aubenas, S. & Demange, X. (eds) *Les Séeberger: Photographes de L'Elégance 1909–1939* (Paris: Seuil, 2006a), 66.
43 Zola, *La Curée*, 41.
44 E. Zola, *Nana* (Paris: Gallimard, 2003 [1880]), 313.
45 Bourdieu, *Field*.
46 Ribes-Tiphaine, *Paris*, 7; S. Tabak, *Chic in Paris* (Seline Edition, 2006); H. Lurçat & I. Lurçat, *Comment Devenir une Vraie Parisienne* (London: Parigramme), back cover.
47 R. Bernstein, *Fragile Glory: A Portrait of France and the French* (New York: Plume, 1991), 73.
48 Fortassier, *Ecrivains*, 140.
49 Balzac, *La Peau de Chagrin*, 153; Delord, *Physiologie*, 36; T. de Banville, *Le Génie des Parisiennes* (Paris: Mille et Une Nuits, 2002 [1881]), 7; *La Vie Parisienne*, cited in Tétart-Vittu, 'Le Chic Parisien', 94–5, but see also Steele, 'Femme Fatale', 319; L-P. Fargue, *Le Piéton de Paris* (Paris: Gallimard, 2005 [1932]), 170.
50 Mercier, *Tableau*, 24; Gozlan, 'Parisienne', 44.
51 Edwards, 'We are Fatally Influenced', 84, 89, but see also Tétart-Vittu, 'Le Chic Parisien', 98, about the late nineteenth century French fashion press.
52 Short, *Global Metropolitan*, 84.
53 C. Roitfeld, cited in Baudriller, M., 'La Tentation du Luxe', in *Stratégies*, no. 1235 (3 May 2002).
54 Delord, *Physiologie*, 22.
55 D. Harvey, *The Condition of Postmodernity* (Oxford: Blackwell, 1990).
56 Barthes, *Fashion System*, 255.
57 Short, *Global Metropolitan*, 18.
58 Short, *Global Metropolitan*, 62.
59 Pinçon & Pinçon-Charlot, *Sociologie*, 53.
60 Fargue, *Piéton*, 170; Delord, *Physiologie*, 10.
61 Delord, *Physiologie*, 14.
62 Fargue, *Piéton*, 174.
63 Delord, *Physiologie*, 18.
64 Delord, *Physiologie*, 25.
65 Barthes, *Fashion System*, 115.
66 Barthes, *Fashion System*, 87, 89.

67 Barthes, *Fashion System*, 89.
68 Barthes, *Fashion System*, 90.
69 Barthes, *Fashion System*, 65.
70 Ibid.
71 Barthes, *Fashion System*, 80.
72 Barthes, *Fashion System*, 282.
73 X. Chaumette, E. Montet & C. Fauque, *Le Tailleur: Un Vêtement-Message* (Paris: Syros-Alternatives, 1992).
74 Chaumette *et al.*, *Le Tailleur*, 24.
75 Steele, 'Femme Fatale', 316, see also T. Garb, *Bodies of Modernity: Figure and Flesh in Fin-de-Siècle France* (London: Thames and Hudson, 1998), 87–8; Vigarello, *Histoire*, 148–50.
76 Martin-Fugier, *Vie Elégante*, 359; Vigarello, *Histoire*, 150.
77 Hansen, 'The portrait', 4.
78 Gronberg, 'Sonia Delaunay'.
79 See T. Greatrex, 'Rainwear', in Steele, V. (ed.) *Encyclopedia of Clothing and Fashion*. Vol. 3 (New York: Thomson Gale, 2005), 80.
80 Jones, *Sexing La Mode*, 192.
81 Rousseau, cited in Fortassier, *Ecrivains*, 37–8, see also Steele, *Paris Fashion*, 26.
82 See L. Tiersten, *Marianne in the Market: Envisioning Consumer Society in Fin-de-Siècle France* (London: University of California Press, 2001), 125, 144–6.
83 Banville, *Génie*, 7, 9.
84 J. Vallès, cited in Higonnet, *Paris*, 115; Rustenholz, *Parisienne(s)*, 13.
85 M. De Certeau, *The Practice of Everyday Life* (Berkeley: University of California Press, 1988).
86 Delord, *Physiologie*, 14.
87 Sheringham, 'City Space', 105.
88 Sheringham, 'City Space', 94.
89 R. Jenkins, *Social Identity* (London: Routledge, 2004), 29.
90 R. Sennett, *The Fall of Public Man* (London: Faber and Faber, 1993), 153, cited in Wilson, *Contradictions*, 64.
91 J. Peers, *The Fashion Doll: From Bébé Jumeau to Barbie* (Oxford: Berg, 2004), 43; Fortassier, *Ecrivains*, 140.
92 Peers, *Fashion Doll*, 42.
93 Rustenholz, *Parisienne(s)*, 13.
94 A. Rifkin, *Street Noises: Parisian Pleasure, 1900–1940* (Manchester: Manchester University Press 1995), 207.
95 A. Hughes, 'The City and the Female Autograph', in Sheringham, M. (ed.) *Parisian Fields* (London: Reaktion, 1994), 118, 126.
96 J-L. Bory, 'De Licorne et de Métro', in *Les Parisiennes*. Exhibition Catalogue (Paris: Musée Galliéra, 1958), 101.
97 See Citron, *Poésie* (2).
98 P. Lançon, 'Belle de la Ville', in *Libération*, supplement 'Tentations' (Friday 6 Oct 2006), VIII.
99 Bernstein, *Fragile Glory*, 74, 75.
100 Martin-Chauffier, *Vraie Parisienne*, 60–61.

101 Higonnet, *Paris*, 21.
102 Balzac, *Ferragus*, 79.
103 Delord, *Physiologie*, 75.
104 P. Conrad, 'A Tale of Two Cities', in *The Observer* (9 October 2005), 13.
105 Rustenholz, *Parisienne(s)*, 8.
106 Garb, *Bodies*, 82.
107 Garb, *Bodies*, 82, 88.
108 Garb, *Bodies*, 84.
109 Ibid.
110 Steele, 'Femme Fatale', 316.
111 Wilson, *Sphinx*, 63.
112 Mordoch, Introduction to Miss.Tic, *Parisienne*.
113 Banville, *Génie*, 11.
114 Delord, *Physiologie*, 33
115 Lurçat & Lurçat, *Vraie Parisienne*, 5.
116 Vilmorin, *Articles*, 35.
117 Fargue, *Piéton*, 172.
118 Fargue, *Piéton*, 173.
119 Ibid.
120 Rustenholz, *Parisienne(s)*, 9.
121 Rustenholz, *Parisienne(s)*, 8.
122 Jones, *Paris*, 176–80.
123 Rustenholz, *Parisienne(s)*, 13.
124 Rustenholz, *Parisienne(s)*, 11.
125 Ribes-Tiphaine, *Paris*, 7.
126 Mordoch, Introduction to Miss.Tic, *Parisienne*.
127 Rustenholz, *Parisienne(s)*, 13.
128 Martin-Chauffier, *Vraie Parisienne*, 37, 122.
129 Wilson, *Sphinx*, 48.
130 Fargue, *Piéton*, 172.
131 Hughes, 'The City', 127.
132 Citron, *Poésie* (2), 159–64.
133 See Citron, *Poésie* (2).
134 C. Lury, *Consumer Culture* (Cambridge: Polity, 1999), 121, drawing on Winship; E. Winship, *Inside Women's Magazines* (London: Pandora, 1987), 12; Lury, *Consumer Culture*, 144.
135 J. Butler, *Gender Trouble: Feminism and the Subversion of Identity* (London: Routledge, 1999), 173.
136 R. Betterton, 'Introduction: Feminism, Femininity and representation', in Betterton, R. (ed.) *Looking On: Images of Femininity in the Visual Arts and the Media* (London: Pandora, 1989). But see also Hahn, 'Fashion Discourses', and Solomon-Godeau, 'The Other Side of Venus', on the commodification of femininity in nineteenth century French print culture.
137 Betterton, 'Introduction', 13.
138 Ibid.
139 Rabine, 'A Woman's Two Bodies', 64.

140 Betterton, 'Introduction', 13.
141 J. Baudrillard, *The Consumer Society* (London: Sage, 1998), 80.
142 Jenkins, *Social Identity*, 85.
143 J. Finkelstein, *After a Fashion* (Victoria: Melbourne U. Press, 1996), 64.
144 Garb, *Bodies*, 87.
145 Caillois, *Mythe*, 154.
146 Finkelstein, *After a Fashion*, 47.
147 Rabine, 'A Woman's Two Bodies', 63.

Chapter 6: *Passante de Mode*

1 C. Baudelaire, 'A une Passante', in *Tableaux Parisiens*, Baudelaire, *The Complete Verse*. Volume I. (London: Anvil Press, 1991 [1860]), 186. Translation by R. Waldron & A. Rocamora.
2 Breward, *Fashion*; Wilson, *Adorned*.
3 C. Baudelaire, 'Le Peintre de la Vie Moderne', in *Baudelaire: Ecrits sur L'Art* (Paris: Le Livre de Poche, 1999 [1863]), 518; Evans, *Fashion*, 8.
4 Evans, *Fashion*, 8; U. Lehmann, *Tigersprung: Fashion in Modernity* (London: The MIT Press, 2000).
5 Berman, *All that is Solid*, 136.
6 See Baudelaire, 'Peintre de la Vie Moderne'.
7 Finkelstein, *After a Fashion*, 106.
8 Sennett, *Fall*.
9 Sennett, *Fall*, 146.
10 Sennett, *Fall*, 27.
11 Simmel, cited in Wilson, *Adorned*, 135.
12 Wilson, *Adorned*, 135.
13 M. Nava, 'Modernity's Disavowal: Women, the City and the Department Store', in Falk, P. & Campbell, C. (eds) *The Shopping Experience* (London: Sage, 1997), 57.
14 See, for instance, K. Tester (ed.) *The Flâneur* (London: Routledge, 1994).
15 C. Leroy, *Le Mythe de la Passante: De Baudelaire à Mandiargues*. Paris: Presses Universitaires de France (1999).
16 Finkelstein, *After a Fashion*, 111.
17 Prendergast, *Paris*, 133; see also Tester, *The Flâneur*.
18 *Nouveaux Tableaux de Paris*, cited in Stierle, *Mythe*, 127.
19 Balzac, *Ferragus*, 78.
20 L. Huart, *Physiologie du Flâneur* (Paris: Lavigne, 1841), 16, 7.
21 Baudelaire, 'Peintre de la Vie Moderne'; Benjamin, *Charles Baudelaire*; Benjamin, *Arcades*; see also K. Tester, 'Introduction', in Tester, K. (ed.) *The Flâneur* (London: Routledge, 1994); Wolff, 'Gender and the Haunting of Cities', in D'Souza, A. & McDonough, T. (eds) *The Invisible Flâneuse?: Gender, Public Space, and Visual Culture in Nineteenth-century Paris* (Manchester: Manchester University Press, 2006).
22 Steele, *Paris Fashion*, 89.
23 Hancock, 'Capitale', 70–71; Hancock, *Paris et Londres*.

24 Rice, *Parisian Views*, 38; J. Wolff, 'The Invisible Flâneuse: Women and the Literature of Modernity', in Wolff, J. *Feminine Sentences: Essays on Women and Culture* (Cambridge: Polity, 1990), 39.
25 Benjamin, *Arcades*, 417.
26 K. Tester, 'Introduction'.
27 E. White, *The Flâneur: A Stroll through the Paradoxes of Paris* (London: Bloomsbury, 2001); T. Clerc, *Paris, Musée du XXIe Siècle* (Paris: Gallimard, 2007).
28 Prendergast, *Paris*, 4.
29 Prendergast, *Paris*, 134–5; Tester, 'Introduction'.
30 Tester, 'Introduction', 1.
31 See also Prendergast, *Paris*, 4; Wolff, 'Gender', 19.
32 Zukin, cited in Nava 'Modernity's Disavowal', 61; Nava, 'Modernity's Disavowal'.
33 L. Conor, *The Spectacular Modern Woman: Feminine Visibility in the 1920s* (Bloomington: Indiana University Press, 2004), xiv.
34 Wolff, 'Gender', 22.
35 Wolff, 'Invisible Flâneuse', 35; Wolff, 'Gender', 19; but see also M. Perrot, 'Le Genre de la Ville', in Perrot, M. *Les Femmes ou les Silences de l'Histoire* (Paris: Flammarion, 2001); G. Pollock, *Vision and Difference: Feminism, Femininity and the Histories of Art* (London: Routledge, 1999), 69.
36 Perrot, *Les Femmes*, 281.
37 A. Gleber, 'Female Flanerie and the Symphony of the City', in Katharina von Ankum (ed.) *Women in the Metropolis: Gender and Modernity in Weimar Culture* (London: University of California Press, 1997).
38 Leroy, *Mythe*, 4.
39 Ibid.
40 Leroy, *Mythe*, 76.
41 Baudelaire, 'A une Passante'.
42 Stierle, *Mythe*, 151.
43 J.-P. Stahl, 'Les Passants à Paris', in *Le Diable à Paris* (Paris: Hetzel, 1845); Stierle, *Mythe*, 153.
44 Stierle, *Mythe*, 153, 154.
45 R. Bowlby, *Carried Away: The Invention of Modern Shopping* (London: Faber and Faber, 2000), 52.
46 Wolff, 'Invisible Flâneuse', 42.
47 G. Brassens, 'Les Passantes', http://www.paroles.net/chansons/1972.htm (Accessed 19 November 2007 [1972]).
48 Leroy, *Mythe*, 80.
49 Proust, *A L'Ombre*, 363.
50 Wolff, 'Invisible Flâneuse', 42.
51 Benjamin, *Charles Baudelaire*, 71, cited in Wolff, 'Invisible Flâneuse', 42.
52 Prendergast, *Paris*, 135.
53 Prendergast, *Paris*, 136.
54 Wilson, *Adorned*, 136.
55 Ibid.

56 G. Simmel, 'The Sociology of Space', in Frisby, D. & Featherstone, M. (eds) *Simmel on Culture* (London: Sage, 1997), 154.
57 Leroy, *Mythe*, 12–14.
58 Leroy, *Mythe*, 10.
59 Leroy, *Mythe*, 10, 12, 58.
60 Benjamin, *Arcades*, 422; Higonnet, *Paris*, 388; Baudelaire, 'A une Passante'; Leroy, *Mythe*, 64; Sternberg, cited in Leroy, *Mythe*, 120; Proust, *A L'Ombre*, 280, 281, see also Leroy, *Mythe*, 122; Brassens, 'Les Passantes'; D. Sylvain, *Travestis* (Paris: J'ai Lu, 1998), 15.
61 P. Bourdieu, *The Logic of Practice* (Cambridge: Polity, 1992).
62 See also R. Felski, *The Gender of Modernity* (London: Harvard University Press, 1995), 16.
63 Leroy, *Mythe*, 78.
64 Wolff, 'Invisible Flâneuse', 42.
65 See Rice, *Parisian Views*.
66 Prendergast, *Paris*, 174.
67 See Leroy, *Mythe*.
68 R. Fallet, *Paris au Mois d'Août* (Paris: Denoël, 2004 [1964]), 60.
69 P. Soupault, *Les Dernières Nuits de Paris* (Paris: Gallimard, 1997 [1928]), 141.
70 Stierle, *Mythe*, 153.
71 Leroy, *Mythe*, 69, 14.
72 A. Varda, *Cléo from 5 to 7*. The Criterion Collection. DVD (2000 [1962]).
73 E. Rohmer, *L'Amour L'Après-Midi*. Arrowfilms. Fremantle Home Entertainment. DVD (2003 [1972]).
74 F. Truffaut, *L'Homme qui Aimait les Femmes* (The Man who Loved Women). MGM. World Films DVD (2001 [1977]).
75 Hall-Duncan, *The History of Fashion Photography*, 9; see also M. Harrison, *Appearances: Fashion Photography since 1945* (New York: Rizzoli, 1991).
76 Hall-Duncan, *History of Fashion Photography*, 9, 26; see also Steele, *Paris Fashion*, 112.
77 Craik, *Face of Fashion*, 98; Hall-Duncan, *History of Fashion Photography*, 18; Steele, *Paris Fashion*, 227.
78 S. Aubenas, 'Les Séeberger', in Aubenas, S. & Demange, X. (eds) *Les Séeberger: Photographes de L'Elégance 1909–1939* (Paris: Seuil, 2006), 16; Hall-Duncan, *The History of Fashion Photography*, 26–30.
79 Hall-Duncan, *History of Fashion Photography*, 68–71; H. Radner, 'On the Move: Fashion Photography and the Single Girl in the 1960s', in Bruzzi, S. & Church Gibson, P (eds). *Fashion Cultures: Theories, Explorations and Analysis* (London: Routledge, 2000), 131; M.L. Roberts, 'Samson and Delilah Revisited', in Chadwick, W. & True Latimer, T. (eds) *The Modern Woman Revisited: Paris between the Wars* (New Brunswick: Rutgers University Press, 2003), 78.
80 Harrison, *Appearances*, 11.
81 Hall-Duncan, *History of Fashion Photography*, 26.
82 See also Harrison, *Appearances*; Radner, 'On the Move'.
83 Craik, *Face of Fashion*, 99.

84 N. Hall-Duncan, 'Fashion Photography', in Steele, V. (ed.) *Encyclopedia of Clothing and Fashion* (New York: Thomson Gale, 2005), 64.
85 Baudelaire, 'A une Passante'; Sylvain, *Travestis*, 15; A. Breton, *Les Vases Communicants* (Paris: Gallimard, 1996 [1932]), 85, cited in Leroy, *Mythe*, 171.
86 J. Kessel, *La Passante du Sans-Souci* (Paris: Gallimard, 2002 [1936]), 12.
87 See *Crash*, 'Les Bandes-sons des Défilés', Paris, Women, Autumn/Winter 2006/2007. Issue 38 (Summer 2006), 86.
88 Comptoir www.comptoirdescotonniers.com (Accessed 8 January 2007).
89 Lançon, 'Belle de la Ville', VIII.
90 Sheringham, 'City Space', 94.
91 Ibid.
92 Rustenholz, *Parisienne(s)*, 5.
93 Rustenholz, *Parisienne(s)*, 6–8.
94 Banville, *Génie*, 64, 65, 65.
95 L. Borrelli, *Fashion Illustration Now* (London: Thames and Hudson, 2004), 91.
96 Vigarello, *Histoire*, 149.
97 Ibid.
98 Balzac, *Muse*, 60.
99 H. de Balzac *La Femme comme il Faut* in *Les Français Peints par Eux-Mêmes* (Paris: L. Curmer éditeur, 1841), 26.
100 Delord, *Physiologie*, 21.
101 Leroy, *Mythe*, 59.
102 See also Betterton, 'Introduction'; Craik, *Face of Fashion*.
103 J. Berger, *Ways of Seeing* (London: BBC, Penguin Books, 1972), 46–7.
104 Leroy, *Mythe*, 75.
105 Aragon, cited in Leroy, *Mythe*, 67.
106 Berger, *Ways of Seeing*; L. Mulvey, 'Visual Pleasure and Narrative Cinema', in Mulvey, L. *Visual and Other Pleasures* (London: Macmillan, 1989).
107 Winship, *Inside Women's Magazines*, 11.
108 Leroy, *Mythe*, 10.
109 Craik, *Face of Fashion*, 70.
110 Leroy, *Mythe*, 1.
111 Winship, 'What's Wrong', 11.
112 Leroy, *Mythe*, 73.
113 Rabine, 'A Woman's Two Bodies', 63.
114 Leroy, *Mythe*, 101.
115 E. Tseëlon, *The Masque of Femininity* (London: Sage, 1997), 75.
116 M. Foucault, *Surveiller et Punir* (Paris: Gallimard, 1993), see also Tseëlon, *Masque*, 69.
117 C. Evans & M. Thornton, *Women and Fashion: A New Look* (London: Quartet Books, 1989), 104.
118 Evans & Thornton, *Women and Fashion*, 104, 106.
119 Bartky, cited in Tietjens Meyers, D. *Gender in the Mirror: Cultural Imagery and Women's Agency* (Oxford: Oxford University Press, 2002), 8.
120 Berger, *Ways of Seeing*, 46.
121 Evans & Thornton, *Women and Fashion*, 106–7.

122 Aragon, cited in Leroy, *Mythe*, 66.
123 See, also, for instance, Betterton, R. 'How do Women look? The Female Nude in the work of Suzanne Valadon', in Betterton, R. ed. *Looking On: Images of Femininity in the Visual Arts and the Media* (London: Pandora, 1989), 219.
124 Lamarthe, 'Elettra dans la Ville', by Zoé Cassavetes, www.Lamarthe.com/swf/index.php (2007).
125 S. Bruzzi, *Undressing Cinema: Clothing and Identity in the Movies* (London: Routledge, 1997), 24.
126 Craik, *Face of Fashion*, 56.
127 Rabine, 'A Woman's Two Bodies', 63.
128 E.A. Kaplan, 'Is the Gaze Male?', in Kaplan, E.A. (ed.) *Feminism and Film* (Oxford: Oxford University Press, 2000), 130–1.
129 Barthes, *Fashion System*.
130 Rabine, 'A Woman's Two Bodies', 63.
131 Kaplan, 'Is the Gaze Male?', 124–7.
132 Grimshaw, cited in M. Macdonald, *Representing Women: Myths of Femininity in the Popular Media* (London: Arnold, 1995), 11.
133 Ballaster *et al.*, *Women's Worlds*, 165–6.
134 C. Breward, *Fashioning London: Clothing and the Modern Metropolis* (Oxford: Berg, 2004), 15.
135 Barthes, *Fashion System*, 252.
136 Barthes, *Fashion System*, 253.
137 Barthes, *Fashion System*, 261.
138 Rabine, 'A Woman's Two Bodies'.
139 J. Baudrillard, *Simulacra and Simulation* (The University of Michigan Press, 1996 [1981]).
140 See also Rabine, 'A Woman's Two Bodies'.
141 See, for instance, A. Tudor, *Decoding Culture* (London: Sage, 1999) for an account of theories of active readership.
142 See also Betterton, 'How do Women look?'.
143 Radner, 'On the Move', 130–31.

Chapter 7: The Eiffel Tower in Fashion

1 See Journal Officiel 'Arrêté du 1er Mai 1886', in V. Hamy, (textes et documents rassemblés par) *La Tour Eiffel* (Paris: La Différence, 1980 [1886]), 45; A. Lanoux, 'Un certain Monsieur Eiffel', in V. Hamy, (textes et documents rassemblés par) *La Tour Eiffel* (Paris: La Différence, 1980), 25; H. Loyrette, 'La Tour Eiffel', in Nora, P. (sous la dir. de) *Les Lieux de Mémoire*. Vol. 3 (Paris: Quarto, 2004), 4276; M-A. Prevoteau, 'Les Grands Moments de l'Histoire de la Tour Eiffel', in *Tour Eiffel 1889–1989*. Magazine created for the centenary of the tower and given to Paris's City Hall guests on 17 June 1989 (1989).
2 B. Lemoine, *La Tour de Monsieur Eiffel* (Paris: Gallimard, 2004); P-L. Sulitzer, 'La Tour Eiffel', in *Tour Eiffel 1889–1989* (Paris: Média Plus Vingt, 1989); Tour Eiffel. http://www.toureiffel.fr/teiffel/fr/print/index.html?current_url (Accessed 7 December 2006).

3 Lemoine, *Tour*, 15; M. Peltier, 'La Dame de Fer', in *Le Figaro Collection. L'Esprit des Lieux*. 'La Tour Eiffel/Paris 1900' (Paris, Gallimard, June 2006).
4 See Lemoine, *Tour*, 48, 65.
5 Higonnet, *Paris*, 160.
6 Protestation, 'Protestation des Artistes', published in *Le Temps*, 14 February 1887, in Hamy, V. (textes et documents rassemblés par) *La Tour Eiffel* (Paris: La Différence, 1980 [1887]).
7 F. Coppée, 'Sur La Tour Eiffel (Deuxième Plateau)', in Coppée, F. *Poésies 1886–1890* (Paris: Alphone Lemerre Editeur, 1891 [1888]), 131.
8 J-K. Huysmans, 'le fer', in *Certains* (Paris: P.-V. Stock, 1904 [1889]), 174, 175, 178.
9 G. de Maupassant, *La Vie Errante* (Paris: Paul Ollendorff, 1890), 1, 2.
10 Loyrette, 'Tour Eiffel', 4276, 4285.
11 Higonnet, *Paris*, 8.
12 G. Eiffel, '*La Réponse de Gustave Eiffel*', in Lemoine, B. *La Tour de Monsieur Eiffel* (Paris: Gallimard, 2004 [1887]), 102.
13 See Tour Eiffel. http://www.toureiffel.fr/teiffel/fr/print/index.html?current_url.
14 Loyrette, 'Tour Eiffel', 4286, 4271.
15 See http://www.insee.fr/fr/ffc/chifcle_fiche.asp?ref_id=NATTEF13501&tab_id=337 (Accessed 20 July 2007); Tour Eiffel. http://www.toureiffel.fr/teiffel/fr/print/index.html?current_url.
16 Loyrette, 'Tour Eiffel', 4289.
17 S. Girardet, C. Merleau-Ponty, A.Tardy, *Le Livre de la Tour Eiffel* (Paris: Gallimard, 1996).
18 G. Apollinaire, 'Zone', in *Alcools* (Paris: Gallimard (1971 [1920]); G. Apollinaire, caligramme in *les tours eiffel de robert delaunay* (Paris: Jacques Damase Gallery (1974 [1918]); J. Cocteau, *Antigone. Les Mariés de la Tour Eiffel* (Paris: Gallimard, 2000 [1921]); Soupault, *Les Dernières Nuits de Paris*; L-P. Fargue, 'De la Tour Eiffel', in Hamy, V. (textes et documents rassemblés par) *La Tour Eiffel* (Paris: La Différence, 1980 [1939]).
19 Lemoine, *Tour*, 82.
20 Sheringham, 'City Space', 88.
21 Apollinaire, 'Zone', 7.
22 Apollinaire, Caligramme.
23 Soupault, *Dernières Nuits*, 30–31.
24 S. Calle, *Sophie Calle m'As-Tu Vue* (Paris: Centre Pompidou, Editions Xavier Barral, 2003).
25 But see also A. Buisine, 'Le Miroir aux Photographes', in *Revue des Sciences Humaines*. 'La Tour'. Vol. LXXXXXIV, no. 218 (April-June 1990) on the Eiffel Tower in photography.
26 Benjamin, *Arcades*, 154.
27 Ibid.
28 Barthes, *Tour Eiffel*, 7.
29 See also Stierle, *Mythe*, 73.
30 Loyrette, 'Tour Eiffel', 4272.
31 Barthes, *Tour Eiffel*, 7.

32 Barthes, *Tour Eiffel*, 7, 8.
33 Barthes, *Tour Eiffel*, 15–16.
34 Barthes, *Tour Eiffel*, 8.
35 Ibid.
36 Barthes, *Tour Eiffel*, 11.
37 Barthes, *Tour Eiffel*, 7.
38 Prendergast, *Paris*, 47.
39 Clair, R. 'Paris qui Dort', in *Under the Roofs of Paris*. The Criterion Collection. DVD (2002 [1924]).
40 Barthes, *Tour Eiffel*, 8–11.
41 Barthes, *Tour Eiffel*, 11.
42 Barthes, *Tour Eiffel*, 8; but see also Citron, *Poésie* (1), 390 on Hugo and panoramic visions of the city.
43 Barthes, *Tour Eiffel*, 8–11.
44 Prendergast, *Paris*, 49.
45 Barthes, *Tour Eiffel*, 7.
46 Barthes, *Tour Eiffel*, 21.
47 B. Cendrars, 'Tour', in Cendrars, B. *Du Monde Entier. Poésies Complètes: 1912–1924* (Paris: Gallimard, 1967 [1913]), 72, 72–3; E. & J. De Goncourt, *Journal: Mémoires de la Vie Littéraire, 1887–1896* (Paris: Robert Laffont, 2004 [1889]), 236.
48 Barthes, *Tour Eiffel*, 19.
49 Loyrette, 'Tour Eiffel', 4280–81.
50 Zola, *Paris*, 510, 511–12.
51 G. Eiffel, cited in Lemoine, *Tour*, 33.
52 Benjamin, *Arcades*, 887.
53 Conley, T. 'Le Cinéaste de la Vie Moderne', in Sheringham, M. (ed.) *Parisian Fields* (London: Reaktion, 1996).
54 J. Stievenard, 'Les Ecoles de la Tour', in *Revue des Sciences Humaines*. 'La Tour'. April-June 1990, Vol. LXXXXXIV, no. 218 (1990), 52.
55 Gronberg, 'Sonia Delaunay', 118.
56 Ibid.
57 Barthes, *Tour Eiffel*, 16, 20, 21, see also Stierle, *Mythe*, 20.
58 Loyrette, 'Tour Eiffel', 4290; M. De Jaeghere, 'L'esprit des Lieux', in *Le Figaro Collection. L'Esprit des Lieux*. 'La Tour Eiffel/Paris 1900' (Paris: Gallimard, June 2006), 3.
59 Lemoine, *Tour*, 89, 33.
60 M-A. Prevoteau, 'Symbole de la Lumière', in *Tour Eiffel 1889–1989*. Magazine created for the centenary of the tower and given to Paris's City Hall invitees on 17 June 1989 (1989).
61 Prevoteau, 'Symbole'.
62 Ibid.
63 Tour Eiffel. http://www.toureiffel.fr/teiffel/fr/print/index.html?current_url.
64 Maupassant, cited in Barthes, *La Tour Eiffel*, 141.
65 Loyrette, 'Tour Eiffel', 4282.
66 Citron, *Poésie* (2), 108.

67 Tour Eiffel. http://www.toureiffel.fr/teiffel/fr/print/index.html?current_url.
68 See Tour Eiffel. http://www.toureiffel.fr/teiffel/fr/print/index.html?current_url.
69 J. Simon, cited in V.F.M 'L'Etranger à L'Exposition'. *L'Exposition de Paris*, in Hamy, V. (textes et documents rassemblés par) *La Tour Eiffel* (Paris: La Différence, 1980 [1889]), 65; E.M. De Vogüé, *Remarques sur l'Exposition du Centenaire* (Paris: Nourrit et Cie, 1889), 24–5, see also Loyrette, 'Tour Eiffel', 4277.
70 Barthes, *Tour Eiffel*, 7.
71 Ibid.
72 Sulitzer, 'Tour Eiffel'.
73 C. Orsenne, *La Tour Eiffel: Un Phare Universel* (Paris: Massin, 2005).
74 H. Lefebvre, *The Production of Space* (Oxford: Blackwell, 1991), 98.
75 S. Prudhomme, 'Discours prononcé au 13e banquet de la Conférence 'Scientia' offert à Monsieur Eiffel le 13 Avril 1889, La Revue Scientifique, 20 avril 1889', in Hamy, V. (textes et documents rassemblés par) *La Tour Eiffel* (Paris: La Différence, 1980 [1889]), 60.
76 J. Giraudoux, cited in Loyrette, 'Tour Eiffel', 4284.
77 Lemoine, *Tour*, 18.
78 Fargue, 'De la Tour Eiffel'.
79 Prevoteau, 'Les Grands Moments'.
80 *Figaro (le)*. *Le Figaro Collection. L'Esprit des Lieux*. 'La Tour Eiffel/Paris 1900' (June 2006); Sulitzer, 'Tour Eiffel'.
81 Barthes, *Tour Eiffel*, 12.
82 See, for instance, J-P. Guillerm, 'Icones de Notre-Dames-La Tour: De Van Eyck à Robert Delaunay', in *Revue des Sciences Humaines*. 'La Tour'. Vol. LXXXXXIV, no. 218 (April-June 1990), 11; Lemoine, *La Tour*, back cover.
83 E.M. De Vogüé, *Remarques*, 18; Fargue, 'De la Tour Eiffel'; Lemoine, *La Tour*, 53.
84 Deguy, *Spleen*, 10.
85 B. Cendrars, 'The Eiffel Tower', in Chefdor, M. (ed.) *Blaise Cendrars: Modernities and Other Writings* (London: University of Nebraska Press, 1992 [1924]), 109.
86 V. Hamy (textes et documents rassemblés par) *La Tour Eiffel* (Paris: La Différence, 1980), 115.
87 Tour Eiffel. http://www.tour-eiffel.fr/teiffel/fr/actualites/page/news_list.html?year=2004 (Accessed 11 July 2005); Sulitzer, 'La Tour Eiffel'; Lemoine, *La Tour de Monsieur Eiffel*, 89; L. Aragon, 'La Tour Parle. A Robert Delaunay', in *les tours eiffel de robert delaunay* (Paris: Jacques Damase Gallery (1974 [1922]), 44.
88 Lemoine, *Tour*, 95.
89 Tour Eiffel. http://www.tour-eiffel.fr/teiffel/fr/print/index.html?current_url; P. Mac Orlan, cited in Lemoine, *La Tour de Monsieur Eiffel*, 124; Sulitzer, 'Tour Eiffel'.
90 See Gronberg, 'Sonia Delaunay', 117.
91 See Gronberg, 'Sonia Delaunay', 119.
92 M-A. Prevoteau, 'Le Spectacle "Paris 89"', in *Tour Eiffel 1889–1989*. Magazine created for the centenary of the tower and given to Paris's City Hall guests on 17 June 1989 (1989).

93 Buisine, 'Le Miroir aux Photographes', 77.
94 Scott, *The Cultural Economies of Cities*, 3–4.
95 Cocteau, *Antigone*, 97.
96 B. Quinn, *The Fashion of Architecture* (Oxford: Berg, 2003), 1; Breward, *Fashioning London*, 16.
97 Balzac, cited in Fortassier, *Ecrivains*, 51.
98 See, for instance, Radford, R. 'Dangerous Liaisons: Art, Fashion and Individualism', in *Fashion Theory*, 2 (2) (1998), 151–63.
99 G. Eiffel, cited in Lemoine, *Tour*, 33; Eiffel 'La Réponse de Gustave Eiffel'.
100 Nora, *Lieux de Mémoire* (Vol. 3).
101 C. Volckman, *Renaissance*. Pathé. DVD (2006).
102 Barthes, *Tour Eiffel*, 15, 20.
103 Stierle, *Mythe*, 28.
104 Quinn, *Fashion of Architecture*, 190.
105 De Jaeghere, 'L'esprit des Lieux', 3.
106 Solomon-Godeau, 'The Other Side of Venus', 114.
107 Le Corbusier, cited in Lemoine, *Tour*, 123.
108 See also Short, *Global Metropolitan*, 77.
109 See Burj Dubai, www.burjdubai.com.
110 Evans, 'Yesterday's Emblems and Tomorrow's Commodities', 94.
111 Jones, *Paris*, 392.
112 Loyrette, 'Tour Eiffel', 4284, 4285.

Conclusion

1 Flaubert, *Madame Bovary*, 112.
2 Bourdieu & Delsaut, 'Le Couturier et sa Griffe', 27.
3 Barthes, *The Fashion System*, 251.
4 Lefebvre, *The Production of Space*, 139.
5 http://blogs.lexpress.fr/cafe-mode; http://www.DeedeeParis.com; http://www.cachemireetsoie.fr.

BIBLIOGRAPHY

Adler, K., Hirshler, E.E., Weinberg, H.B., Park Curry, D., Rapetti, R., Riopelle, C. *Americans in Paris: 1860–1900*. London: The National Gallery Company Ltd. (2006).
Adler, K. '"We'll Always Have Paris": Paris as Training Ground and Proving Ground', in Adler, K., Hirshler, E.E., Weinberg, H.B., Park Curry, D., Rapetti, R., Riopelle, C. *Americans in Paris: 1860–1900*. London: The National Gallery Company Ltd. (2006).
Albert, P. *La Presse Française*. Paris: La Documentation Française (2004).
Alter, R. *Imagined Cities: Urban Experience and the Language of the Novel*. London: Yale University Press (2005).
Apollinaire, G. 'Zone', in *Alcools*. Paris: Gallimard (1971 [1920]).
— Caligramme in *les tours eiffel de robert delaunay*. Paris: Jacques Damase Gallery (1974 [1918]).
Appadurai, A. *Modernity at Large: Cultural Dimensions of Globalization*. Minneapolis: University of Minnesota Press (1996).
Aragon, L. 'La Tour Parle. A Robert Delaunay', in *les tours eiffel de robert delaunay*. Paris: Jacques Damase Gallery (1974 [1922]).
ARD *Paris Ile-de-France, Une Région Attractive*. (2005) www.paris-région.com/upload/document/D131.pdf. Accessed 18 July 2007.
Arnaud, C. 'Les Grands Boulevards', in *Paris Portraits*. Paris: Gallimard (2007).
Aubenas, S. 'Grands Couturiers: Figures du Chic', in Aubenas, S. & Demange, X. (eds) *Les Séeberger: Photographes de L'Elégance 1909–1939*. Paris: Seuil (2006).
— 'Les Séeberger Photographes de Mode', in Aubenas, S. & Demange, X. (eds) *Les Séeberger: Photographes de L'Elégance 1909–1939*. Paris: Seuil (2006).
Aubenas, S. & Demange, X. (eds) *Les Séeberger: Photographes de L'Elégance 1909–1939*. Paris: Seuil (2006).
Austin, J.L. *How to Do Things with Words*. London: Oxford University Press (1971).
Ballaster, R. Beetham, M. Frazer, E. Hebron, S. *Women's Worlds: Ideology, Femininity and the Woman's Magazine*. London: Macmillan (1991).
Balzac, H. de *La Femme comme il Faut*, in *Les Français Peints par Eux-Mêmes*. Paris: L. Curmer éditeur (1841).
— *Histoire et Physiologie des Boulevards de Paris*, in *Le Diable à Paris*. Paris: J. Hetzel (1846).
— *Physiologie de l'Employé*, in *Traite de la Vie Elégante. Physiologie du Rentier de Paris. Physiologie de l'Employé. Les Boulevards de Paris*. Paris: Bibliopolis (1911a [1841]).

Bibliography

— *Physiologie du Rentier de Paris*, in *Traite de la Vie Elegante. Physiologie du Rentier de Paris. Physiologie de l'Employé. Les Boulevards de Paris*. Paris: Bibliopolis. Also published as *Monographie du Rentier* in *Les Francais Peints par Eux-Mêmes*. Vol. 3. Paris: L. Curmer éditeur (1911b [1841]).
— *Physiologie de la Toilette*, in *Traité de la Vie Elégante. Physiologie de la Toilette. Scènes Eparses*. Paris: Nouvelle Société D'Edition (1946 [1830]).
— *Les Illusions Perdues*. Paris: Le Livre de Poche (1983 [1837–43]).
— *La Femme de Province*, in Balzac, H. de *La Muse du Département*. Paris: Gallimard, also in *Les Français Peints par Eux-Mêmes*. Paris: L. Curmer éditeur (1984a [1841]).
— *La Muse du Département*. Paris: Gallimard (1984b [1843–4]).
— *Ferragus*, in Balzac, H. de *Ferragus. La Fille aux Yeux d'Or*. Paris: Flammarion (1988a [1833]).
— *La Fille au Yeux d'Or*, in *Ferragus. La Fille aux Yeux d'Or*. Paris: Flammarion (1988b [1834–5]).
— *La Peau de Chagrin*. Paris: Gallimard (1999 [1831]).
— *Splendeurs et Misères des Courtisanes*. Paris: Gallimard (1999b [1843–7]).
— *La Duchesse de Langeais*, in *La Duchesse de Langeais. La Fille aux Yeux d'Or*. Paris: Flammarion (2001 [1834]).
— *Traité de la Vie Elégante*. Paris: Arthème Fayard (2002 [1830]).
Banville, T. de *Le Génie des Parisiennes*. Paris: Mille et Une Nuits (2002 [1881]).
Bancquart, M-C. *Paris des Surréalistes*. Paris: La Différence (2004).
— *Paris dans la Littérature Française après 1945*. Paris: La Différence (2006).
Barbera, A. 'Des Journaux et des Modes', in *Femmes Fin de Siècle*. Paris: Paris-Musées (1990).
Barbier, P. *A L'Opéra au Temps de Balzac et Rossini*. Paris: Hachette (2003).
Barrère, C. & Santagata, W. *La Mode*. Paris: La Documentation Française (2005).
Barthes, R. *La Tour Eiffel*, photographies d'André Martin. Paris: CNP/Seuil (1989 [1964]).
— *The Fashion System*. Berkeley: University of California Press (1990 [1967]).
Baudelaire, C. 'A une Passante', in *Tableaux Parisiens*, Baudelaire, *The Complete Verse*. Vol. I. London: Anvil Press (1991 [1860]).
— 'Le Peintre de la Vie Moderne', in *Baudelaire: Ecrits sur L'Art*. Paris: Le Livre de Poche (1999 [1863]).
Baudrillard, J. *The Consumer Society*. London: Sage (1998 [1970]).
— *Simulacra and Simulation*: The University of Michigan Press (1996 [1981]).
Baudriller, M. 'La Tentation du Luxe', in *Stratégies*, no. 1235 (3 May 2002).
Benjamin, W. *Charles Baudelaire*. Paris: Payot (2002 [1938–9]).
— *The Arcades Project*. London: Belknap Harvard (2003).
— 'Paris, the Capital of the Nineteenth Century', in Benjamin, W. *The Arcades Project*. London: Belknap Harvard (2003 [1935]).
Berger, J. *Ways of Seeing*. London: BBC, Penguin Books (1972).
Bergeron, L. *Les Industries du Luxe en France*. Paris: Editions Odile Jacob (1998).
Berman, M. *All that is Solid Melts into the Air*. London: Verso (1997).
Bernard, L. *The Emerging City: Paris in the Age of Louis XIV*. Durham: Duke University Press (1970).

Bernstein, R. *Fragile Glory: A Portrait of France and the French*. New York: Plume (1991).
Betterton, R. 'How do Women look? The Female Nude in the work of Suzanne Valadon', in Betterton, R. ed. *Looking On: Images of Femininity in the Visual Arts and the Media*. London: Pandora (1989).
— 'Introduction: Feminism, Femininity and representation', in Betterton, R. (ed.) *Looking On: Images of Femininity in the Visual Arts and the Media*. London: Pandora (1989).
Binh, N.T. 'Paris, a cinephile dream', talk delivered at the Institut Français, London (4 Feb. 2007).
— *Paris au Cinéma*. Paris: Parigramme (2005).
Billot, C. & Rey, C. 'Le Printemps', in *les Cathédrales du Commerce Parisien*. Paris: Action Artistique (2006).
Bory, J-L. 'De Licorne et de Métro', in *Les Parisiennes*. Paris: Musée Galliéra (1958).
Borrelli, L. 'Dressing Up and Talking about It: Fashion Writing in *Vogue* from 1968 to 1993', in *Fashion Theory*, 1 (3) (1997), pp. 247–60.
— *Fashion Illustration Now*. London: Thames and Hudson (2004).
Bourdieu, P. *Distinction: A Social Critique of the Judgement of Taste*. London: Routledge (1986).
— *The Logic of Practice*. Cambridge: Polity (1992).
— *The Field of Cultural Production*. Cambridge: Polity (1993).
— 'Haute Couture and Haute Culture', in Bourdieu, P. *Sociology in Question*. London: Sage (1993).
Bourdieu, P. *La Misère du Monde*. Paris: Seuil (1993).
Bourdieu, P. (with Boltanski, L., Castel, R., Chamboredon, J.C.) *Photography. A Middle-Brow Art*. Cambridge: Polity Press (1996).
Bourdieu, P. & Delsaut, Y. 'Le Couturier et sa Griffe: Contribution à une Théorie de la Magie', *Actes de la Recherche en Sciences Sociales*, 1, pp. 7–36 (1975).
Bouyala-Dumas, D. *La Mode en France*. Paris: AFAA (1997).
Bowlby, R. *Carried Away: The Invention of Modern Shopping*. London: Faber and Faber (2000).
Brassens, G. 'Les Passantes', http://www.paroles.net/chansons/1972.htm (Accessed 19 November 2007 [1972]).
Breton, A. *Les Vases Communicants*. Paris: Gallimard (1996 [1932]).
Breward, C. *Fashion*. Oxford: Oxford University Press (2003).
— *Fashioning London: Clothing and the Modern Metropolis*. Oxford: Berg (2004).
— 'Fashion's Front and Back: "Rag trade" Cultures and Cultures of Consumption in Post-war London *c*. 1945–1970', in *The London Journal*, 31 (1) (July 2006), pp. 15–40.
Bruzzi, S. *Undressing Cinema: Clothing and Identity in the Movies*. London: Routledge (1997).
Buisine, A. 'Le Miroir aux Photographes', in *Revue des Sciences Humaines*. 'La Tour'. April-June 1990, Vol. LXXXXXIV, no. 218 (1990).
Burj Dubai, www.burjdubai.com (Accessed 14 January 2009).
Butler, J. *Gender Trouble: Feminism and the Subversion of Identity*. London: Routledge (1999).

Caillois, R. *Le Mythe et l'Homme*. Paris: Gallimard (2002 [1938]).
Calle, S. *Sophie Calle m'As-Tu Vue*. Paris: Centre Pompidou, Editions Xavier Barral (2003).
Cendrars, B. 'Tour', in Cendrars, B. *Du Monde Entier. Poésies Complètes: 1912–1924*. Paris: Gallimard (1967 [1913]).
Cendrars, B. 'The Eiffel Tower', in Chefdor, M. (ed.) *Blaise Cendrars: Modernities and Other Writings*. London: University of Nebraska Press (1992 [1924]).
Charle, C. *Paris fin de Siècle: Culture et Politique*. Paris: Seuil (1998).
Charles-Roux, E. *Chanel*. London: Collins Harvill (1990).
Charon, J-M. *La Presse Magazine*. Paris: La Découverte (1999).
Chartier, R. 'Trajectoires et Tensions Culturelles de l'Ancien Régime', in Burguière, A. & Revel, J. (sous la dir. de) *Histoire de la France*. Paris: Seuil (2000).
Chaumette, X., Montet, E., Fauque, C. *Le Tailleur: Un Vêtement-Message*. Paris: Syros-Alternatives (1992).
Chéroux, C. 'Jacques Henri Lartigue: The Memory of the Instant', in D'Astier, M., Bajac, Q., Sayag, A. (eds) *Lartigue. Album of a Century*. Hayward Gallery Publishing (2004).
Citron, P. *La Poésie de Paris dans la Littérature Française de Rousseau à Baudelaire*. Vol. 1. Paris: Minuit (1961).
— *La Poésie de Paris dans la Littérature Francaise de Rousseau à Baudelaire*. Vol. 2. Paris: Minuit (1961).
Clair, R. 'Paris qui Dort', in *Under the Roofs of Paris*. The Criterion Collection. DVD (2002 [1924]).
Clark, T.J. *The Painting of Modern Life: Paris in the Art of Manet and his Followers*. London: Thames and Hudson (1985).
Clerc, T. *Paris, Musée du XXIe Siècle*. Paris: Gallimard (2007).
Cocteau, J. *Antigone. Les Mariés de la Tour Eiffel*. Paris: Gallimard (2000 [1921]).
Collard, S. 'The Elusive French Exception', in Godin, E. & Chafer, T. (eds) *The French Exception*. Oxford: Berghan Books (2004).
Compagnon, A. *Le Démon de la Théorie*. Paris: Seuil (1998).
Comptoir www.comptoirdescotonniers.com (Accessed 8 January 2007).
Conekin, B. & de la Haye, A. (eds) 'Vogue', in *Fashion Theory*, 10 (1/2), Special Double Issue, (March/June 2006).
Conley, T. 'Le Cinéaste de la Vie Moderne', in Sheringham, M. (ed.) *Parisian Fields*. London: Reaktion (1996).
Conor, L. *The Spectacular Modern Woman: Feminine Visibility in the 1920s*. Bloomington: Indiana University Press (2004).
Conrad, P. 'A Tale of Two Cities', in *The Observer* (9 October 2005).
Coppée, F. 'Sur La Tour Eiffel (Deuxième Plateau)', in Coppée, F. *Poésies 1886–1890*. Paris: Alphone Lemerre Editeur (1891 [1888]).
Corbin. A 'De l'Histoire des Representations à l'Histoire sans Nom', in *Politix*, 21, pp. 7–14 (1993).
— 'Paris-Province', in Nora, P. (sous la direction de) *Les Lieux de Mémoire*. Vol. 2. Paris: Gallimard (1997).

Courtivron, I. de, ' "Never Admit!": Colette and the Freedom of Paradox' in Chadwick, W. & True Latimer, T. (eds) *The Modern Woman Revisited: Paris Between the Wars*. New Brunswick: Rutgers University Press (2003).
Craik, J. *The Face of Fashion*. London: Routledge (1995).
Crash. 'Les Bandes-sons des Défilés', Paris, Women, Autumn-Winter 2006/2007. Issue 38 (Summer 2006).
Crewe, B. *Representing Men: Cultural Production and Producers in the Men's Magazine Market*. Oxford: Berg (2003).
Crewe, L. & Goodrum, A. 'Fashioning New Forms of Consumption: The case of Paul Smith', in Bruzzi, S. & Church Gibson, P. (eds) *Fashion Cultures: Theories, Explorations and Analysis*. London: Routledge (2000).
Cronin, A.M. *Advertising Myths: The Strange Half-Lives of Images and Commodities*. London: Routledge (2004).
Crowther, P. 'Sociological Imperialism and the Field of Cultural Production: The Case of Bourdieu', in *Theory, Culture and Society*, 11 (1994), pp. 155–69.
Davis, A. *Magazine Journalism Today*. Oxford: Focal Press (1994).
De Certeau, M. *The Practice of Everyday Life*. Berkeley: University of California Press (1988).
De Goncourt, E. & J. *Journal: Mémoires de la Vie Littéraire, 1887–1896*. Paris: Robert Laffont (2004 [1889]).
De Jaeghere, M. 'L'esprit des Lieux', in *Le Figaro Collection. L'Esprit des Lieux*. 'La Tour Eiffel/Paris 1900'. Paris: Gallimard (June 2006).
De Marly, D. *Worth: Father of Haute Couture*. London: Elm Tree Books (1980).
— *Louis XIV & Versailles*. London: B.T. Batsford Ltd (1987).
De Vogüé E.M. *Remarques sur l'Exposition du Centenaire*. Paris: Nourrit et Cie (1889).
Deguy, M. *Spleen de Paris*. Paris: Galilée (2001).
DeJean, J. *The Essence of Style: How the French Invented High Fashion, Fine Food, Chic Cafés, Style, Sophistication, and Glamour*. New York: Free Press (2006).
Delord, T. *Physiologie de la Parisienne*. Paris: Aubert et Cie, Lavigne (1841).
Delpierre, M. *Le Costume: La Haute Couture 1945–1995*. Paris: Flammarion (1997).
Delvau, A. *Les Plaisirs de Paris*. Paris: Achille Faure (1867).
Deyon, P. *Paris et ses Provinces*. Paris: Armand Colin (1992).
Donald, J. *Imagining the Modern City*. London: The Athlone Press (1999).
Dosse, F. *Histoire du Structuralisme I*. Paris: la Découverte (1992).
Dupuy-Berberian *Monsieur Jean, L'Amour, La Concierge*. Paris: Les Humanoïdes Associés (2005).
Edwards, B. '"We are Fatally Influenced by Goods Bought in Bond Street": London, Shopping, and the Fashionable Geographies of 1930s *Vogue*', in Conekin, B. & de la Haye, A. (eds) 'Vogue', in *Fashion Theory*, 10 (1/2), Special Double Issue, March/June (2006).
Edwards, T. *Men in the Mirror: Men's Fashion, Masculinity and Consumer Society*. London: Cassell (1997).
Eiffel, G. 'La Réponse de Gustave Eiffel', in Lemoine, B. *La Tour de Monsieur Eiffel*. Paris: Gallimard (2004 [1887]).

Bibliography

Evans, C. 'Yesterday's Emblems and Tomorrow's Commodities: The Return of the Repressed in Fashion Imagery Today', in Bruzzi, S. & Church Gibson, P. (eds) *Fashion Cultures: Theories, Explorations and Analysis*. London: Routledge (2000).
— *Fashion at the Edge: Spectacle, Modernity and Deathliness*. London: Yale University Press (2003).
Evans, C. & Thornton, M. *Women and Fashion: A New Look*. London: Quartet Books (1989).
Fallet, R. *Paris au Mois d'Août*. Paris: Denoël (2004 [1964]).
Falluel, F. 'Les Grands Magasins et la Confection Féminine', in *Au Paradis des Dames*. Paris: Paris-Musées (1990).
Fargue, L-P. 'De la Tour Eiffel', in Hamy, V. (textes et documents rassemblés par) *La Tour Eiffel*. Paris: La Différence (1980 [1939]).
— *Le Piéton de Paris*. Paris: Gallimard (2005 [1932]).
Fargues, N. *One Man Show*. Paris: Gallimard (2002).
Featherstone, M. *Consumer Culture and Postmodernism*. London: Sage (1994).
Felski, R. *The Gender of Modernity*. London: Harvard University Press (1995).
Figaro (le). Le Figaro Collection. *L'Esprit des Lieux*. 'La Tour Eiffel/Paris 1900' (June 2006).
Film France *Répartition Géographique des Tournages Cinéma et Télévision en 2005*. Document provided in October 2007 by Film France, Commission Nationale. Paris (2005).
Finkelstein, J. *After a Fashion*. Victoria: Melbourne U. Press (1996).
Flaubert, G. *Dictionnaire des Idées Reçues*. Paris: Mille et Une Nuits (2000).
— *Madame Bovary*. Paris: Gallimard (2001 [1856]). My translations adapted from Flaubert, G. *Madame Bovary*. Translated by Geoffrey Wall. London: Penguin (2003).
Fortassier, R. *Les Ecrivains Français et la Mode*. Paris: Puf (1988).
Foucault, M. *The Archaeology of Knowledge*. London: Routledge (1989).
— *The History of Sexuality*. Vol. 1. London: Penguin (1990).
— *Surveiller et Punir*. Paris: Gallimard (1993).
— *L'Ordre du Discours*. Paris: Gallimard (1999).
Français Peints par Eux-Mêmes (Les) Paris: L. Curmer éditeur (1841).
François-Poncet, J. *Rapport D'Information No 241*. Sénat. Paris: Délégation du Sénat à l'Aménagement et au Developpement durable du Territoire (2003).
Fumaroli, M. *L'Etat Culturel: Essai sur une Religion Moderne*. Paris: Fallois (1991).
— *Trois Institutions Littéraires*. Paris: Gallimard (1994).
Furbank, P.N. & Cain, A.M. [Trs.] *Mallarmé on Fashion*. Oxford: Berg (2004).
Gaillard, J. 'Préface', in Zola, E. *Au Bonheur des Dames*. Paris: Gallimard (1980).
Gaillard, M. *La Tour Eiffel*. Paris: Flammarion (2002).
Galignani *Galignani's New Paris Guide*. Paris: A. & W. Galignani & Co (1862).
Garb, T. *Bodies of Modernity: Figure and Flesh in Fin-de-Siècle France*. London: Thames and Hudson (1998).
Garcia, N. *Place Vendôme*. Artificial Eye. DVD (1998).
Gauthier, G. 'Culture et Citoyenneté', in Lecourt, D., Nicolet, C., Perrot, M., Poulat, E., Ricoeur, P. *Aux Sources de la Culture Française*. Paris: La Découverte (1997).
George, J. *Paris Province: de la Révolution à la Mondialisation*. Paris: Fayard (1998).

Gilbert, D. 'Urban Outfitting: The City and the Spaces of Fashion Culture', in Bruzzi, S. & Church Gibson, P. (eds) *Fashion Cultures: Theories, Explorations and Analysis.* London: Routledge (2000).

Girardet, S., Merleau-Ponty, C. Tardy, A. *Le Livre de la Tour Eiffel.* Paris: Gallimard (1996).

Girardin, D. de *Lettres Parisiennes du Vicomte de Launay.* I. Paris: Mercure de France (2004 [1836–40]).

Gleber, A. 'Female Flanerie and the Symphony of the City', in Katharina von Ankum (ed.) *Women in the Metropolis: Gender and Modernity in Weimar Culture.* London: University of California Press (1997).

Goffman, E. *The Presentation of Self in Everyday Life.* London: Penguin (1990).

Gourdon, E. *Physiologie du Bois de Boulogne.* Paris: Charpentier (1841).

Gow, D. '£2bn deal ends family feud', in *Guardian* (30 March 2005).

Gozlan, L. 'Ce que c'est qu'une Parisienne', in *Le Diable à Paris.* Paris: Hetzel (1845).

Grau, F-M. *La Haute Couture.* Paris: Puf (2000).

Gravier, J-F. *Paris et le Désert Français en 1972.* Paris: Flammarion (1972).

Greatrex, T. 'Rainwear', in Steele, V. (ed.) *Encyclopedia of Clothing and Fashion.* Vol. 3. New York: Thomson Gale (2005).

Green, N.L. *Ready-to-Wear, Ready-to-Work: A Century of Industry and Immigrants in Paris and New York.* London: Duke University Press (1997).

Greimas, A.J. *La Mode en 1830.* Paris: Puf (2000).

Gronberg, T. 'Sonia Delaunay's Simultaneous Fashions and the Modern Woman', in Chadwick, W. & True Latimer, T. (eds) *The Modern Woman Revisited: Paris between the Wars.* New Brunswick: Rutgers University Press (2003).

Grumbach, D. *Histoires de la Mode.* Paris: Seuil (1993).

Guillerm, J-P. 'Icones de Notre-Dames-La Tour: De Van Eyck à Robert Delaunay', in *Revue des Sciences Humaines.* 'La Tour'. Vol. LXXXXIV, no. 218 (April-June 1990).

Hahn, H. 'Fashion Discourses in Fashion Magazines and Madame de Girardin's *Lettres parisiennes* in July Monarchy France' (1830–1848). In *Fashion Theory*, 9 (2) pp. 205–28 (2005).

Hall-Duncan, N. *The History of Fashion Photography.* New York: Alpine Book Company (1979).

— 'Fashion Photography', in Steele, V. (ed.) *Encyclopedia of Clothing and Fashion.* New York: Thomson Gale (2005).

Hamy, V. (textes et documents rassemblés par) *La Tour Eiffel.* Paris: La Différence (1980).

Hancock, C. 'Capitale du Plaisir: the Remaking of Imperial Paris', in Driver, F. & Gilbert, D. (eds) *Imperial Cities: Landscape, Display and Identity.* Manchester: Manchester University Press (1999).

— *Paris et Londres au XIX Siècle: Représentations dans les Guides et Récits de Voyages.* Paris: CNRS Editions (2003).

Hansen, D. 'The portrait as a Work of Art', translation of 'Das Portrait als Kunstwerk', in *Monet und Camille.* Kunsthalle Bremen: Hirmer (2005).

Harouel, J.L. *Culture et Contre-Cultures.* Paris: Quadrige/Presses Universitaire de France (1998).

Harrison, M. *Appearances: Fashion Photography since 1945*. New York: Rizzoli (1991).
Harvey, D. *The Condition of Postmodernity*. Oxford: Blackwell (1990).
Heinich, N. *Les Ambivalences de l'Emancipation Féminine*. Paris: Albin Michel (2003).
Hermes, J. *Reading Women's Magazines*. Cambridge: Polity (1995).
Hesmondhalgh, D. *The Cultural Industries*. London: Sage (2002).
Higonnet, P. *Paris: Capital of the World*. London: Belknap Press (2002).
Hirshler, E.E. 'At Home in Paris', in Adler, K., Hirshler, E.E., Weinberg, H.B., Park Curry, D., Rapetti, R., Riopelle, C. *Americans in Paris*. London: The National Gallery Company Ltd (2006).
Huart, L. *Physiologie du Flâneur*. Paris: Lavigne (1841).
— *Physiologie de la Grisette*. Paris: Lavigne (1841).
Hughes, A. 'The City and the Female Autograph', in Sheringham, M. (ed.) *Parisian Fields*. London: Reaktion (1994).
Hugo, V. *Les Misérables*. I. Paris: Gallimard (1995 [1862]).
— *Les Misérables*. II. Paris: Gallimard (1995 [1862]).
Hussey, A. *Paris: The Secret History*. London: Viking (2006).
Huysmans, J-K. 'le fer', in *Certains*. Paris: P.-V. Stock (1904 [1889]).
Ihl, O. 'Les territoires du Politique', in *Politix*, 21 (1993), pp. 7–14.
Insee http://www.insee.fr/fr/ffc/chifcle_fiche.asp?ref_id=NATTEF13501&tab_id=337 (Accessed 20 July 2007).
Janin, J. 'La Grisette', in *Les Français Peints par Eux-Mêmes*. Paris: L. Curmer éditeur (1841).
Jenkins, R. *Social Identity*. London: Routledge (2004).
Jobling, P. *Fashion Spreads: Word and Image in Fashion Photography since 1980*. London: Routledge (1999).
Jones, C. *Paris: Biography of a City*. London: Penguin (2006).
Jones, J. *Sexing* La Mode: *Gender, Fashion and Commercial Culture in Old Regime France*. Oxford: Berg (2004).
Jost, H. 'Economie de la Presse de Mode', in Richoux-Bérard, S. & Bonnet, F. (eds) *Glossy*. Marseille: Images en Manoeuvres Editions (2004).
Journal Officiel 'Arrêté du 1er Mai 1886', in Hamy, V. (textes et documents rassemblés par) *La Tour Eiffel*. Paris: La Différence (1980 [1886]).
Kamitsis, L. 'La Mode au Musée, Paradoxe et Réalités', in *L'Album du Musée de la Mode et du Textile*. Paris: Union Centrale des arts Décoratifs (1997).
Kaplan, E.A. 'Is the Gaze Male?', in Kaplan, E.A. (ed.) *Feminism and Film*. Oxford: Oxford University Press (2000).
Kawamura, Y. *The Japanese Revolution in Paris*. Oxford: Berg (2004).
Kessel, J. *La Passante du Sans-Souci*. Paris: Gallimard (2002 [1936]).
Lahire, B. 'Champ, Hors-champ, Contrechamp', in Lahire, B. (sour la dir. de) *Le Travail Sociologique de Pierre Bourdieu. Dettes et Critiques*. Paris: La Découverte (1999).
Lamarthe. 'Elettra dans la Ville', by Zoé Cassavetes, www.Lamarthe.com/swf/index.php (2007).
Lançon, P. 'Belle de la Ville', in *Libération*, supplement 'Tentations', (Friday 6 October 2006).

Lanoux, A. 'Un certain Monsieur Eiffel', in Hamy, V. (textes et documents rassemblés par) *La Tour Eiffel*. Paris: La Différence (1980).
Le Petit Larousse, Paris: Larousse (1994).
Lecercle, J-P. *Mallarmé et la Mode*. Librairie Séguier (1989).
Lefebvre, H. *The Production of Space*. Oxford: Blackwell (1991).
Lehmann, U. *Tigersprung: Fashion in Modernity*. London: The MIT Press (2000).
Lemert, C.C. *French Sociology. Rupture and Renewal Since 1968*. New York: Columbia University Press (1981).
Lemoine, B. *La Tour de Monsieur Eiffel*. Paris: Gallimard (2004).
Les Parisiennes. Exhibition Catalogue. Paris: Musée Galliéra (1958).
Leroy, C. *Le Mythe de la Passante: De Baudelaire à Mandiargues*. Paris: Presses Universitaires de France (1999).
Loyrette, H. 'La Tour Eiffel', in Nora, P. (sous la dir. de) *Les Lieux de Mémoire*. Vol. 3. Paris: Quarto (2004).
Lurçat, H. & Lurçat, I. *Comment devenir une Vraie Parisienne*. London: Parigramme (2002).
Lury, C. *Consumer Culture*. Cambridge: Polity (1999).
— *Brands: The Logos of the Global Economy*. London: Routledge (2004).
Macdonald, M. *Representing Women: Myths of Femininity in the Popular Media*. London: Arnold (1995).
Macdonald, M. *Exploring Media Discourse*. London: Arnold (2003).
Marchand, B. *Paris, Histoire d'une Ville*. Paris: Seuil (1993).
Marrey, B. *Les Grands Magasins: des Origines à 1939*. Paris: Librairie Picard (1979).
Martin-Chauffier, G. *Une Vraie Parisienne*. Paris: Grasset (2007).
Martin-Fugier, A. *La Vie Elégante ou la Formation du Tout-Paris: 1815–1848*. Paris: Points (1990).
Maupassant, G. de *La Vie Errante*. Paris: Paul Ollendorff (1890).
McLoughlin, L. *The Language of Magazines*. London: Routledge (2000).
McRobbie, A. *British Fashion Design: Rag Trade or Image Industry?* London: Routledge (1998).
Mercier, L-S. *Le Tableau de Paris*. Paris: La Découverte (2000 [1781–88]).
Michelin *Guide de Tourisme. Paris*. Paris: Pneu Michelin (1994).
Miles, S. & Miles, M. *Consuming Cities*. New York: Palgrave (2004).
Milner, A. *Contemporary Cultural Theory*. London: UCL Press (1995).
Mistinguett 'Ça, c'est Paris', in http://www.paroles.net/pages/print=12135, 1927 (Accessed 28 April 2008).
Moeran, B. 'A Japanese Discourse of Fashion and Taste', in *Fashion Theory*, 8 (1) (2004), pp. 35–62.
Moore, K. *Jacques Henri Lartigue: The Invention of an Artist*. Princeton: Princeton University Press (2004).
Morais, C. *Pierre Cardin: The Man who Became a Label*. London: Bantam Press (1991).
Mordoch, L. Introduction to Miss.Tic, *Parisienne*. Diffusion Alternatives (2006).
Morin, E. *L' Esprit du Temps 1. Névrose*. Paris: Grasset (1982 [1962]).
Morrish, J. *Magazine Editing: How to Develop and Manage a Successful Publication*. London: Routledge (1996).

Bibliography

Moureau, F. *Le Mercure Galant de Dufresny (1710–1724) ou le Journalisme à la Mode.* Oxford: The Voltaire Foundation (1982).
Mulvey, L. 'Visual Pleasure and Narrative Cinema', in Mulvey, L. *Visual and Other Pleasures.* London: Macmillan (1989).
Multier, R. & Tévessin, G. *Un Taxi Nommé Nadir.* Paris: Actes Sud BD (2006).
Nava, M. 'Modernity's Disavowal: Women, the City and the Department Store', in Falk, P. & Campbell, C. (eds) *The Shopping Experience.* London: Sage (1997).
Nora, P. (sous la direction de). *Les Lieux de Mémoire.* Vol. 1. Paris: Gallimard (1997).
— (sous la direction de). *Les Lieux de Mémoire.* Vol. 2. Paris: Gallimard (1997).
— (sous la direction de). *Les Lieux de Mémoire.* Vol. 3. Paris: Gallimard (1997).
Ofr, 'Rue des Martyrs', in *Guide Paris.* Paris: Ofr (2005).
Orban, C. *Fringues.* Paris: Albin Michel (2002).
Orsenne, C. *La Tour Eiffel: Un Phare Universel.* Paris: Massin (2005).
Parkhurst Clark, P. *Literary France: The Making of a Culture.* Berkeley: University of California Press (1991).
Parkhurst Ferguson, P. *Paris as Revolution: Writing the Nineteenth-Century City.* Berkeley: University of California Press (1994).
Patureau, F. *Le Palais Garnier: Dans la Société Parisienne 1875–1914.* Liège: Mardaga (1991).
Peers, J. *The Fashion Doll: From Bébé Jumeau to Barbie.* Oxford: Berg (2004).
Peltier, M. 'La Dame de Fer', in *Le Figaro Collection. L'Esprit des Lieux.* 'La Tour Eiffel/Paris 1900'. Paris: Gallimard (Juin 2006).
Perrot, M. 'Le Genre de la Ville', in Perrot, M. *Les Femmes ou les Silences de l'Histoire.* Paris: Flammarion (2001).
Perrot, P. *Les Dessus et les Dessous de la Bourgeoisie.* Paris: Editions Complexe (1984).
Pinçon, M. & Pinçon-Charlot, M. *Sociologie de la Bourgeoisie.* Paris: La Découverte (2003).
Poe, E.A. 'The Purloined Letter', in *The Fall of The House of Usher and Other Writings.* London: Penguin (1986).
Poisson, G. *Les Grands Travaux des Présidents de la République.* Paris: Parigramme (2002).
Pollock, G. *Vision and Difference: Feminism, Femininity and the Histories of Art.* London: Routledge (1999).
Pons, P. 'A Tokyo, le luxe européen à la folie'. In *Le Monde* (19 February 2005).
Prendergast, C. *Paris and the Nineteenth Century.* Oxford: Blackwell (1992).
Prevoteau, M-A. 'Les Grands Moments de l'Histoire de la Tour Eiffel', in *Tour Eiffel 1889–1989*. Magazine created for the centenary of the tower and given to Paris's City Hall guests on 17 June 1989 (1989).
— 'Le Spectacle "Paris 89"', in *Tour Eiffel 1889–1989*. Magazine created for the centenary of the tower and given to Paris's City Hall guests on 17 June 1989 (1989).
— 'Symbole de la Lumière', in *Tour Eiffel 1889–1989*. Magazine created for the centenary of the tower and given to Paris's City Hall invitees on 17 June 1989 (1989).
Prigent, S. *Paris en Dates et en Chiffres.* Paris: Editions Jean-Paul Gisserot (2005).
Protestation, 'Protestation des Artistes', published in *Le Temps*, 14 February 1887, in Hamy, V. (textes et documents rassemblés par) *La Tour Eiffel.* Paris: La Différence (1980 [1887]).

Proust, M. *A L'Ombre des Jeunes Filles en Fleurs*. Paris: Gallimard (1997 [1919]).
— *Du Côté de chez Swann*. Paris: Gallimard (1999 [1913]).
— *Le Côté de Guermantes*. Paris: Gallimard (2000 [1920]).
Prouvost, C. *Le Look de Paris*. Paris: Hermé (1986).
Prudhomme, S. 'Discours prononcé au 13e banquet de la Conférence 'Scientia' offert à Monsieur Eiffel le 13 Avril 1889, La Revue Scientifique, 20 avril 1889', in Hamy, V. (textes et documents rassemblés par) *La Tour Eiffel*. Paris: La Différence (1980 [1889]).
Quinn, B. *The Fashion of Architecture*. Oxford: Berg (2003).
Rabine, L. 'A Woman's Two Bodies: Fashion Magazines, Consumerism, and Feminism', in Benstock, S. & Ferriss, S. (eds) *On Fashion*. New Brunswick: Rutgers University Press (1994).
Radford, R. 'Dangerous Liaisons: Art, Fashion and Individualism', in *Fashion Theory*, 2 (2) (1998), pp. 151–63.
Radner, H. 'On the Move: Fashion Photography and the Single Girl in the 1960s', in Bruzzi, S. & Church Gibson, P. (eds), *Fashion Cultures: Theories, Explorations and Analysis*. London: Routledge (2000).
Rawsthorn, A. *Yves Saint Laurent: A Biography*. London: Harpers Collins (1996).
Ribes-Tiphaine, A. *Paris Chic and Trendy*. Paris: Parigramme (2006).
Rice, S. *Parisian Views*. London: MIT Press (1997).
Rifkin, A. *Street Noises: Parisian Pleasure, 1900–1940*. Manchester: Manchester University Press (1995).
Rigby, B. *Popular Culture in Modern France*. London: Routledge (1991).
Roberts, M.L. 'Samson and Delilah Revisited', in Chadwick, W. & True Latimer, T. (eds) *The Modern Woman Revisited: Paris between the Wars*. New Brunswick: Rutgers University Press (2003).
Rocamora, A. (2002) 'Le Monde's *Discours de Mode*: Creating the *Créateurs*', in *French Cultural Studies*, 13 (1), pp. 83–98.
Rocamora, A. & O'Neill, A. (2008) 'Fashioning the Street: Images of the Street in the Fashion media', in Shinkle, E. (ed.) *Fashion as Photograph: Viewing and Reviewing Images of Fashion*. London: I.B.Tauris.
Rohmer, E. *L'Amour L'Après-Midi*. Arrowfilms. Fremantle Home Entertainment. DVD (2003 [1972]).
Rustenholz, A. *Parisienne(s)*. Paris: Parigramme (2001).
Saiki, S. *Paris dans le Roman de Proust*. Paris: Sedes (1996).
Savidan, D. 'La Création en Capitale', in *Le Figaro* (23 January 2003).
Scheibling, J. 'La France. Permanences et Mutations'. http: //pweb.ens-Ish.fr/omilhaud/scheibling.doc (Accessed 30 April 2007).
Scott, A.J. *The Cultural Economies of Cities*. London: Sage (2000).
Sénat, 'Banquet Républicain', in http://www.14juillet.senat.fr/banquet2000/banquet.html. (Accessed 6 February 2007).
Sennett, R. *The Fall of Public Man*. London: Faber and Faber (1993).
Sessi, *La Mode en Chiffres*. Edition 2005. Service des Etudes et des Statistiques Industrielles. Ministère de L'Economie des Finances et de l'Industrie. Paris (2005).
Sex and the City, Episode 17, in The complete season 6, disc Five, HBO. DVD (2004).

Sheringham, M. 'City Space, Mental Space, Poetic Space: Paris in Breton, Benjamin and Réda', in Sheringham, M. (ed.) *Parisian Fields*. London: Reaktion (1996).
Short, J.R. *Global Metropolitan: Globalizing Cities in a Capitalist World*. London: Routledge (2006).
Simmel, G. 'The Sociology of Space', in Frisby, D. & Featherstone, M. (eds) *Simmel on Culture*. London: Sage (1997).
Solomon-Godeau, A. 'The Other Side of Venus: The Visual Economy of Feminine Display', in de Grazia, V. *The Sex of Things: Gender and Consumption in Historical Perspective*. London: University of California Press (1996).
Soupault, P. *Les Dernières Nuits de Paris*. Paris: Gallimard (1997 [1928]).
Stahl, J.-P. 'Les Passants à Paris', in *Le Diable à Paris*. Paris: Hetzel (1845).
Steele, V. *Paris Fashion: A Cultural History*. Oxford: Berg (1998).
— 'Femme Fatale: Fashion and Visual Culture in Fin-de-siècle Paris', in *Fashion Theory*, 8 (3) (2004), pp. 315–28.
Stierle, K. *Le Mythe de Paris: La Capitale des Signes et son Discours*. Paris: Ed. de la Maison des Sciences de L'Homme (2001).
Stievenard, J. 'Les Ecoles de la Tour', in *Revue des Sciences Humaines*. 'La Tour'. April-June 1990, Vol. LXXXXXIV, no. 218 (1990).
Sulitzer, P-L. 'La Tour Eiffel', in *Tour Eiffel 1889–1989*. Paris: Média Plus Vingt (1989).
Sylvain, D. *Travestis*. Paris: J'ai Lu (1998).
Tabak, S. *Chic in Paris: Style secrets and Best Addresses*. Seline Edition (2006).
Tardi, j. *M'As-tu Vu en Cadavre?* D'après le roman de Léo Malet. Casterman (2000).
Tester, K. 'Introduction', in Tester, K. (ed.) *The Flâneur*. London: Routledge (1994).
Tester, K. (ed.) *The Flâneur*. London: Routledge (1994).
Tétart-Vittu, F. 'Le Chic Parisien', in *Femmes Fin de Siècle, 1885–1895*. Paris: Editions Paris-Musées (1990).
— 'Le Catalogue', in *Au Paradis des Dames: Nouveautés, Modes et Confections, 1810–1870*. Paris: Paris- Musées (1992).
Texier, E. *Tableau de Paris*. Tome Premier. Paris: Paulin et le Chevalier (1852).
Thomas, G.M. 'Women in Public in the Parks of Paris', in D'Souza, A. & McDonough, T. (eds) *The Invisible Flâneuse?: Gender, Public Space, and Visual Culture in Nineteenth-century Paris*. Manchester: Manchester University Press (2006).
Tibéri, J. 'Paris, Capitale de la Mode, "Think Fashion"', Conférence de Presse. Intervention de Paris. Dossier de Presse, Mairie de Paris (Friday 14 January 2000).
Tiersten, L. *Marianne in the Market: Envisioning Consumer Society in Fin-de-Siècle France*. London: University of California Press (2001).
Tietjens Meyers, D. *Gender in the Mirror: Cultural Imagery and Women's Agency*. Oxford: Oxford University Press (2002).
TourEiffel.http://www.tour-eiffel.fr/teiffel/fr/actualites/page/news_list.html?year=2004 (Accessed 11 July 2005).
TourEiffel. http://www.tour-eiffel.fr/teiffel/fr/print/index.html?current_url (Accessed 7 December 2006).
Troy, N.J. *Couture Culture: A Study in Modern Art and Fashion*. London: The MIT Press (2003).

Truffaut, F. *L'Homme qui Aimait les Femmes* [The Man who Loved Women]. MGM. World Films. DVD (2001 [1977]).
Tseëlon, E. *The Masque of Femininity*. London: Sage (1997).
Tudor, A. *Decoding Culture*. London: Sage (1999).
Valeurs Actuelles 'Prêt-à-porter. Paris sort ses Griffes' (30 August 2002).
Vallès, J. (2007 [1882–3]) *Le Tableau de Paris*. Paris: Berg International.
Varda, A. *Cléo from 5 to 7*. The Criterion Collection. DVD (2000 [1962]).
Vasseur, N. *Il Etait une Fois le Sentier*. Paris: Liana Lévi (2000).
Veillon, D. *La Mode sous L'Occupation*. Paris: Payot (1990).
V.F.M. 'L'Etranger à L'Exposition'. *L'Exposition de Paris*, in Hamy, V. (textes et documents rassemblés par) *La Tour Eiffel*. Paris: La Différence (1980 [1889]).
Vigarello, G. *Histoire de la Beauté*. Paris: Seuil (2004).
Vigny, A. de 'Paris', in *Poemes Antiques et Modernes*. Paris: Hachette (1914 [1831]).
Vilmorin, L. de *Articles de Mode*. Paris: Le Promeneur (2000).
Vittu, J-P. 'Le Printemps de la Presse Mode', in *Au Paradis des Dames*. Paris: Paris-Musées (1992).
Volckman, C. *Renaissance*. Pathé. DVD (2006).
Waquet, D. & Laporte, M. *La Mode*. Paris: Puf (1999).
Wargnier, S. 'Eloge de l'Intermédiaire', in *Glossy*. Musée de la Mode de Marseille: Images en Manoeuvres Editions (2004).
White, E. *The Flâneur: A Stroll through the Paradoxes of Paris*. London: Bloomsbury (2001).
Williams, R.H. *Dream Worlds*. Berkeley: University of California Press (1991).
Wilson, E. *Adorned in Dreams: Fashion and Modernity*. London: Virago (1987).
— *The Sphinx in the City*. London: Virago (1991).
— *The Contradictions of Culture: Cities, Culture, Women*. London: Sage (2001).
Winship, E. *Inside Women's Magazines*. London: Pandora (1987).
Winship, J. 'What's Wrong with Images of Women?', in Betterton, R. (ed.) *Looking On: Images of Femininity in the Visual Arts and Media*. London: Pandora (1989).
Wolff, J. 'The Invisible Flâneuse: Women and the Literature of Modernity', in Wolff, J. *Feminine Sentences: Essays on Women and Culture*. Cambridge: Polity (1990).
— 'Gender and the Haunting of Cities', in D'Souza, A. & McDonough, T. (eds) *The Invisible Flâneuse?: Gender, Public Space, and Visual Culture in Nineteenth-century Paris*. Manchester: Manchester University Press (2006).
Yonnet, P. *Jeux, Modes et Masses: 1945–1985*. Paris: Gallimard (1985).
Zola, E. *Au Bonheur des Dames*. Paris: Gallimard (1996 [1882]).
— *La Curée*. Paris: Le Livre de Poche (1996 [1871]).
— *Paris*. Paris: Gallimard (2002 [1898]).
— *Nana*. Paris: Gallimard (2003 [1880]).

INDEX

Numbers in bold signify illustrations

Ackerman, Michael 112, **113**
A la Recherche du Temps Perdu see
 Proust, Marcel
Apollinaire, Guillaume
 Alcool 159
Aragon, Louis 169
Arnaud, Claude
 Paris Portraits 14
Auteuil racetrack 44
Avenue du Bois de Boulogne (*see also*
 Avenue Foch) 42, 43
Avenue Foch 31, 42

Bag (magazine) 81–82, **82**
bals Musard 36
Balzac, Honoré de
 Comédie Humaine 14, 46
 Ferragus 70, 114, 129
 La Duchesse de Langeais 90
 La Femme de Province 13, 14, 91
 La Fille aux Yeux d'Or 15, 70, 90–91
 La Peau de Chagrin 38, 100
 Les Illusions Perdues 40–41, 132
 in *Madame Bovary* 19
 on Parisian women 20, 90–91, 105
 Physiologie du Mariage 13
 Physiologie du Rentier de Paris 13
 portrayal of Paris in 36
 on *la province* 73
 Splendeurs et Misères des Courtisanes
 37, 91, 97, 117
 Traité de la Vie Elégante 38, 40, 66,
 175
Banville, Théodore de
 Le Génie des Parisiennes 100, 143
barricades 7
Barthes, Roland
 La Tour Eiffel 160, 162, 165, 167, 178
 The Fashion System 60, 67, 74, 75,
 106, 186
Baudelaire, Charles
 A une Passante 126, 131, 134, 138
 on flaneurs 130,
 on modernity 127
 'Painter of Modern Life' 129
 Tableaux Parisiens 133, 134–135
Beaubourg *see* Pompidou Center
Benjamin, Walter 129–130, 160
Berain, Jean 25
Bergé, Pierre 32
Bernstein, Richard
 Fragile Glory 113
Bertin, Rose 26
Blumenfeld, Erwin **170**, 171
Bon Marché, Le (department store)
 46, 47
Bois de Boulogne 41–44
Boisron, Michel
 Une Parisienne 117
Boulevard des Italiens 19, 45
Bourdieu, Pierre
 on discourse 54–56, 59–60, 185
 on 'fields' 28, 39, 49, 76
 on linguistic signs 60, 74

social oppositions, cultural
 reproduction of 11
on symbolic production 55, 56, 57,
 74, 185
Bovary, Madame *see* Madame Bovary;
 Flaubert, Gustave
Bresson, Robert
 Les Dames du Bois de Boulogne 43
Breton, André 45, 70, 138, 142
 Nadja 110
Brillat-Savarin, Jean Anthelme
 Physiologie du goût 13

Cabinet des Modes 109
Calle, Sophie
 'A Room with a View' 159
Chabrol, Claude 22
Chambre syndicale de la couture 29, 30, 39
'Chambre syndicale de la confection et de la couture pour dames et fillettes' *see* Chambre syndicale
'Champs-Elysées' (scent) 119
Charles Jourdan (shoes) 178, 179, 181, **182**
Charles X 14
Chatrouse, Emile François
 Une Parisienne **93**
Chirac, Jacques 7, 31
Clair, René
 Les Grandes Manoeuvres 93
 Les Toits de Paris 121
 'Paris qui Dort' 159, 161–162, 163, 171
Clerc, Thomas
 Paris, Musée du XXI Siècle 130
'Crieries de Paris' 12
Colbert, Jean-Baptiste 25–26
Collège de France 9
Comédie Humaine 14, 46
Comité Colbert 25
Commune 7
Coppée, François 157

Cordonnier, Ed. 137
courtisane see courtesan
courtesan 20, 27, 96
couturier, rise of 28–29
Cresson, Edith 31
Curran, Charles Courtney 21

DEFI 31
'défilé de Longchamp' 41
De Girardin, Delphine 11, 44–45, 73
Deguy, Michel
 Spleen de Paris 9, 167
de Jaeghere, Michel 180
de Jandun, Jean
 L'Eloge de Paris 12, 185
Delaunay
 Robert and Sonia 21, 164
 Robert
 La Femme et la Tour 167, **168**, 173
 La Ville de Paris 167–168, **168**, 173
 Portrait of Madame Mandel 169
 Sonia 169
Delord, Taxile
 Physiologie de la Parisienne 90, 91–92, 100, 118
Delsaut, Yvette
 Le Couturier et sa Griffe 59–60, 76 *see also* Bourdieu, P
Delvau, Alfred
 Les Plaisirs de Paris 18–19, 20, 46
de Nerval, Gérard 134
Deneuve, Catherine 94, 98
 Belle de Jour 94, 103, 115
 Place Vendôme 50–51, 94
 in *Le Dernier Métro* 112
Dentelle de Calais **176**, 177
department stores 46–47
de Vigny, Alfred
 'Paris' (poem) 16
de Villeneuve, Guillaume 12
de Vilmorin, Louise 72
Dior Christian 39, 49, 50, 51
Divorce, Le (film) 22, 51

Index

Doisneau, Robert 22
Doillon, Lou 124
Duran, Carolus
 Portrait de Madame Edgar Stern 92–93, **93**

Eiffel, Gustave 157, 163
Eiffel Tower
 lieu de mémoire 9
 in fashion 156–184
 history of 156–158
 illumination of 164
'Elettra dans la Ville' 149–150
Elle (magazine) 61, 65, 74, 83, 98, 99, 154
Elysée Palace 31
'*esprit*' 65
 definition 72
 of Paris as creative source 71–74
Expositions (Universelles), Paris 166
 1855 7
 1889 156–157, 166
 1900 92

Fallet, René
 Paris au Mois d'Août 135
Fargues, Nicolas
 One Man Show 38–39
fashion plates 27
Faubourg Saint-Germain 26, 27
Fédération française de la couture 29, 30
'Fédération française du prêt-à-porter féminin' 30
flâneurs 71, 114, 129–132, 133–134, 135, 149
Flaubert, Gustave 10, 14, 19
 L'Education Sentimentale 95
 Madame Bovary
'Fondation Louis Vuitton' 44
Fonssagrives, Lisa **170**
Fontaine, Anne
 Nathalie 115
Foire Saint-Germain 48

Foucault, Michel
 on discourse 54, 56–57, 58, 60
 Archaeology of Knowledge 57
French Revolution 4, 5, 6, 13, 16, 27
Fronde uprisings 119

Galeries Lafayette 46, 47, 48
Galignani, *New Paris Guide* 28
Galliano, John 39, 44, 70
Garcia, Nicole
 Place Vendôme 50–51
Garnier, Charles 36, 157
Gaultier, Jean-Paul 33, 44, 173, **174**
Gauthier, Guy 72
Gavarni 87
Gazette, La 66
Giraudoux, Jean 165–166
Giron, Charles
 Femme aux gants (La Parisienne) 92, **93**
Gissey, Henry 25
Givenchy, Hubert de 70
Goffmann, Erving
 The Presentation of Self in Everyday Life 52–53, 74
Goncourt brothers 14, 100
Gourdon, Edouard
 Physiologie du Bois de Boulogne 41–42
Grand Boulevard 7
grands travaux 8
griffe (fashion label) 54–55
'griffe spaciale' 50
grisette 13, 27, 96, 143
Grumbach, Didier 78
Guichard, Jean 110
'Guggenheim effect' 183

Harouel, Jean-Louis 72
Hausmann, Baron Georges 7, 8, 12, 19, 42
Heine, Heinrich 16
Henry IV 6

Hepburn, Katharine 51
Hetzel, Jules
　Les Passants à Paris 132
Hugo, Victor 14,
　Les Misérables 15, 21
　Notre-Dame De Paris 162

Impressionists 87
Industrial Revolution, influence on fashion 24, 111–112, 127
Institut Français de la Mode 31, 34

James, Henry
　The Ambassadors 17
Janin, Jules 96

Kessel, Joseph
　La Passante du Sans-Souci 138
Kiraz, Edmond 143
　Les Parisiennes **88**, 89, 117, 122
Klapisch, Cédric
　Riens du Tout 121

La Dernière Mode (magazine) 40
La Famille (magazine) 66
Lamarthe 149–150
La Mode (magazine) 66
Lançon, Philippe 112–113, 141–142
Lang, Jack 31
La Parisienne 86–125
　as cover girl 94–95, **94**
　as player in the fashion trade 95–96
　as prostitute 115–116
　in visual arts 86–90
La passante 126–155, **128**
　in fashion, 136–145, **138, 139, 140**
　object of gaze 145–146, **146**
Lartigue, Jacques Henri 42, **43**
La Villette 8
Lefebvre 165, 186
L'Eloge de Paris 12
Lelong, Lucien **170**, 171
Le Mercure Galant 27

Lemoine
　on Eiffel Tower 167, 169
Le Monde (newspaper) 77–78
Leroy, Claude
　Le Mythe de la Passante 129, 131–132, 144
　Les Français Peints Par Eux-Mêmes 13, 144
Les Misérables 15, 21
Le Tableau de Paris 12, 13, 16
letters pages 67–68
Lettres d'un Sicilien à ses Amis 25
Lieux de Mémoire 9
L'Officiel de la Couture et de la Mode de Paris (L'Officiel) (magazine) 67, 68, 139
London, as threat to Paris 77, 85
Longchamp racetrack 41, 44
lorette 96
Louis XIV 4, 6, 10, 24, 25, 26, 27
Louis XV 4
Louis XVI 4
Louvre 6, 8, 9, 26, 31, 39
'Love in Paris' (scent) 174, 175
Lurçat, Hélène & Irène
　Comment Devenir une Vraie Parisienne 99, 118
Lutecia/Lutèce 3, 4
Luxembourg gardens 41

Madame Bovary 10, 19, 131
magazine industry, French 60–61, 67–68
Mallarmé, Stéphane 40
Manet, Edouard
　La Parisienne 87, 108, **108**
Marais district 26
Marie Antoinette 26
Martin, André 160
Martin-Chauffier, Gilles
　Une Vraie Parisienne 92, 113, 120
Maupassant, Guy de 157, 164
mayoral receptions, Grand Palais, 6

Index

Mercier, Louis-Sébastien
 Le Tableau de Paris 12, 13, 15, 71, 73, 101
Mercure Galant 66
Michelin, guide vert 20
midinette 143
'Midnight Poison' (scent) 39
Milan, as threat to Paris 76, 77, 78, 85
Miss.Tic 89–90, **89**, 117, 120
Mistinguett 119
Mitterand, François 8, 31
 Danielle 31, 32
Monet, Claude
 Camille 87, **87**
Montaigne 4
Moral, Jean 137
Mori, Hanae 34
Munkacsi, Martin 137
Musée du quai Branly 8
Musée des Arts de la Mode *see* Musée de la Mode et du Textile
Musée de la Mode et du Textile 31, 34, 39
Musée Galliéra 34

Nadelman, Elie
 'La Femme Française' 100
Napoleon III 6–7, 8, 19, 42
New York, as threat to Paris 78–79, 85
Ninotchka (film) 22, 51
Nouvelle Vague 22

Officiel see L'Officiel
Opera 36–38, 39
Orban, Christine
 Fringues 47

Palais de Chaillot 31, 170
Palais Garnier (*see also* Opera) 32, 36, 39, 157
Palais Royal 4, 27, 31
'panoplies' 122
Panthéon 9

paper dolls 122, 123
Parc Monceau 40
'Paris' (scent) **171**, 180–181, **181**
Paris,
 boulevards 7, 19, 45–46
 as 'capital of the 19th century' 15–16, 179, 180
 in cinema 22, 51, 121
 as city of pleasure 18, 19
 department stores 46–47
 and Enlightenment 15–16
 as fashion city 24–53
 guidebooks to 18, 19, 20, 42, 45–46, 49–50, 99
 history 3–8, 24–30
 illumination of 7, 15–16, 18, 48, 179
 luxury goods trade, rise of 25–26
 in painting 21
 in photography 21–22
 as prostitute 19
 as 'tableau' 12–13, 16
 university *see* University of Paris
 as world capital 15, 16, 69
'*Paris, capitale de la Mode*' (Paris City council initiative) 32
'Paris, c'est la Mode' (tv program) 67
Paris Chic and Trendy (guidebook) 49, 99, 120
parisianisme 11
Parisienne *see* 'la Parisienne'
'Paris Modes' (tv program) 67
Paris/*province* split 3, 5, 9, 10, 11, 12, 17, 38, 68, 186
passante *see* 'la passante'
Philip II Augustus 6
Physiologie du Mariage 13
physiology genre 13
Piaf, Edith 22, 119
Place Vendôme 48, 50, 81
Plaisirs de Paris 18, 20
Poe, Edgar Allen
 'The Man of the Crowd' 128
Pol, Antoine

'Les Passantes' 132–133
Pompidou Center 8
Pompidou, Georges 8
'Portraits of Left Bank Women'
 (exhibition) 120, **122**
prêt-à-porter 28, 29, 33
Printemps store 46, 183
Proust, Marcel
 A la Recherche du Temps Perdu 27, 42
 A L'Ombre des Jeunes Filles en Fleurs 39, 43
 Du Côté de chez Swann 42–43
 Le Côté de Guermantes 35, 37, 73
 portrayal of Paris in 36, 37, 40
 on Parisian women 92
province, relationship with Paris *see* Paris/*province* split

Raymond, Emmeline 96
Realists 87
Réda, Jacques 110
Renaudot, Théophraste 66
Renoir, Auguste
 Lise 87
 La Parisienne 87
Republican celebrations 6
revolution, French, *see* French Revolution
revolution, 1830 13, 14, 15, 16
Ribes-Tiphaine, Adrienne *see* Paris Chic and Trendy
right bank *see rive droite*
rive droite 48–49
rive gauche 49
'Rive Gauche' (scent) 119
Rohmer, Eric
 L'Amour l'Après-Midi 136, 138
Roitfeld, Carine 102
Rousseau, Jean-Jacques
 La Nouvelle Eloise 109
Rubempré, Lucien de 40, 132
rue de la Coutellerie 26
rue de la Paix 48

rue Saint-Honoré 26
Rustenholz
 Parisiennes 109, 142–143

'Salon International de la Lingerie'
 (advertisement) 172, **173**
salons (trade exhibitions) 33
salons 72–73
Samaritaine, La (department store) 46
Sargent, John Singer
 In the Luxembourg Gardens 41, **41**
 Madame X (Madame Pierre Gautreau) 88–89, **88**, 92
Second Empire 5
Séeberger brothers 44, 137
Sennett, Richard
 The Fall of Public Man 127–128
Sentier, le 51–52
Sex and the City 51
shopping maps 81–83, **82**
'Soir de Paris' (scent) 79
Sorbonne 4
Soupault, Philippe
 Les Dernières Nuits de Paris 135–136, 159
Stahl, J-P *see* Hetzel
Stendhal 36
Sternberg Jacques
 'Les Citadines' 134
Stiletto (magazine) 65, 67, 68
St Laurent, Yves *see* Yves St Laurent
Surrealists 17, 45
Sylvain, Dominique
 Travestis 134, 138
symbolic production 54–56
système étoilé 5

Tabak, Susan
 Chic in Paris: Style secrets and Best Addresses 99
tailleur, le (skirt-suit) 107, 108
Tautou, Audrey 119
Texier, Edmond

Index

Tableau de Paris 6, 13, 16
Théatre de la Mode 30
Thurman, Uma 173, **173**
Tibéri, Jean 32
Tissot, James 114–115
trench, le (trenchcoat) 107, 108
Triangle d'Or 50, 51
trottin 96, 143
Truffaut, François
 L'Homme qui Aimait les Femmes 136, 138, 141
 Les 400 Coups 163
Tuileries gardens 40

University of Paris 5

Vallès, Jules
 Tableau de Paris 13
Varda, Agnès
 Cléo de 5 à 7 136, 138, 145
Versailles 4, 10, 26

Vogue Paris
 history 67–68
 key place in fashion industry 86, 95
 Parisiennes in 101, 102, 103, 105
Volckman, Christian
 Renaissance 178

White, Edmund
 The Flâneur 130
Wilson, Lambert 142
Worth, Charles Frederick 29, 33, 48, 97

Yves St Laurent 32, 43, 94, 121, 125, 174, **175**, 180

Zola, Emile
 Au Bonheur des Dames 47
 La Curée 42, 97
 L'Oeuvre 114
 on Eiffel Tower 163
 representations of Paris in 15, 70